THE ALLURE OF

French

AND

ITALIAN

DÉCOR

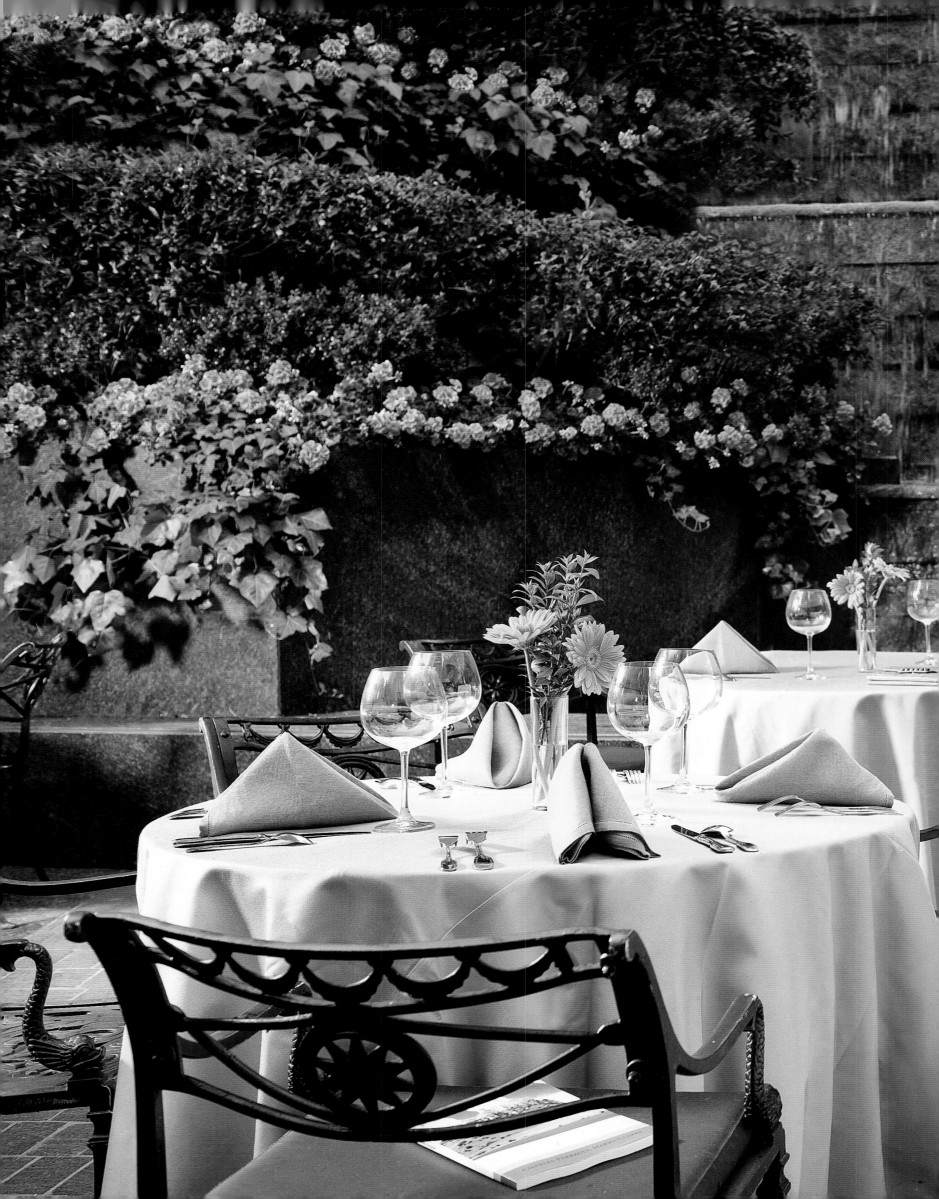

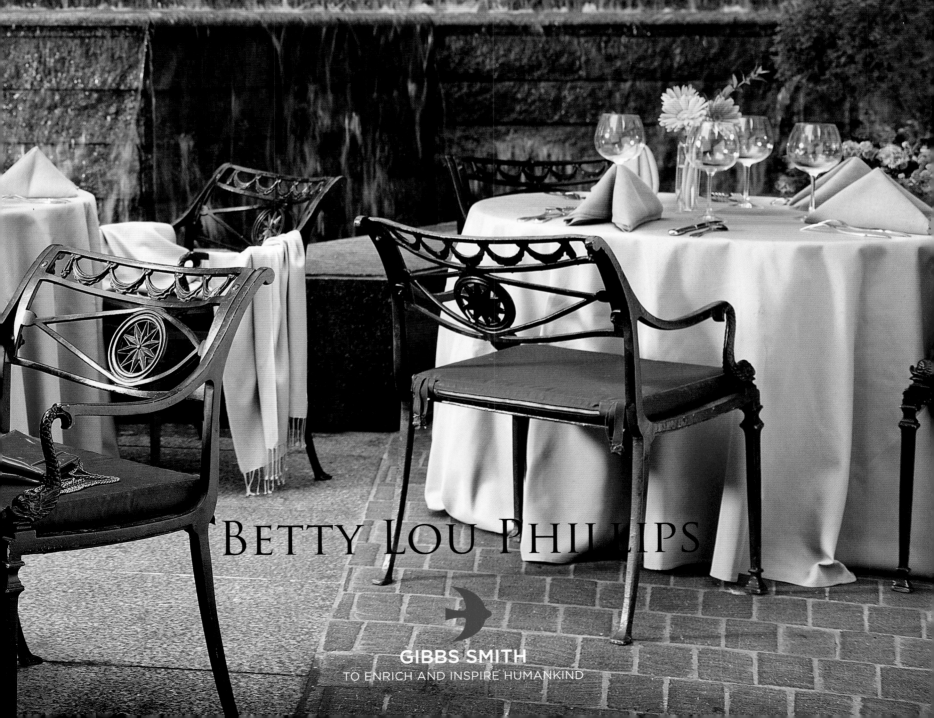

THE ALLURE OF
French
AND
ITALIAN
DÉCOR

BETTY LOU PHILLIPS

GIBBS SMITH
TO ENRICH AND INSPIRE HUMANKIND

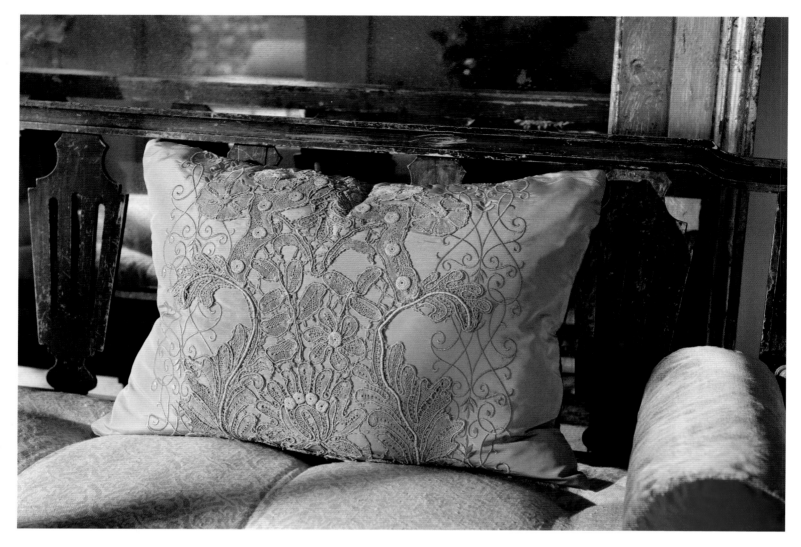

In seventeenth-century France, lace was a status symbol of sorts worn by both men and women, including the kings of France. A century later, it began satisfying the cravings of women who longed for exquisite lingerie. Commonplace or not, a discreet tier of hand-embroidered antique lace gives a pillow an identity that does not escape notice.

COVER: Elevating the art of interior design: *passementerie* with an aristocratic air—fashioned in a modest atelier outside Rome—and noble fabric, also made in Italy for Christopher Hyland, NYC.

BACK JACKET: Antique gilt-edged mirrors add historical cachet while prompting memories of time spent in Barcelona, Spain. In a nod to Louis XV, a painted *canapé* (settee) from Jacqueline Adams Antiques, Atlanta, dons a Jab USA silk.

PRECEDING OVERLEAF: In gastronomically obsessed Paris—where there is more than a hint of snobbery—it is always, "Where did you dine?" not, "Where did you eat?"

FACING: Unassuming luxury dresses a fashion-forward gallery with floor-to-ceiling French doors that open to verdant grounds. A pair of nineteenth-century settees from Turin—in the Piedmont region of Italy—procured from Watkins Culver, Houston, wears "Venezia" by Pintura Studio, NYC. Bolsters in Rose Cumming's silk velvet help pull together the look, assisted, of course, by mirrors from M. Naeve, Houston, and a multicultural mix of French and Italian antique candlesticks purchased on shopping forays abroad. Pendants by Paul Ferrante, Los Angeles, and nineteenth-century Italian double-arm sconces from Château Domingue, Houston, cast warm light on the series of structural ribs dividing the barrel vault ceiling into three equal segments.

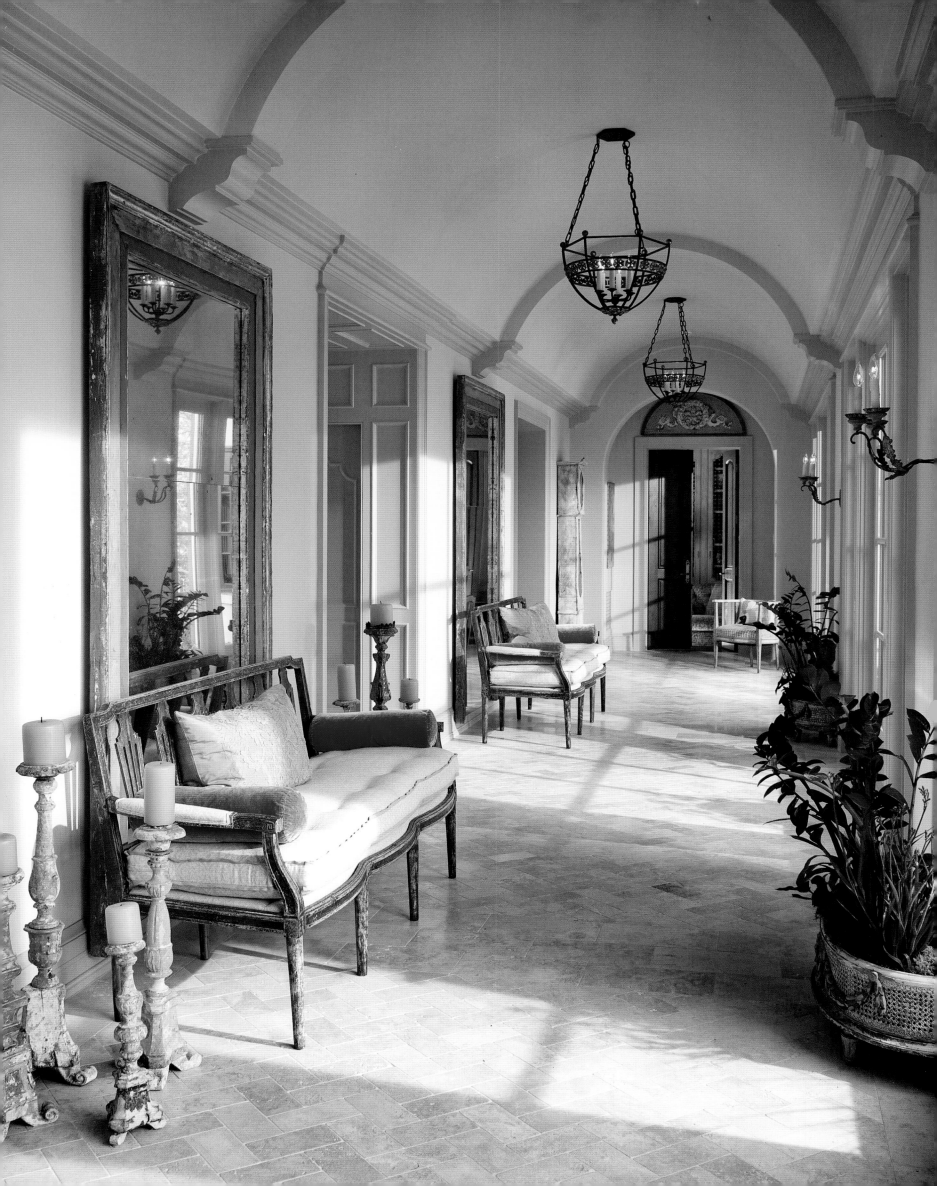

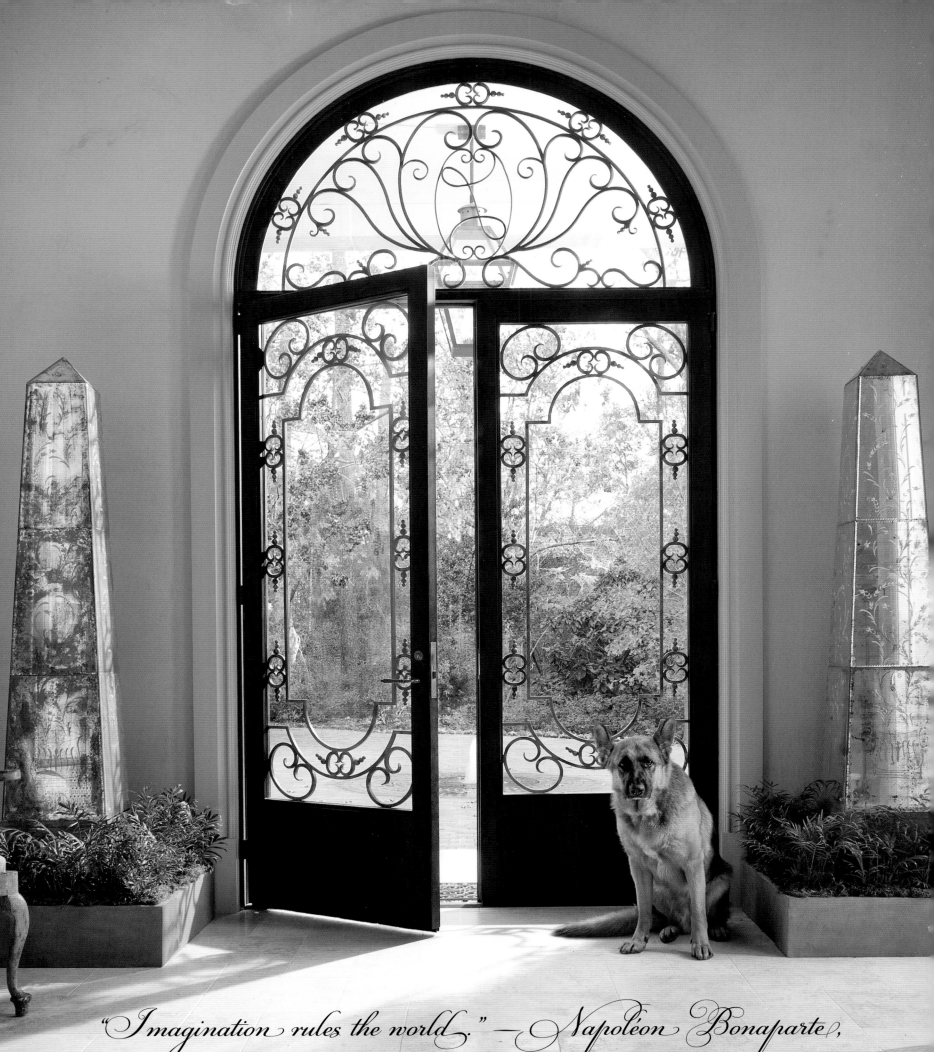

"Imagination rules the world." — Napoléon Bonaparte,

15 August 1769–5 May 1821

Contents

Noble doors, guarded by the family's German shepherd, are worthy of Europe's finest ironsmiths. Influenced by his studies in Florence and Rome, architect Ken Newberry translated a look from Cortina—the renowned resort bordering Tuscany and Umbria, where he has a home—to a villa in the States. Mirrored obelisks are vintage Italian pieces from dealer Murielle Abeger, Atlanta.

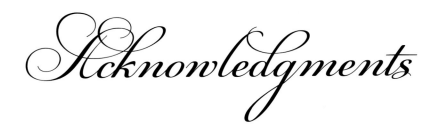

Acknowledgments

Taking an idea from concept to design-book-worthy hardback is a sweeping process, a collaborative effort on the part of many people whose attention to detail is extraordinary. All this calls for a little name-dropping.

For opening their doors and welcoming us into their homes, I thank Anna and Tim Brown, Daphne and Frank Goldsberry, Drs. Armineh and Ara Tavitian, Amy and Neil Leibman and more.

I am highly indebted to Larry E. Boerder, Ken Harbert, John Sebastian, Tony Weigand, Dave Paynter, Jonathan Hamilton, Dean Blaine, Steve Markham and Chris Cordero. Without their assistance, perseverance and expertise, this book would not have been possible.

Also meriting a warm thank-you: Seth Pariser and Christopher Hyland, Corinthia Runge, Britni Brock, Julie Willenbrock, Christy Gatchel, Esther Gandal, Lisa Frederick, Amanda Lang, Robin Stevens and Lloyd Homan.

I sincerely appreciate the efforts of the following artisans: Allan Rodewald, Daniel Heath, Deborah Nesbit, Rachel Lea, David Brown, Charlie Peters, Ruben Sanchez, Amish Desai, Terri Jenny, Penny Sanders, Raegan McKinney, Mindy Geron, Linda Swain, Jonathan Andrew Sage, Gillian Bradshaw Smith and Joan Cecil.

In-the-know designers say every house should have a bit of Fortuny . . . so Interiors by BLP created dazzling napkin rings that magnify the shimmer of dessert plates by Bernardaud. And now every home, aircraft and private yacht can have fine china, crystal, sterling silver flatware and linens—all at discounted prices, thanks to Dallas-based Dahlgren Duck with affiliate offices in England, Italy and Switzerland.

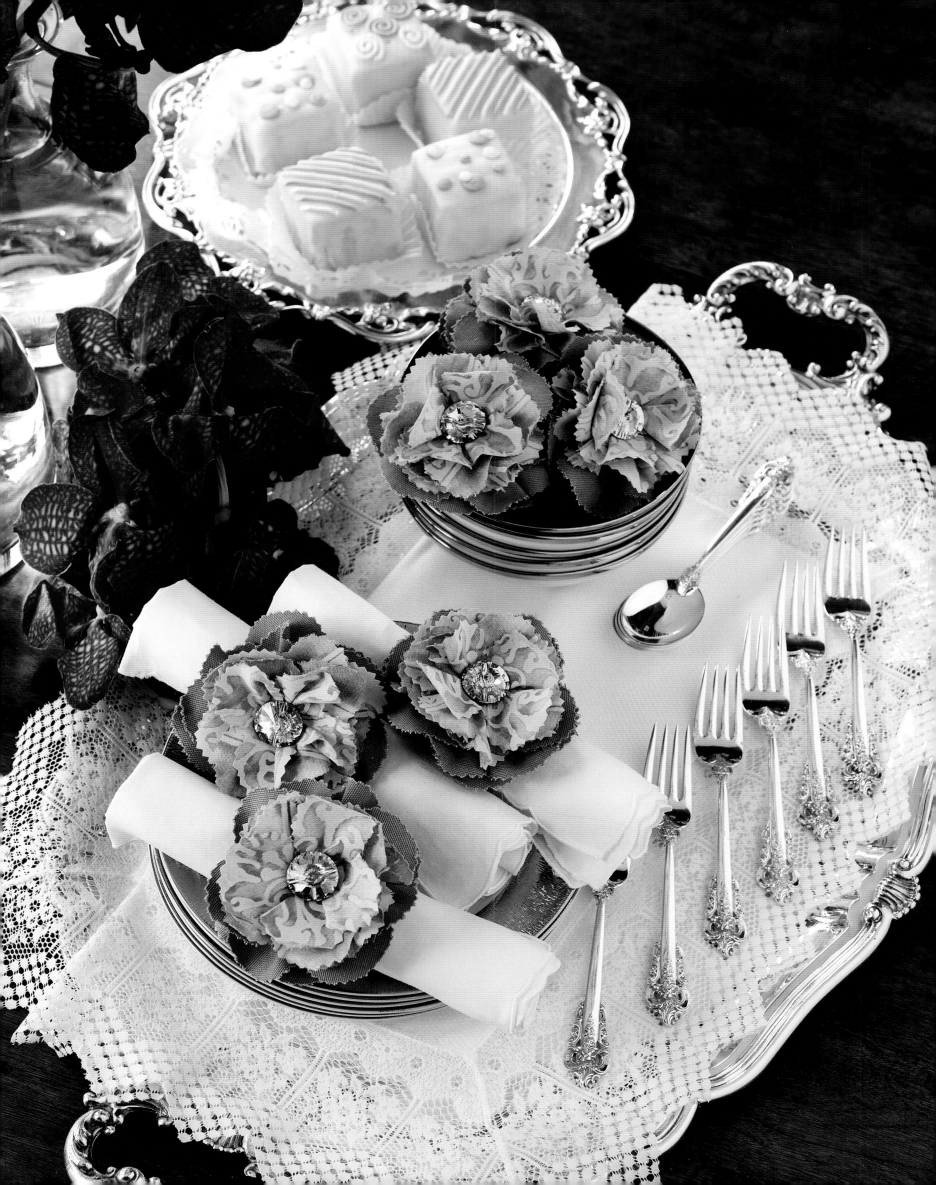

Without question, I want to thank friend extraordinaire Letitia Jett-Guichard and her reason for living in France, Alexandre Guichard. Also deserving of thanks: Annick McNally, Patrick McNally, Bruno de la Crois-Vaubois, Thierry Granger and Albian Bastide.

I am more than grateful to Janice Pedersen Stuerzl for her invaluable research support. Time and time again, I thank Andrea Smith Overly for her prized design assistance. And she joins me in thanking our design-savvy team: Kelly Phillips, Brenda Lyle and Lea LaFortune. Together we applaud designer Marilyn Phillips and pay homage to Jesus Marroquin, Ivan Marroquin, Monica Alvarez, Brian Walker, Donna Burley, Robert Turner, Sandra Catlett, Jodie Newby, Charles McKinney, Kip Holt, Jayne Taylor, Noel McDoniel, Mackenzie Frankenberg, Joe Demoruelle, Pete Wilton, Connie McAnally, John Boggess, Yash Parmar, Gina Campbell, Michelle Toleos, Maloree Banks, Michael Moore, Gloria Jones, Zoltan Szabo, Maury Riad, Mickey Riad, Samantha Feder and Charlie Ngui, in addition to those who keep us up and running: Jerry Nogalski, Danny Salavar and Tom Johnson.

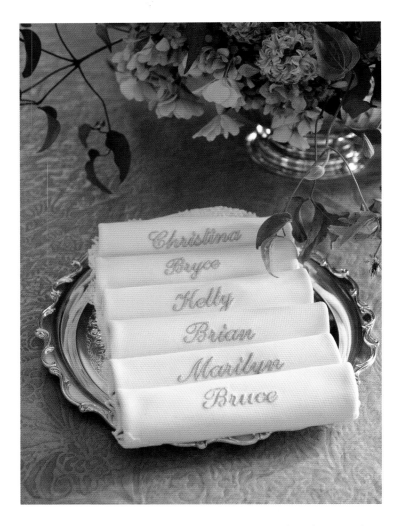

Place cards lend a sense of occasion to special gatherings, but, then, so can personalized napkins that send a message about the importance of one's family.

As always, we have true admiration and appreciation for the talented photographers with whom we worked: Dan Piassick and his assistants Jason Jones and Stefania Rosini as well as photographer Scott Womack. In addition, we thank those who helped on photo shoots: Jorge Perez, Andrew Olson, Juanita Figuerio and Ana Bohilla.

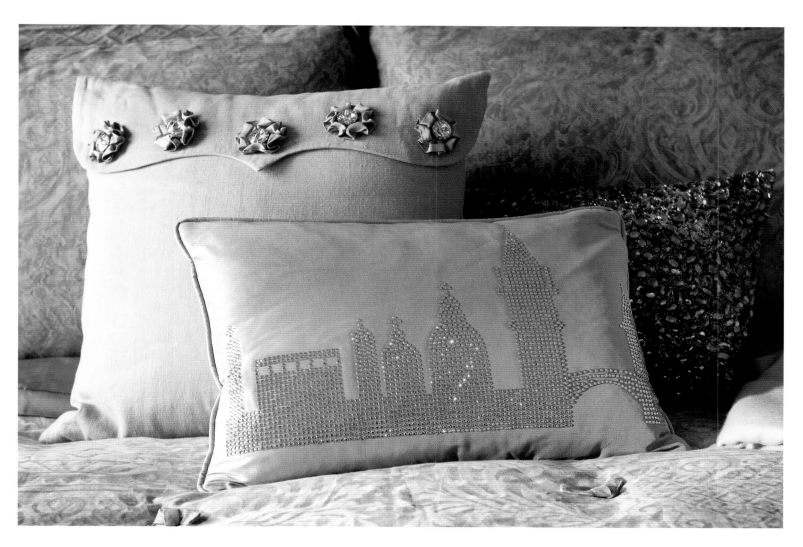

A crystal-studded pillow by Anthony Ruben depicts the noble city of Venice, with its storied Grand Canal and navigable inland waterways, to say nothing of its Doge's Palace, St. Mark's Basilica and glass factories on the tiny island of Murano, in the Venetian lagoon. Since it is easy to become lost in the hundreds of alleyways in Venice's six *sestieri,* or neighborhoods, gondolas and *vaporetti* (water taxis) are often the preferred mode of transportation for the 16 million tourists who travel to the city each year.

Add to the above list my appreciation for book designer Cherie Hanson, cover designer Sheryl Dickert, and love for my long-time editor Madge Baird, who channels her energy into polishing the manuscript, then revels in the excitement of its debut and basks in the glory when it captures sought-after bids for attention.

Finally, a big thank-you to my husband—and the family who brightens our lives. Without their understanding, this project would not be. And *merci par avance* to you, the reader, for inviting *The Allure of French & Italian Décor*—my eleventh design book—into your home.

Until tomorrow . . .

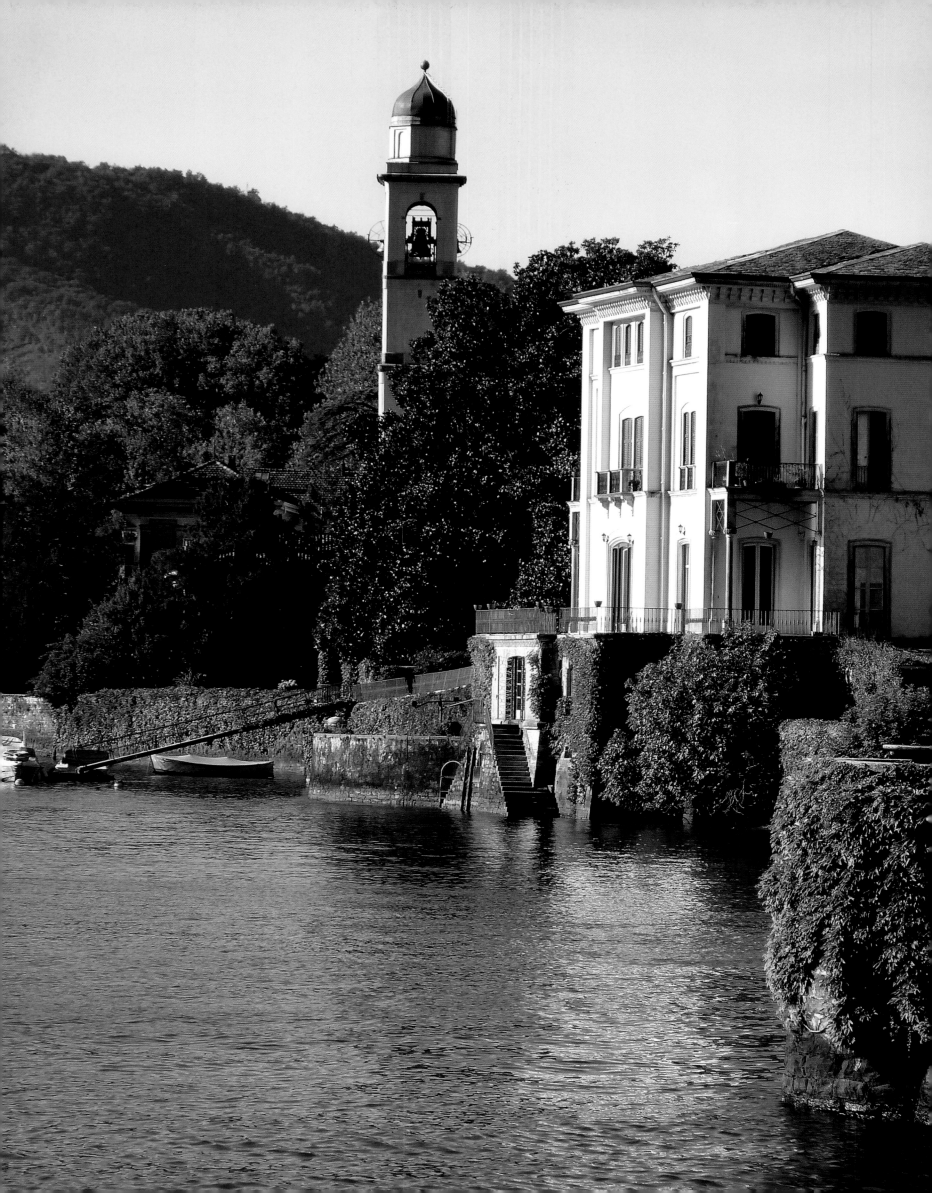

Introduction

For centuries, as we all know, France and Italy have fueled the creativity of aspiring artists, musicians, writers and intellectuals, initially from across Europe then in waves from across the seas. These countries have long been the go-to spots for fashionistas, serious foodies and design mavens as well. Economic uncertainty notwithstanding, the Republic of France still sets the standard for show-stopping couture, sumptuous dining and inimitable visual arts. Indeed, to this day, the land that produces the world's choicest Champagne, cheese and *chocolat*—not to mention *haute* fashion by Chanel, Hermès, Louis Vuitton and Lanvin—shows no sign of loosening her très chic grip on the planet's tastemakers.

The beauty of the Italian Lake District first attracted the Romans more than 2,000 years ago. Later, Renaissance nobility found the idyllic area suitable for their opulent palaces and posh *palazzi*. By the eighteenth century, those on a Grand Tour considered the region an essential stop.

The items of choice for international travel: passport, camera, cell, sunglasses and adapters. And, with the iPad meeting computing needs, it also is an ideal travel companion. The leather case from Smythson of Bond Street assures it travels safely.

The cradle of Western civilization, meanwhile, thrust cultures forward, giving us not only the foundation of modern nationhood, symbols of capitalism and the emancipation of women, but perhaps without quite intending to do so, the gift of *how* to live. For when it comes to *la dolce vita*—the good life, or the sweet life, as some like to say—we cannot help but be captivated by the Italian passion for building deep, satisfying relationships, extending warm, artful hospitality and spending carefree afternoons with family and cherished friends whether in the garden or by the sea.

Never mind that days are more complex than that, or that stylistic elements ranging from stunning Palladian arches to humble ceramic olive jars merit mention, too. Or even that this beloved boot-shaped peninsula also has her diva moments on the global stage. Yes, the sophisticated houses of Valentino, Gucci, Prada, Armani, Fendi, Bottega Veneta, and Missoni rule the runways with enviable flair—all facilitated by a regal array of fabrics from Italy's internationally lauded textile mills. Indeed, from fashion interior design has learned a lot: about style, comfort and possibly above all, about the power of creative might, namely small details unfailingly noticed that awe and inspire.

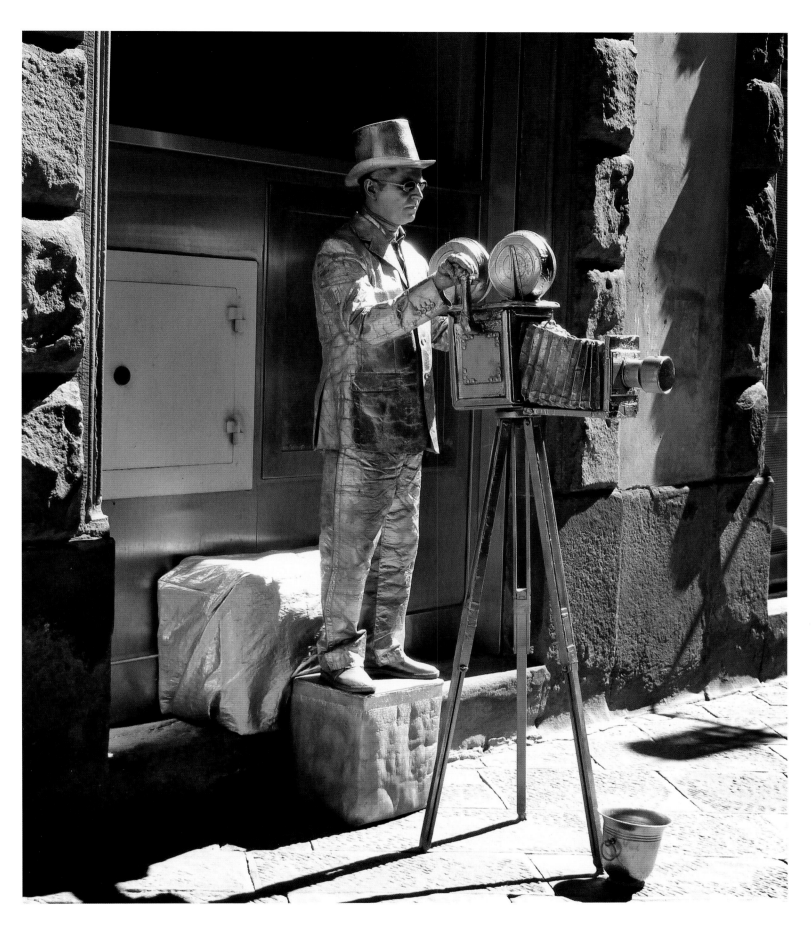

Remember the movie *Letters to Juliet,* where Vanessa Redgrave sells us on the dream of finding one's true love fifty years after letting him get away? Well, on a cobblestone street in the medieval town of Siena, one can expect to happen upon the film's mime—that human statue that scarcely moves—when following the movie's producers through narrow alleyways and past the Duomo to the Piazza del Campo, one of Europe's most famous squares. Every year on July 2 and August 16, the *piazza* is the site of Il Palio, a bareback horse race that is an 800-year-old tradition.

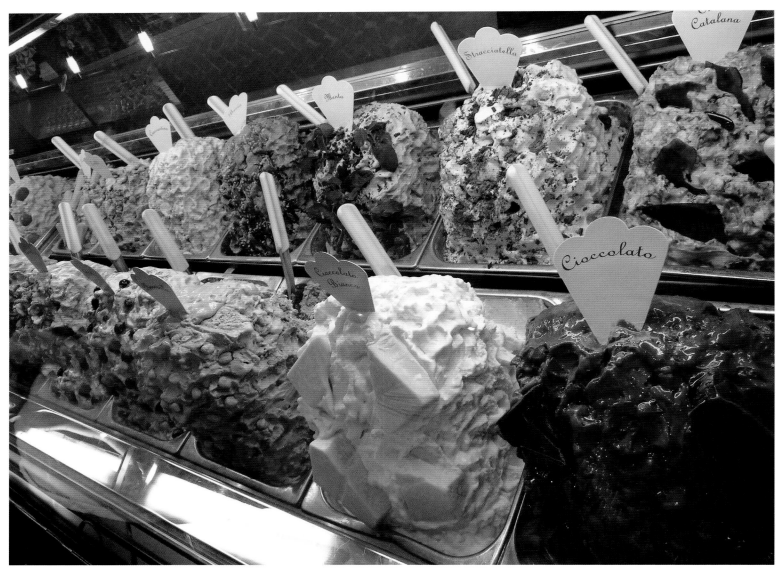

Supposedly, Roman Emperor Nero (A.D. 54–68) sent his men trekking into the jagged Alps for the expressed purpose of collecting snow for making flavored ice. If so, it is hardly surprising that Italians today flaunt what might be the best ice cream on earth and rightfully boast about serving more than 31 flavors. Nineteenth-century Italian immigrants introduced America to this frozen treat.

RIGHT: In the aftermath of World War II, Italy abolished its monarchy. However, the charm of Villa D'Este, a sixteenth-century princely residence in Cernobbio, 34 kilometers east of Rome on Lake Como, continues attracting globetrotters who long to live royally.

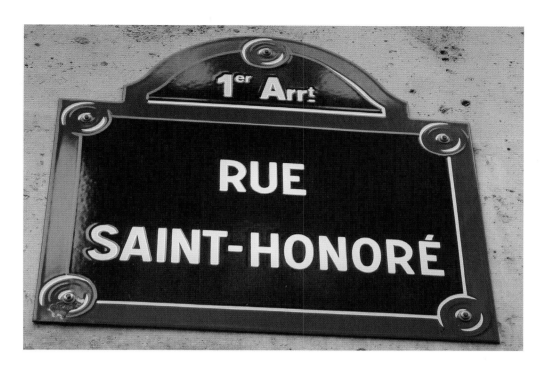

With her hands tied behind her back, her hair cropped short and her head held high, a composed Marie-Antoinette rode in an open tumbrel down the rue Saint-Honoré on her way to the guillotine—just weeks before her 38th birthday. For the hour-long ride from the Conciergerie to the Place de la Révolution, now the Place de la Concorde, she wore a simple white cotton dress, black petticoat and white cap with black ribbon. Today, the rue du Faubourg Saint-Honoré—an extension of rue Saint-Honoré—is one of the most fashionable streets in the world. At number 55 is the Élysée Palace, the official residence of the President of the Republic of France.

It is perhaps inevitable, then, that we connect the past to the present, soulfully embracing the artistry that France and Italy prize while adding a dose of modernity. So what if our stately Italian *ville* and wireless French *châteaux* lack the gilded opulence of fancier dwellings on foreign shores? Or if our furnishings are not necessarily museum-worthy? There is certainly no shortage of glamour in how we live today.

Mingling centuries-old armoires and glittering rock crystal chandeliers with painted pieces and gleaming mirrors, in ways unexpected and fresh, translates into timeless, unabashedly *soigné* yet livable rooms appropriate for the times. For if the furnishings of France enchant the eye, Italian pieces sing to the soul. Rich patinas, satisfying earthen hues and myriad natural materials—Carrara marble, ancient terra-cotta, color-saturated Venetian glass—evoke a passion undimmed through the ages.

—Betty Lou Phillips, ASID

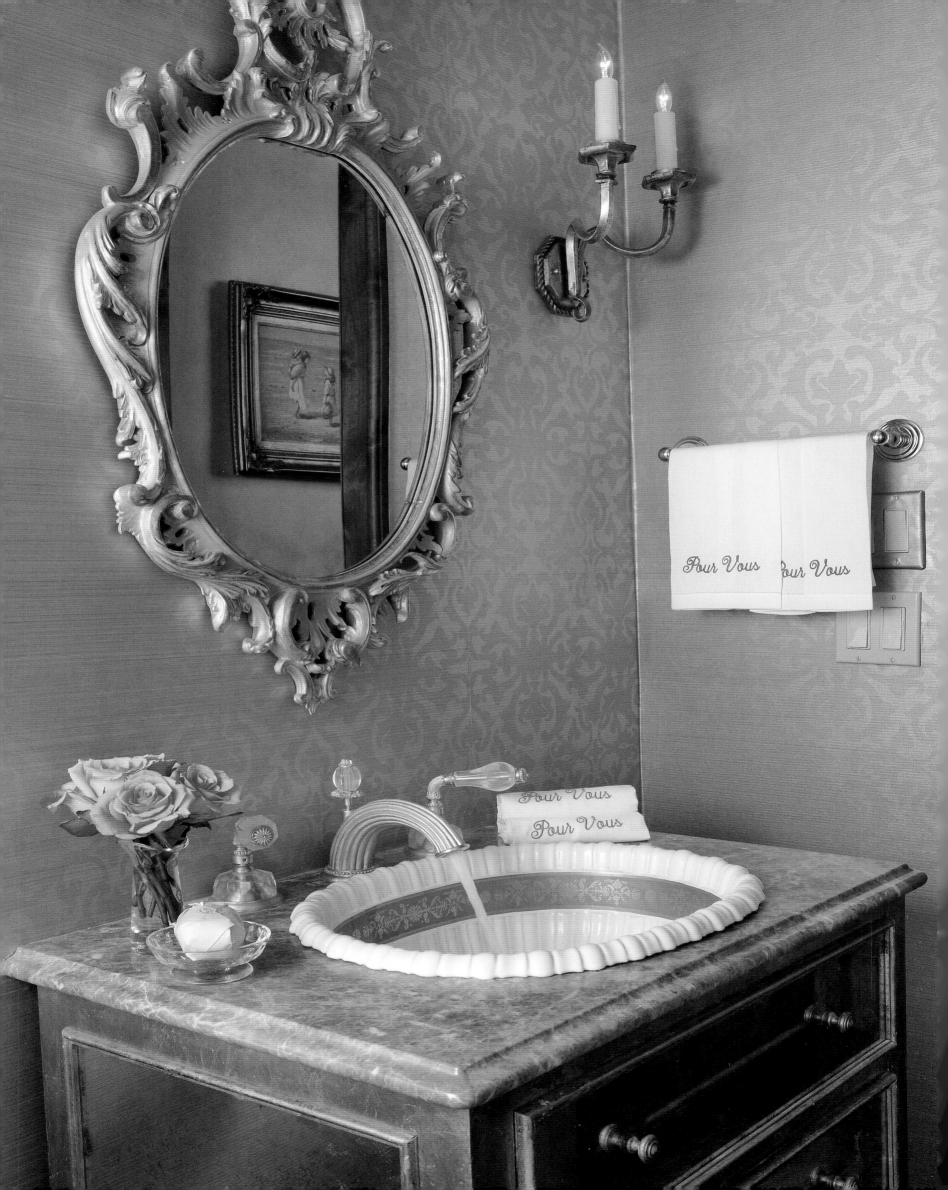

Centuries-Old ELEGANCE

In the discriminating world of interior design, France and Italy have forever commanded respect, setting standards of excellence with their fine furniture, regal array of textiles and treasured silk tapestries. Also enrapturing an international roster of admirers for some years now are translucent porcelains, stunning crystal, delicate embroidered linens and *papiers peints,* or painted wallpapers, about which the people of these nations are rightfully proud. As it happens, even proud stateside *habitués* readily concede that the French and Italians have an edge when it comes to creating artful, elegant interiors with the aura of romance and glamour.

A retrofitted commode lords over a powder room flaunting fittings and a ruffled china sink from Sherle Wagner—the company that built its reputation for luxury in the 1940s by introducing 24-karat gold-plated fixtures. The influence of Paris extends to practicalities such as hand towels embroidered with the words *pour vous,* or for you.

When it comes to where to mount a curtain rod, there are two options if the space between the window casing and the crown molding is large. Either split the difference between the window casing and the crown. Or, better yet, mount the decorative rod high and fill the empty space with an architectural element, such as this carved overdoor salvaged from a château in France. In its new role, the panel draws the eye to a stripe by Travers in the soft colors favored by Madame de Pompadour and Marie-Antoinette. The trim is from Janet Yonaty, Los Angeles.

For centuries, Italy was the undisputed arbiter of taste and style—deeply rooted in the region's vulnerable history of invasions by the Austrians, French and Spanish, each of which left an imprint of their customs and ways of living after claiming this picturesque land as their own. Milan and Florence, for example, fell under the French dominion, while Spain ruled Sicily and Naples. Austria controlled Venice until the nineteenth century. From a network of duchies, principalities and countless independent city-states, the Republic of Italy was created on March 17, 1861, with Turin as the capital. For political reasons, the center of government moved to Florence in 1866, and finally Rome became the capital in 1871, a year after being conquered. > 25

With European flair yet a family-friendly attitude, a *salon* looks as if it evolved over time. Flanking the eighteenth-century limestone fireplace, or *cheminée,* is a pair of mirrored wall panels a century younger from The Mews, Dallas. Nearby, stands a Louis XV–inspired bench ready to provide extra seating. The mirrored coffee table by Murray's Iron Works out-dazzles tables that are more traditional. Ultra-luxe French crystal chandelier is by Baccarat.

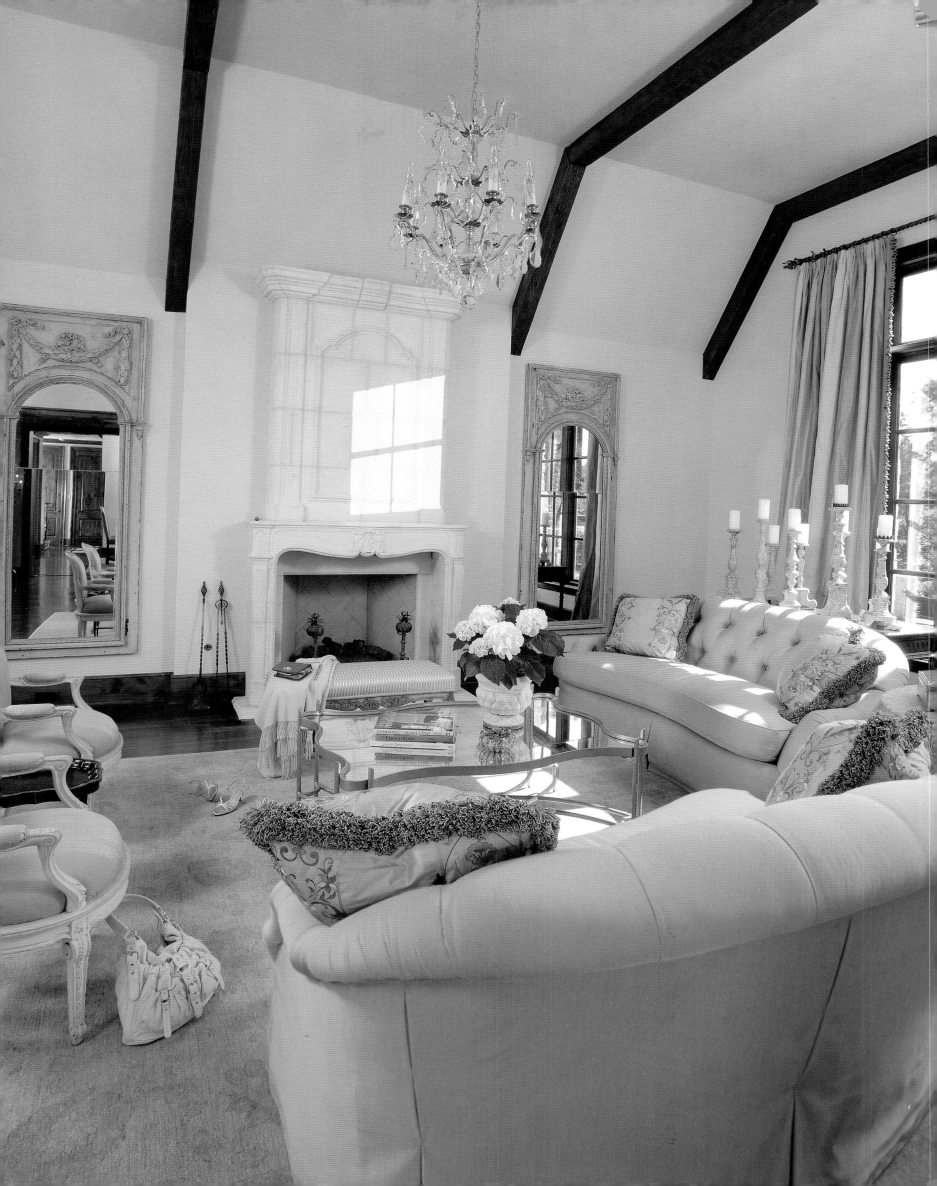

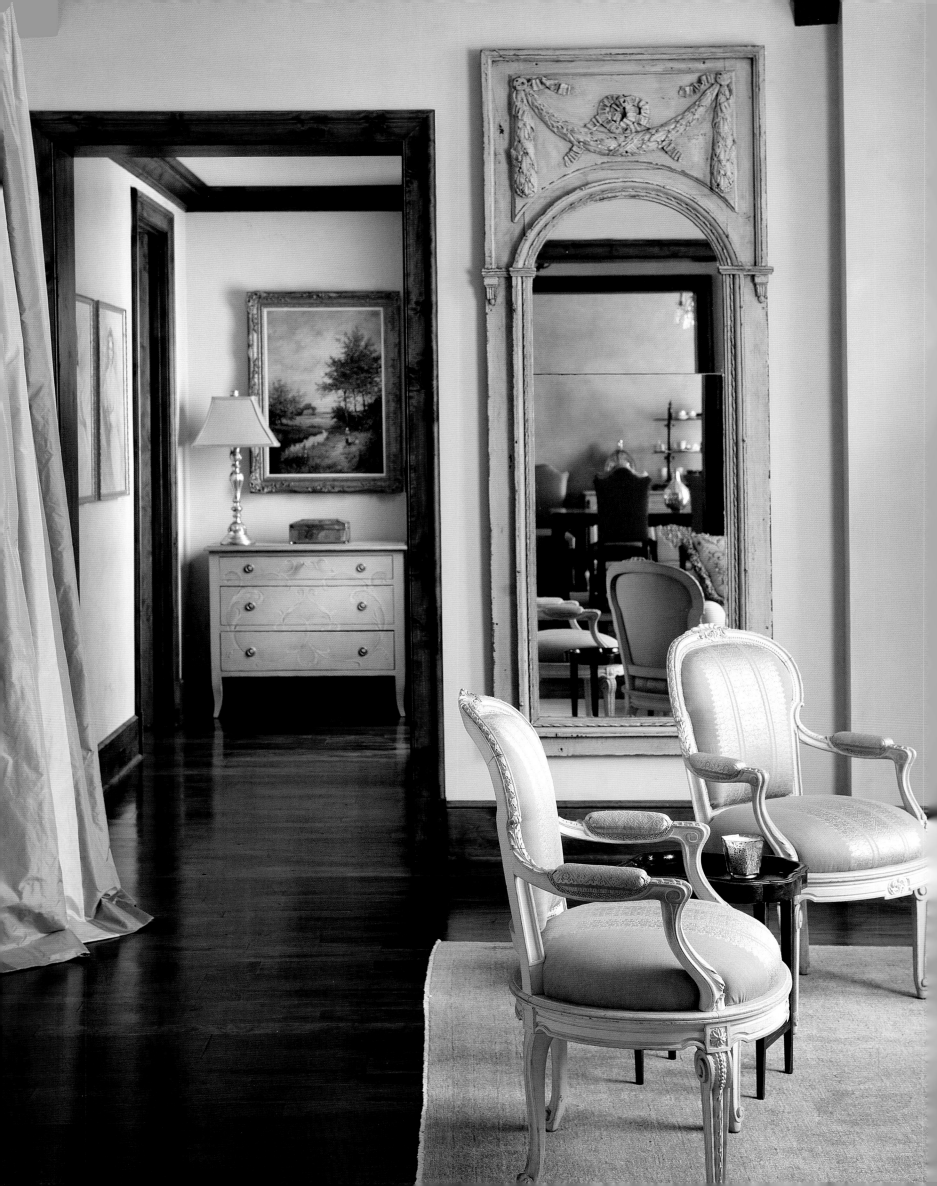

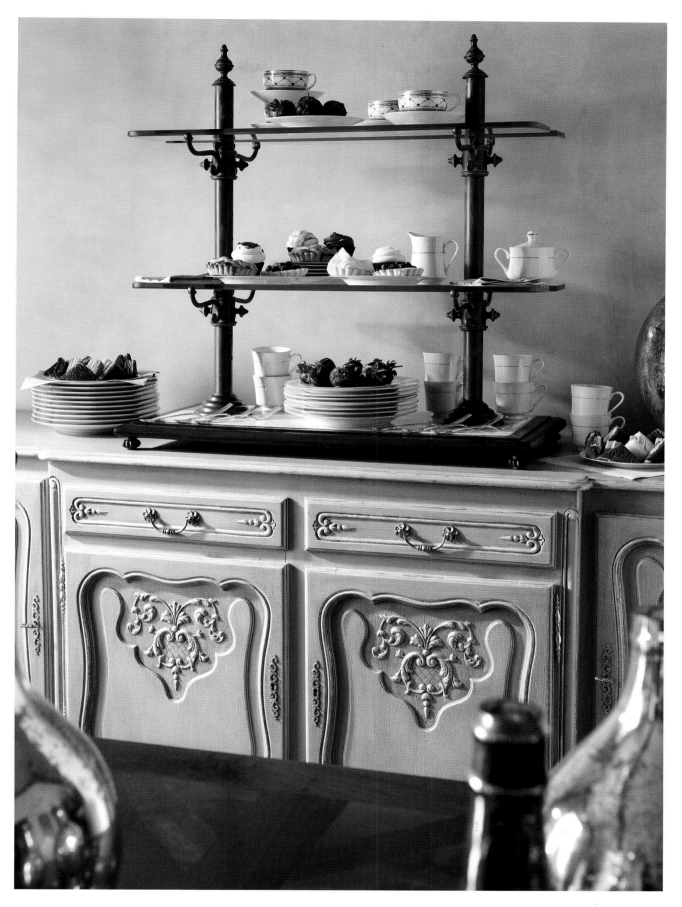

Holding most everything a dining room needs is an *enfilade* dating back to the nineteenth century. Above it rests a reproduction French *pâtisserie* stand.

FACING: Harmonious shades of blue glisten when Venetian plaster walls and the Louisiana sun meet in a *salon*. Unceremoniously, fabric from F. Schumacher sheathes the face of Louis XVI chairs, while a Jim Thompson check swaddles the back. An Oriental area rug from Stark Carpet grounds the room.

During the Middle Ages, distinct regional styles had emerged after the Romans destroyed much of Italy's earlier Etruscan culture, whose exquisite gold and bronze metalwork was influenced by the Greeks. The Romans too borrowed elements from the Greeks; however, they deserve credit for effective technological advances and skillful engineering that made it possible to span spaces with arched corridors, vaulted ceilings and rounded domes. Since then, their influence in Europe and the West has remained indisputable.

A bit of Italy crossed the Atlantic with John Notman, who emigrated from Scotland in 1831. Notman receives universal credit for introducing the Italianate villa to the United States. In 1839, he designed Riverside, a private residence in Burlington, New Jersey, that appeared as if transported from Tuscany. To the dismay of historic preservationists, Riverside was razed in 1961. Nearby, however, the much-photographed Prospect mansion, built in 1851 at the center of Princeton's campus, stands in testament to the architect's love for Italy.

Indifferent to changing times, *ville, palazzi* and *châteaux* on sprawling European estates resound with the refined elegance of centuries-old furniture, expertly woven fabrics and Aubusson carpets unfurled under aristocratic feet. Of course, not everyone lives in such imposing architectural grandeur meticulously dressed. Barely 25 percent of Parisians live in houses, while in tidy smaller French hamlets, 75 percent of the people dwell in single-family homes within a stone's throw of each other. >28

Gracing the walls are centuries-old French oils on canvas from Jacqueline Adams Antiques, Atlanta. Initially, dining was a "moveable feast." The first grand dining room was completed in 1776, in the Château de Montgeoffroy in the Loire Valley—an area known as Valley of the Kings. Until the mid-nineteenth century, the dining room was not common in stateside homes.

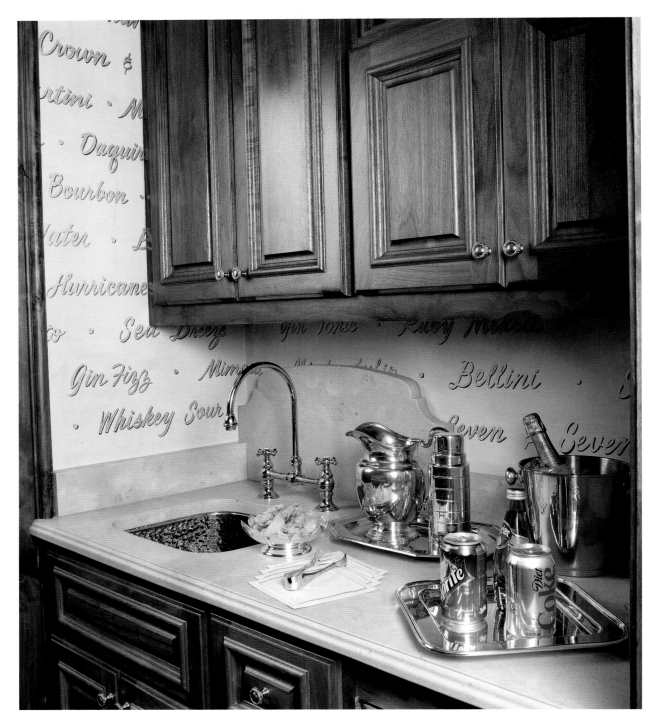

Want bottled water? A glass of Champagne or potato chips? No problem—all are in stock. Actually, there is no shortage of offerings at this wet bar, since Houston artist Allan Rodewald hand painted a list of drinks. The handsome Art Deco silver cocktail shaker is from Ralph Lauren Home; linen cocktail napkins by Sferra. Hilton International set new hospitality standards in 1974 by making mini-bars a luxury hotel staple.

RIGHT: When it comes to measuring up, a tea towel that can help with conversions is incredibly handy.

FACING: Most European kitchens are small by American standards, and galley-style—meaning narrow, with counters on both sides of a central walkway and space-saving appliances that are 24 rather than 30 inches deep. Copper and cutting boards are staples in Parisian kitchens, often from E. Dehellerin in the 1st *arrondissement*.

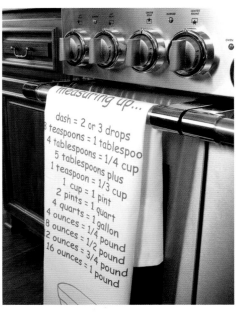

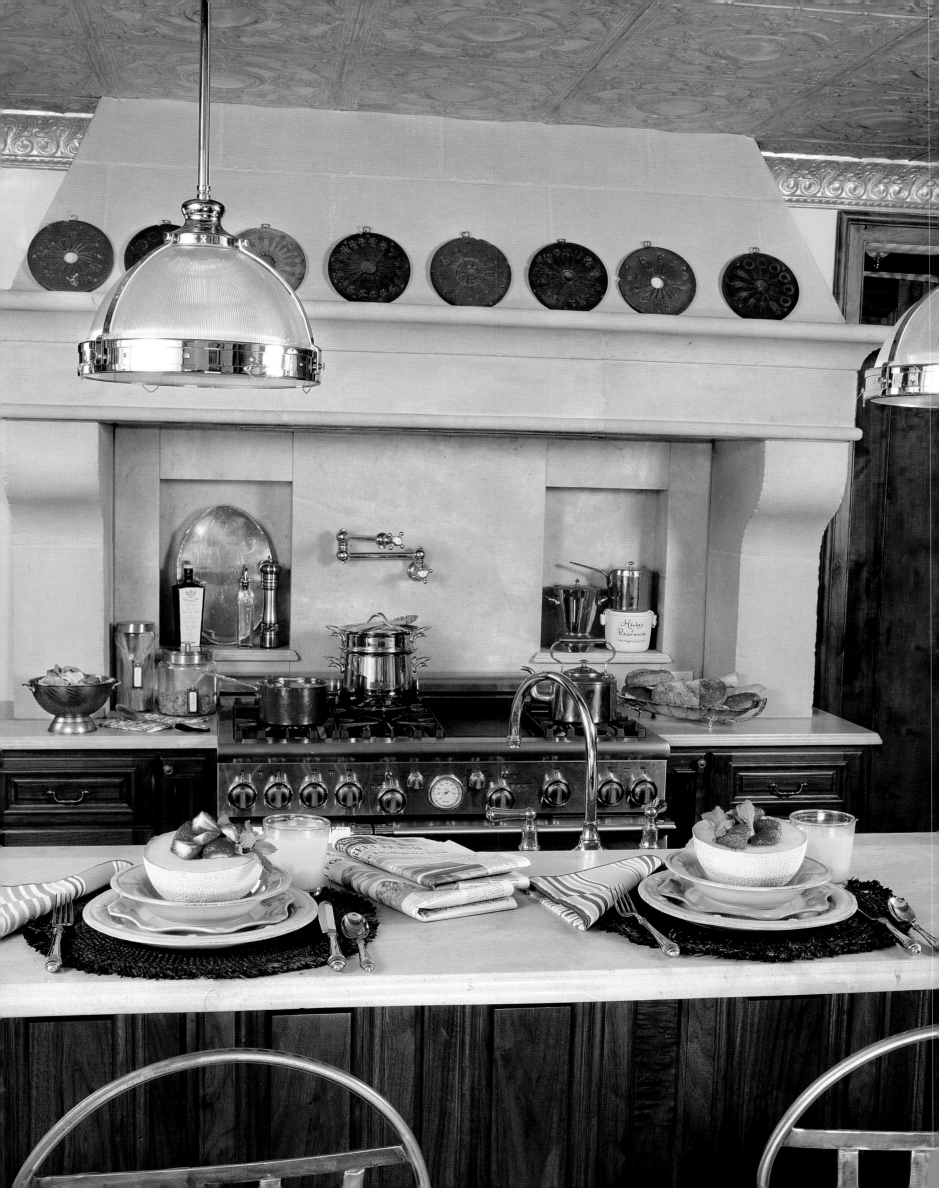

Similarly, in scattered Italian cities bearing evidence of the nation's turbulent past, families often inhabit *palazzi* that have been converted into intimate, airy apartments with lofty doors opening wide onto balconies bedecked with flowers. Frankly, owning palatial havens with chilly halls, flaking plaster, hefty maintenance fees and long-ignored grounds simply does not appeal to the sensibilities of many French and Italian aristocrats, or even to those the French call the *jeunesse dorée*—the young and moneyed—a more relaxed privileged generation. They see the size of a house as less important than its furnishings and the way those pieces mirror the life within. For them, there is no signature look any more than there is one distinctive way to live. There is, however, a classic approach to space planning—guided by intelligence, awareness and panache. It is a given that furnishings should be the best one can afford, testifying to one's impeccable taste while discreetly offering a window into one's soul.

With the botanical name for chocolate being *theobroma*—or food of the gods—it is understandable that the Paris phone book would have several pages of listings for *chocolatiers*. Among spots eager to soothe the soul or help mend a broken heart, none may be more resplendent than Angélina's, once the tearoom of choice for Gabrielle "Coco" Chanel and others from the fashion, art and literary establishments. Vintage chocolate pots are from Ainsworth-Noah, Atlanta.

FACING: Until Madame de Pompadour removed her *chambre à coucher* from the list of public rooms, the bedroom was where high-level meetings took place. Since then, the French have opted to keep doors to their bedrooms tightly closed.

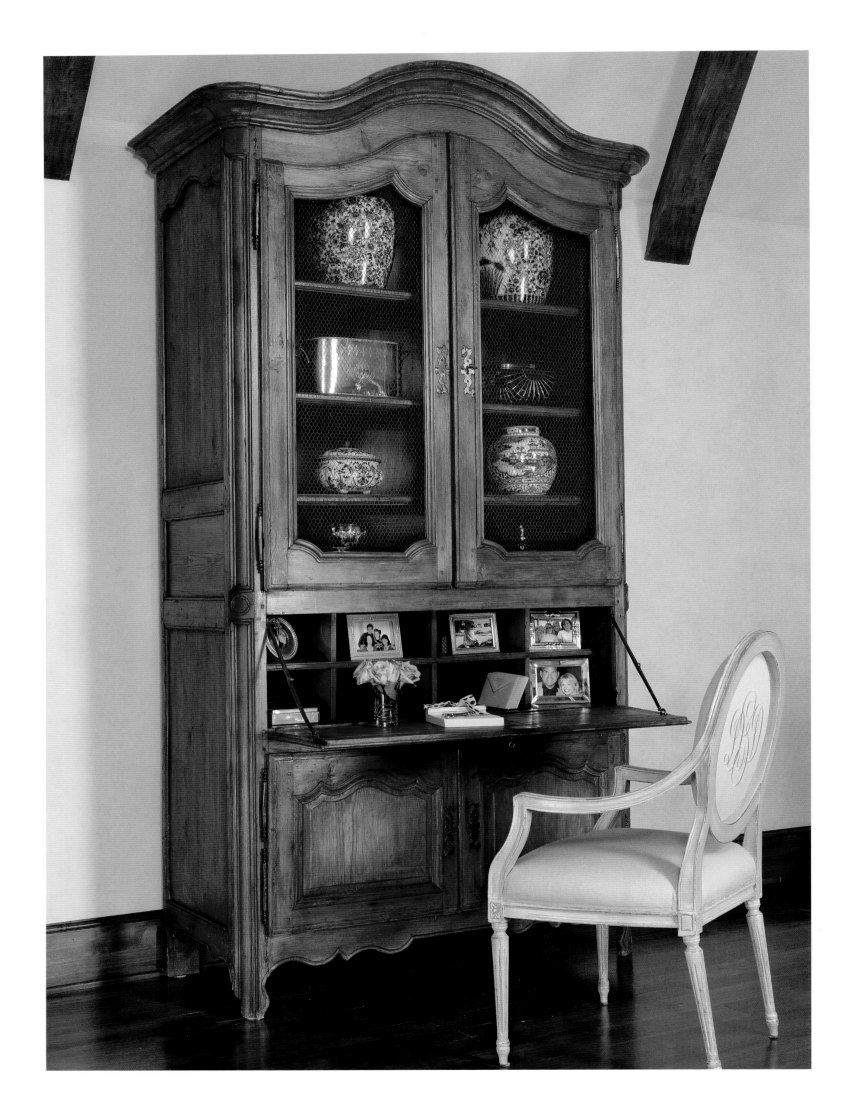

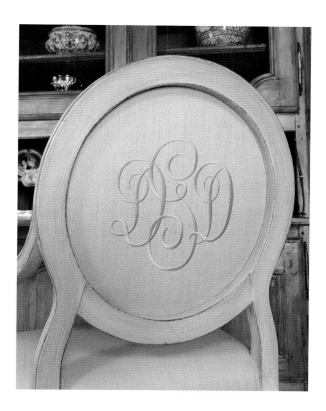

Monogramming by Joan Cecil, Dallas, adds a feminine touch to an oval-back chair.

Tellingly, then, spaces are chicly rendered works of art, exuding a passion for beauty, an intuitive sense of scale, harmony of color and reflections of one's inner self. Marrying old-world craftsmanship with an audacious mix of treasures handed down from caring ancestors, settings look as if they've been furnished at an unhurried pace by several generations of family who had explicit ideas on style. Ancestral portraits, sculpture, cherished books and other enviable links to bygone eras holding court hundreds of years later, offer the reassuring feeling of the familiar while somehow making imposing, pleasingly proportioned rooms appear even grander.

It is not enough, however, for quarters to brim with prized objects displayed like museum artifacts. Ultimately, convention dictates that possessions must lay the foundation for a look of one's own making that reflects one's priorities and personality.

For centuries, this pine Louis XV *secrétaire* stood in a monastery in the South of France foothills of Mont Ventoux—meaning "windy mountain." Then Atlanta-based Jacqueline Adams Antiques discovered it quite by chance, and in contrast to its former secluded life, the piece now oversees the comings and goings of an active family that marvels at its beauty and the mix of antique European and Chinese porcelains it holds.

As a result, the humble and the grand mingle graciously, relaxing formality and balancing the splendor of rooms. Masterfully cut and flawlessly tailored window treatments brush the floor with soft braid or fringe trimming drizzled from pencil-thin piped edging. A stream of perfectly matched stripes and patterns, including storied toiles, affectionately hug upholstery, though in less dressy spaces tailor's tucks often nestle amid shapely slipcovers as unassuming seagrass offhandedly blankets well-traveled floors.

Everywhere one looks, artfully placed blooms of cascading flowers look obligingly unarranged. With neither the French nor the Italians inclined to compromise their standards, D. Porthault and Frette linens—fashioned of Egyptian cotton in France and Italy, respectively—carefully pressed and spritzed with scented water, make beds romantically inviting. *En suite,* enough thick, fluffy towels to stock comfortably Paris's legendary Hôtel Ritz or the princely sixteenth-century Villa d'Este that sits on the banks of Italy's Lake Como outside Milan soak up centuries of history.

Form dovetails with function in traditional Italian kitchens, which inevitably appear tidy, orderly and clutter-free. With "a place for everything and everything in its place" when not in use, spring-latched cupboard doors mask precisely stacked molds, various-sized mixing bowls, colanders and metal cauldrons. Fruits and vegetables not requiring refrigeration sit in small metal boxes on balconies until called upon to express regional preferences. >.39

Guided by the residents' worldly travels, Houston artist Allan Rodewald hand painted a canvas that Dallas-based Robert Turner & Associates installed on the study ceiling of this Shreveport, Louisiana, home. Walnut paneling frames the study with literary leanings and "his" and "her" chairs. Lending animal magnetism is an area rug from Stark Carpet. Straight Stitch, Dallas, fabricated the window treatment.

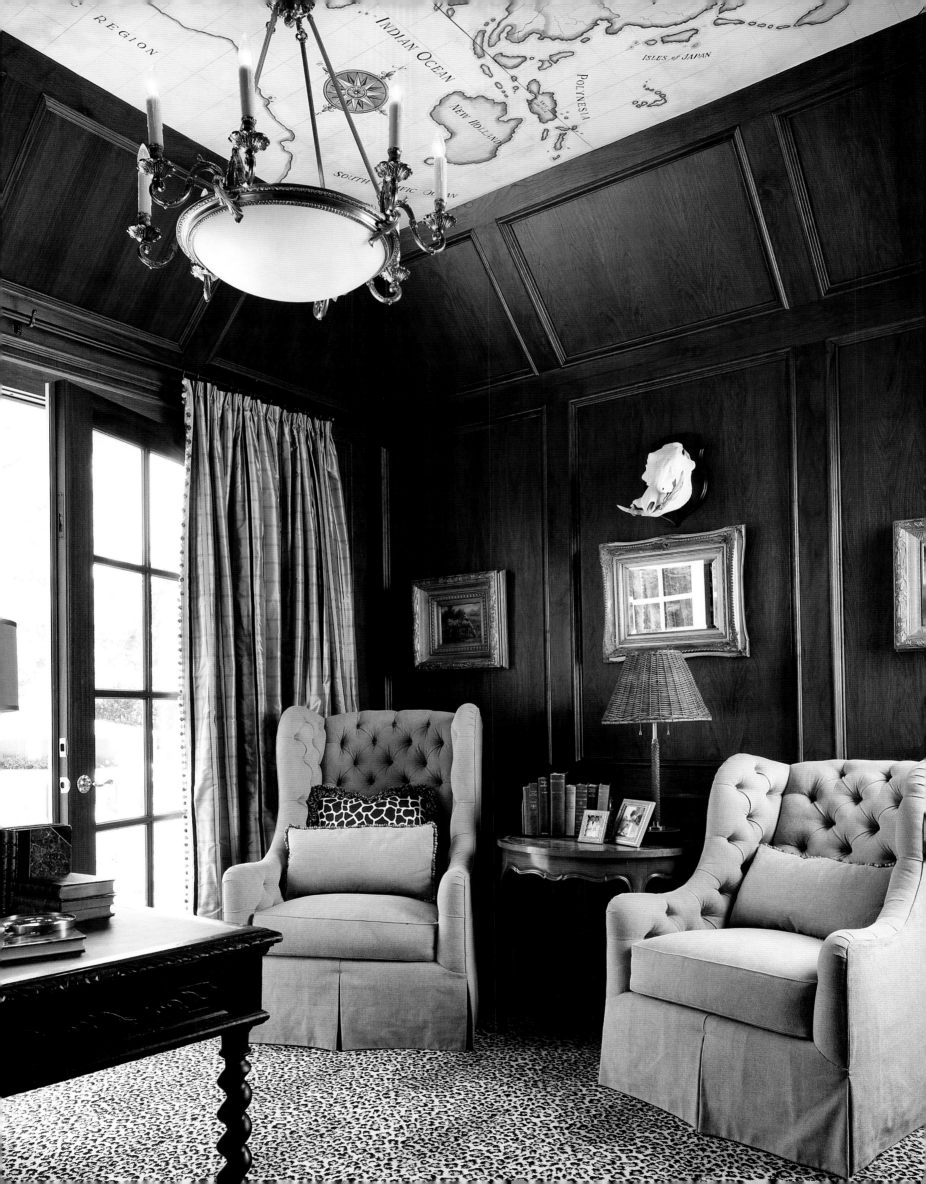

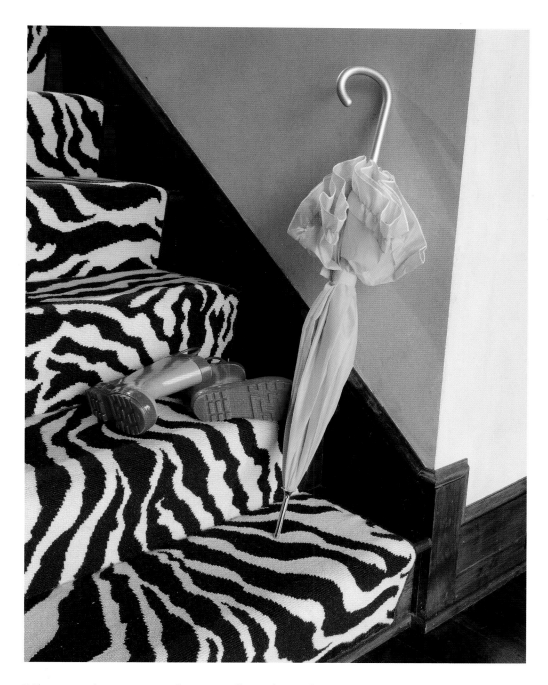

When an ordinary patterned carpet will not do, a zebra on the wild side—with bold brown stripes—dashing up a staircase can make a daring statement. The runner is 100 percent wool, meaning it is both forgiving and practical.

RIGHT: Samuel & Sons' playful button trim picks up on the room's savvy color palette, while Leslie Hannon Custom Trimmings adds dash to decorative pillows.

FACING: When not texting friends, or surrounded by them, the artist in residence unleashes her creative visions. A Designers Guild sheer descends from the window, as Malabar's ribbed fabrics in high-voltage hues cover chairs. Bulging bookshelves sit across the room.

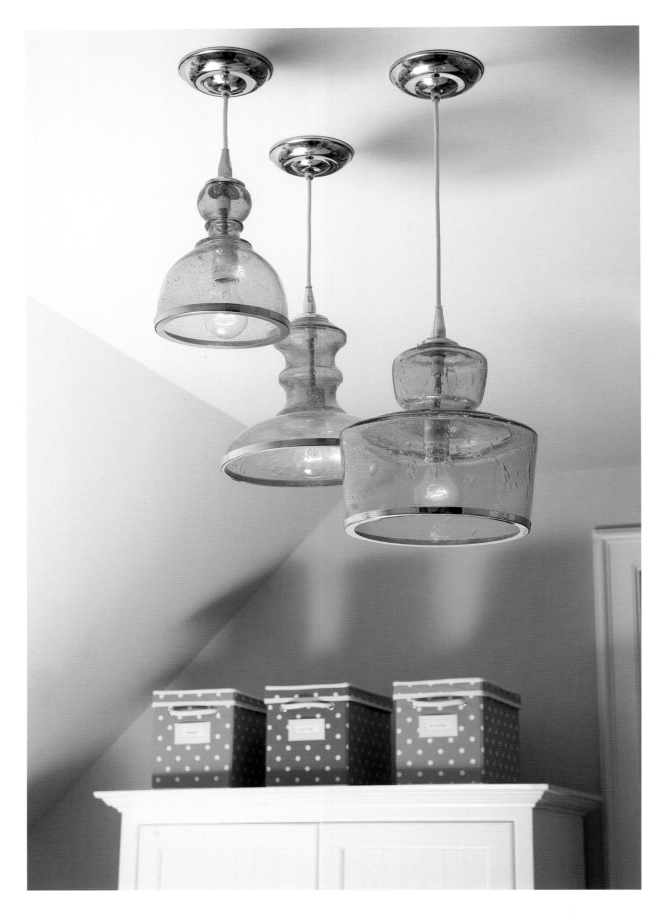

In high style, a cluster of pendant fixtures dangles from the ceiling, casting light on polka dot memory boxes.

FACING: With hip Pottery Barn the go-to stop for cool teen rooms, a teenager wakes up in her dream bed. Overhead, a super-sized canvas by the in-house artist is on display. Vintage nightstands (one unseen) from Parkhouse Antiques, hold artsy "stuff" she prefers out of sight. Covering up a trundle for sleepover friends is a Sanderson cotton.

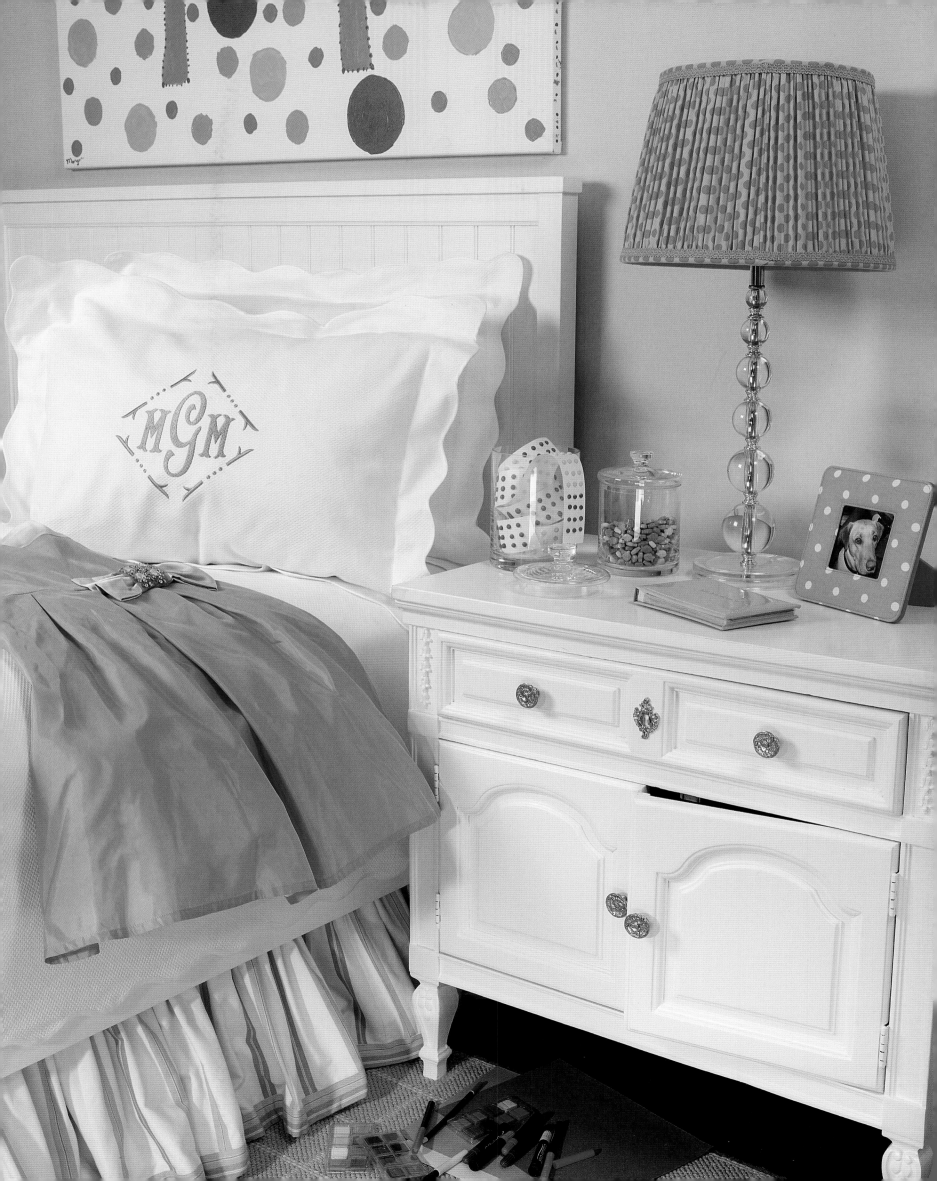

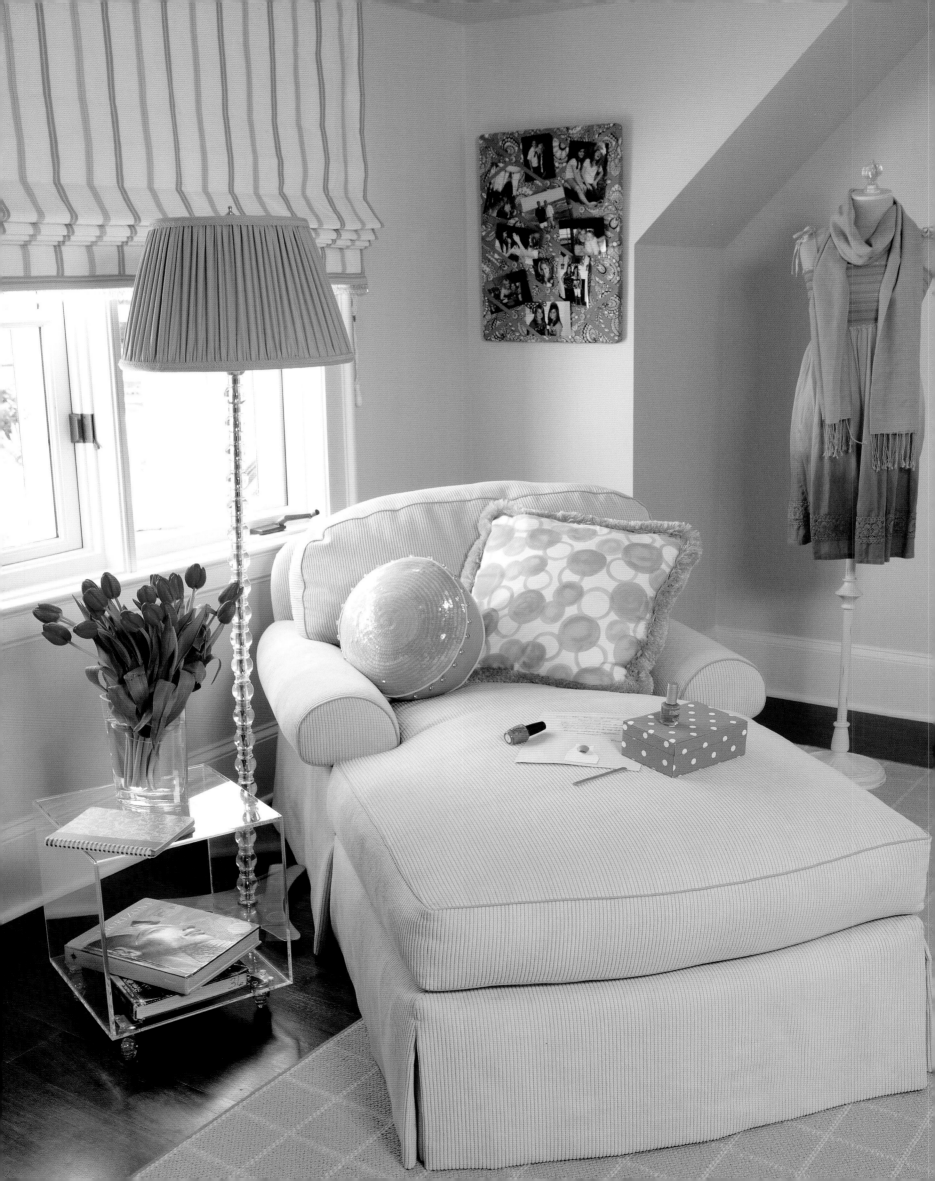

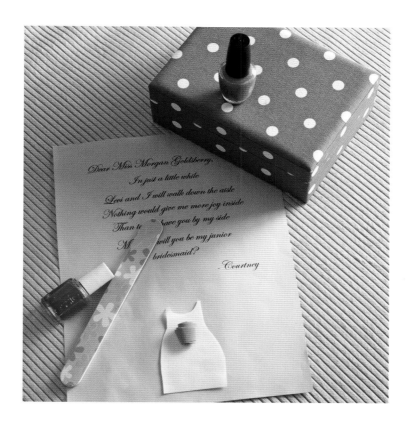

Being asked to be a junior bridesmaid is an invitation much too precious for an American pre-teen to pass up. Bridesmaids and junior bridesmaids are not part of the wedding culture in France. Instead children—young boys and girls dressed, as one would suspect, in the most adorable clothes—attend the bride. French law specifies that the bride and groom each must have one but no more than two adult witnesses. (They dress as they please; there is no coordination, buying of dresses or color themes.) A religious ceremony is optional, as only the civil marriage is recognized.

In French kitchens, practicality holds sway. Baskets for storing crusty breads and scores of copper pots in graduating sizes crowd ceilings, hanging out within easy reach on pot racks or *crémaillères,* which are nearly as integral as cross-timbers and weathered walls in the south of France.

Most kitchens in France do not have upper cabinets. Rather, open shelving allows ready access to *la batterie de cuisine*—pitchers, platters, goblets, tureens and other needed items. Countertops burst with dozens of utensils for every imaginable purpose, while colorful faïence—pottery with luminous glazes—and oversized Continental-size flatware—heavier and larger than corresponding pieces in the United States—garnish tables set on terra-cotta tile betraying its age.

Fabric from Osborne & Little lends a groovy kind of chic to a chaise, while a dress form that wandered from an *haute* atelier on Paris's Avenue Montaigne adds whimsical flair with its contour-hugging silhouette.

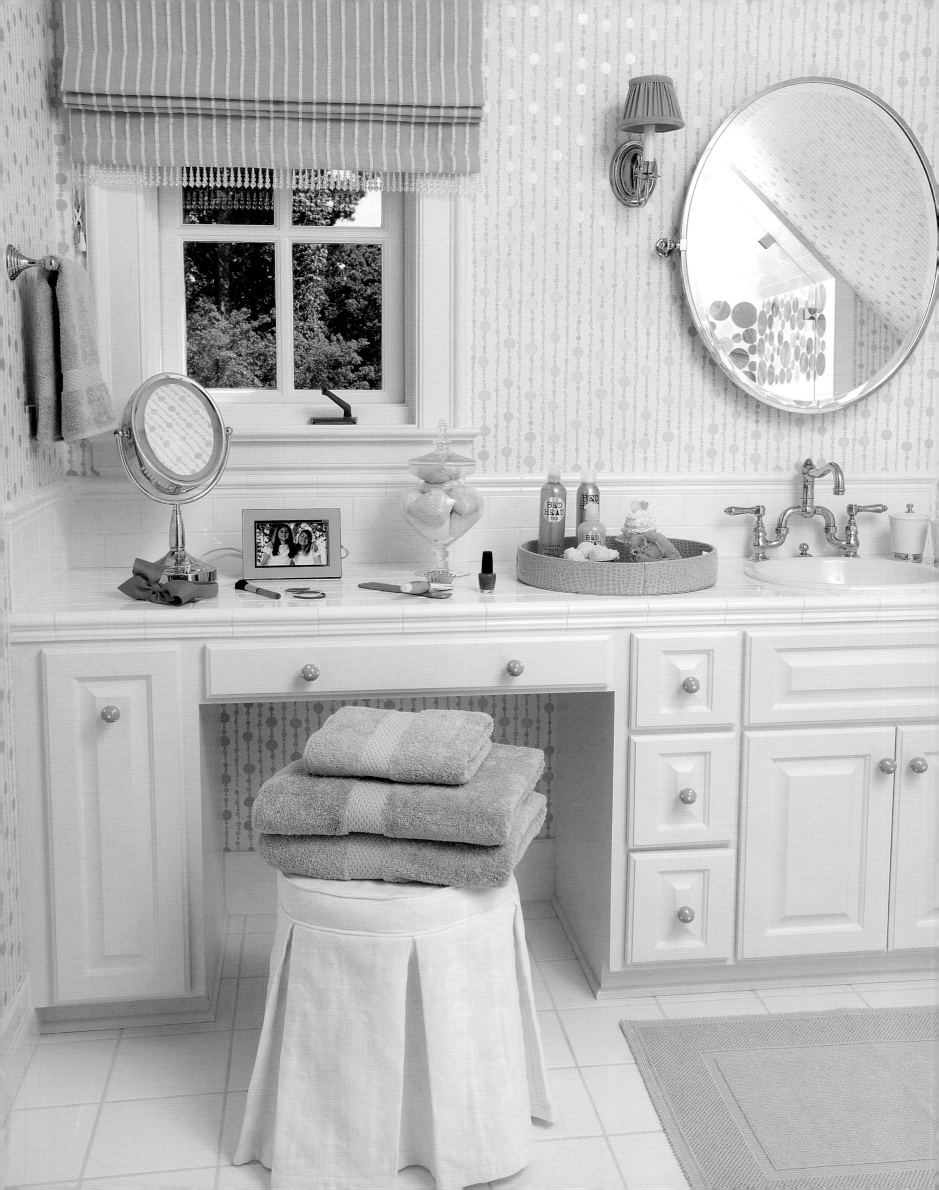

In contrast, when the Mediterranean sun sinks into the horizon, dining rooms sparkle like diamonds—impeccably set—as glistening silver, breathtaking crystal and a noble mix of delicate china highlight culinary talents. For serious cooks, cuisine is more than a means to satisfy the pangs of hunger; it is a theatrical production, inventively propped, perfectly staged and, most importantly, designed to elicit applause. Fittingly, then, candlelight swirls over flavors and aromas needing little introduction, drawing attention to the link between how food looks and the architectural manner in which it is presented.

In France, the expression *epater le bourgeois* means "to astonish them"—and particularly Parisians have more than risen to the challenge of bracing occasions with this attitude. Whether a casual breakfast, a picnic lunch, an afternoon tea or a leisurely dinner *à deux,* nothing escapes attention. Noticeably, service plates are liberal-sized, goblets gleam and linens appear painstakingly pressed. Masses of the same cut flower, assembled with a Parisian touch—tightly packed and equal in height—suit the spirit of the style-savvy.

Little wonder, then, that for centuries, France and Italy have enticed a world hungry to share their unique flavor and flair, or that we continue studying the tastes and talents of these undisputed stylistic superpowers.

Who says a bathroom cannot be fun as well as functional? With fashion-forward towels by Yves Delorme, playful York Wallcovering and Renaissance Collection tile, this room manages to be just that. Cabinet pulls are from Pottery Barn. Malabar fabric lines the shade.

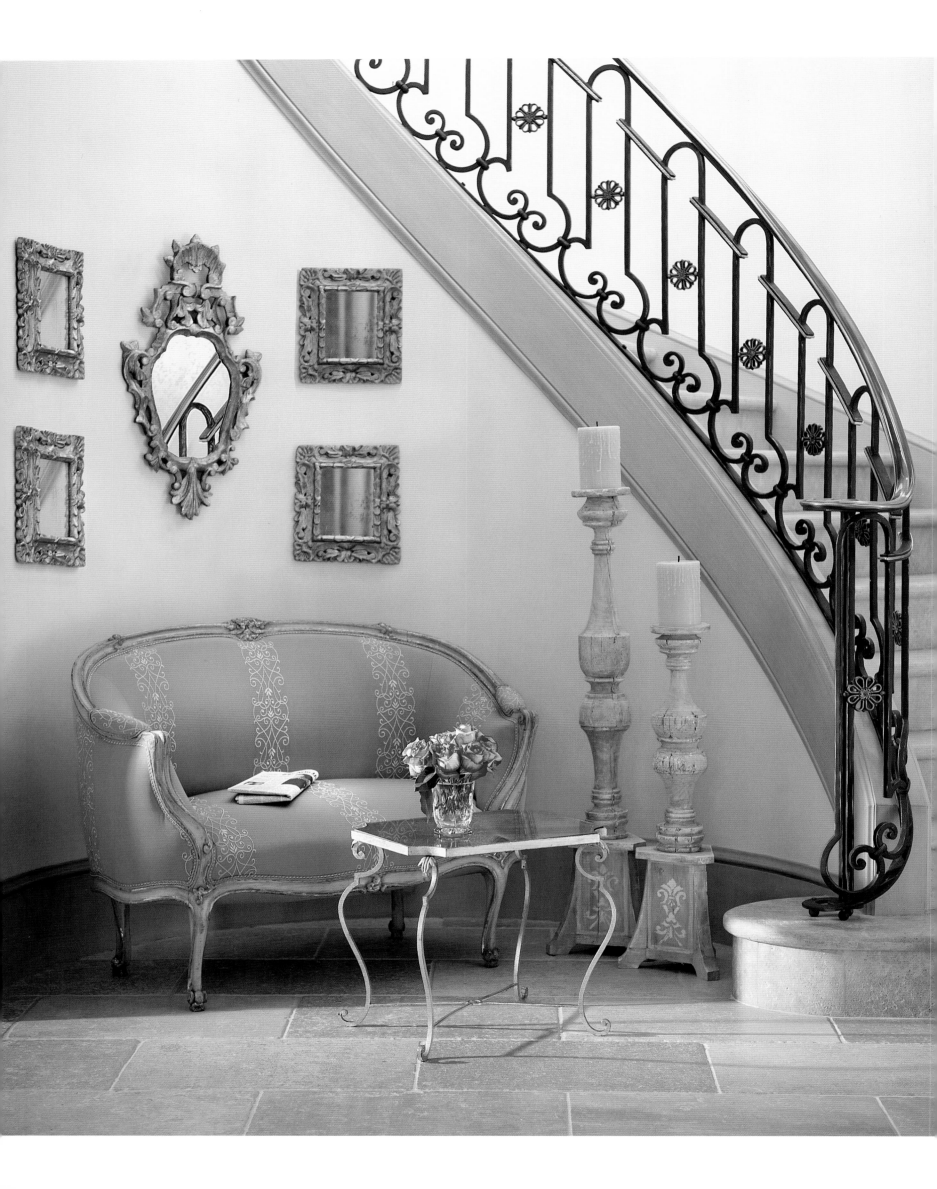

MAGNETISM OF
French Design

The storming of the Bastille on 14 July 1789 may have marked the fall of the *ancien régime*—the political and social system in place at the onset of the French Revolution. However, quite clearly, the exquisite artistry of France's *ébénistes magnifiques* (magnificent furniture makers) and other gifted craftspeople effectively ensured that the impact on design of three Bourbon monarchs, all named Louis with Roman numerals after their names, did not fade. For it is not by chance, surely, that the awe-inspiring influence of Louis XIV, his great-grandson Louis XV and his grandson Louis XVI not only still exerts a powerful hold on the kingdom they once ruled but also reaches a broad audience as it travels through twenty-four time zones around the globe these hundreds of years later.

Antique gilt-edged mirrors add historical cachet while prompting memories of time spent in Barcelona, Spain. In a nod to Louis XV, a painted *canapé* (settee) from Jacqueline Adams Antiques dons a Jab USA silk.

It is fair to say that each monarch boldly imposed exacting standards on all art forms during his reign, though plainly, none more so than Louis XIV, the Sun King, who seemingly spared no expense in the pursuit of beauty. After pushing his visions of the decorative arts to extremes, he flung open the gates to his sumptuously appointed 700-room showplace, the Château de Versailles, astounding the world with its glitz and grandeur, not to mention nearly seventy sweeping staircases and an excess of mirrors. In doing so, he motivated generations of tastemakers who, in turn, would bring France further acclaim.

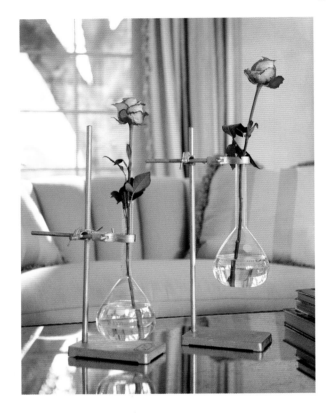

Meriting a spot on a mirrored table from Murray's Iron Works are glass beakers, mid-twentieth-century laboratory flasks on adjustable stands, from W. Gardner, Ltd.

In the fickle world of design, where ideals come and go, FFF—an acronym for Fine French Furnishings—command a large and loyal following in the United States. Among those who revere quality craftsmanship, it is a symbol of pride, reflecting the glory of the ages if not a particular era. By no means, however, are we alone in an appreciation instilled long before 1 January 2002, when the euro replaced the French franc and currency in eleven other European Union countries. With FFF and, above all, eighteenth-century furnishings, thought to be the height of elegance, everyone from royals with titles to countless luxury lifestyle-driven commoners whose names are less known—from as close as Canada and as far away as Russia, to say nothing about those living across Continental Europe—are also besotted fans despite an uncertain economy.

A California *salon* swathed in Venetian plaster appears elegant, not stuffy, when unassuming sisal lays the foundation for furnishings centered on a carved eighteenth-century stone mantel—from the Reims area, east of Paris—and Exquisite Surfaces, Los Angeles. Fabric from Lee Jofa covers chairs, while Bergamo and Coraggio textiles, woven in Italy, adorn the loveseats and sofa.

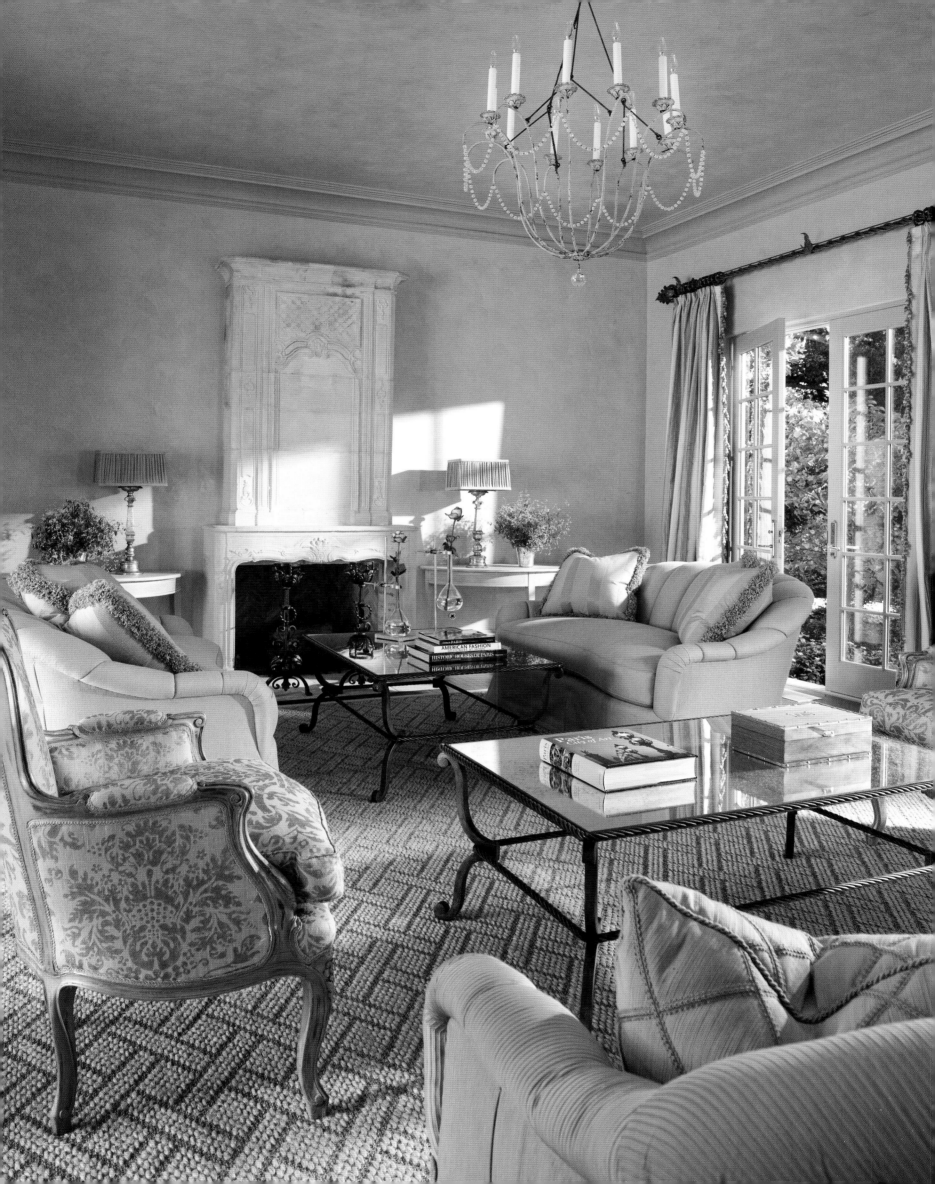

There are sound arguments in favor of the white dinner plate, such as "Hamilton" from the Presidential collection of Lenox, which presides on a Ralph Lauren Home charger. Not until the eighteenth century were drinking glasses placed on the table, and it was the nineteenth century before even the wealthy could afford a series of matching glasses in several sizes.

Of course, the French decorative arts can take many forms. Mirroring Louis XIV's extravagant spirit and the upward spiral of sumptuousness that followed the Baroque period (1645–1715) in the Régence era (1700–30), connoisseurs of grandeur marry nobly carved, richly embellished gilded pieces fashioned from the finest woods with shimmering brocades threaded with gold, though perhaps none more assiduously than certain Europeans dazzled by the ornate splendor of the period. Never mind that the plush *salons* of some Manhattan apartments are indeed bedazzling, most stateside residents consider the style of Louis XIV far too ornate for their households, as do those living in the Canadian province of Québec—where 80 percent of the people speak French and FFF resonate.

Embracing sophisticated yet less fussy, stuffy and pretentious décor, most enthusiasts favor seductive silks, ethereal sheers and sensuous chairs from the more beguiling Rococo period (1730–60)—a time when Louis XV and his stylish mistress, Madame de Pompadour, had great influence on the decorative arts.

An assortment of glass hurricanes and candlesticks from Ralph Lauren Home line a table where gray Venetian plaster walls serve as the backdrop—in keeping with the highly respected views of Karl Lagerfeld, the king of *haute* couture, who once remarked, "The color of Paris is gray."

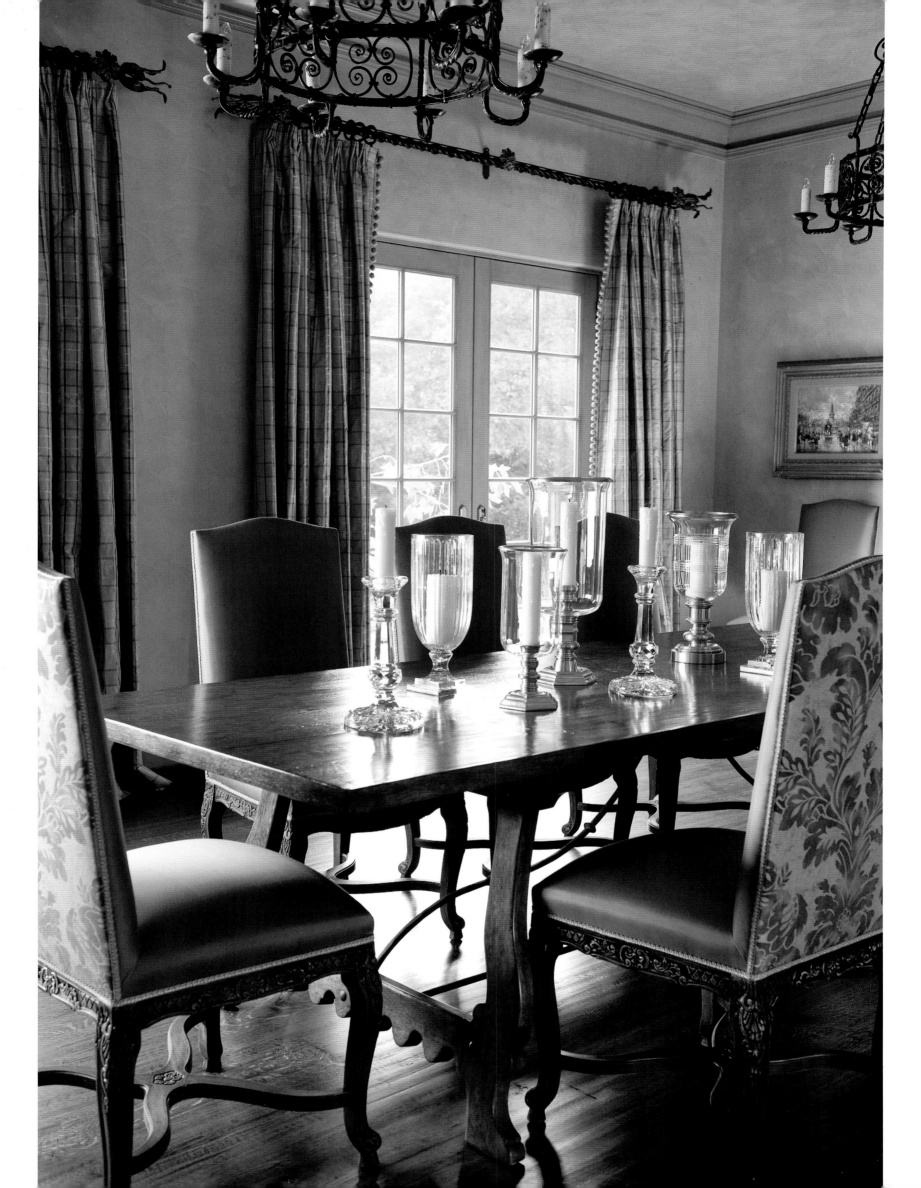

Madame de Pompadour was a devotee of the theater, interested in the running of Gobelin, the tapestry workshop, and a passionate admirer of Sèvres porcelain, supported in its early years by funding from Louis XV. Not only did she deftly spread the Sèvres name across Europe by generously presenting finely glazed pieces to foreign diplomats, but she also procured hundreds of distinctive pieces for herself.

By all accounts, chair pads plumped with down—and layered in Malabar cottons—prompt family and friends to linger at the table.

FACING: A breakfast room with a view of the gardens and pool is awash with French influences. Garnering certain deference by virtue of its age is a Louis Philippe *bibliothèque* with iron grill happened upon at W. Gardner, Ltd. Chairs in a hand-rubbed finish from the Kerr Collection gather around a Portuguese-inspired dining table from Michael Taylor, Los Angeles. The chandelier and most other accessories are old, some very old.

As the persuasive force behind pushing the king to move his court from Versailles to Paris and permitting nobles to live in their own houses, she deserves credit for the period's hallmark interiors. In keeping with royal whims, the court shuttled the king's prized possessions—furniture, tapestries and sculptures—from one domicile to the next. And to her it was clear that this latest destination demanded refined, shapelier silhouettes suited to living areas more modestly scaled than the vast, lofty spaces of sumptuous Versailles.

Patronizing the top *marchands-merciers* (dealers in works of art and antiques) on the ultrachic rue du Faubourg Saint-Honoré, she replaced heroic-proportioned baroque ceremonial furnishings with graceful *bergère* chairs—upholstered armchairs with enclosed sides—and unforgiving *canapés* with integrated *l'élastique,* or springs that boosted comfort levels. Although regally carved commodes remained seriously formal, gone were tall, ostentatious-appearing, fabric-covered armchairs with exposed wood frames, haughty-looking backs and stretchers reinforcing the legs—as well as an era when only the self-indulgent Sun King (1643–1715) was allowed to sit in a *fauteuil,* while lesser nobility and all others sat on hard, humble stools and benches.

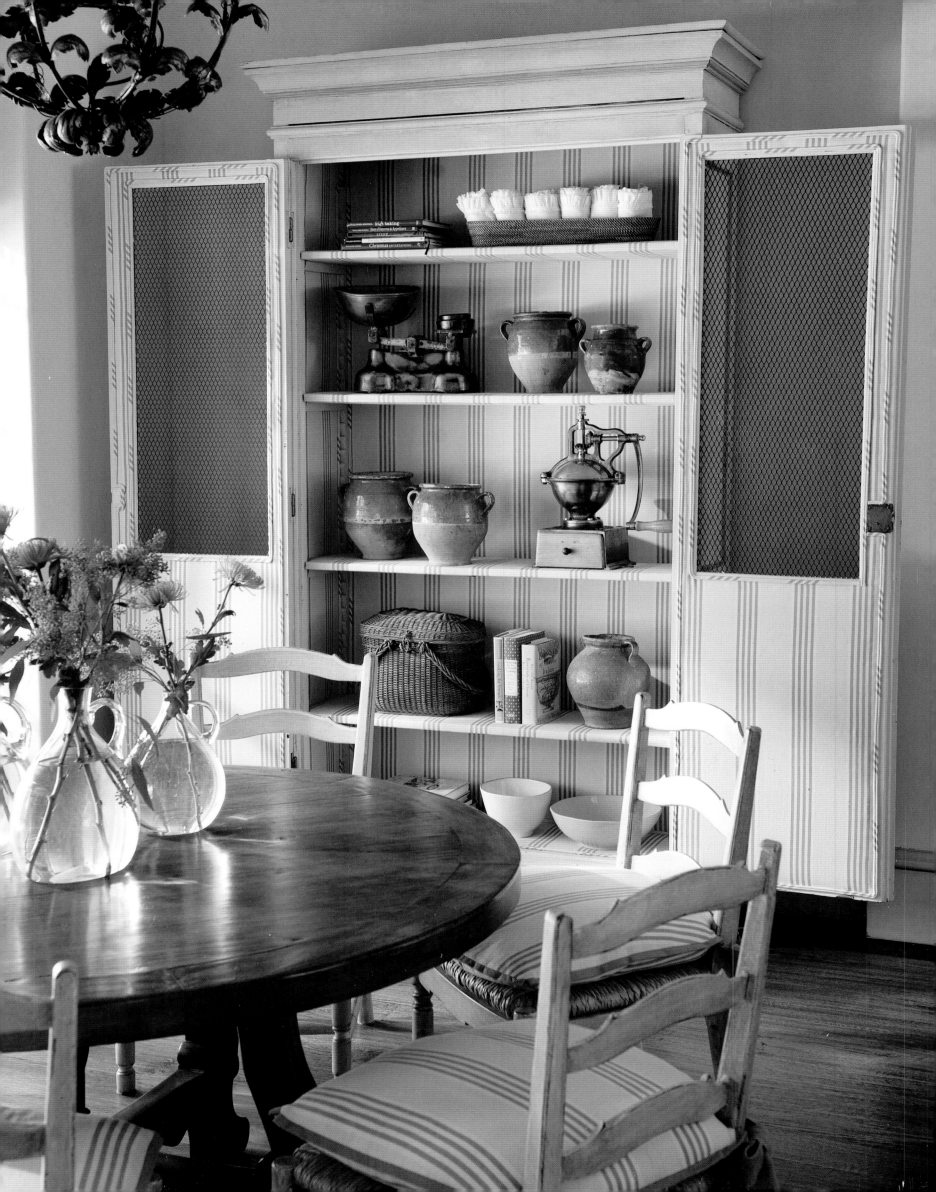

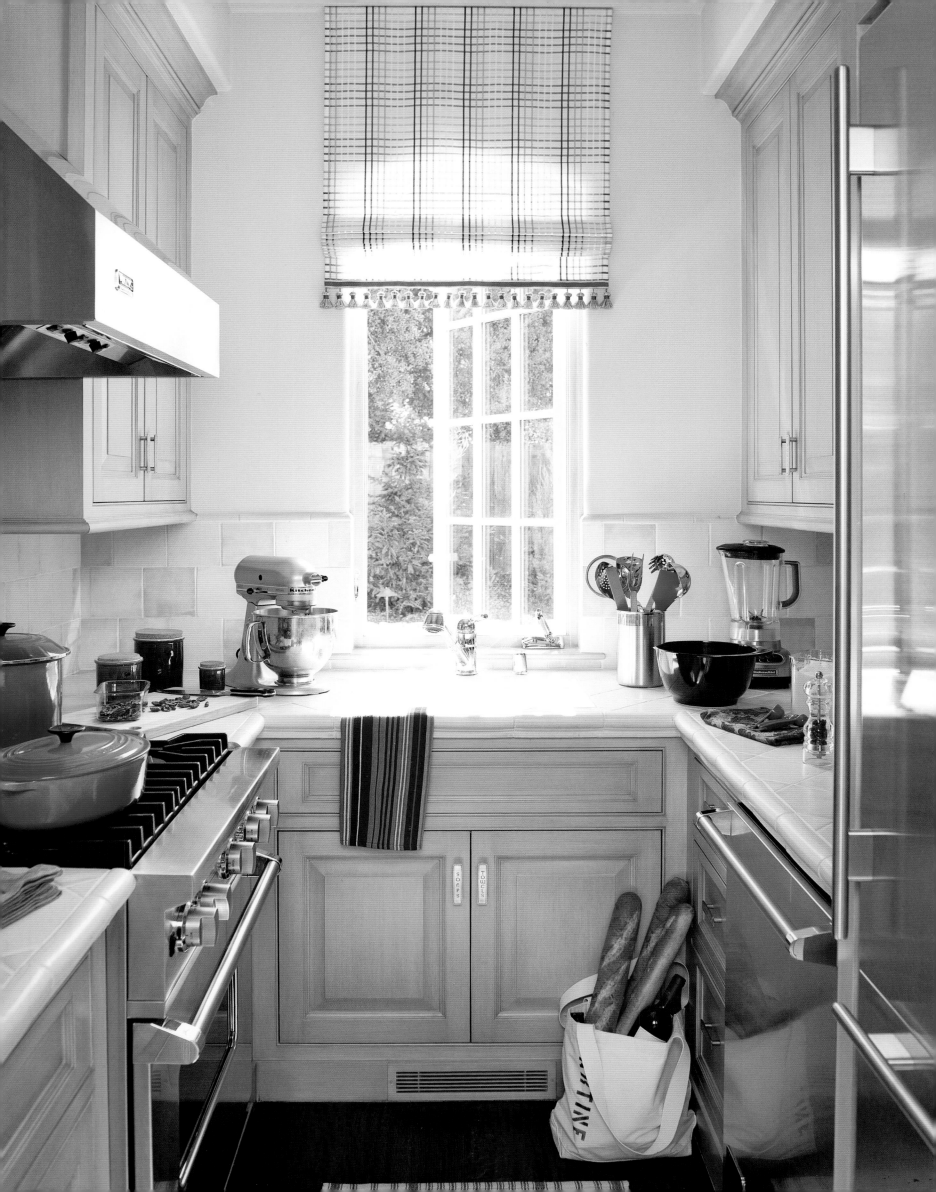

Hardware from Notting Hill's "Kitchen ID Series" insures that one finds what he or she is looking for on the first try.

FACING: Challenging or not, where better than in the family's catering kitchen to try making a *tarte Tatin* with apples, a *pain au chocolat* or small wonders, such as *les petits macarons*—the Parisian "sandwich" of choice. Until recently, *macarons* have been difficult to procure in the United States. Then Ladurée, the Parisian pastry shop that made them famous, opened an outpost on Madison Avenue.

As masculine straight lines gave way to feminine, curvy shapes, Madame de Pompadour set a new tone for elegant decorating. For her, however, gracious living was about more than a string of palaces, priceless works of art, or even a savvy mix of fine fabrics and suitably regal furniture. Whereas Louis XIV chairs stiffly lined the walls, she urged that seating float in the center of a room—to promote the art of conversation. Putting her unparalleled taste and innate flair to good use, she also replaced cold, unpleasantly austere spaces with more inviting, not overly composed use-specific rooms—comfortably heated and bathed in candlelight. Since she was mistress of the house, her authority went unchallenged, no doubt to the chagrin of reigning Queen Marie Lesczynska, the Polish-born wife of Louis XV, whose name is often misspelled in history books if mentioned at all.

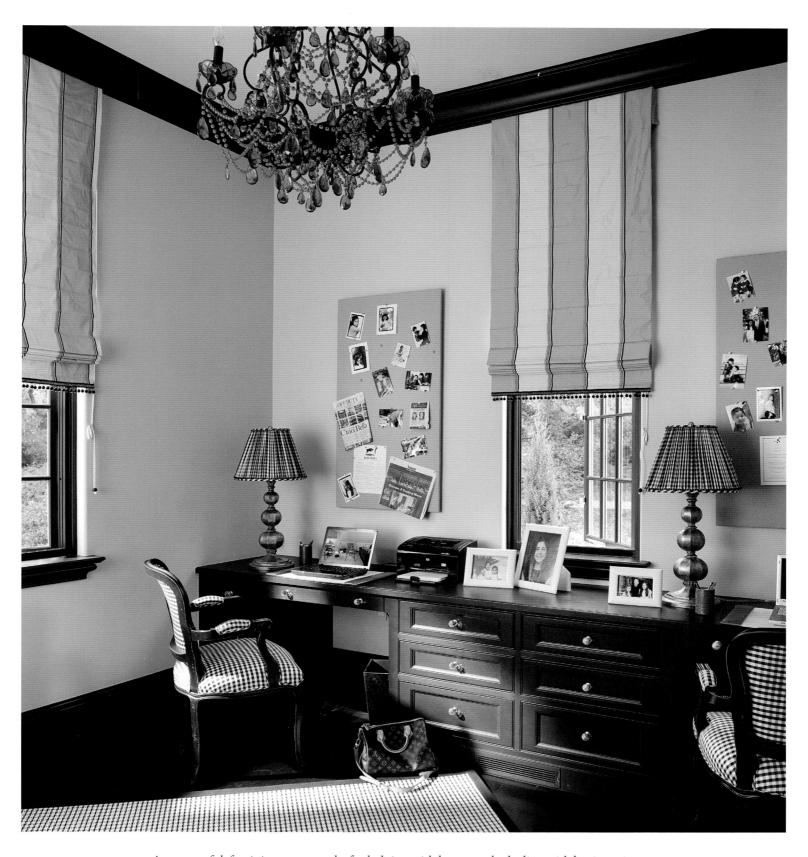

A purposeful, feminine space works for helping with homework, dealing with business issues and quiet moments too. Both the chandelier and chairs are from Jayson Home, Chicago. On the windows: a Manuel Canovas silk with Designers Guild trim.

FACING: The chic night porter's chair, or *guerite,* meaning sentry or guard, originated in sixteenth-century France, where its domed, egg-like shape kept drafts at bay from a gatekeeper stationed at the *château* entrance. Often, a hinged shelf held a lantern and a drawer under the seat held his personal needs, as he generally spent the night in the chair. A Marvic toile covers the chair from Artistic Frame, NYC. Houndstooth area rug by Stark Carpet. Antique plate warmer from Ainsworth-Noah.

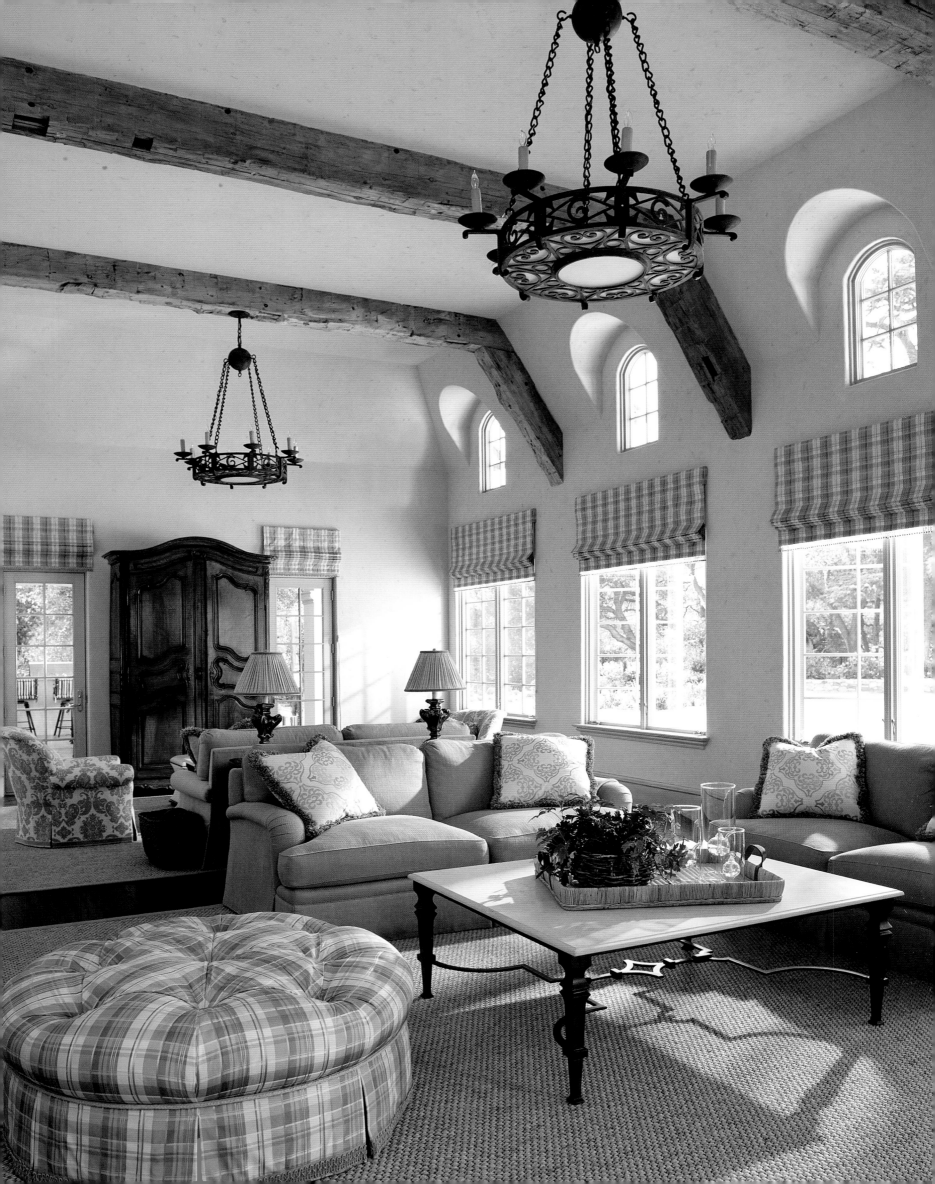

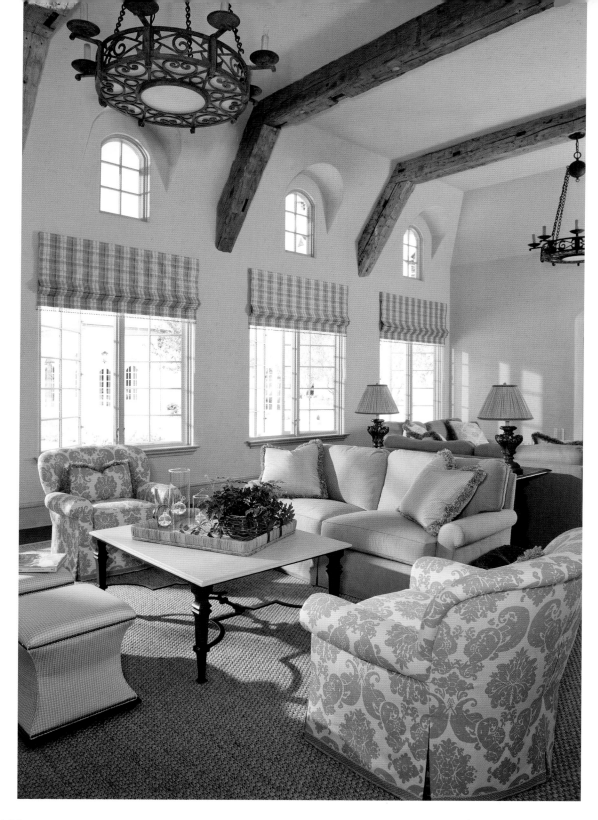

Furnishings and fabrics—a patterned Opuzen linen on chairs, moss green Bergamo chenille covering sofas and plaid Cowtan & Tout silk decking ottomans—take their cue from textures of the great outdoors. Playing a supportive role: Nancy Corzine silk on Roman shades embellished with Samuel & Sons trim.

RIGHT: When a playful Kravet tape darts across the skirts of chairs (one unseen) the result is eye-catching.

FACING: In a great room apportioned into areas for watching movies and catching up, a handsomely carved marriage armoire that withstood the bedlam of eighteenth-century France sets the stage for upholstery scaled to the size of the room. The pair of nineteenth-century hand-cut and -worked steel chandeliers once hung in a hotel in Avignon, France.

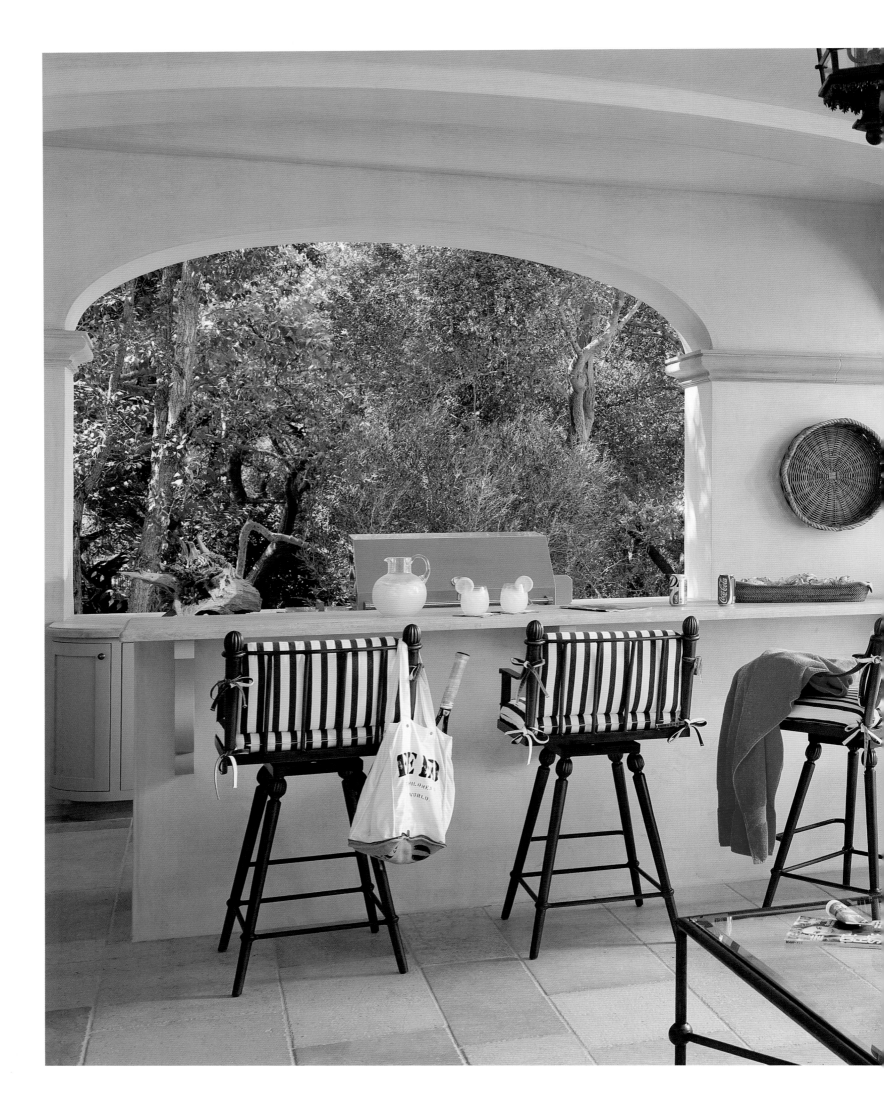

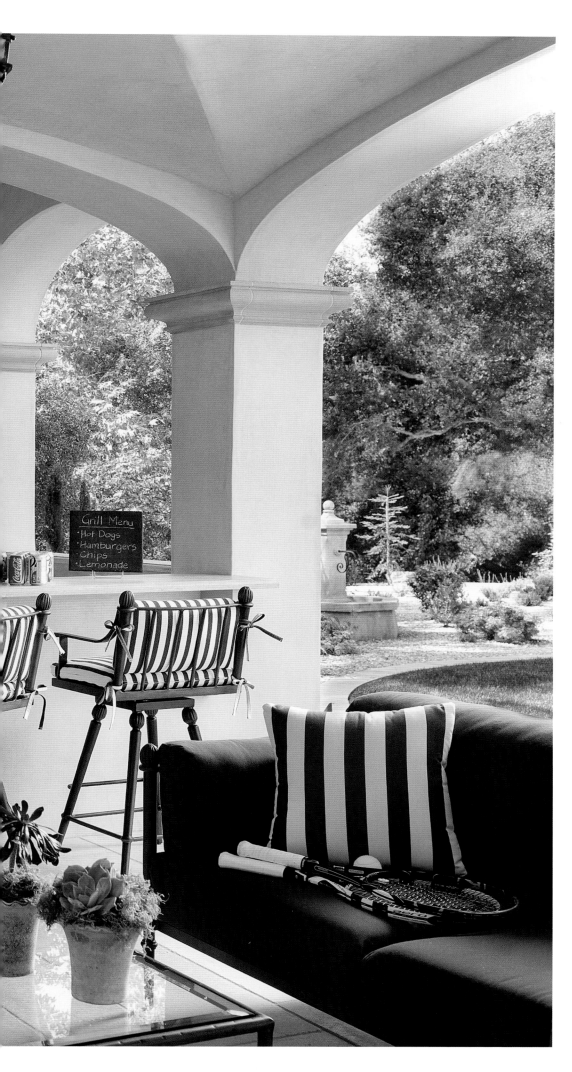

With a densely wooded lot as a backdrop, a loggia offers an escape from the California sun while taking indoor-outdoor living up a notch. A wave of technological advancements of outdoor finishes and fabrics has let a new generation of furniture move outside.

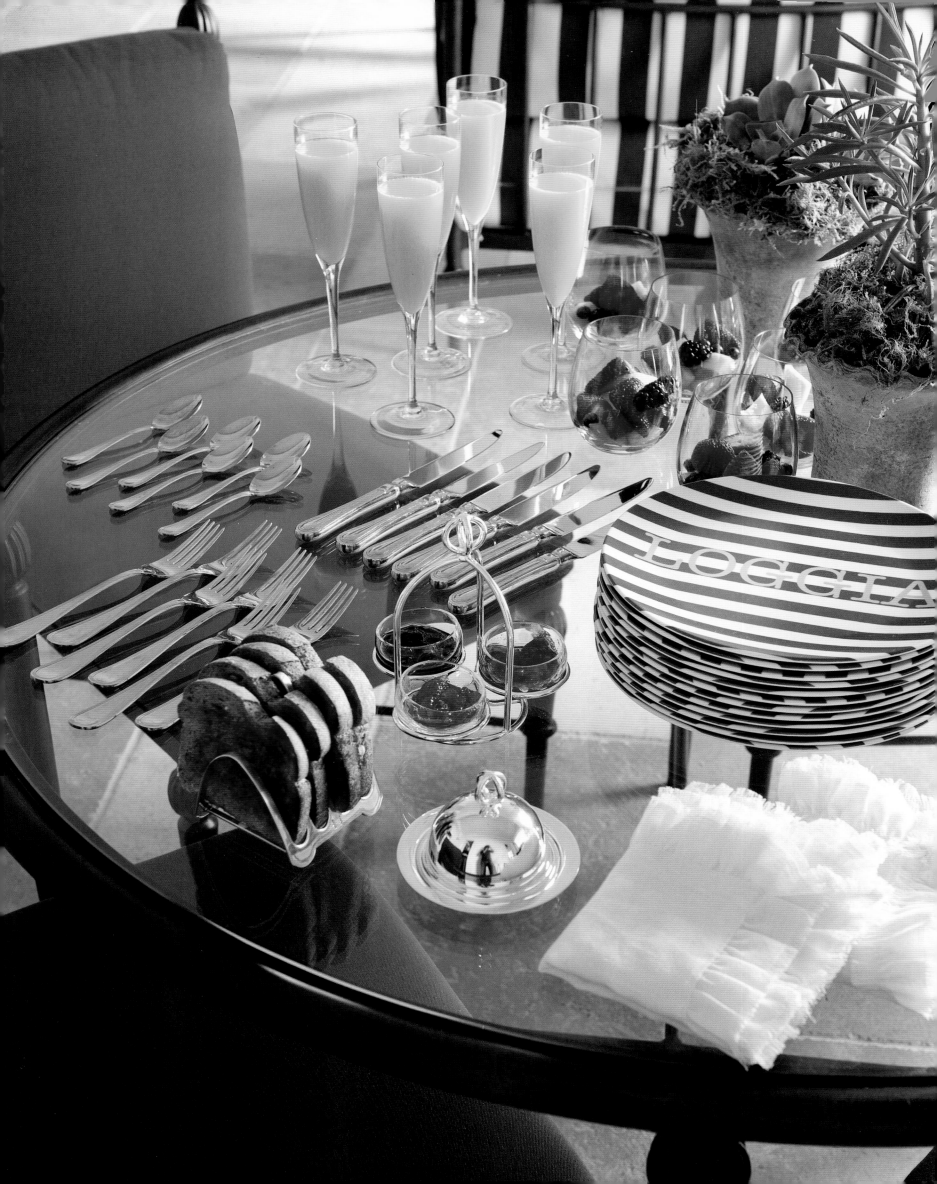

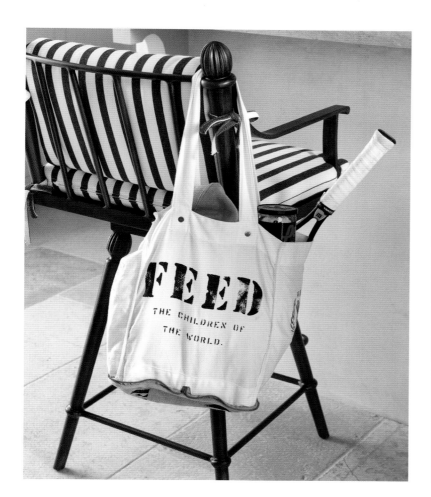

FEED, the accessory company co-founded by Lauren Bush Lauren, uses fashion as a tool for social change by raising funds for a worthy cause. Since 2007, it has provided more than 60 million meals via organizations such as the United Nations World Food Program. With starvation the number-one killer in Africa, the proceeds of each FEED bag sold supplies lunch for one African student every day of the year.

UPPER RIGHT: Serendipity 3 in Manhattan serves the world's most expensive *haute* dog, featuring the ultimate culinary delights *pâté de foie gras* and truffles.

LOWER RIGHT: No-fuss gourmet-on-the-go clearly beats so-so take-out, whether served in a classy red plastic basket or not.

FACING: *En plein air,* an intimate breakfast area overlooking a gravel garden offers coffee and fresh orange juice to start. Skipping breakfast—*petit déjeuner*—is not something French women do. Even the slender take time to eat properly. And those with discerning palates save trees by ditching paper plates. Planet-friendly, dishwasher-safe La Cadeaux tableware brings the blue of the Mediterranean to this loggia.

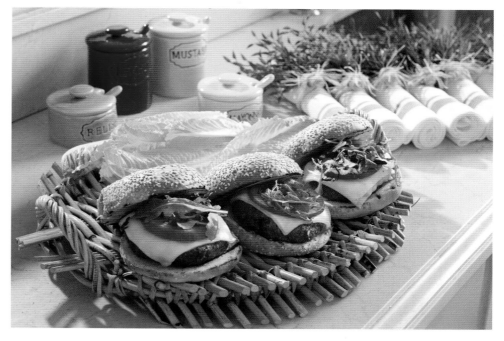

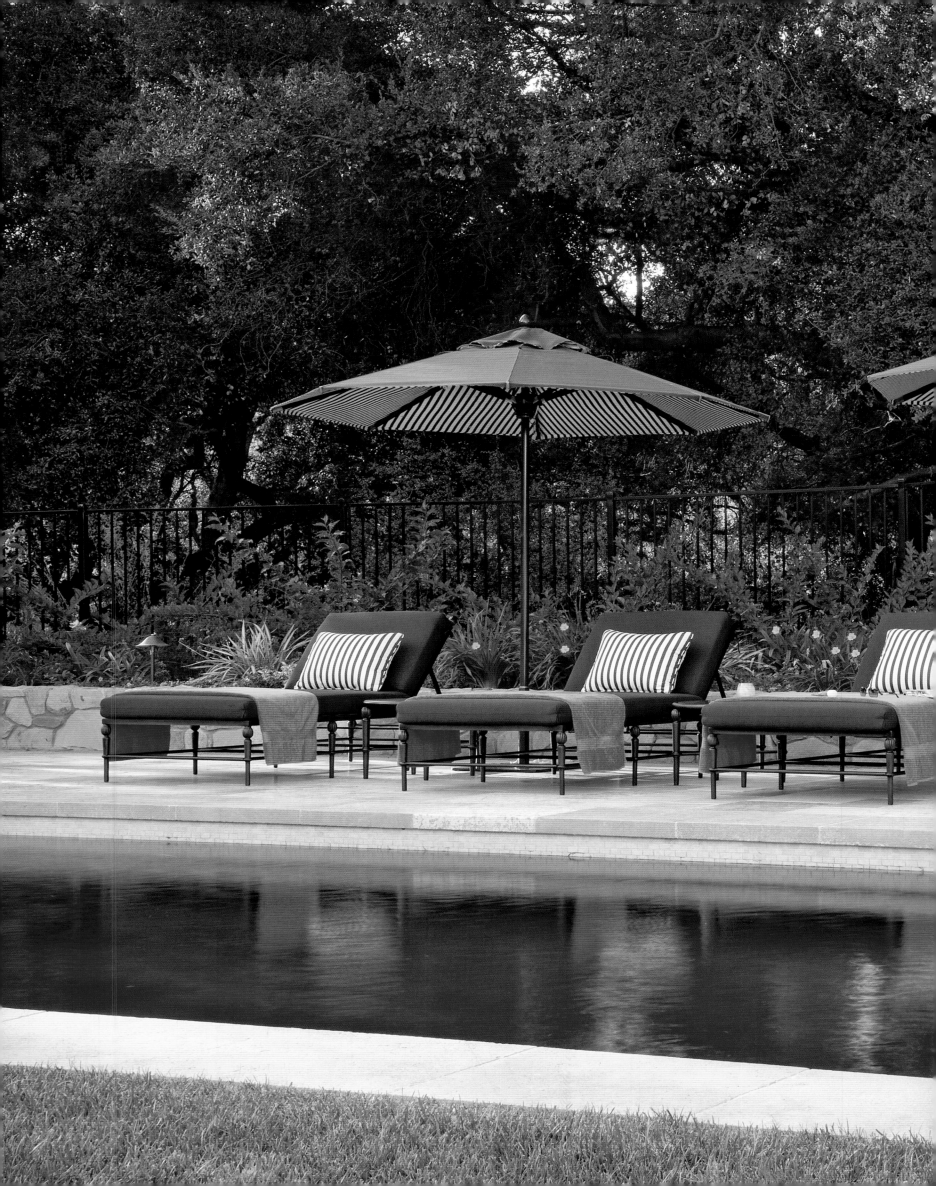

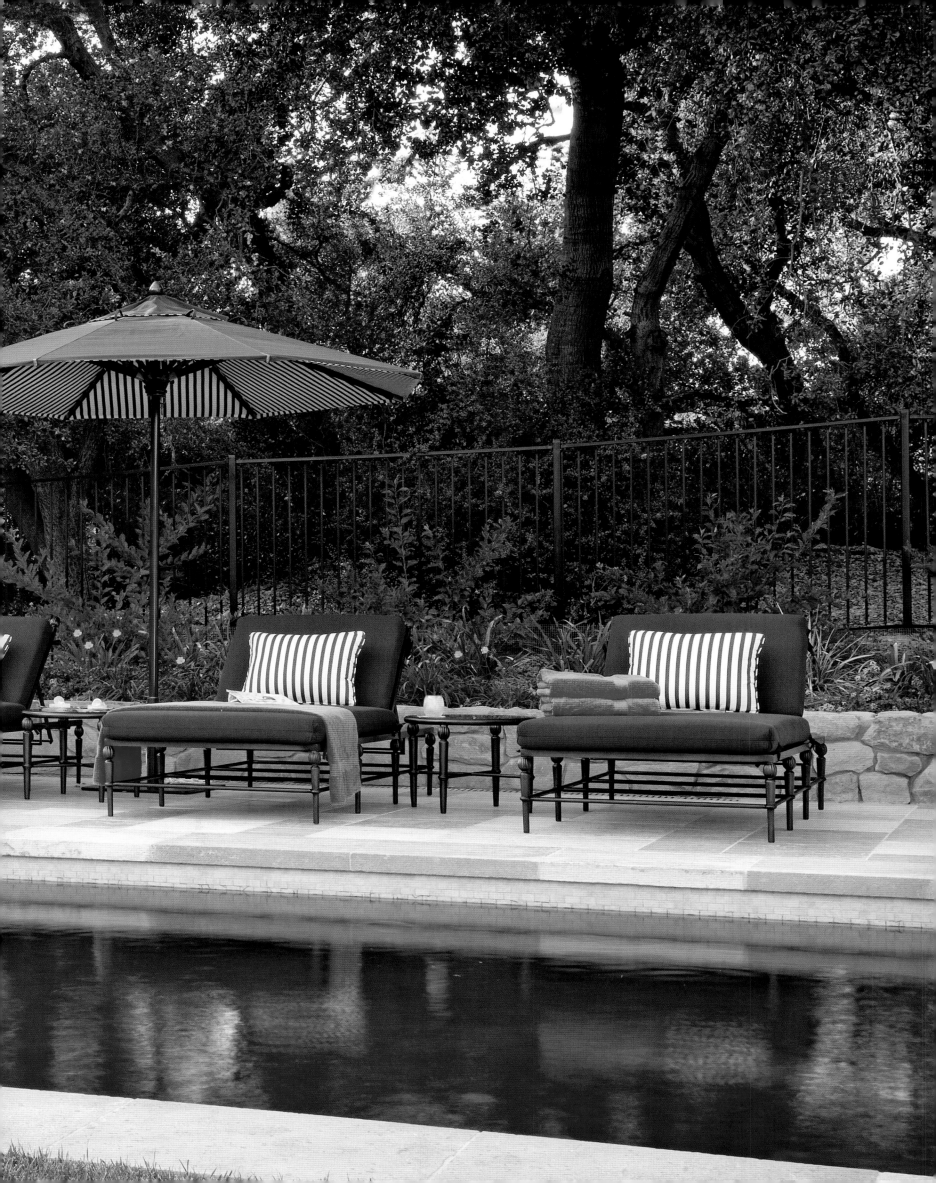

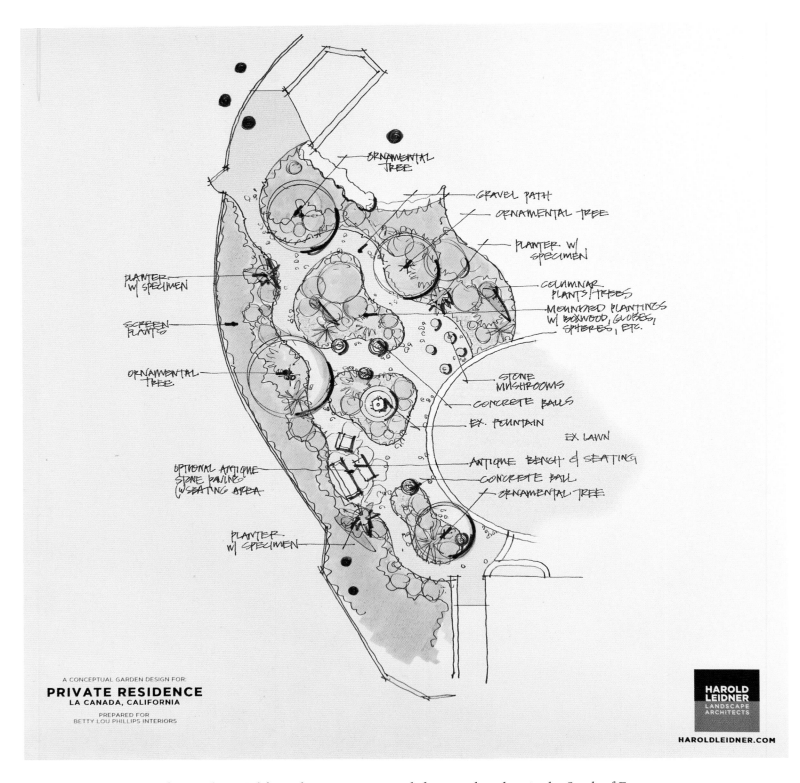

ORNAMENTAL TREE

GRAVEL PATH
ORNAMENTAL TREE

PLANTER W/ SPECIMEN

PLANTER W/ SPECIMEN

COLUMNAR PLANTS/TREES

MOUNDED PLANTINGS W/ BOXWOOD, GLOBES, SPHERES, ETC.

SCREEN PLANTS

ORNAMENTAL TREE

STONE MUSHROOMS

CONCRETE BALLS

EX. FOUNTAIN

EX LAWN

OPTIONAL ANTIQUE STONE PAVING W/ SEATING AREA

ANTIQUE BENCH & SEATING

CONCRETE BALL

ORNAMENTAL TREE

PLANTER W/ SPECIMEN

A CONCEPTUAL GARDEN DESIGN FOR:

PRIVATE RESIDENCE
LA CANADA, CALIFORNIA
PREPARED FOR
BETTY LOU PHILLIPS INTERIORS

HAROLD LEIDNER
LANDSCAPE ARCHITECTS

HAROLDLEIDNER.COM

After southern California homeowners marveled at gravel gardens in the South of France, Dallas landscape architect Harold Leidner went to work.

PRECEDING OVERLEAF: In August, much of France shuts down and the French flee to coastal and mountain towns for *les vacances d'été*. With hundreds of festivals across the republic, more than 80 percent of the people forego far-flung vacations in favor of spending their holidays in *la belle* France. Chaises wear beachside couture: Perennials solution-dyed acrylic outdoor fabrics, guaranteed against fading for three years.

Artisans from across Europe soon settled in Paris in the hope of providing less imposing, exquisitely crafted, elegant furnishings to the court of Louis XV, the king's subjects and Madame de Pompadour, naturally. At the same time, famed Gobelin tapestries made in Paris and carpets from Aubusson, Beauvais and the merged Savonnerie and Gobelin factories continued adding layers of luxury to rooms, much as they do today.

These days, however, other Americans with patrician propensities find that the unassuming majesty of neoclassical furnishings (1760–89), the style of much-maligned Marie-Antoinette and Louis XVI, overthrown during the French Revolution, suit everyday living. Once deemed a disconcerting reminder of the pair's ill-fated reign, many distanced themselves from the mode until Empress Eugénie (1826–1920), the elegant wife of Napoléon III, endorsed the Queen's less formal taste.

Though she hardly robbed the palace of glamour, nor of drama, Marie-Antoinette eschewed the opulence—and ultra-stuffy formality—the court deemed appropriate for royalty. So she could live as she wished, in 1774, Louis XVI presented his wife with the title to the Petit Trianon, a small *château* set on the grounds of the Palace of Versailles, built by Louis XV as a gift for Madame de Pompadour, who passed away before its completion.

Apparently not content to leave well enough alone, Marie-Antoinette revamped the royal gardens to include meandering paths, rolling hills and picturesque streams, much to the chagrin of oppressed taxpayers. On the grounds of Versailles, she also commissioned a farming village, the Petit Hameau—at great expense, to be sure—resulting in angry cries from detractors. While most these days would view her decorative leanings as only a degree less queenly than her predecessor's, many at court found her wayward taste and elusive persona unsettling. >68

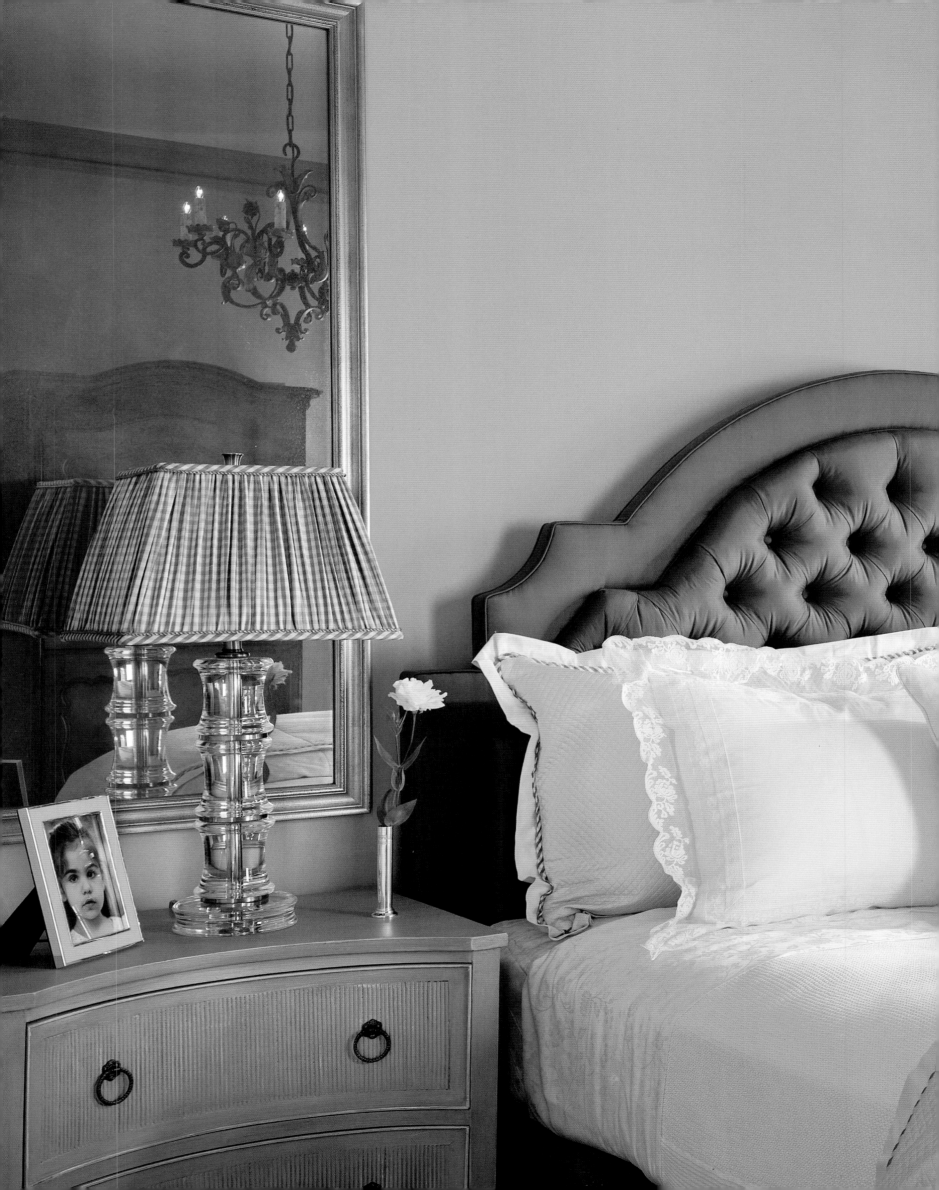

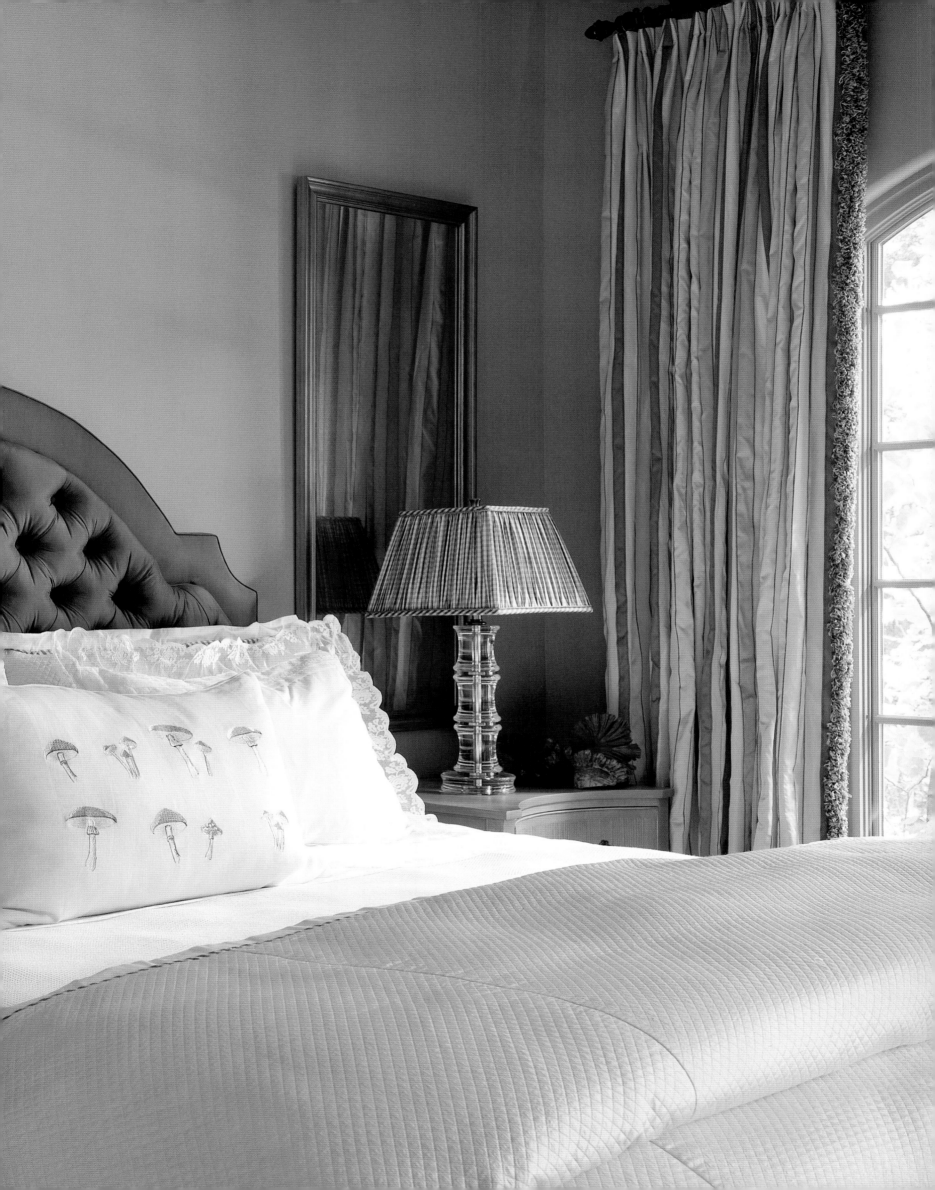

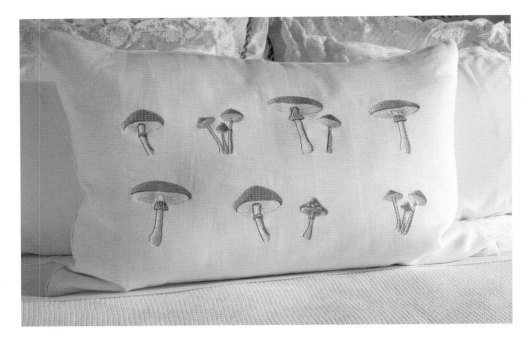

LEFT: Mad for mushrooms? With more than 600 species of mushrooms, not surprisingly, the fungus has inspired recipes, music, art, fables and festivals—in addition to a statement-making Yves Delorme pillow with metallic threads.

Forests throughout France are mushroom havens. No matter that it takes a bit of know-how to differentiate the edible from the harmful, mindful French foragers are wild about *cèpes,* whether sautéed, steamed, roasted or grilled with a bit of butter or drop of oil and some garlic.

FACING: Tufting—the process of drawing a cord through a cushion to create highs and lows—underscores the appeal of a chair from Marroquin Upholstery parked next to a Louis XV *bonnetière* from Jacqueline Adams Antiques. The Yves Delorme spring green throw lifts the palette.

PRECEDING OVERLEAF: Taking a cue from the irresistible mushroom, one of the culinary world's greatest obsessions, a California guest room echoes its subtle palette of greige, taupe and ivory. Lamps from Ralph Lauren Home flank a tufted headboard wrapped in fabric from J. Robert Scott. (The thickness of the padding and the density of the tufting determine the lushness of an upholstered headboard.) The Bergamo stripe, flowing from iron rods, flaunts Leslie Hannon Custom Trimmings, while bedside mirrors—glazed to look a century old— add interest by visually expanding a room made up with Ralph Lauren Home's couture-inspired bed linens.

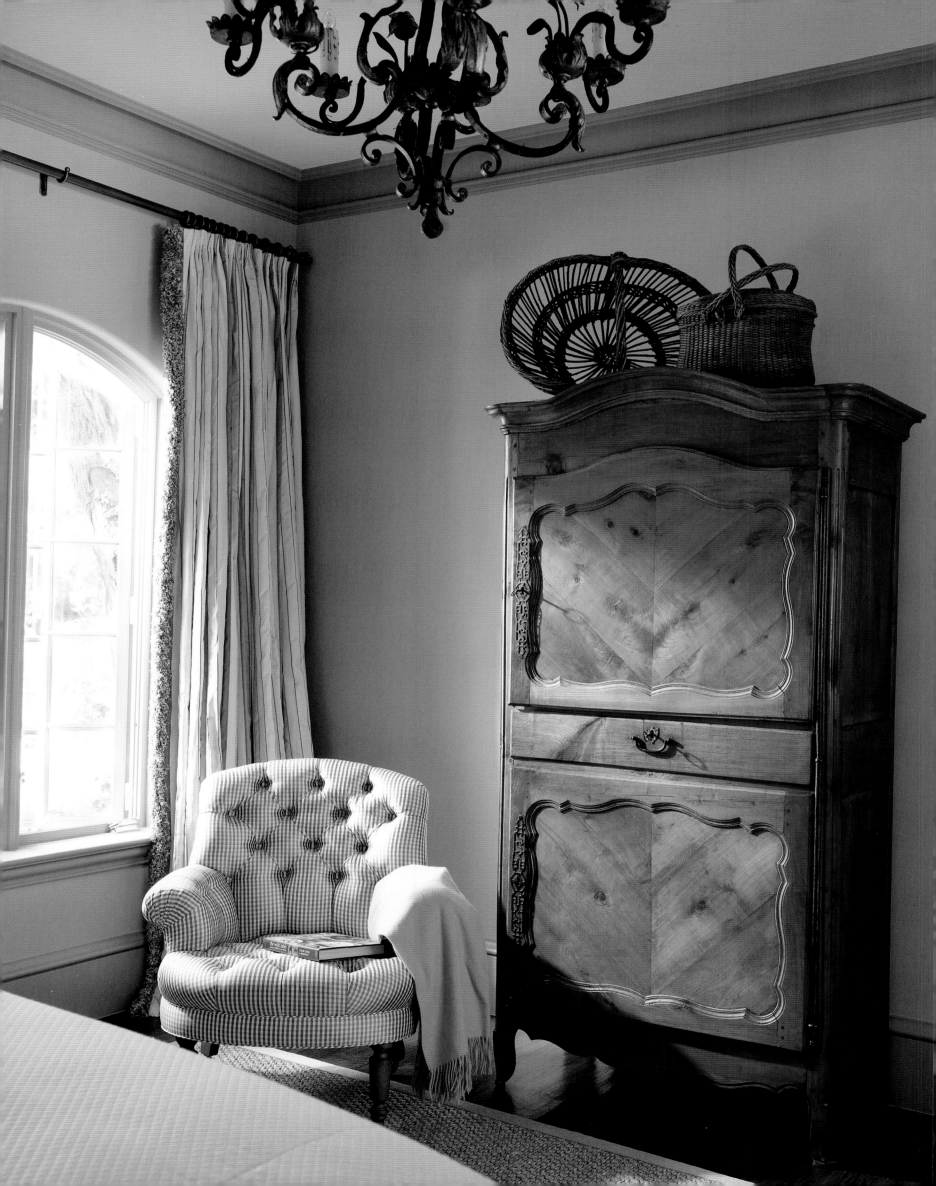

At the Petit Trianon, the Queen distanced herself from the thousands at Versailles, welcoming into her generously proportioned refuge only those personally invited, while keeping all others at bay. A misstep or not, she also snubbed elaborately frescoed ceilings, majestically carved walls and sheaths of mirrors. Distinct from the grandeur ablaze at Versailles, serene greens, demure violets, watery blues, pale pinks and clotted creams abounded with the bold, color-saturated, jeweled hues—emerald, ruby and sapphire—of earlier eras falling from favor.

Motifs with sprays of flowers entwined in delicate ribbons filled baskets and urns, spilling onto fabrics and neoclassical furniture with slender, tapered legs and precise geometric shapes that borrowed ornamentation from ancient Greece and Italy's excavations of Pompeii and nearby Herculaneum. Wreaths, rosettes and garlands flourished, too, as Marie-Antoinette paid homage to Mother Nature, her muse.

For most of us in the United States, overindulgence no longer has a place among twenty-first-century economic worries, never mind the global financial crises. Far less—or certainly less—lofty is now plenty inside many stateside spaces. In a notable shift, a more conservative way of life is emerging, in keeping with the new international mood. >76

Fittings from Danbury, Connecticut–based Waterworks and sconces from Urban Electric in North Charleston, South Carolina, meet in a guest bathroom, where a freestanding vintage pharmacy chest doubles as a linen closet.

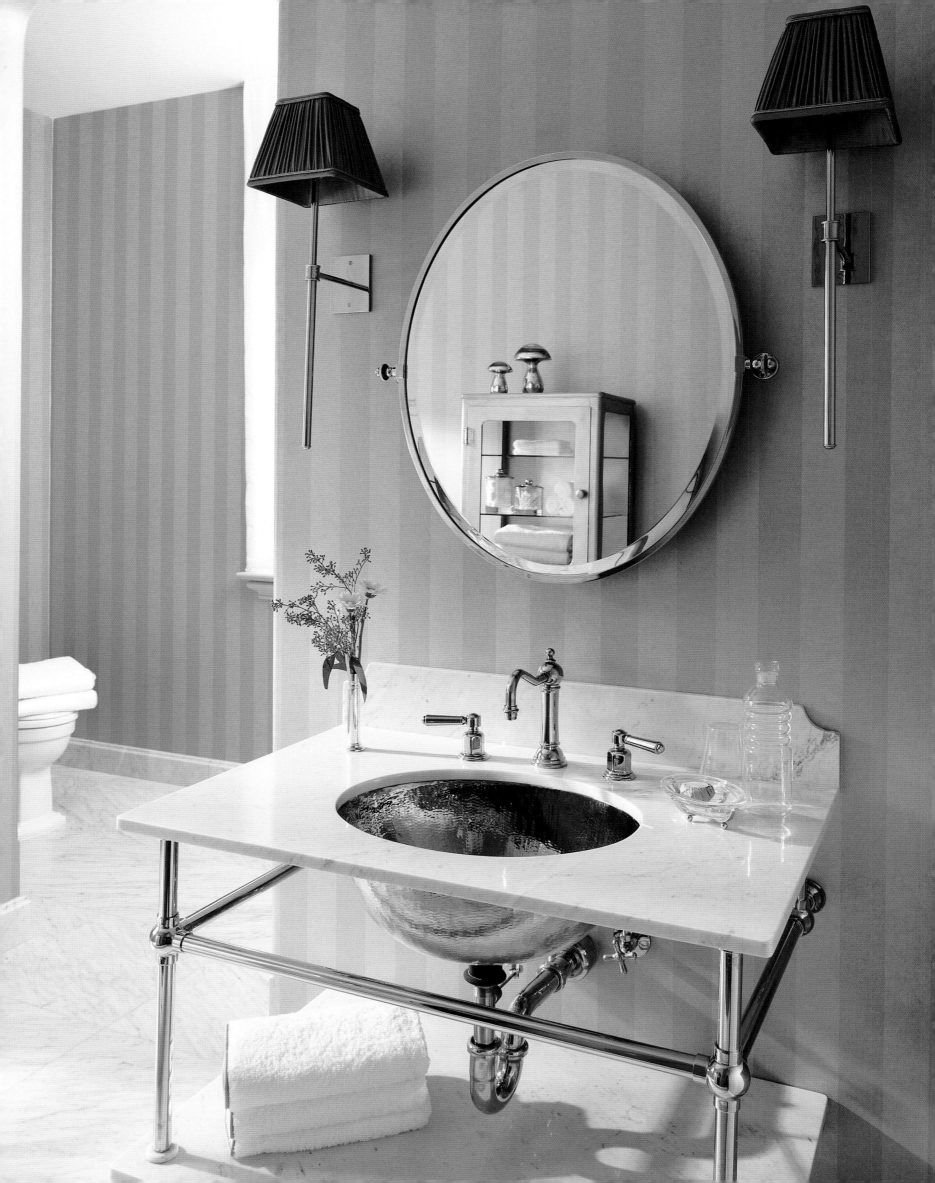

If the scoring system for tennis seems hard to grasp, we need look only to our lack of comprehension. The zero appearing on a scoreboard in France apparently looked like an egg, or *l'oeuf,* to some. When tennis became popular in the United States, our ears heard "love" rather than *l'oeuf,* and *viola,* love equals zero. Similarly, rather than *deux,* which is French for "two," we heard "deuce," implying one must score two additional points to win the game. Embroidery by Joan Cecil.

FACING: A spot only steps from the back door is just right for dropping off textbooks or sports equipment on the way in and serves as an ideal place for putting on running or tennis shoes before heading to the road or court.

BELOW: Time-worn terra-cotta tile from Exquisite Surfaces lines a stairway leading to bedrooms, giving a new construction the feeling of age. In the area now known as Tuscany, the Etruscans first used terra-cotta, literally, "cooked earth."

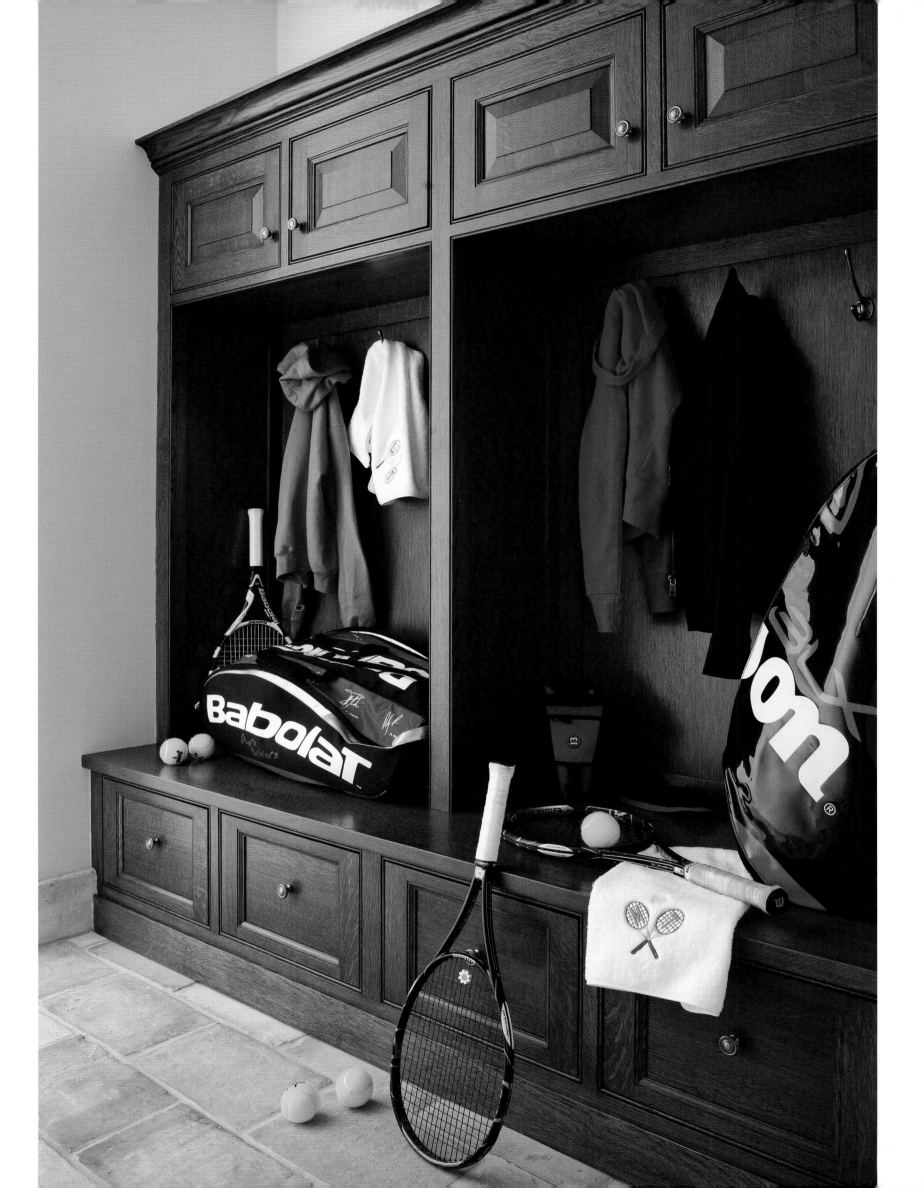

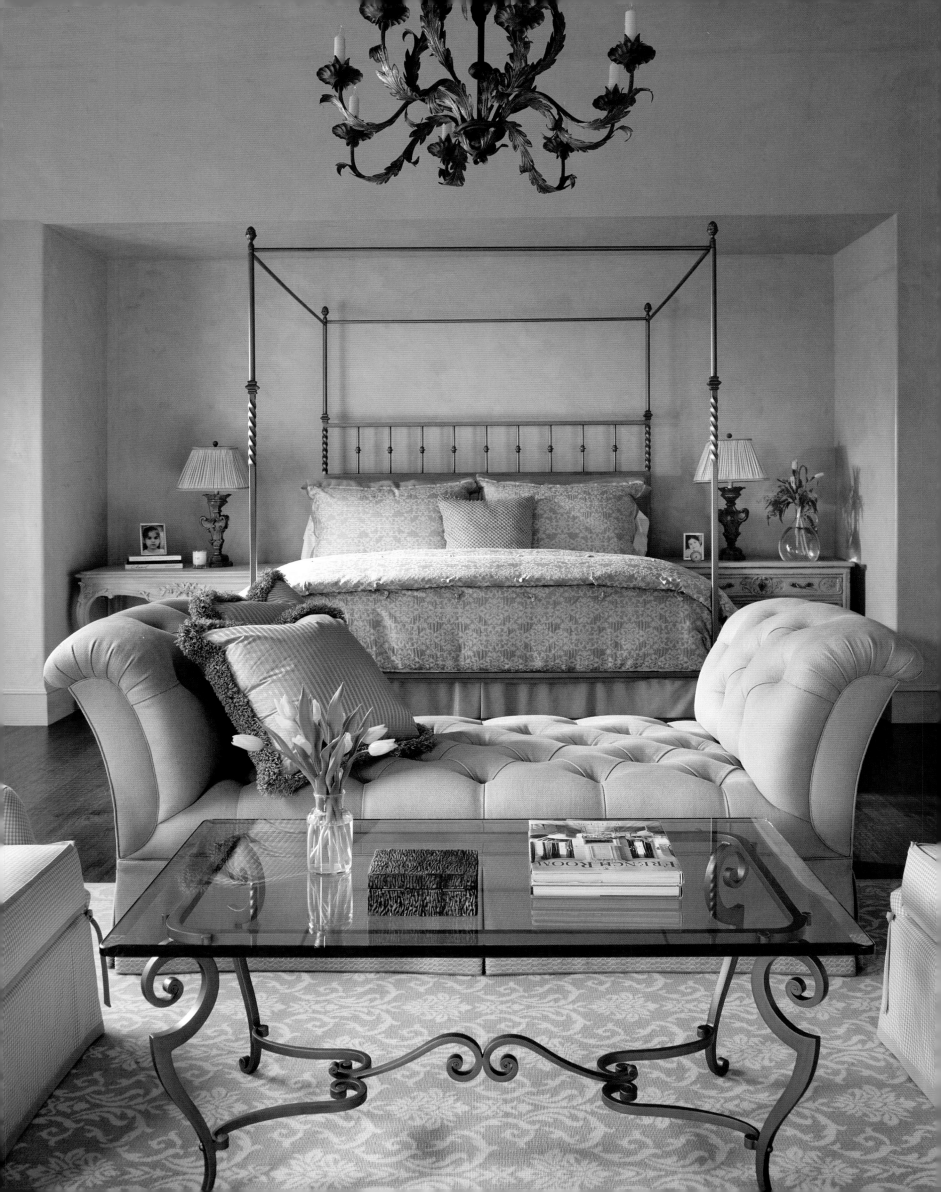

Yes, Paris has the Louvre, Florence the Uffizi and Madrid the Prado. Garnering accolades in the gallery of a home outside Los Angeles are splendid watercolors of the latter by Dallas architect and artist Daniel Heath, 2012 winner of the prestigious Rieger Graham Prize, a national competition that results in a classical design fellowship at The American Academy in Rome, Italy.

LEFT: A railroaded, sheer overlay that is a mix of flat and boucle yarns heightens the drama of the bedskirt's major fabric, "Elizabeth" for Brillant, USA.

FACING: In 1240, when privacy was nonexistent, Henry III of England commissioned the first king-sized bed, an unforgettable *lit à colonnes,* or four-poster, with painted canopy. Heavy curtains protected him from draughts plus screened him from servants passing through his chambers. Today, fabrics from Brillant, USA and Nancy Corzine turn a spacious master suite into an intimate space worthy of the bed from Murray's Iron Works.

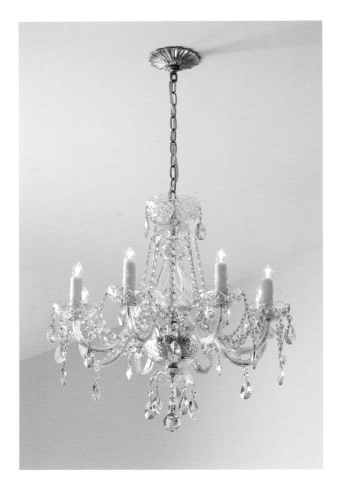

In some homes, the living room and dining room are the focus, while other rooms are randomly furnished—unlike here, where a vintage chandelier helps a teen's room emit a spirit equal to other rooms of the home.

RIGHT: With color she creates a look all her own. Lamps are from Brunschwig & Fils, shades by Cele Johnson Custom Lamps & Shades , and chests from the Wisteria catalog. Bed linens are by Matouk.

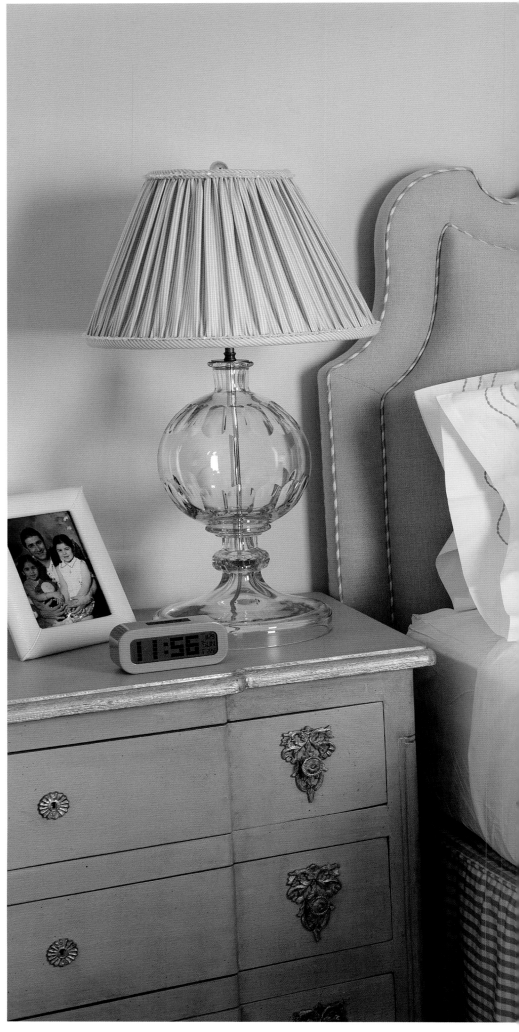

No matter that our furnishings are not worthy of the court of Versailles; they are close enough. Or that no dwelling with restaurant kitchen, elevator to all levels and exhilarating views is complete these days without an enviable mix of treasures, however modest, culled from various periods as well as assorted nations. For most, an artful mix of comfort and chic is a priority emblematic of the times. So, when left to our own devices, we inextricably link elegance with grace and living graciously in settings redolent with French history—as, presumably, was Louis XIV and his descendants' ardent wish.

A bold print relaxes the look of an eighteenth-century bench. Shag rug by Stark Carpet.

FACING: A teen's room reads edgy, decked in sherbet flavors—lime, lemon and orange—fun photos and a distinctive Paris desk. The *étagère* with French Forties flair doubles as a space to stash favorite childhood treasures. Those only somewhat less favored reside in an unseen closet.

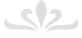

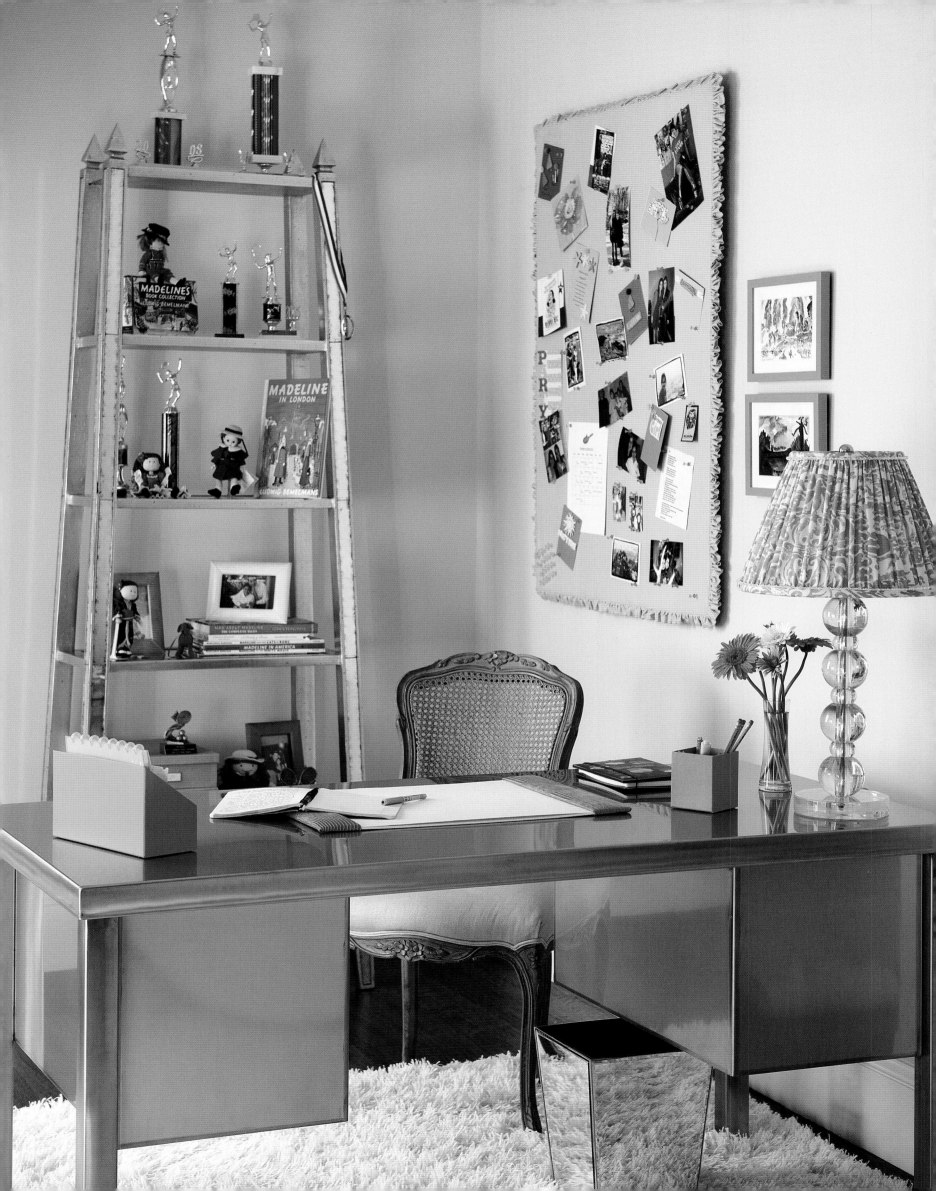

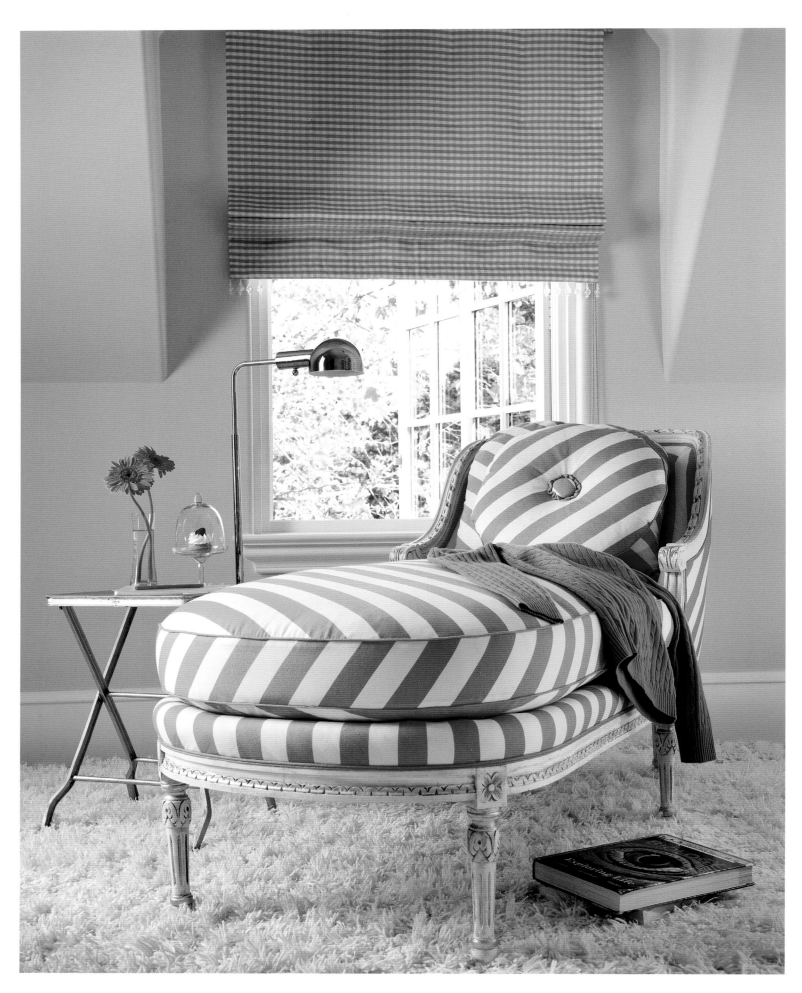

Comfortable? To be sure. But credit the bright, airy diagonal stripe with giving a chaise—
direct from Marroquin Upholstery—a bit of drama. The small book table, or drinks table, if
you will, is a practical addition from Brown, Houston.

An ideal bathroom begins with the basics then adds personal pizzazz: glass tile from the Renaissance Collection, wallcovering from Tyler Hall, mirrored boxes from Restoration Hardware and towels from Yves Delorme.

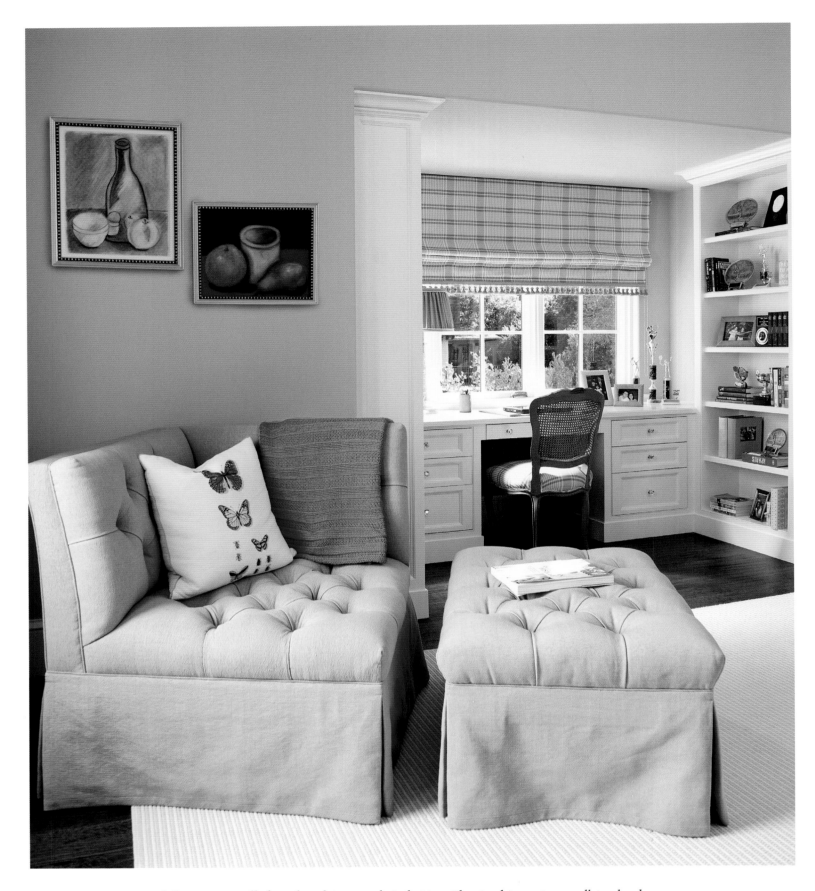

When a room calls for a shapely corner chair that is neither too big nor too small, too hard nor too soft, one tailor made by Marroquin Upholstery rises to the occasion. The coral throw gives the space added oomph. Wool rug from Stark Carpet.

FACING: Mirrored furniture projects a French Forties look. Bolts of soft, flowing linens—a Kravet solid and a stripe—also express the popular style. Bed linens edged in aqua are from Matouk. Picture frames by Helene Batoff Interiors, Wynnewood, Pennsylvania, create a mini photo gallery.

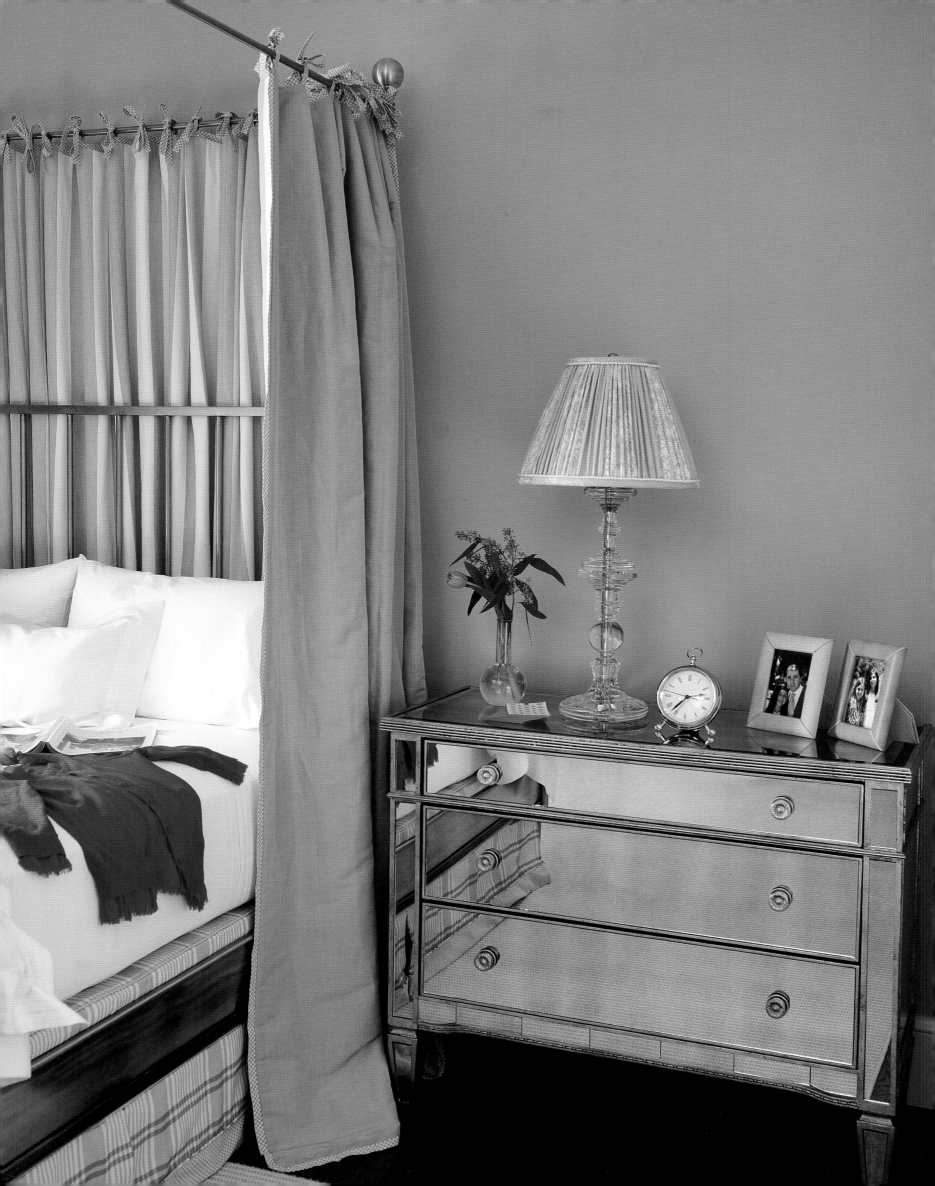

When it comes to adding interest to a crystal lamp from Brunschwig & Fils, faux pearls from M&J Trimming, NYC, belie their small size. Cele Johnson Custom Lamps & Shades fabricated the gathered shade.

FACING: With beauty being the luck of the draw, the French believe that a young girl must grow up knowing that it is in her best interest that she is more than an empty shell. Watery blue wallcovering from Schumacher. Cosmetic bag from Tiffany's. Towels by Yves Delorme.

BELOW: A teen who loves butterflies puts a personal stamp on her bulletin board. In 2004, Karl Lagerfeld designed two stamps for the French Postal Service, both lauding Chanel. One featured the iconic Chanel No. 5 perfume flask on a quilted heart, the other, a sketch of a Chanel model in front of the Eiffel Tower, the quintessential symbol of French identity.

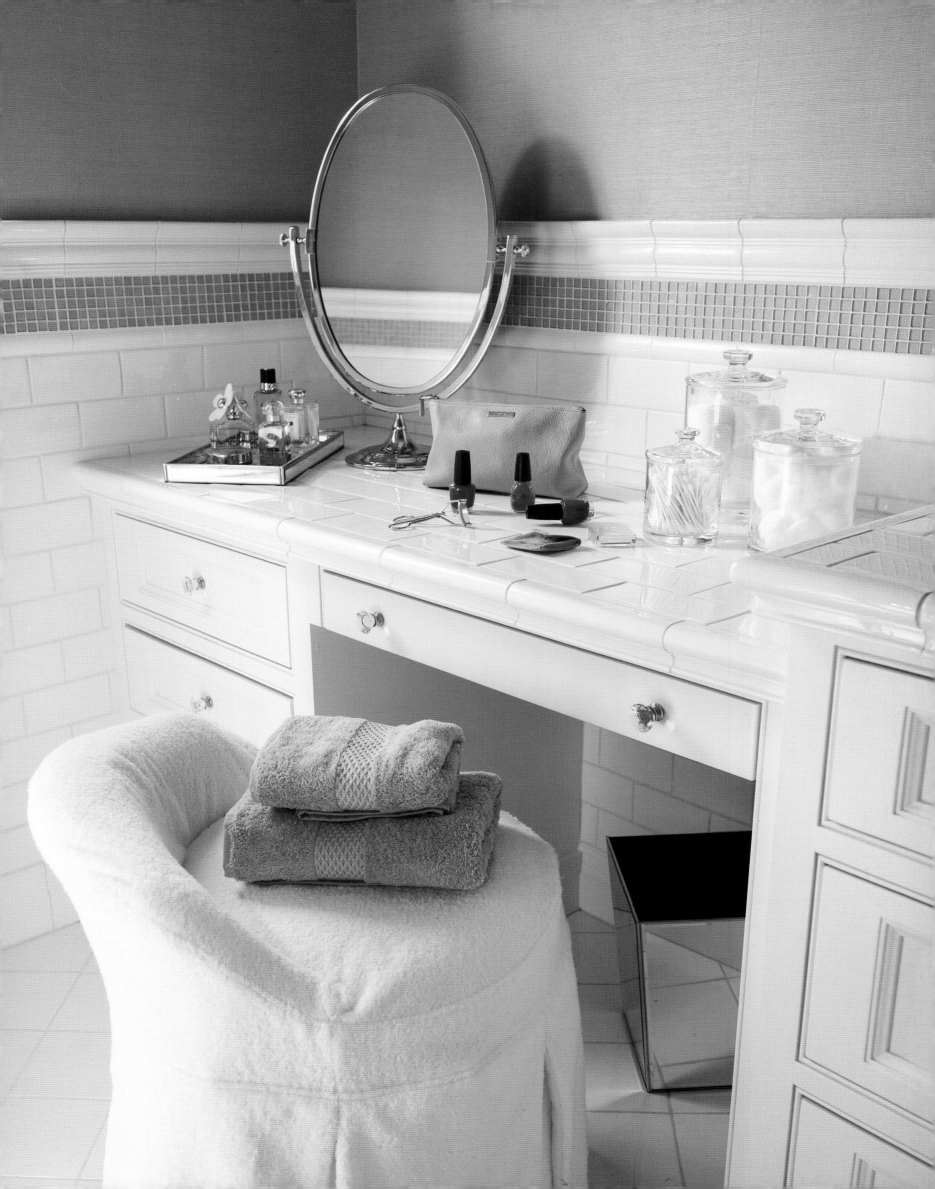

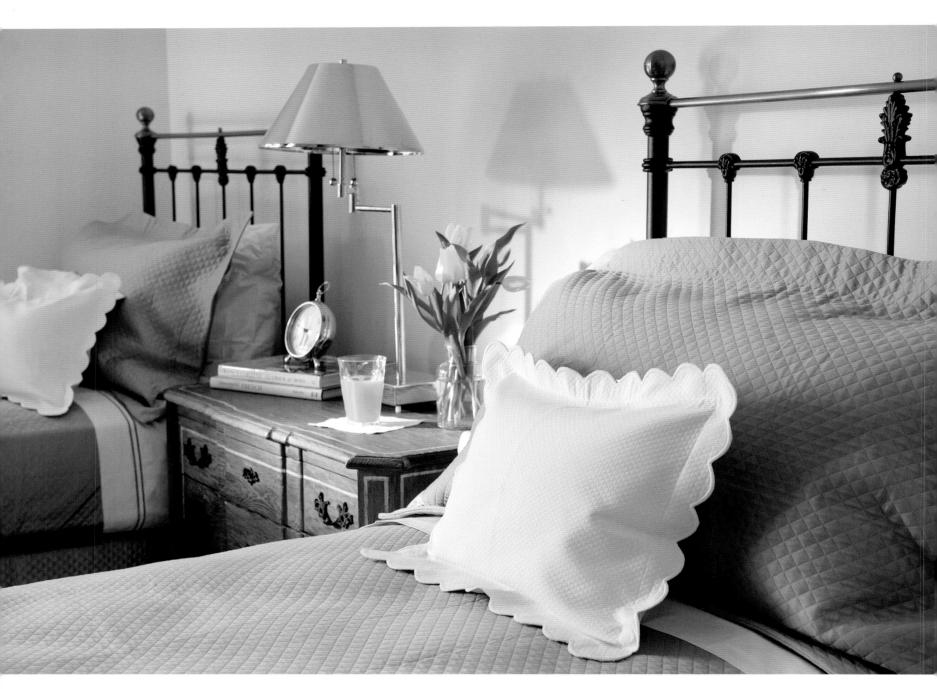

Modern luxury is staying in a guest apartment with the subtle play of soft yellow (on walls) and seagull gray (on matelassé bed coverings by Sferra). Those living in the States like to prop pillows up against the headboard for a dramatic effect, while Europeans generally lay their pillows flat and cover them with the coverlet or bedspread.

RIGHT: Small wonders such as cabinet knobs from Atlas Homewares' "Bon Voyage Collection" can add interest.

FACING: Whites. Colors. Darks. Clothing comes in infinite shades, so it makes sense that a laundry room should not be plain vanilla. Wallcovering by York puts an exhilarating spin on the space.

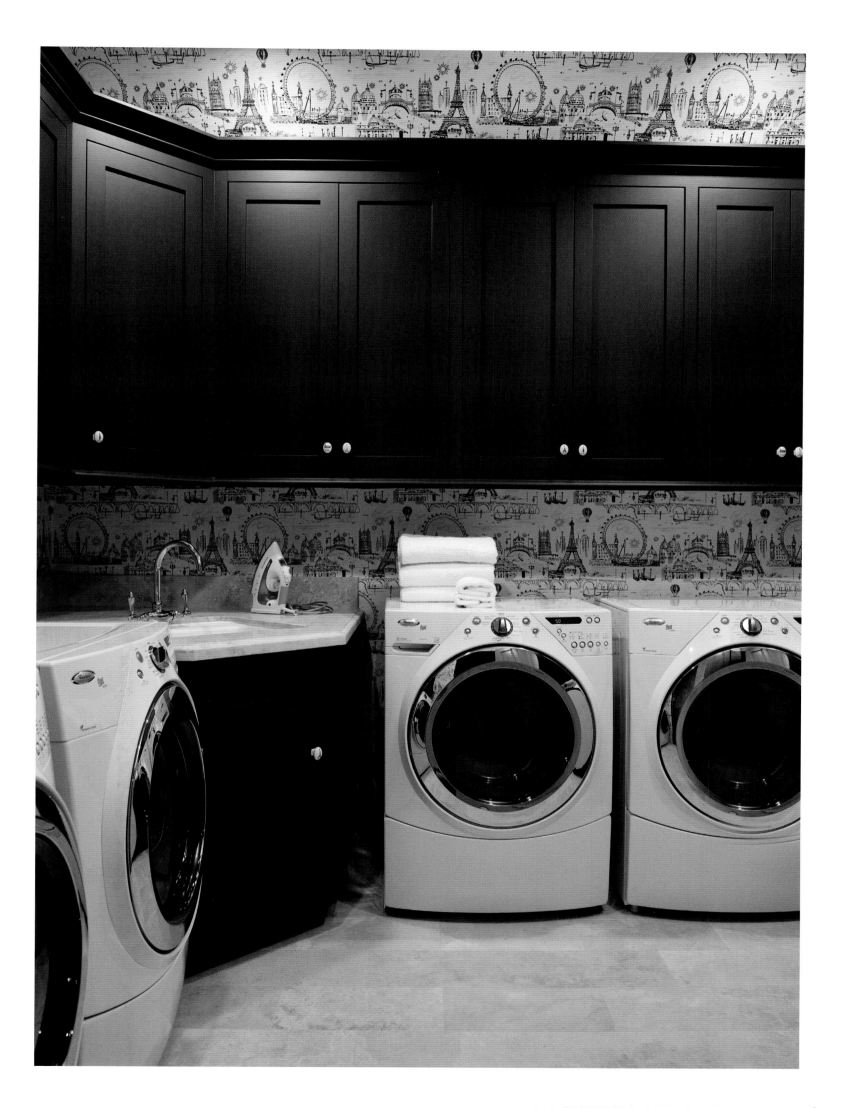

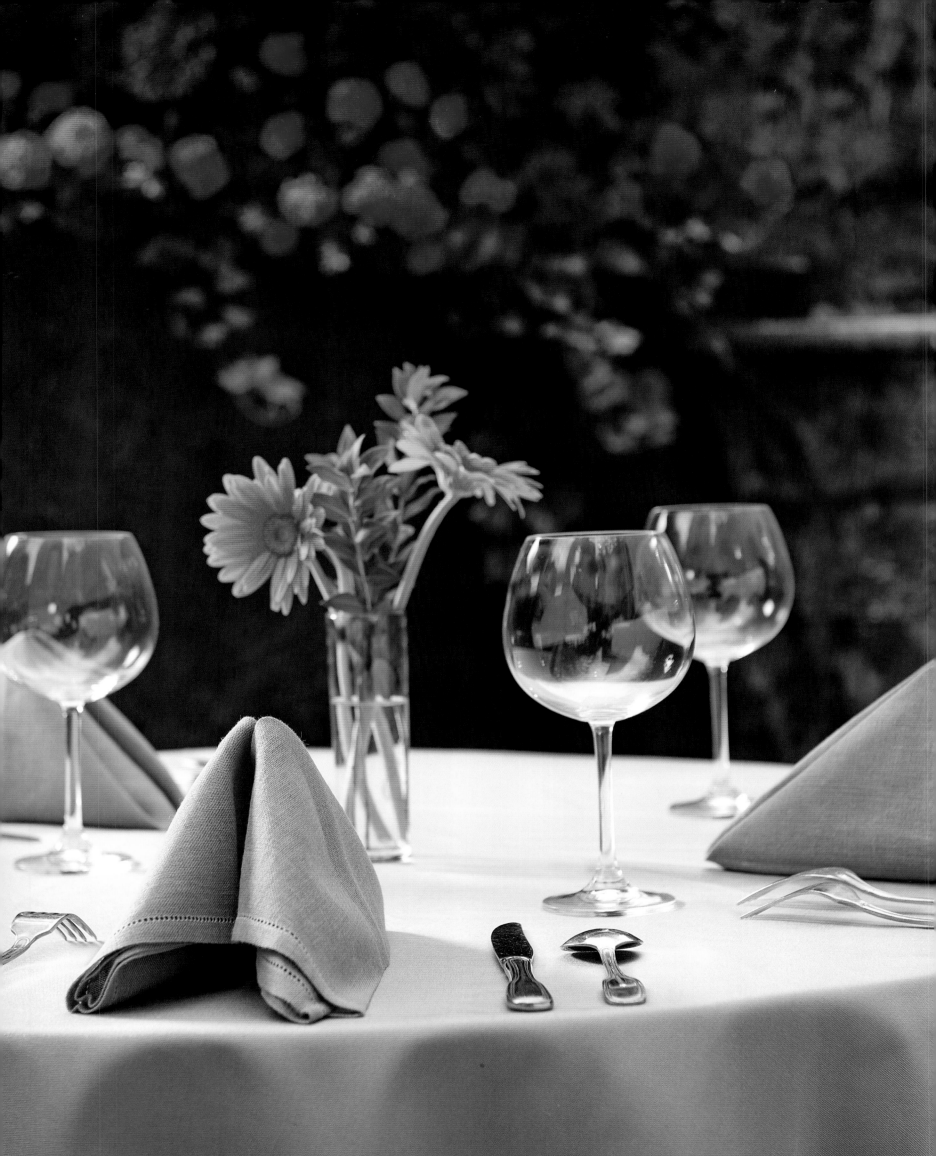

ACQUIRED
Taste

With their maddening self-confidence, their superior notions concerning cuisine, their practiced manners and their matchless sense of style, not to mention their self-assured approach to design, those of us swathed in their influence might justifiably wonder whether a chic gene lurks within the French DNA. How could we not? As tastemakers, they reign supreme—with a reach that extends worldwide.

Many in France credit the formidable Catherine de Médici (1519–89), who came to Paris at age fourteen to wed the future King Henri II (1519–59), with defining acceptable table manners. Educated in Florentine mores, she brought along an entourage of Italian chefs and pastry cooks, in addition to dozens of silver dinner forks packed in her luggage. Linens are from Neiman Marcus.

The Marché Biologique, an organic market held every Sunday morning on the Boulevard Raspail in the 7th *arrondissement*, is one of the best outdoor markets in the City of Light.

Quite naturally, then, the thought morphs into the nurture versus nature debate, where there are definitely clues pointing to the nurture side of the argument. Or is it possible, even probable, that nurturing propels their nature? If the remarkable energy that determined parents pour into passing their birthright of gracious living on to a new generation is any indication, the answer is "yes." Never mind that in his recently published book, *La France Perd La Mémoire (France is Losing Its Memory,* 2010), historian Jean-Pierre Rioux implies that the nation has lost touch with its past. Nearly everything is up for debate in France. So . . .

In today's multicultural republic, it is safe to assume that few are more passionate about France than those who grew up in *l'hexagone*—as the French often call their country—and view their culture as part of their identity. As if on cue, these guardians of Gallic tradition move with impressive speed, striving to impart prized tenets of their beloved *art de vivre* on the stroller-set by introducing them to museums, historic sites, flea markets, tony boutiques and heralded Michelin-starred restaurants in a country where the options are plentiful.

An amusing complement to the great outdoors: tinted crystal glasses—each a different tree form representing a harmonious forest—from the Museum of Modern Art, NYC. (Despite their various shapes, each glass has a thirteen-ounce capacity.) Italian-made Bertozzi napkins and napkin rings are available from Bergdorf Goodman.

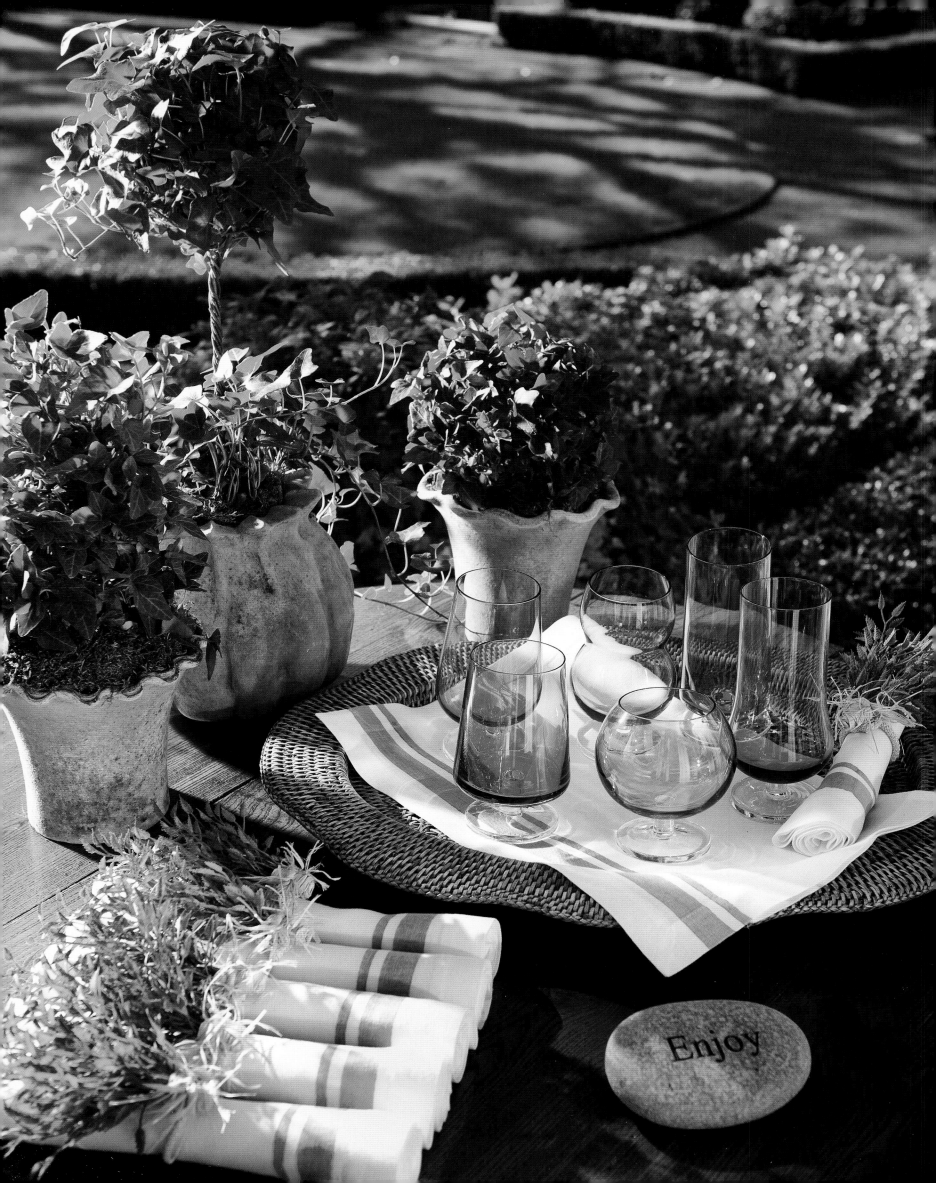

To be sure, the French fervor for fine food starts early. As evidence, three-year-olds in *école maternelle* (nursery school) have their first experience baking pies. Not long after most tots are old enough to launch toy sailboats in the Jardin du Luxembourg, if not before, diligent parents take it upon themselves to charm and coach their offspring into embarking upon a lengthy aesthetic apprenticeship. And to their credit, charming and coaching, or what might more precisely be called "imprinting," works. By the time most *les petites* are "tweens," they are on a well-plotted way to becoming skilled at discerning the fine from the pedestrian, to say nothing of developing noble manners. Under the auspices of the same ardent stewardship, teens typically learn to revere everything from brushstrokes and balustrades to brocade, bullion and *boiserie,* which suggests a bit about the difficulty of their study but results in the lifetime aspiration of paying homage to the artistry of France.

With a *pâtisserie* on nearly every Parisian block, it makes one wonder how the French avoid snacking. One can only guess it is because their meals are truly satisfying, unless it is that whenever an advertisement for food that could be construed as snack-worthy appears on television, a small line running across the bottom of the screen cautions viewers about non-meal-associated eating.

Street markets in the South of France personify the spirit of the region with fresh fruits, vegetables, cheeses, olives and more.

If this were not enough—amidst the ups and downs of growing up—budding connoisseurs learn to spend selectively, make careful choices, buy the best they can afford and not settle for the mediocre or commonplace, whether selecting fresh ingredients from the season's bounty, savory cheeses, wine, clothing or home furnishings. Taught by those more than qualified to speak, next-generation sons and daughters graduate quickly. Steeped in Gallic culture, they put their knowledge to work, exhibiting both price consciousness and awareness that quality matters.

In other words, like father, like son/like mother, like daughter. The French instill in their children a remarkable discipline. Tellingly, most are capable of living for years without purchasing a rug, table or commode until one comes along that is finely crafted, with presence and the patina of age—a patience and restraint that appears all the more impressive in our age of excess and unwillingness to wait more than a nanosecond for most anything.

True to their roots, nearly every object that crosses the threshold of an eighteenth-century *hôtel particulier* converted into *appartements* or a *mas* (farmhouse) in the south of France has meaning, is prized because of its rich history or simply the family memories it prompts. Though some furnishings may not be the sort one would lust over, parents pass on to their children an appreciation for vintage pieces to which only they have access. For the French, design is about layering one's personal past, not about perfection or a "decorated" look.

To put it nicely, the notion of a room being "just so" is singularly American. In French eyes, a bit of ornamental wear and tear documenting yesterdays is a prized symbol of style. As if intent on making a point, a Sèvres porcelain tureen crackled with age or a somber family portrait in its original, ravaged frame evokes nothing short of reverence, from the coast of Normandy to the Mediterranean Sea. More bluntly, seldom are well-worn carpets, any more than *canapés* wearing faded fabrics or unraveling cane-back chairs, relegated to attics or shuttled off to secondhand stores. There is broad agreement that hand-me-downs from family must occupy a privileged place even if they fail to measure up to notions of Parisian elegance.

Homes that want for nothing generally exude understated beauty, which is not as effortless as it looks, as wealth and discretion must walk hand in hand. Clearly, the French frown on overt displays of prosperity—an attitude that dates back to pre-revolutionary days. For them, comfort and tastefulness are paramount, not high-priced luxuries or extravagant ways. With a *savior-faire* of their own, yet barely distinguishable from their parents', each new generation that comes of age ardently embraces—consciously or unconsciously—the same distinctive artistry that brought the country international fame.

In France, seemingly there are flowers everywhere one looks. Gardens are a mix of perennials and annuals to provide maximum summer and fall blooms. And flowers in paint box colors line the streets. A trend on the rise in Paris is long-stemmed blooms angled in one direction—either east or west—in a tall glass vessel with clear cellophane crunched inside.

So, does it not stand to reason that the French may very well be genetically predisposed? Or is it a right that arguably had its birth in the France of Louis XIV? Either way, nurturing helps to shape and express a nature embedded in the Gallic psyche. For inevitably, the French *art de vivre* passes from one generation to the next, celebrating a heritage while setting an example for all to see.

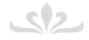

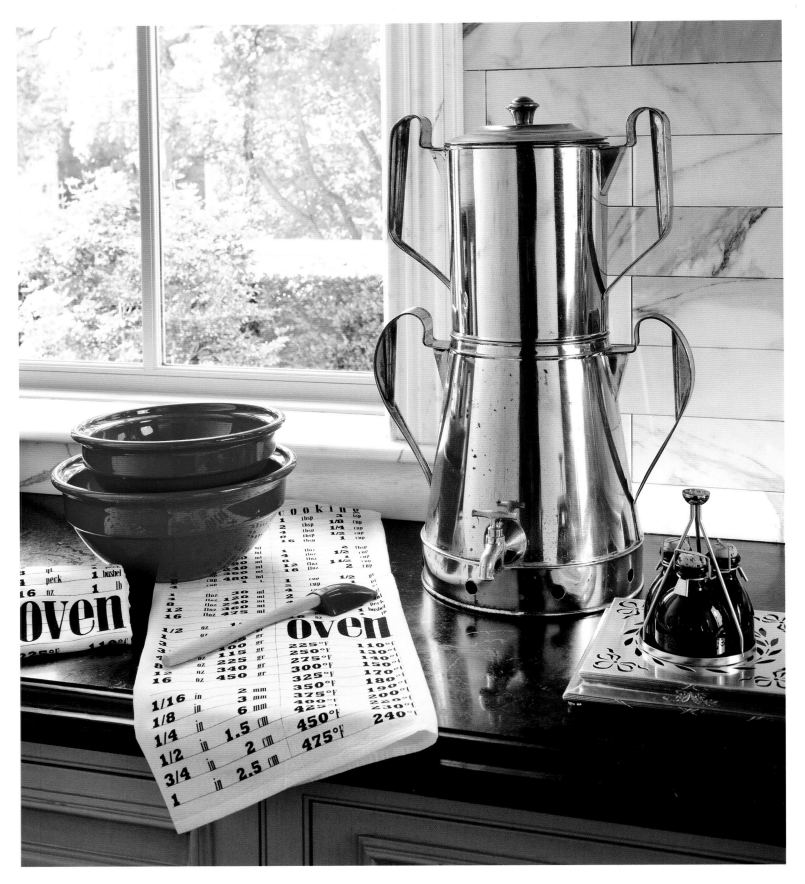

In Louis XVI's day, France had no fewer than 800 types of weights and measures, varying from one province to the next. People measured their height by the "king's foot" and "king's thumb" until the fall of the *ancien régime*. A decade later, 150 countries adopted the metric system, though not until 1866 did the congress of the United States authorize its use. Today the United States is still the only industrialized country in the world that does not use metrics as its predominant system of measurement. For those wanting to go along with the rest of the world yet needing some help, there is a "Useful" towel—a white cotton flour sack with conversions and measurements from Bailey Doesn't Bark. Vintage coffee pot from Ainsworth-Noah.

Who KNEW?

Who knew that it would be extremely difficult being a noble in modern France? The issue? For reasons known mostly to France, it has long been deemed un-noble to be employed unless serving the king. And as we all recognize, since the fall of the monarchy, France no longer has a king. Making life even tougher for aristocrats, many of the country's once great families are disappearing without a male heir to carry on, and countless male heirs are finding it impossible to carry the financial burden of maintaining their families' palatial estates. Now, the *Wall Street Journal* reports that the Association for the Mutual Assistance of French Nobility has stepped in to help down-and-out nobles regain some of the past glory by helping financially to get them through these tough times.

And who knew that hearty soups called *restaurants* (meaning restoratives in mid-eighteenth-century France) would prompt a raft of dining places with gilded mirrors, crystal chandeliers and set hours where patrons sit at private tables and order from menus? Or that Le Grand Véfour, founded as Café de Chartres in 1784, is the oldest continually operating *le restaurant* in Paris. Here, Napoléon and Josephine sometimes enjoyed an evening on the town.

Of course, to most of us, the word *cachet* suggests influence, status, prestige, respect, importance—all highly fitting for a word with royal roots. Yet, in pre-revolutionary France, the words that now come to mind were far from apt. Indeed, a subject was wary of catching the king's eye, as a *lettre de cachet* bearing the personal stamp of the monarch then in power was seldom a blessing. Expected or not, a letter of the seal was most likely to be a condemnation, demanding imprisonment or commanding death.

On the brighter side . . .

LES SALONS

Les salons—prestigious social gatherings of prominent, intellectually minded people—were rooted in Italy's *salones,* smartly appointed rooms within Roman *palazzi* with suitably dazzling façades. Seventeenth- and eighteenth-century France, however, deserves credit for building the cultural cachet of this pleasurable way to pass the day. In *salons* equally *luxueux,* as the French would say, Parisian men and women from the literary establishment, along with philosophers and luminaries from the worlds of art, music and politics, would frequently meet to discuss the latest news, exchange ideas and gossip, all at the invitation of refined, wealthy women known as *salonnières.*

With a matchless mix of elegance and grace, an Oushak area rug from Carol Piper Rugs and a 1940s sofa from Kay O'Toole Antiques—upholstered in its original manner—paint a *salon* with importance. Fortuny fabric on coral pillows is vintage. In 1926, the homeowner's paternal grandfather surprised her grandmother with the piano.

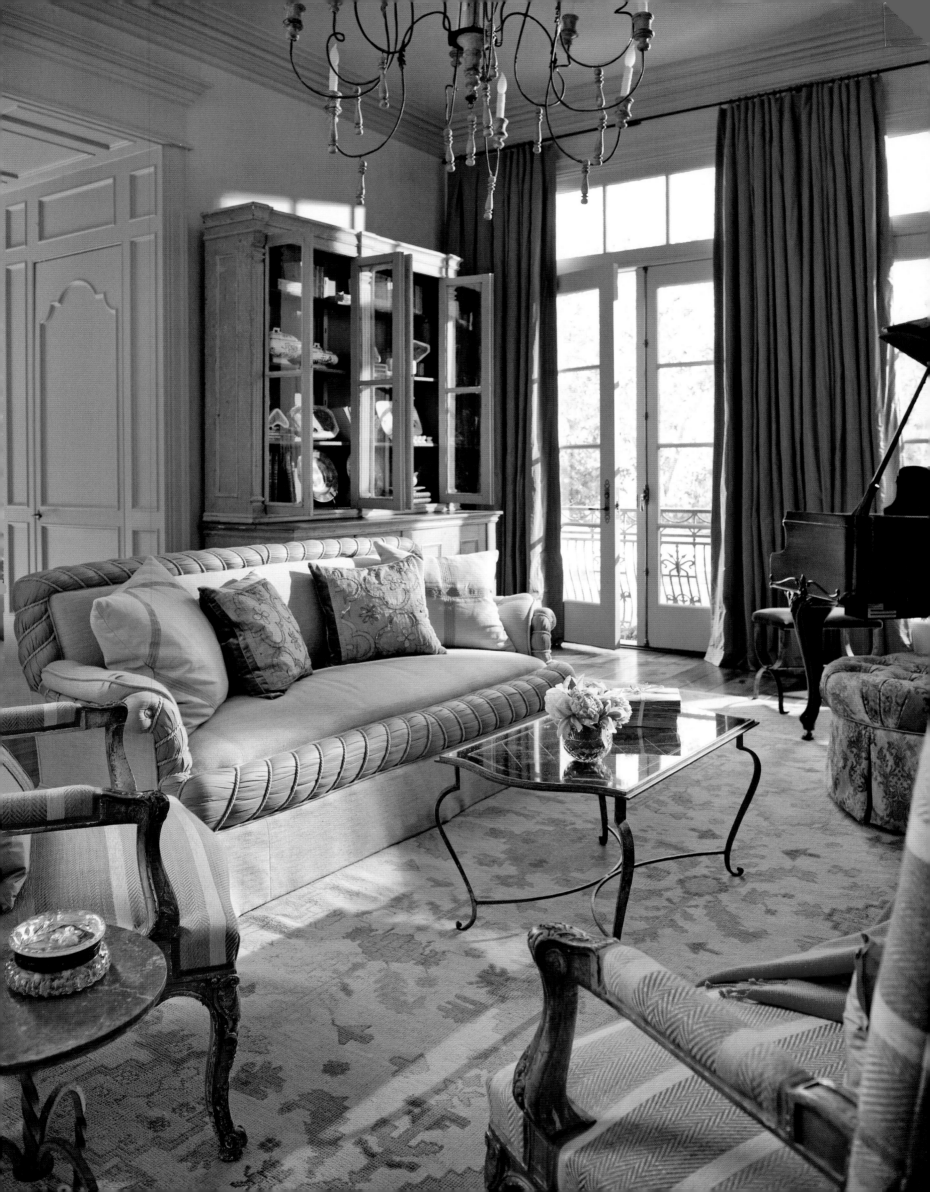

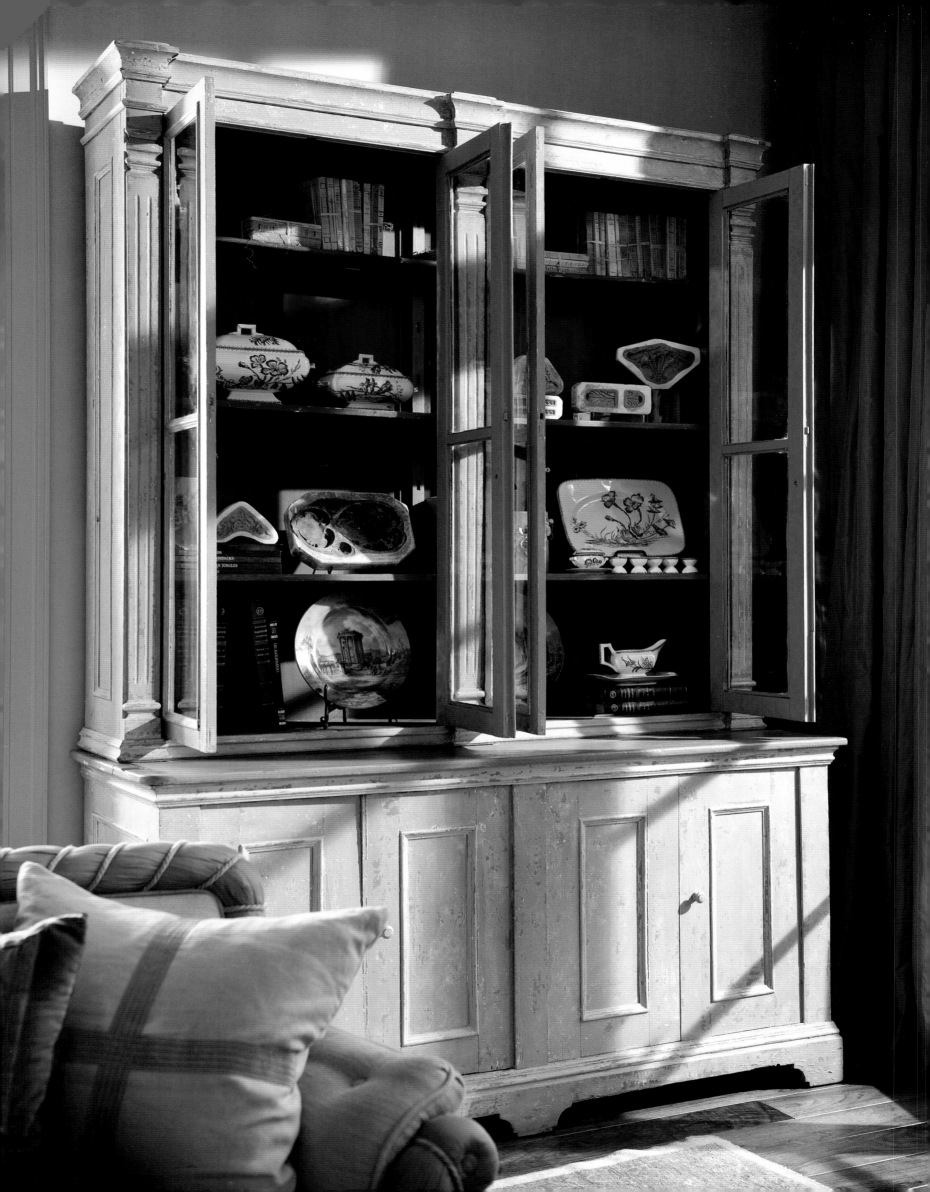

In their key role, hosts chose an eclectic mix of guests with care, and then ideally served as moderators, selecting topics that would generate conversation if not spirited debates. To date, though, even historians cannot agree as to what was, and what was not, considered appropriate to talk about. Yet, they do concur that women were the cornerstones of *les salons,* funneling fresh social and political ideas into a nation where men dominated public life, held bias against women and until 1944 denied women the right to vote.

Among the distinguished seventeenth-century *salonnières*—with set parameters that she expected guests to follow—was French society hostess Catherine de Vivonne, the marquise de Rambouillet (1588–1665), known as Madame de Rambouillet. A century later, Marie Thérèse Rodet Geoffrin (1699–1777) would host twice weekly many of the most influential *philosophes* (avant-garde intellectuals) and *encyclopédistes* (writers) in her elegant Parisian townhouse on the now luxury-laden, boutique-lined rue du Faubourg

French artist Édouard Manet (1832–83) painted modern-day life with its beggars, prostitutes, bourgeoisie and flowers. Enamored with peonies, he planted them in his Gennevillier garden, then in 1864–65 painted a series of canvases focusing on the blooms.

Saint-Honoré. As a leading figure of the French Enlightenment—the movement that promoted liberty and equality, strongly influencing our own notions about human rights and the role of government—her growing importance earned her international recognition. Eager to learn of the political and social leanings spawned at her *salon,* both the King of Sweden and Catherine the Great of Russia corresponded regularly, mindful that her think tanks could lead to change. *> 104*

A room both sumptuous and inviting plays host to a pair of stately Louis XV *bibliothèques* (one unseen) whose original eighteenth-century paint inspired the setting's palette: *crème caillée,* or clotted cream, and coral. Skelton St John discovered the pieces at the Paris flea market, which attracts natives searching for furniture, dealers hoping to discover treasures that others have overlooked and designers hunting *objets de charme* for clients' homes. In keeping with a law passed in 1537, the Bibliothèque nationale de France—the national library—must serve as the repository for every book printed in France. As a result, there are numerous satellite locations in addition to the main branch in Paris.

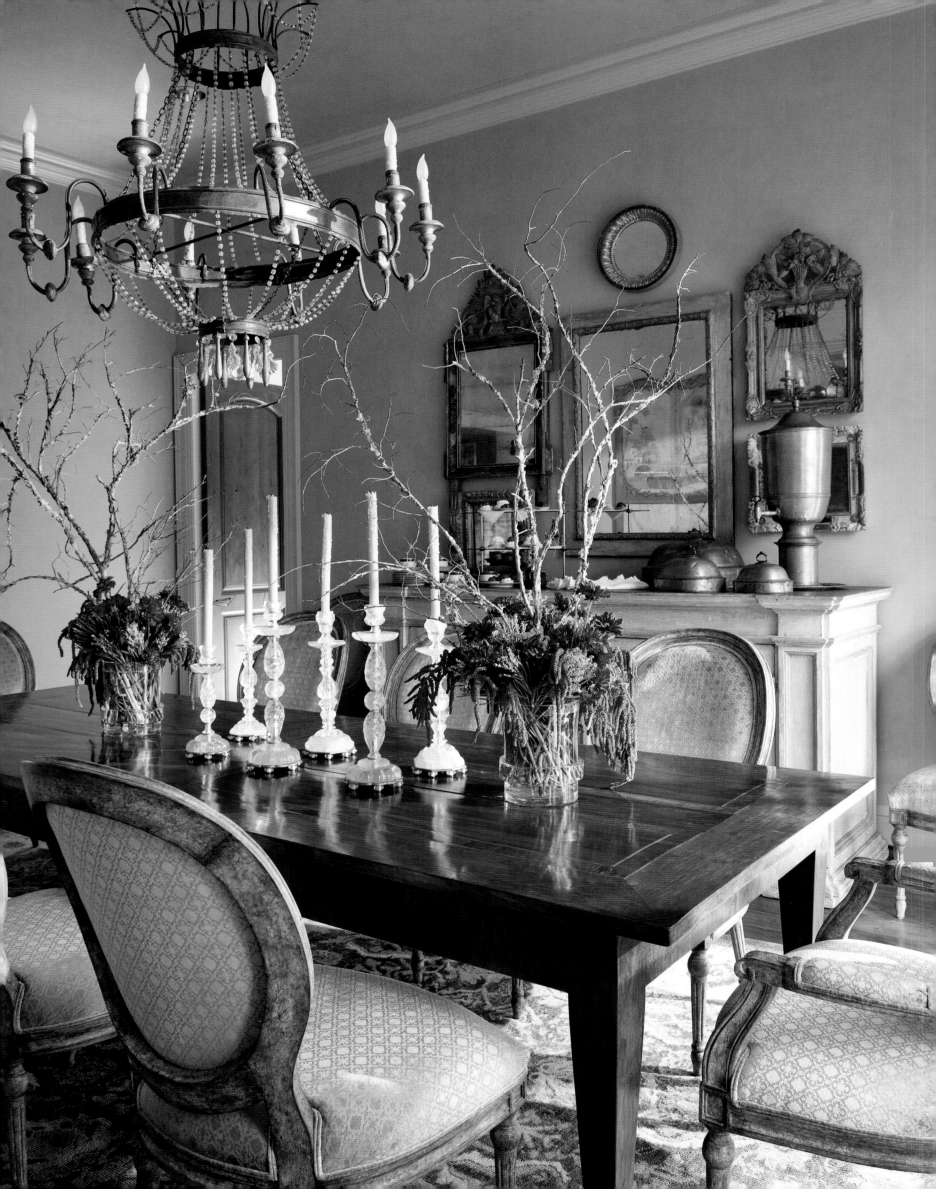

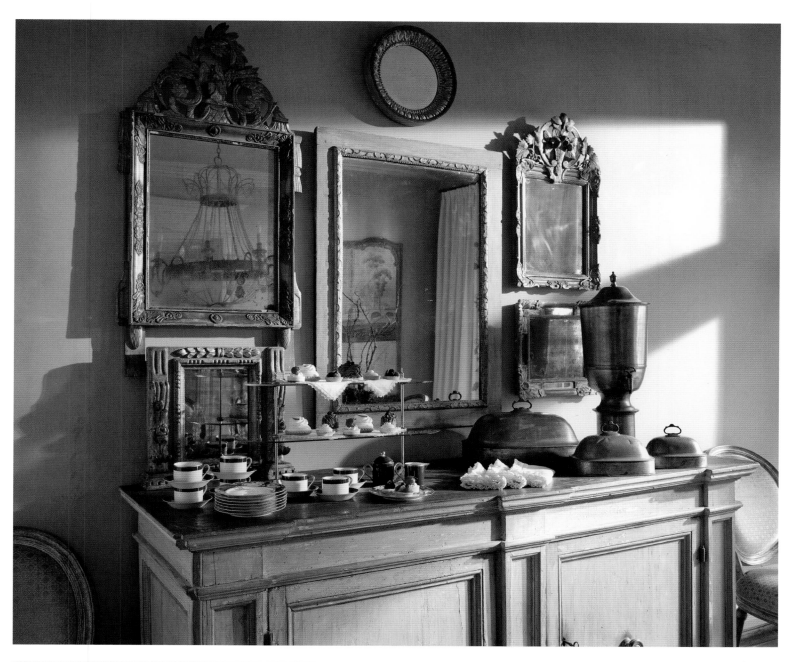

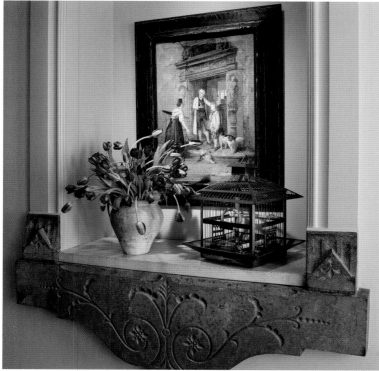

There is no suppressing an appetite for collecting over time gilded, antique mirrors that reflect furnishings in a room. The eighteenth-century painted Tuscan credenza is from Watkins Culver.

LEFT: Like grandmother, like granddaughter. Some traits run deep—such as a fondness for birds. A birdcage that once belonged to her maternal grandmother puts the personal into a niche off the breakfast room.

FACING: The walnut table is of Italian descent, circa 1820, while the wood and crystal chandelier from the same period is French, gleaned from Neal & Company. To insure the table looked its stylish best, Houstonian Jonathan Andrew Sage incorporated mossy elm branches, burgundy hanging amaranths, small green berzillia berries and black dahlias in the arrangements. Rock crystal candlesticks with European roots are from the renowned Marché aux Puces de Saint-Ouen, surely the world's largest flea market.

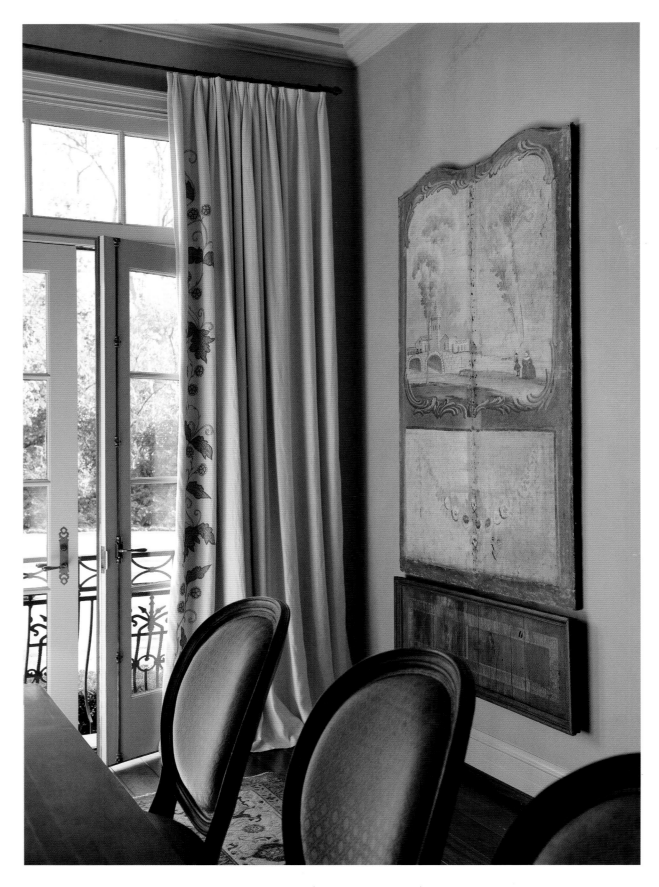

Panels from an eighteenth-century French screen (one pair is unseen) flank the entrance to a dining room, lending an old-world air. Lacy's, Inc., fabricated the billowing window treatment, a fashionable Florio Collection embroidered silk taffeta from India. Reportedly, that country's textile cottage industry employs 35 million people.

FACING: In France, it is impossible to avoid admiring well-dressed and well-behaved children, to say nothing about well-mannered dogs, which are welcomed in the French capital's finest restaurants. Here, a GP & J Baker embroidered linen garnishes windows. The chandelier and table are old, from The Gray Door and Joyce Horn Antiques, respectively. Mismatched Terra Firma pottery, hand made using vintage lace and textiles, is from Kuhl-Linscomb.

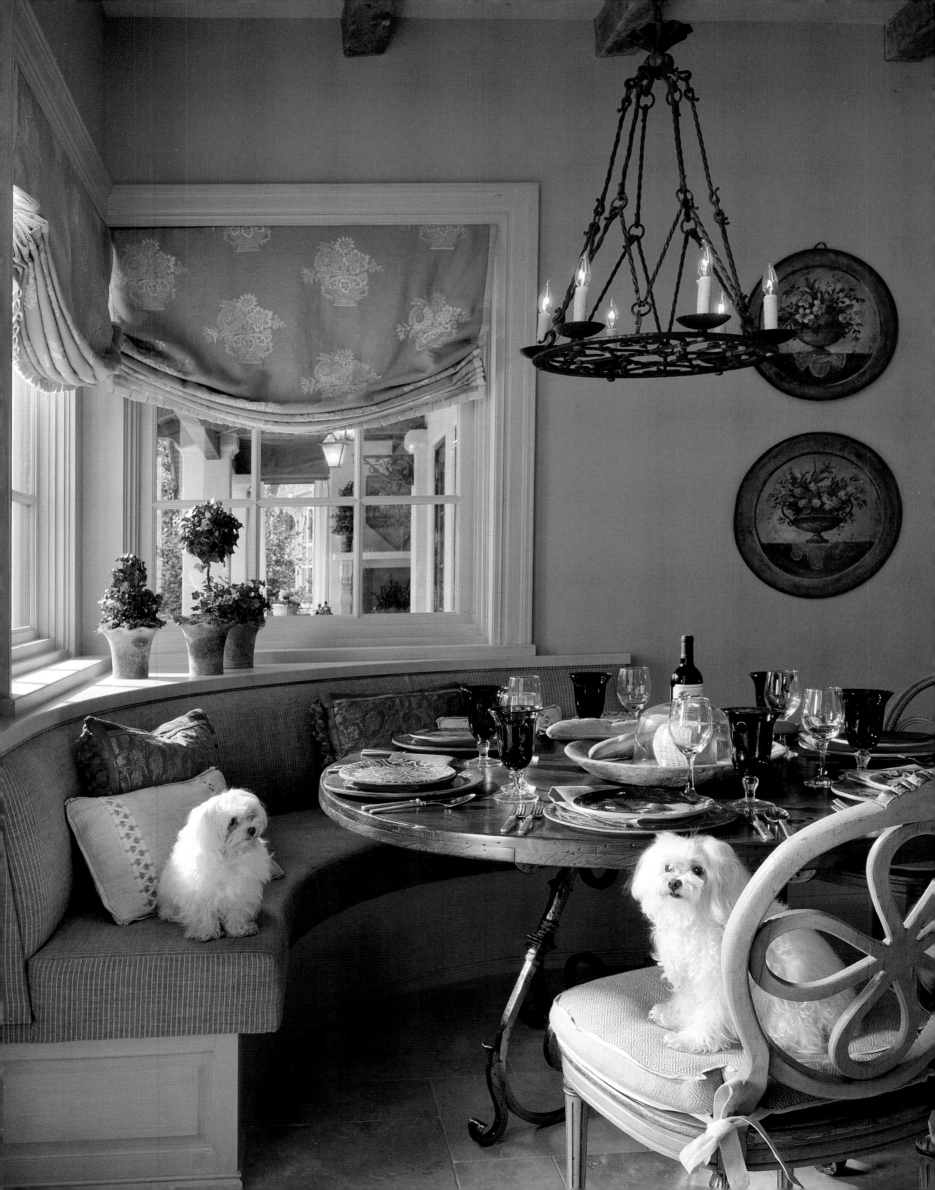

Here, Madame d'Étiolles—the future royal mistress, or *maîtresse-en-titre,* of Louis XV, as Madame de Pompadour would become known at court— was among the frequent guests, feasibly developing her literary passion and social charm, to say nothing of preparing to become an influential woman playing an active role in France's decision-making for nineteen years. (Not that the French benefited from her efforts to shape foreign policy. Even if done with a modicum of grace, her political missteps resulted, for one, in the loss of Canada.) It was the marriage arranged by her father and Le Normant de Tournehem, the man suspected of being her birth father, to the latter's nephew, financier Charles-Guillaume Le Normant d'Étiolles, in 1741 that offered the required respectability, and thus entrée into the glittering social circle she coveted.

Perhaps predictably, the French Revolution marked an end of *les salons,* albeit only briefly. Today the tradition continues in mini-*salons,* as the art of conversation and appreciation for its subtleties are highly valued in France. It is, in fact, quite unthinkable to fail to be an interesting and engaging communicator—translated as witty and intelligent—especially in inherently snobbish Paris, where always questioning and doubting lead to further discussion and therefore are seen as hallmarks of refinement.

LA TOILETTE

Most every woman today fancies time alone in her boudoir—that intimate spot where she can fixate on the image she presents to the world without others hovering over her, if not take refuge with her dignity intact. But it was not always so. In pre-revolutionary France—an era when curtains surrounding a bed offered the only escape from prying eyes and the practice of rising and shining entailed dousing one's hair with pomades and powders, putting on one's face with a feathery white puff and selecting lavish finery befitting one's role—having space to oneself was hardly a concern. >110

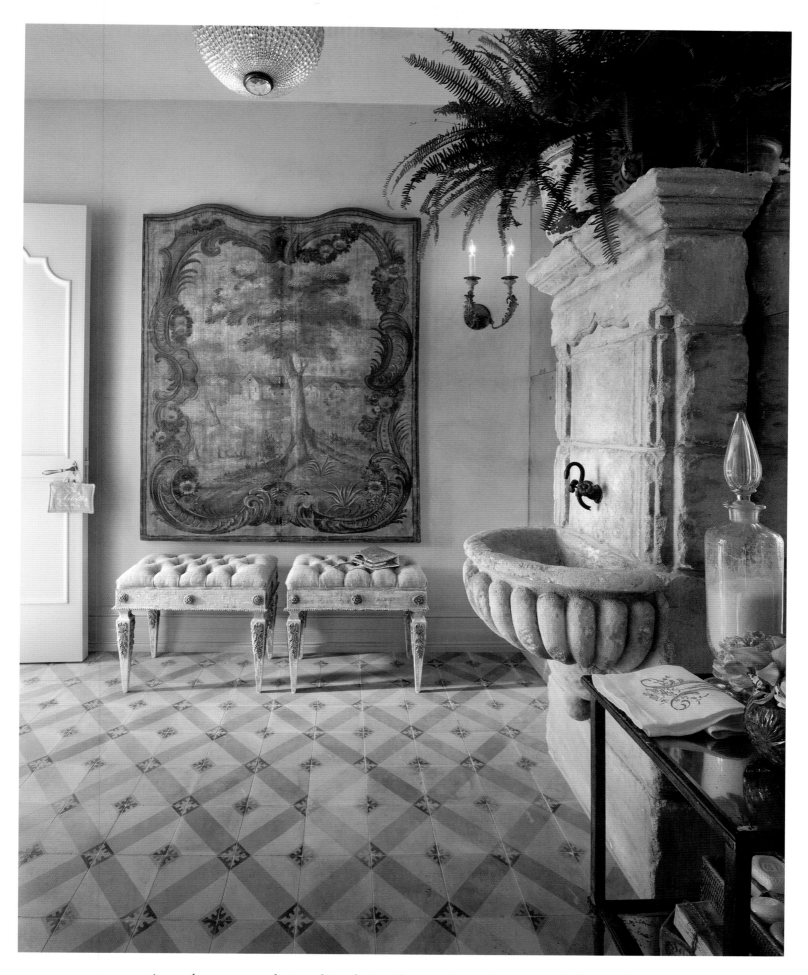

A powder room awash in reclaimed stone boasts nineteenth-century tile flooring from Chateau Domingue and a wall fountain—hand crafted in Provence from limestone equally old—unearthed at Le Louvre Antiques. Hand-painted linen panels circa 1850 preside over tufted Louis XVI benches from Kay O'Toole Antiques.

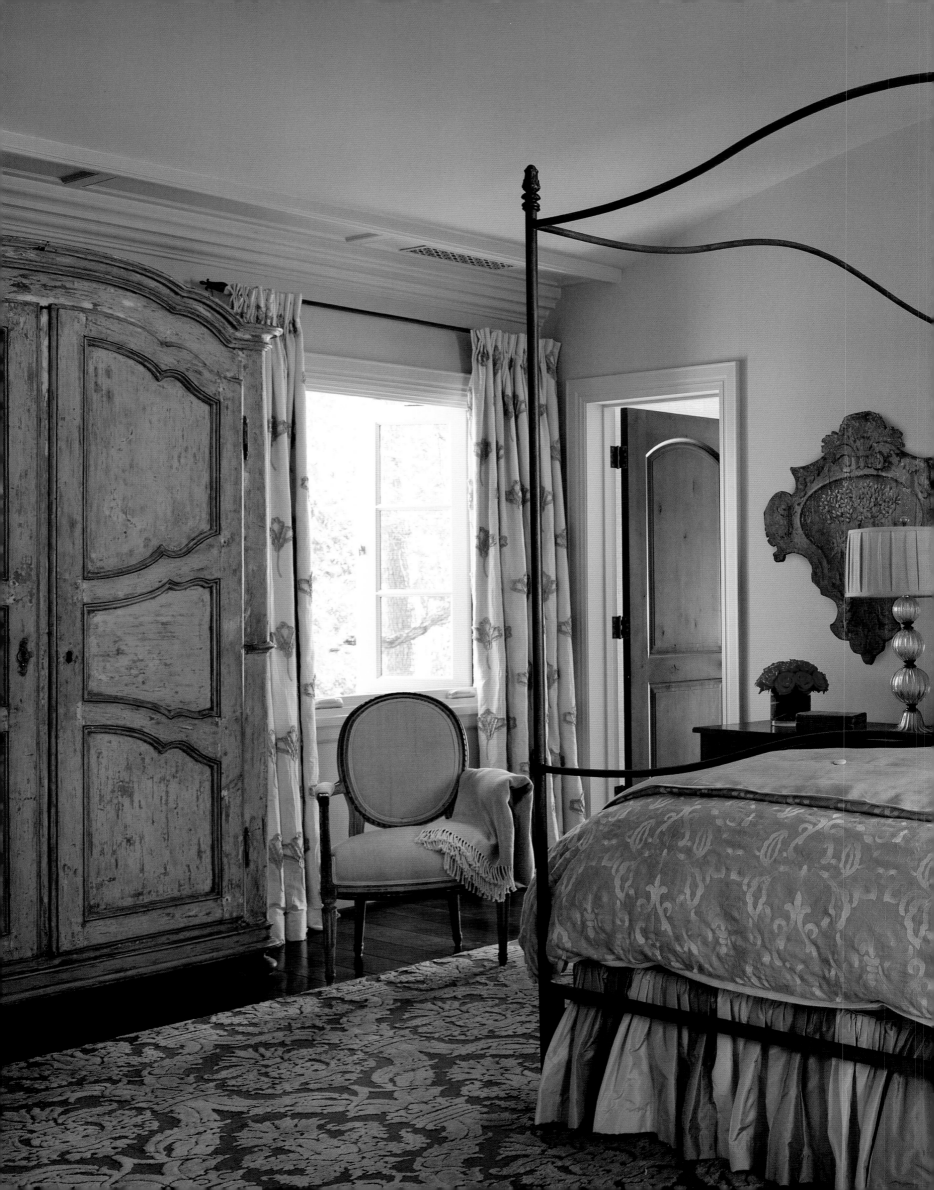

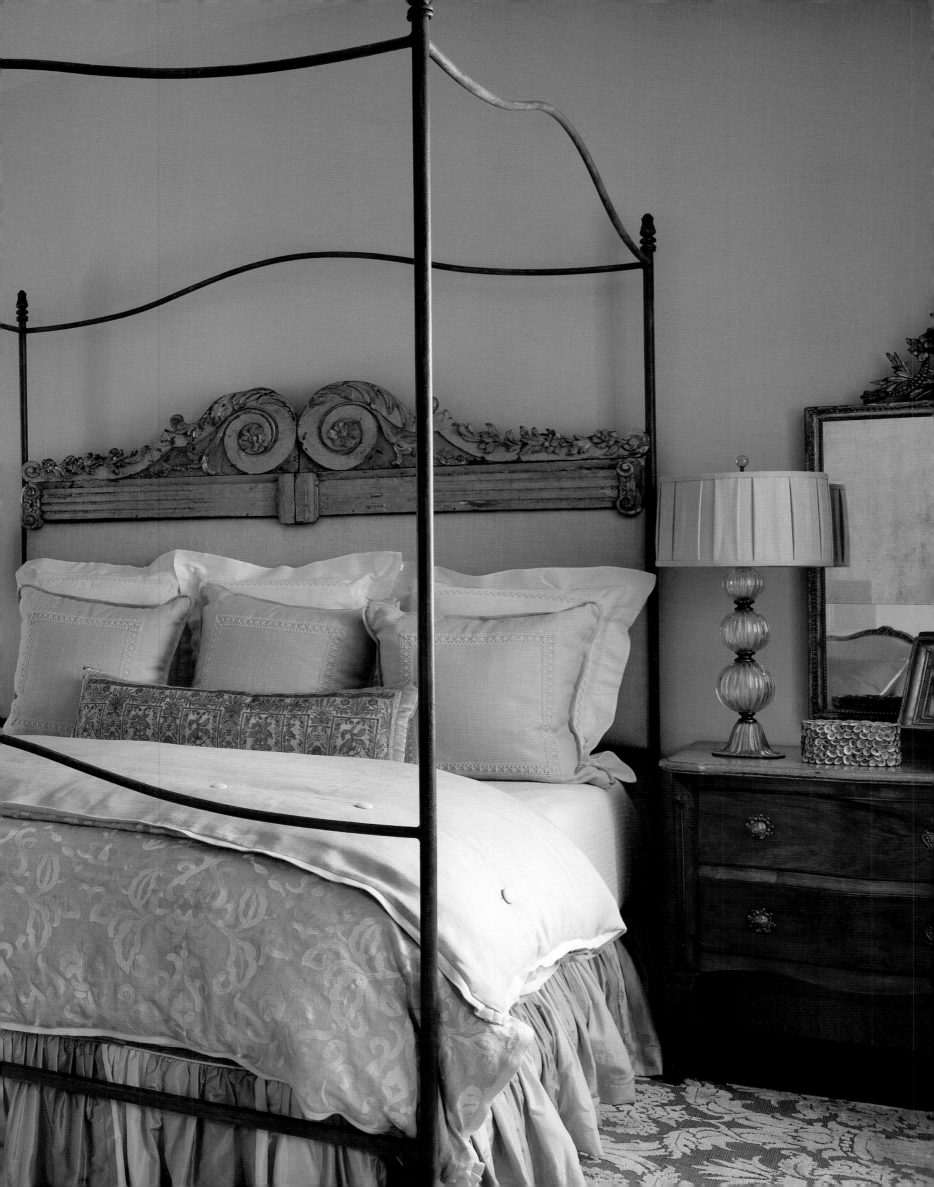

Dwellings in the French capital flaunt layered lighting—brilliant crystal chandeliers, lamps and wall sconces along with flattering candlelight. Generally, lamps do not match, but they do finish at the same height. The iron chandelier pictured is nineteenth-century French with rare rock crystal jeweled drops and rock crystal *bobeches* (cups beneath the light sleeves, once used to catch wax from dripping candles). An eighteenth-century Swedish trunk from Tara Shaw Antiques, New Orleans, serves as a coffee table.

PRECEDING OVERLEAF: Architectural elements from nineteenth-century France make up a bed fabricated by Bill Peck, Houston. A century older but still wearing its original paint is a "Tree of Life" from Italy. Also eighteenth-century Italian is the polenta armoire from the Piedmont region, south of Milan. The word *polenta* comes from the maize color of cornmeal mush, according to Bill Gardner (at W. Gardner, Ltd.), who has had several similar armoires.

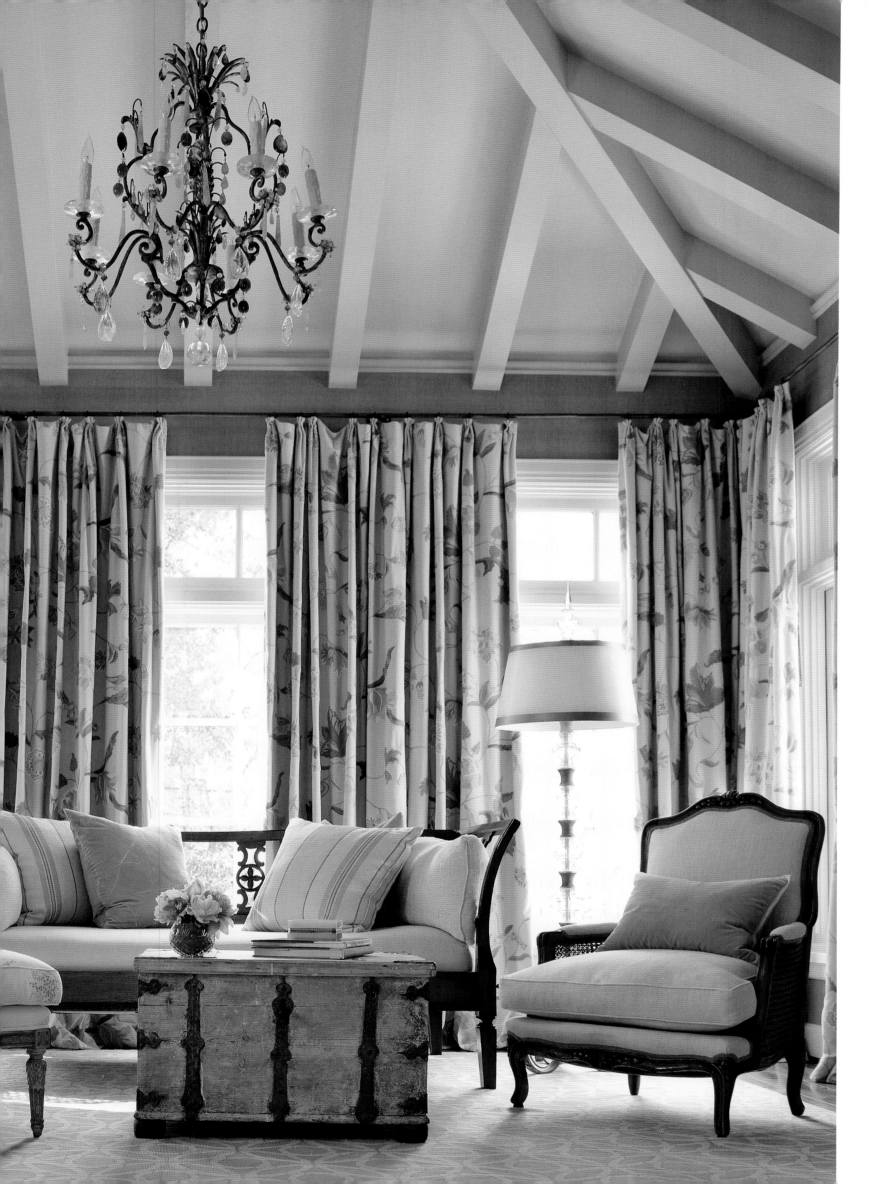

And little wonder. In an age when we must rush out of the door far too early, what could be more luxurious than rarely rising before noon, getting dressed to the nines then spending hour upon pleasurable hour at *la toilette*, whether one has a shred of privacy or not?

In seventeenth- and eighteenth-century France, aristocratic women of means capitalized on their femininity without thinking twice about people in their space, or dressing rooms with more than a hint of opulence. At *la toilette*—daily, invitation-only gatherings—the most savvy improved their position in society, when not securing their place at court by nurturing relationships critical to their ascent. Those less inclined fussed with their hair and makeup and gossiped with friends while the day slipped away.

Among nobles, it was not enough for a woman merely to have a pleasing voice and look elegant. Whether blessed with beauty or not, charm was a necessity. Grace, too, was mandatory, an art to be acquired. To that end, the boudoir became center stage for multitasking, or telegraphing practiced poise while moving about, unlocking and locking hidden storage compartments in one's dressing table or adorning oneself with quite noticeable jewelry for a more radiant look.

Flaunting one's wealth is considered *déclassé* in France today; however, doing so was acceptable when the Bourbon monarchs ruled. Every posh woman of considerable means coveted an intricately designed, beautifully crafted table as a status indicator. Serving as a more subtle class marker was a layer of fine fabric or enviable embroidered lace that draped over the wood piece—thus, the name *toilette*, French for "small cloth."

A petite gold pot often held powder if not rouge. Meanwhile, an assortment of boxes hosting pins and combs satisfied feminine whims, garnered guests' attention, suggested luxury and perhaps led the way for the *toilette* set—mirror, candlesticks, small pots, boxes, makeup puffs and silver tray—to become the *ne plus ultra* of accessories and the traditional gift for the era's new brides.

In Paris, looks vary widely from one *bonne adresse* to another; however, rarely do the French stray from their unified approach to decorating, which is faithful to their heritage. Pillow is from Yves Delorme.

Thinking she looked her best when at *la toilette,* Madame de Pompadour would receive visitors in her *en suite* accommodations—one of ten rooms set just one floor above Louis XV's quarters and accessible by a narrow stairwell tailored to his sexual pleasure—overlooking the perfectly tended *parterres* (formal gardens) suiting the grand exterior of Versailles. While serving light refreshments, she attended to social and political matters and worked at developing important relationships with *philosophes,* religious advisors and courtiers. When not promoting her self-image, she concerned herself with what some might see as less-pressing issues—meeting with dressmakers, milliners and trades people who supplied exquisite ribbons, trimmings and fabrics—all in the hope of keeping the king enthralled for her remaining years.

When it comes to versatility, a boudoir pillow, sometimes called a breakfast pillow, can serve multi purposes. *Boudoir* is from the French *boudere,* meaning to sulk; so literally, the boudoir is a room designed for sulking.

TELLING TALES

Much like favored seventeenth- and eighteenth-century furniture with provenance, or a back-story, Parisian Charles Perrault (1628–1703) had tales to tell. Although a lawyer by training, telling captivating stories and writing for young people were his true passions. And so, once upon a time, he wrote *Little Red Riding Hood, Cinderella, The Sleeping Beauty* and *Tales of Mother Goose* to the delight of his children, those dwelling at the Court of Versailles and families everywhere.

For the sweetest dreams, a room for overflow guests boasts Schweitzer Linen's 600-thread count Egyptian cotton bedding, delicately hand embroidered with wisteria vines. Toile by Marvic; check on the reverse side of the coverlets (one unseen) from Cowtan & Tout.

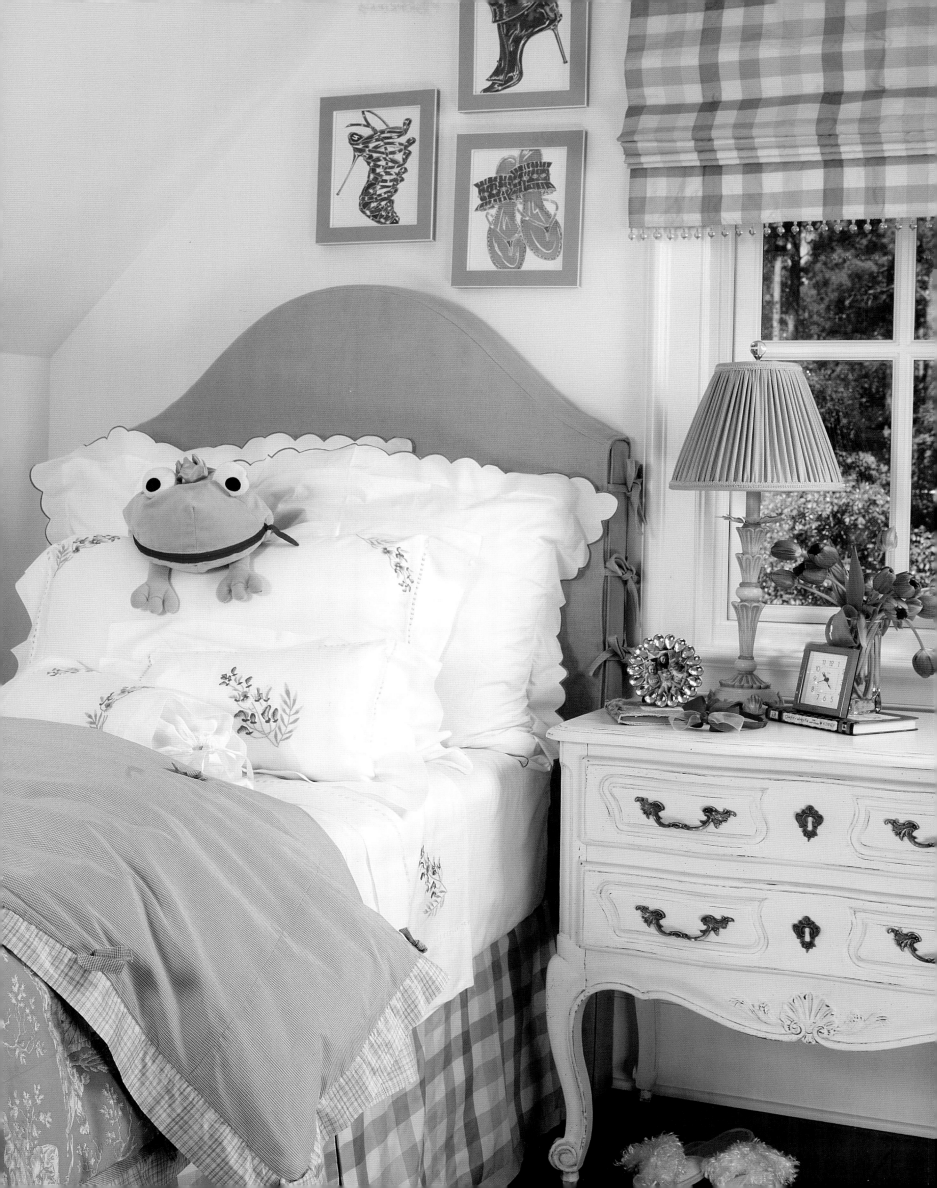

Suffice it to say, Perrault's lifetime achievements require no embellishing. He rose to the prestigious post of Controller of His Majesty's Buildings after helping shape the design competition for the massive eastern façade, or great colonnade, of the Louvre (1667–70). In addition, he took the lead in influencing Louis XIV to incorporate thirty-nine fountains in the royal gardens of Versailles, each evoking one of Aesop's thought-provoking fables. Also, he was the mastermind behind promoting the king to his loyal subjects as Apollo, the Sun God, around whom the world revolved—a triumph that would result in Louis XIV being forever revered as the Sun King, with immeasurable power. What's more, in 1697, Perrault became an exalted member of the Académie Française.

A crystal chandelier from I Lite 4 U, Santa Ana, California, looms in the room, reflecting hues in the coverlets.

Despite the glory and veneration this multifaceted and multitalented man received throughout his lifetime, being the creator of the modern fairy tale brought him lasting renown.

Story-telling toiles came to the United States after the American Revolution and remain popular today, although Americans still use them more sparingly than the French do. Also, in this country we commonly mix them with solids, stripes and checks. The key to deft blending is staying within the colorway of the toile. Towels from Yves Delorme.

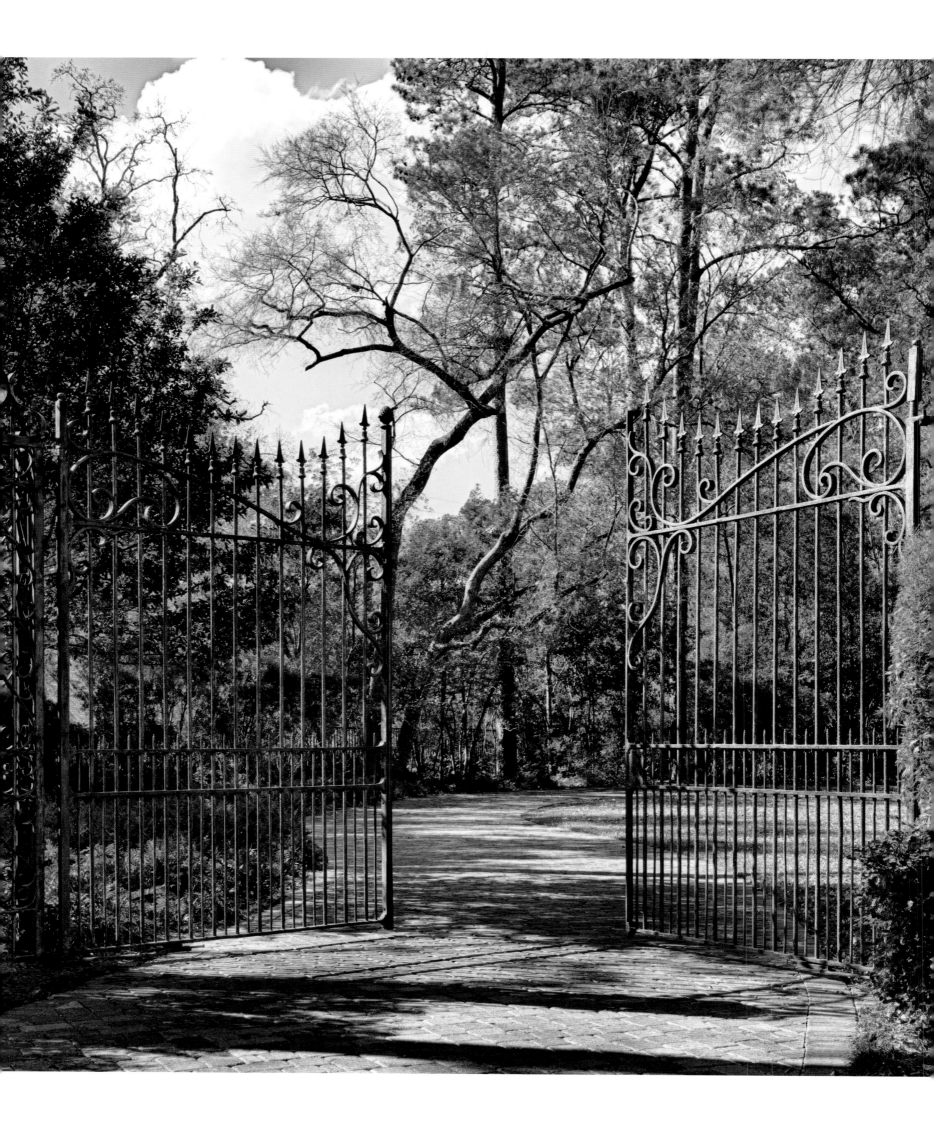

GRAND *Tour*

In the seventeenth and eighteenth centuries, an era when socially rigid England was fixated on class, moneyed young men often traveled a Continental circuit culminating with an extended stay in Rome. A Grand Tour of mainland Europe was a finishing school of sorts, which is to say, it was a requisite status symbol in English society, giving those with considerable means an air of notability—if not nobility—unlike their less-privileged peers. More importantly, however, a jaunt abroad generally proved economically valuable, a bankable investment that helped those known as grand tourists sail through life, as ultimately, it was an emblem of the educated, virtually guaranteeing career advancement.

Handsome eighteenth-century wrought-iron gates, which Houston architect Ken Newberry happened upon in France, not only make for a grand entrance but also insure a positive first impression is lasting.

Seeing the world anew could span years. What's more, to say that a Grand Tour could cost a small fortune is an understatement. Well-to-do grand tourists embarked with the trappings of their privileged lives: a staff that included their "bear-leader"—a scholar and chaperon—as well as valets, coachmen, a personal chef and perhaps an artist to chronicle the voyage as a visual reminder. En route to a host of now-fabled destinations, experiences varied greatly. Many encountered a plethora of perils, from illness and war to robbery and shipwreck, at times making even the most well-considered foray not quite as grand as may have been imagined.

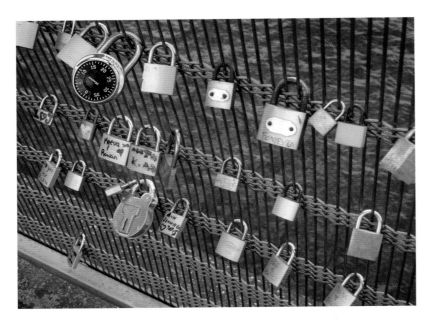

In the "City of Love," some things never change. Tourists flock to the Louvre, Notre-Dame Cathedral and the Eiffel Tower, while the Pont des Arts Bridge serves as a studio for artists painting *en plein air*. Also, for years now, lovers by the hundreds or maybe thousands have been fastening padlocks to the fences of this pedestrian bridge and as a symbol of their enduring love tossing the keys into the river Seine below—unaware, perhaps, that authorities periodically clear the padlocks to prevent their weight from damaging the bridge's infrastructure.

Grand Tourists and their retinues typically crossed the choppy English Channel at the Port of Dover, stepping onto French soil in Calais. From there, the parties would set off on a three-day trek to Paris. Once fitted for new clothes, many proceeded to decamp for a season or longer for their first taste of Continental culture. Honing linguistic skills ranked high on the list of pursuits for young men who took the experience seriously, rather than merely seeking adventure or intent on climbing the class ladder. Those bent on further broadening their horizons often applied themselves to lessons in sculpture, drawing and painting *en plein air* before calling upon the royal court. Well-cut coats, proper manners and influential connections put an elite corps on course to serve at the court of Versailles before eventually packing their belongings and setting out for Italy. >123

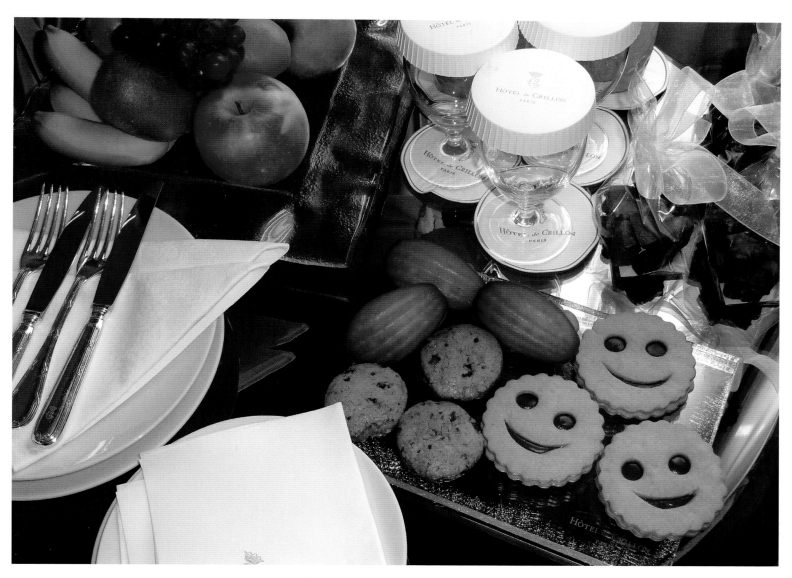

There are, of course, myriad ways to show children a delightful time in culture-rich Paris. Scene-stealing cookies wow young guests at the Hôtel de Crillon, where centuries-ago Marie-Antoinette took piano lessons. In 1758, Louis XV commissioned what is now the posh hotel as an office for the French government. On the eve of the revolution, in 1788, the Comte de Crillon acquired it. (Today most government buildings are on the Left Bank.)

RIGHT: Amidst the nineteenth-century turmoil of transforming the medieval city of dark alleys into the modern City of Light—with broad boulevards, hidden sewers and glorious public parks—Emperor Napoléon III had his prefect, Baron Georges-Eugène Haussmann, embed in Paris's identity classic *pavés mosaïques* laid in a semicircular motif that road builders call *queue de paön,* a peacock's tail. Although lovely to look at, cobblestones are not easy to walk on, especially when wearing stilettos—and like New York, Paris is a walking city.

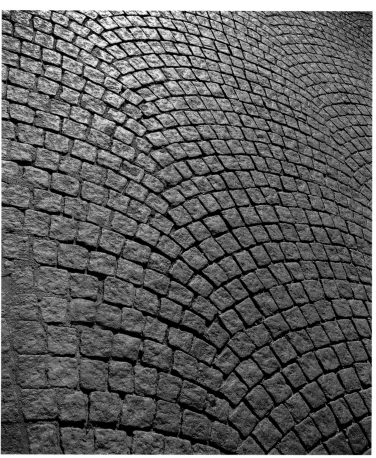

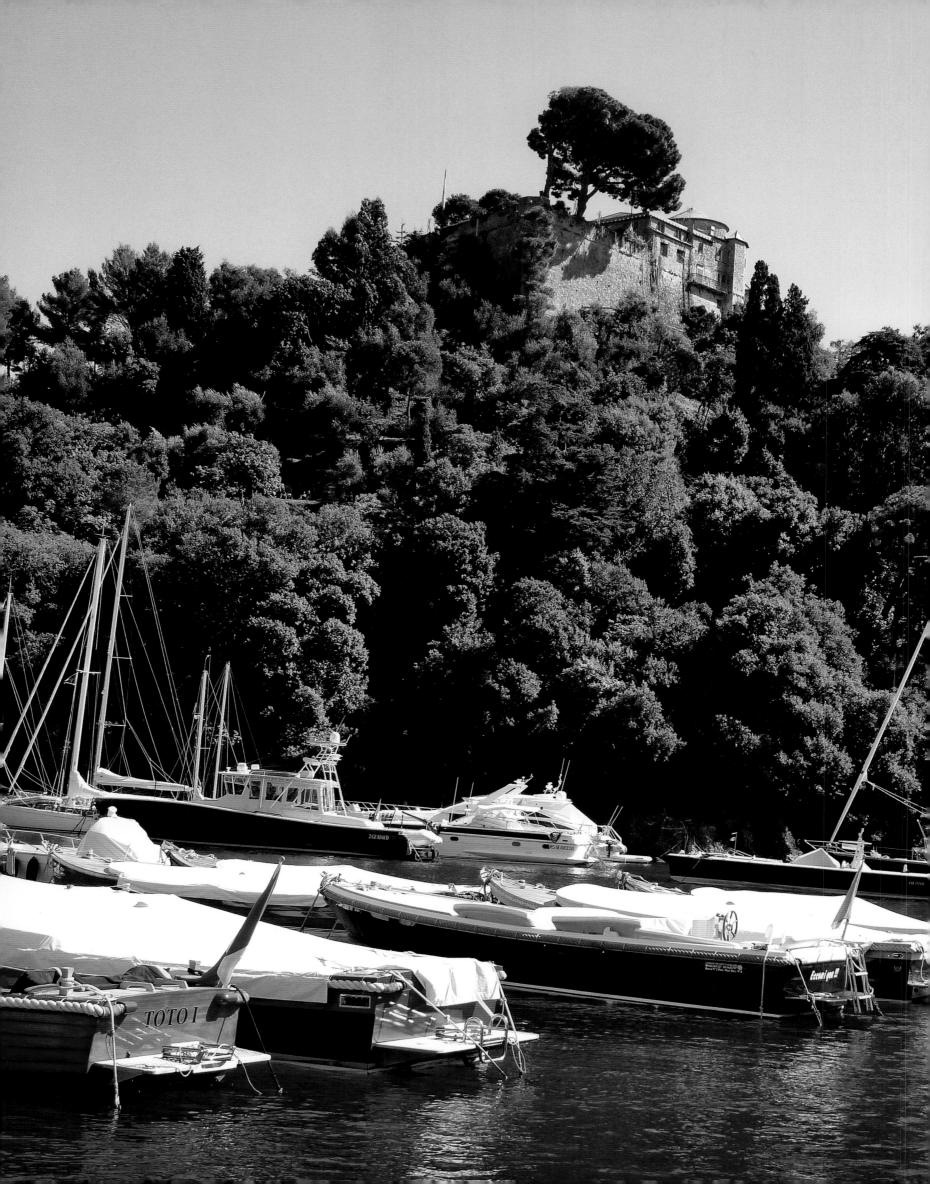

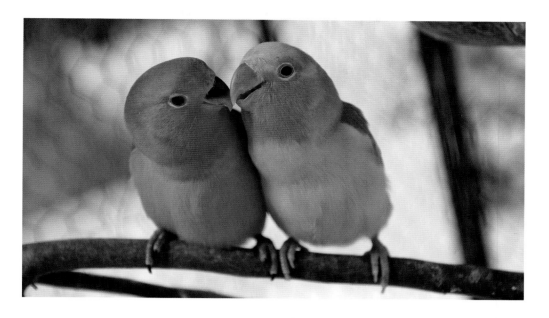

Undeniably passionate about each other, these peach-faced lovebirds—also known as rosy-faced—are unshakable companions. Their domain is one that most any bird would be proud to call home, as it sings with style and has ample curb appeal.

FACING: Sun-soaked Portofino, formerly a small fishing village that lured the Romans, now attracts jet-setters with pricey boats and yachts.

In the village of Tivolo—in the Italian Lake District's peaceful Lazio region—the local open-air market square abounds with flawless fresh fruits impeccably displayed.

Not everyone took the same route. The more adventurous traveled from Paris to Lyon then farther south to Marseille, journeying by sea from Marseille to Livorno, in the Tuscany region, or Genoa, although the Italians' lack of necessary sailing skills at that time made passage risky. Meanwhile, the wary typically trekked from Paris to Lyon then over the Alps. For the latter, Geneva was a subsequent stop, by default rather than preference. Despite the breathtaking beauty of the Alps, coaches— the mode of transport used at the time—simply could not traverse the treacherous Mont Cenis pass, ascending 6,827 feet. Invariably, the harrowing peaks and rocky precipices forced willing travelers to navigate by mule or sled. Regardless of the hassles, those who pressed on reaped extravagant rewards.

Some 100 kilometers (62 miles) northwest of Florence, in Italy's picturesque Tuscany region, sits Carrara, settled by the Romans early in the second century B.C. Although the ancient city never fails to captivate tourists, the mountainous sweeps of dazzling Carrara marble looming above the town leave the most vivid impression. From here came the block of snow-white marble from which Michelangelo later sculpted his widely praised seventeen-foot *David,* now standing in Florence's Piazza della Signoria. Also chiseled from Carrara marble are the large columns of the Pantheon in Rome. Quarry workers extract 15,000 tons of the precious stone from these mountains daily.

On the other side of the Alps, just over Italy's border, Turin embraced her Anglo visitors, schooling them in the arts of dance, dressage and fencing, thus helping further distinguish them from other lads. Interest in boar hunting or sketching early churches occupied many patrician afternoons. This is not to suggest that all shrunk from a prolific nightlife. Undaunted by the cost, magnificent operas, lavish meals and fine wines frequently beckoned late into the night if not the wee hours of the following day. Until, that is, anxious bear-leaders, mindful perhaps of disapproval from parents who footed their considerable fees, encouraged their youthful charges, ready or not, to move on to Florence—the birthplace of the Renaissance—or Venice, also suitably rich in legacies and élan.

All roads, however, ultimately led to Rome, befitting its vaunted history as the intellectual, scientific and artistic center of the Renaissance and Baroque culture. Here, a *cicerone* frequently assumed leadership over the young men's instruction. Without benefit of modern-day public museums, knowledgeable Italian guides attracted tony followers by proffering access into normally off-limits patrician homes with important private collections of art and antiquaries.

Crates filled with Roman relics migrated back home, along with other worldly riches, as the typical grand tourist acquired vast amounts of artwork as well as rugs and Etruscan vases, Greco-Roman vessels, musical instruments, silk and other storied treasures, which would bring prestige and symbolic value once prominently displayed. In this, upper class British travelers fulfilled an expressed mission of their quest: to collect, preserve and revel in the finest objects and ideals Western civilization had to offer.

Doors similar to those found leading to a nineteenth-century *hôtel particular*—now divided into privately owned *appartements*—on the Left Bank of the busy French capital often top the wish list of those building stateside homes.

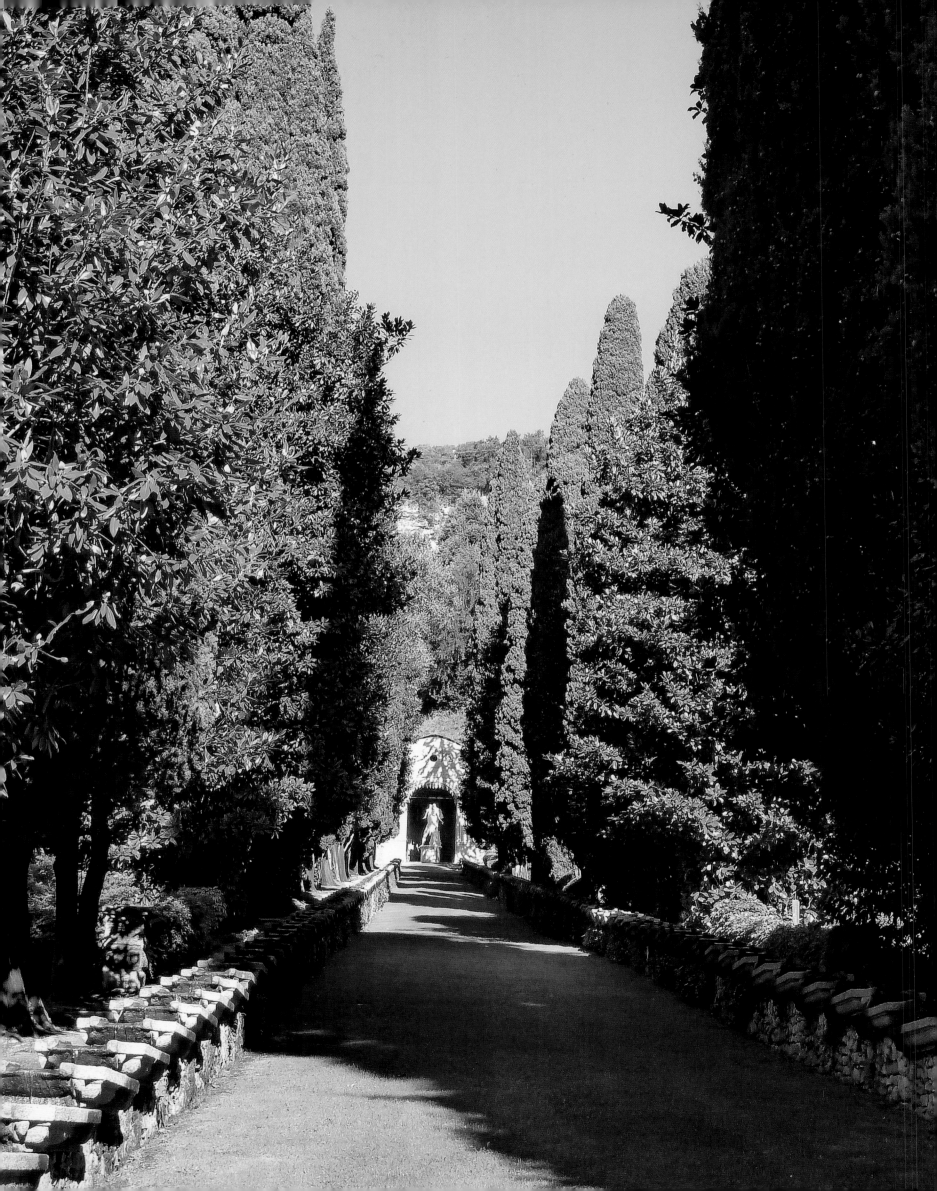

While some young men returned home after a compulsory stop in Rome, many others traveled south to the once prosperous resort towns of Herculaneum and Pompeii, buried by volcanic ash from Mount Vesuvius in A.D. 79. Here, large-scale excavations were taking place early in the eighteenth century. Not that the Eternal City lacked ruins of its own through which men could tromp. Until 1809, when Napoléon ordered the clearing of the Forum, livestock roamed free among the crumbling remains of marble columns and ancient travertine steps in view of the Colosseum, one of the country's venerated monuments.

For most, interest in making a Grand Tour waned with the fall of the monarchy at the onset of the French Revolution. Yet, by the late eighteenth century, the expedition had spread classical ideas and a bit of sophisticated French and Italian style across Europe, as well as bridged the gap to the United States, which by then had successfully broken away from Great Britain. In the Constitution, founders of the United States explicitly rejected the lofty structure that braced European society, or at least pretended class differences did not exist, in an effort to homogenize America. But even without the Grand Tour trading on class anxiety as it once did, class differences thrived.

Certainly, traversing continental Europe has lost some of its glamour in this era of long security lines and delayed, snugly packed flights; yet, traveling today is still easier, of course, than it was in the eighteenth century. Perhaps inevitably, curiosity in civilizations worldwide has opened our minds and proved rewarding. Fashioning our own global empires of sorts from the latest stops on our own Grand Tours, we think nothing of lugging home a bazaar of influences that bring pleasure, evoke memories and reflect our worldly taste.

In 1568, the noble family of Cardinal Tolomeo Gallio built terraced water gardens at Villa d'Este, on the shores of Lake Como in northern Italy.

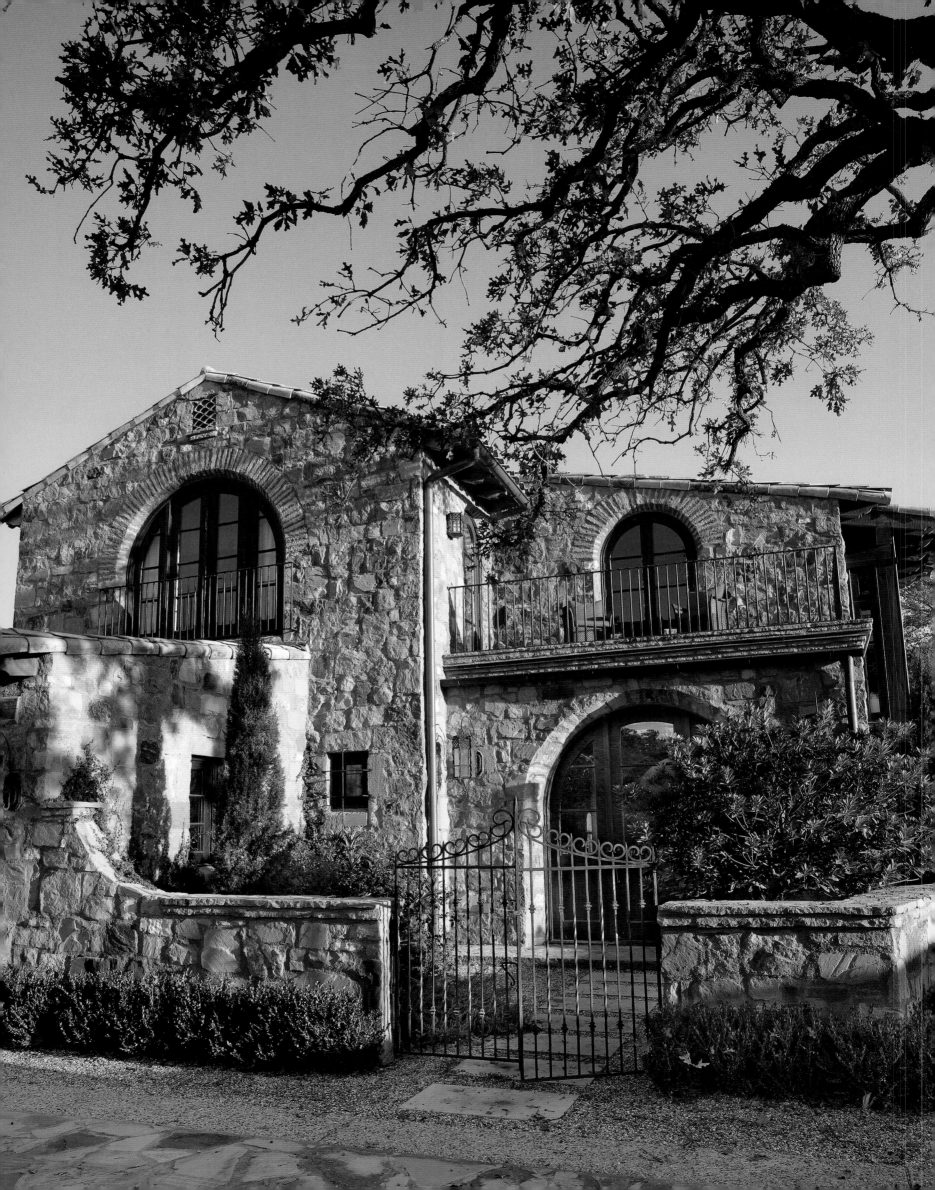

Italian WAY OF LIFE

Few countries elicit awe quite like Italy. While its bureaucracy can be mystifying, its art and beauty are ongoing feasts for our admiring gaze; its tangled history, assimilated culture and relaxed sophistication, sources of endless fascination.

As if this were not enough, seducing us are *case coloniche*—the typical Tuscan farmhouses steeped in countless charms, sun-bleached *ville* with easygoing elegance—and their extravagant, more celebrated cousins, sumptuous *palazzi,* whose *au courant* proportions merit high praise. In the midst of such plenty are the landscapes that inspired Renaissance artists Leonardo da Vinci, Raphael and Michelangelo, framed by vineyards, olive groves and neat rows of cypress trees.

With indigenous stone, terra-cotta roof tiles and a walled courtyard, a weekend getaway on this side of the Atlantic could nestle equally blissfully amid the gently rolling hills overlooking Florence, Siena or Pisa.

In each of Italy's twenty regions resides unique character and charm, stemming from the customs, climate and terrain. But it is tranquil, centrally huddled Tuscany, Umbria, Marche and Lazio, awash with old-world rhythms and a colorful air, that have given life to the style known as Italian Country, which has proven irresistible. And no wonder. Despite exterior trappings or how intimate the enclosures, interiors resound with an unabashed reverence for beauty. Yet settings are distinctly Italian: expressive, airy and, most tellingly, inviting.

A light fixture brings an old-world look to a new-world setting an ocean away from Tuscany, while vines trail overhead and along the walls.

Never mind that Italy has a staggering number of congenial places to dine—some pricey, but also a wealth of reasonable *ristoranti* and even less-expensive small *trattorie,* or *taverne,* not to mention unpretentious *osterie,* or wine bars, in busy neighborhoods that lend themselves to people-watching. Stopping by each other's homes is practically a daily ritual (which, in fact, may be why young men in Italy are all too often known as mamma's boys), if not to share lingering meals, then to sip *espresso* or for the sole purpose of doing nothing more than relaxing, thus preserving the tradition of *dolce far niente,* or sweet idleness.

Though tastes differ, mellow gelato hues, sensuous textures and fluid, natural fabrics—including widely revered Fortuny, now printed on cotton only—mingle with customary Italian flair, gently jarring spaces that might otherwise appear too serious with a sense of delight. > 137

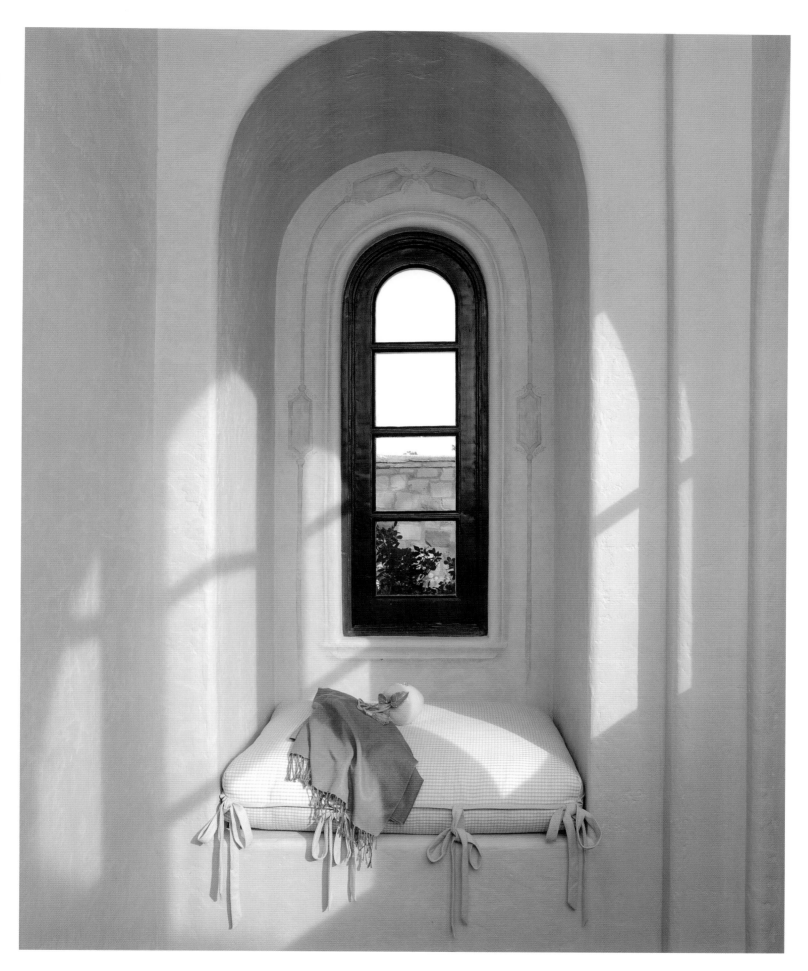

A window seat unceremoniously offers guests a place to lay their pashmina shawls and handbags, while a *bonnetière* (unseen) welcomes coats. In Italy, windows tend to be small, with working shutters proffering protection against strong winds along the peninsula's more than 4,722 miles of coastline—and inland, from the cold winter air and harsh summer rays.

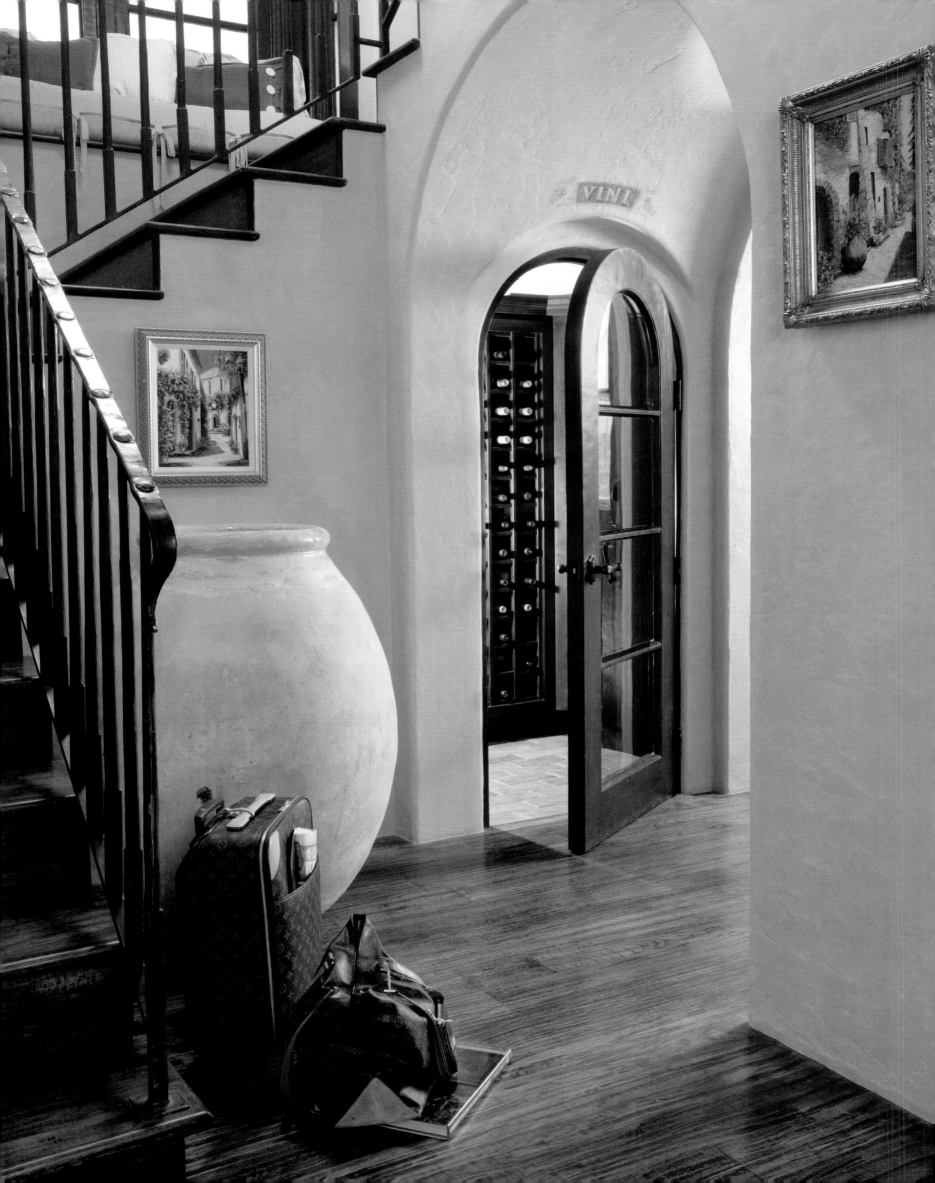

Prompting this once commonplace niche to become more highly regarded is a map of Italy's Tuscany region, the work of Houston artist Allan Rodewald, whose works of art have been exhibited at the Louvre.

FACING: Many of Italy's most *magnifico* wines come from the centrally located Tuscany region, as well as the area to the northwest surrounded on three sides by the Alps, fittingly known as Piedmont—literally, "at the foot of the mountains." A cellar tucked under the stairs stocks more than a few bottles from both locales, while a Biot pot—from Biot, France—with age-old charm parks on random-width, hand-scraped hickory plank flooring, rich and warm. Louis Vuitton's iconic brown-and-gold monogrammed Pégase Weekender is ideally sized for a few days away, regardless of where one is headed.

With seasonal ingredients being the foundation for regional dishes and cultural resistance to non-fresh foods, a trip to the *agora*, or neighborhood market, is often a several times weekly if not an everyday event for those living in Italy. Since the people in each of the country's twenty regions are passionate about their distinct traditions, local dialect and rich culinary history, those who grew up on generations-old specialties now host friends and family with homegrown recipes that more than hint of their *regione'* influence, whether Tuscan, Sicilian, Venetian or another.

LEFT: The unassuming apron with strings that tie in the back dates back to the Middle Ages, when monks and nuns frequently wore sleeveless garments called *scapulars* over articles of clothing. By the nineteenth century, servants were wearing apron-like garments as part of their uniforms. The practice prevailed and was adopted by homemakers, with the apron becoming associated with cooking and housework, of course.

FACING: Word is that Napoléon favored Camembert, made with raw milk, produced in the Normandy village of the same name. It is common for the French to name their cheeses after the town or region where they are made. The slate cheese board is from Viva Terra catalog.

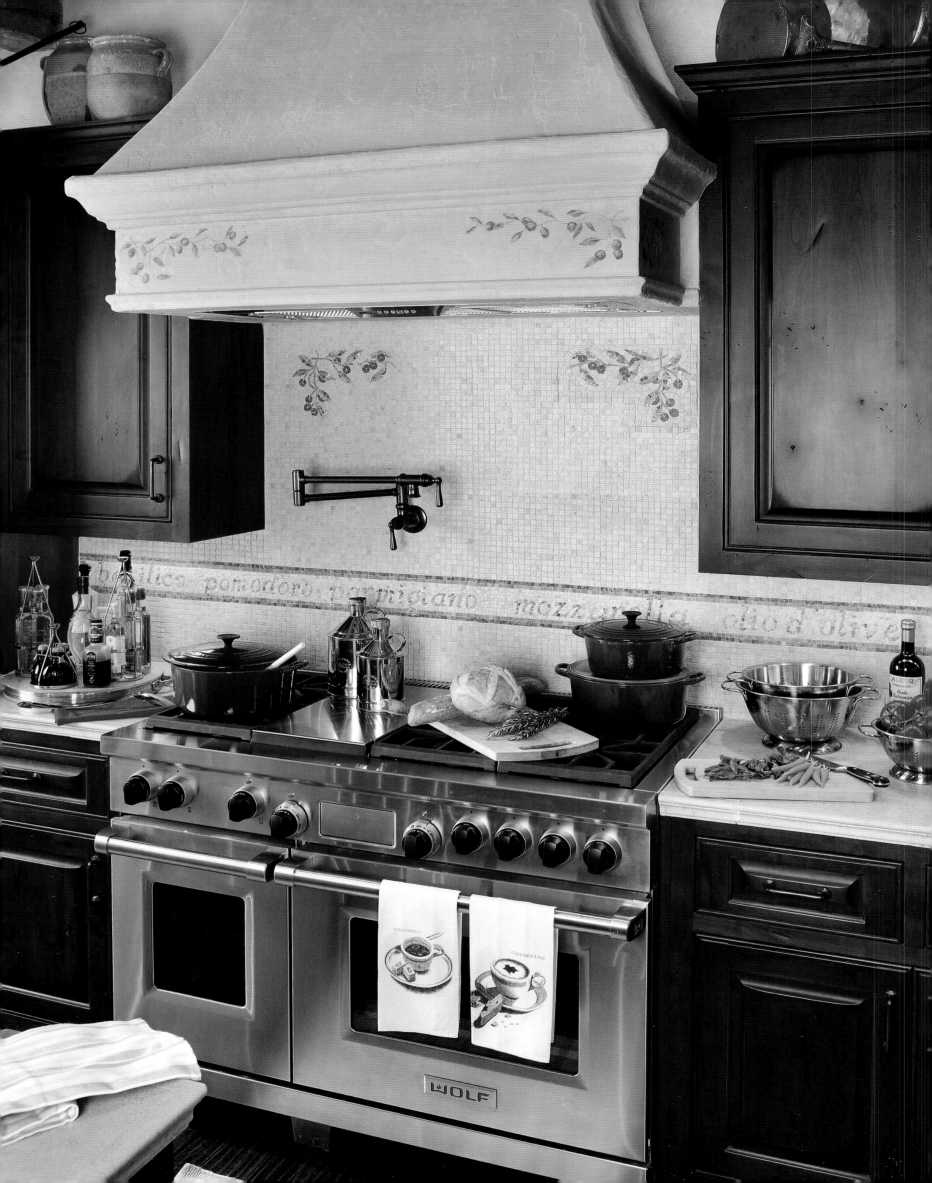

Taking both its name and cues from the fifth-century capital of Roman mosaic art, New Ravenna Mosaics in Exmore, Virginia, offers an updated take on an artistry that continues to fascinate. The handcrafted montage garnishing the backsplash adds to the joy of cooking while assuring that this modest kitchen stands apart.

Somehow, the sturdy silhouettes of finely crafted commodes, tables and chairs with a former life manage to speak for themselves, without any one piece being too forward. Chandeliers worthy of the country's artisans flicker in eye-catching mirrors hung opposite one another, giving even small quarters more presence—though size, Italians argue, has nothing to do with style.

Since there is an aversion to heavy window treatments, curtains hang freely with minimum fuss, meaning sans tiebacks. Memorably patterned stone floors meanwhile bask in one another's reflected glow, rarely spoiled by rugs. > 145

Classic Italian kitchens appear efficient, orderly and clutter free. Bringing a bit of Italy home, spring-latched cupboard doors mask precisely stacked molds, various-sized mixing bowls, colanders and pitchers, while the cabinets here make a convincing case for the beauty of alder.

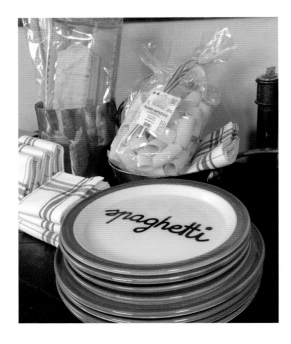

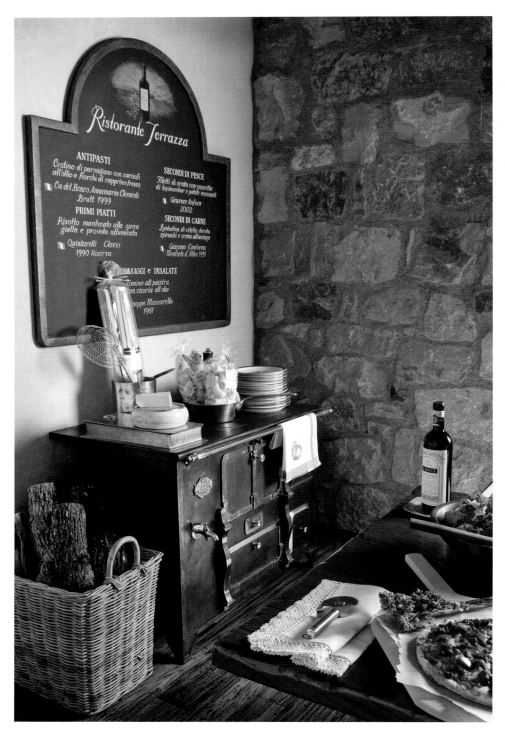

UPPER LEFT: Everyone knows that pasta with olive oil, basil leaves and fresh tomatoes has long been the soul of Italian cooking; but perhaps unbeknownst to many is that in Italy, spinning one's spaghetti in a tablespoon is an etiquette faux pas. According to John F. Mariani, author of *How Italian Food Conquered the World*, the word *spaghetti* did not appear in print until 1939. When it comes to the nation's flag, the green stands for the country's plains and hills, the white for the snowy Alps and the red for blood spilled in Italy's wars for independence.

LOWER LEFT: Demand for Parmigiano-Reggiano to grate over spaghetti, fettuccine and other homemade pastas is strong in Italy, but France, Germany, Britain, Canada and the United States also sing its praises. An industry made up of about 430 small, family-owned businesses dot the plains outside the northern city of Parma, where milk for the cheese comes exclusively from hay-fed cows milked twice a day, and each wheel ripens for at least a year. To maintain standards of taste, Italian law rigidly controls production.

In an era of sleek, self-cleaning ranges, a nineteenth-century cast-iron stove that predates these lustrous innovations unexpectedly presides, while a vintage chalkboard lauds the specials of the day. Naples, Italy is the cradle of pizza topped with green, white and red ingredients, the colors of the flag. Since 2004, a national law mandates that to be called *Neapolitian* [sic] pizza, the dough must be hand kneaded, the pizza must be round—no more than 35 centimeters (13.8 inches) in diameter—and only specified flour, salt and yeast can be used. Also mandatory: extra virgin olive oil, tomatoes from soil in the Mount Vesuvius region and costly mozzarella made from the milk of water buffalo.

FACING: A stone archway divides a villa with an open floor plan into separate, inviting areas suiting family life. Dining chairs made in Italy and covered in Lee Jofa and Pierre Frey fabrics gather around an early-nineteenth-century Catalane table—with iron supports, curved trestle base and nature's imperfections—from Le Louvre Antiques. The set of recycled glass vessels is from the Viva Terra catalog.

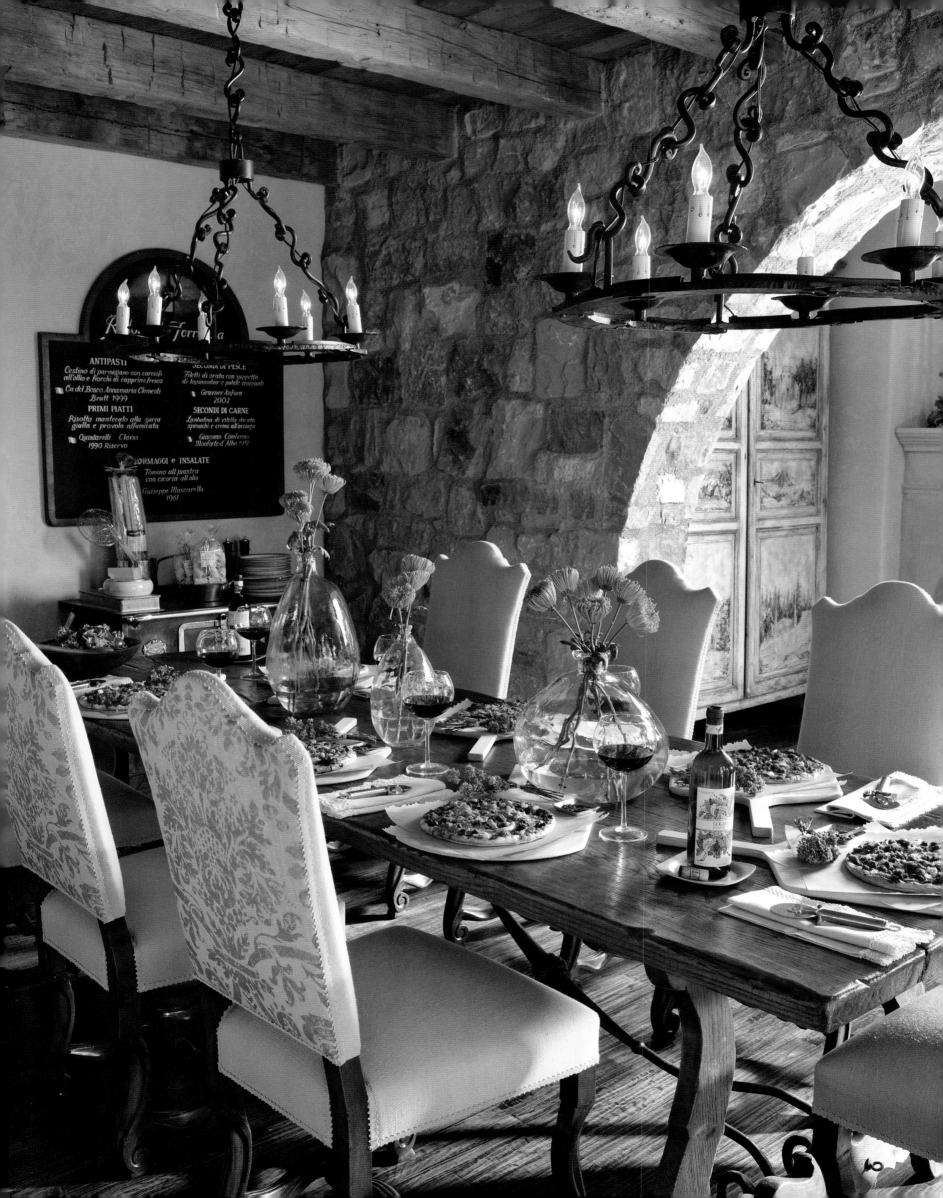

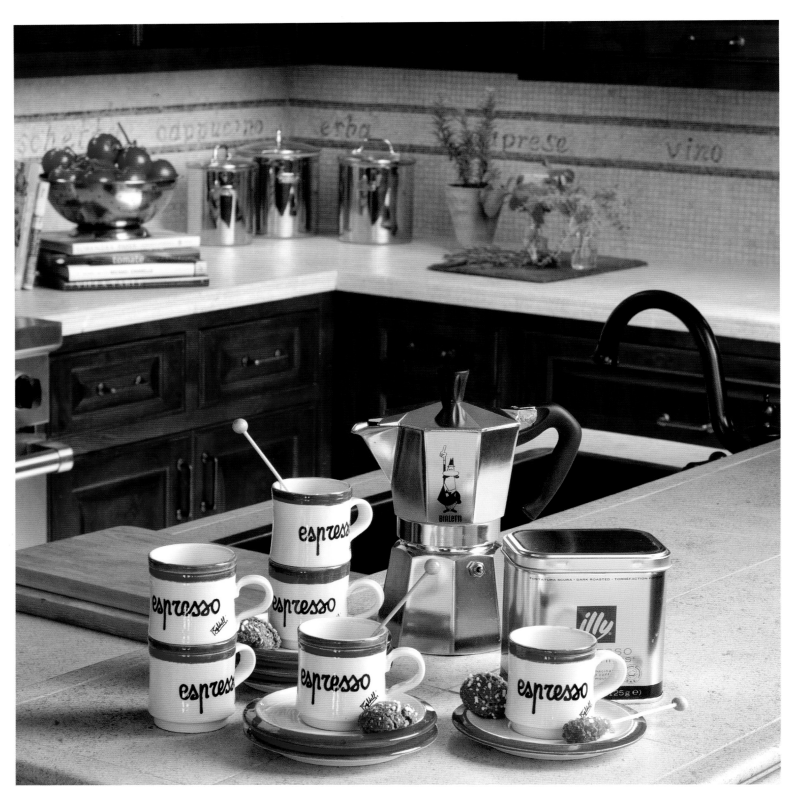

One need not become a master barista, much less jet to Rome, to savor an aromatic demitasse of espresso—though where better than in Rome to sit outdoors in good weather and people watch than at a charming sidewalk *caffè*? Producing a deep, dark, blissful cup, however, does require following some simple rules, starting with a scrupulously clean machine and water at a temperature below boiling: 100 degrees on the Celsius scale, or less than 212 degrees Fahrenheit. Otherwise, the drink will taste bitter and smell burned. And unless served in a porcelain cup, the heat will dissipate much too rapidly. To be sure, espresso pots and porcelain cups are staples in Italian homes.

FACING: Strawberries have long had the reputation of being a love potion. Reportedly, the Sun King, Louis XIV, was as passionate about them as his many mistresses. On bar stools, a Bergamo solid and Jane Churchill check pair easily.

A collection of candlesticks, deliberately grouped in a casual manner, graces a mantel where a relic of a bygone age also attracts attention. The antique window gate, circa 1850, from Le Louvre Antiques, once helped shield an unassuming *mas,* or farmhouse, from the unrelenting midday Provençal sun.

FACING: Reflecting purpose, practicality and panache, an interior pays homage to the relaxed yet stylish lifestyle of the Italian people. Pet-friendly chenille on sofas is by Glant. A prized print from the widely revered house of Fortuny adorns chairs and pillows. The Summer Hill coffee table doubles as a place to play games while touting a new look, thanks to Sanders Studio, Dallas. Bare windows frame the view and a painting of hillside *case coloniche* (farmhouses) by Gillian Bradshaw-Smith, who creates sets for the New York City Ballet.

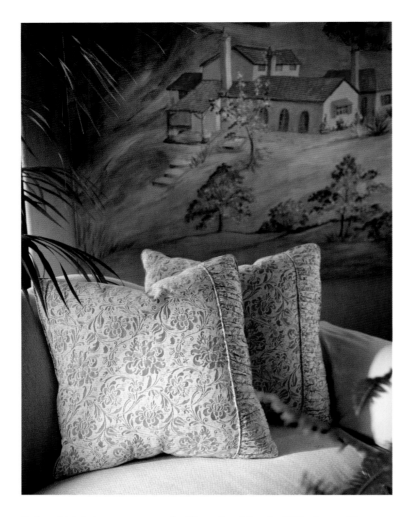

Behind high iron gates on the Venetian island of Giudecca, Fortuny produces rich, all-cotton fabrics with classical Italianate motifs in great secrecy. Offsetting that intriguing mystique is a fringed throw by D. Porthault—the ninety-some-year-old purveyor of fine French linens.

UPPER RIGHT: Reclaimed hand-hewn oak timbers, characteristic of ceilings in Italian farmhouses, support the roof, while an iron chandelier casts a warm glow on the area below.

LOWER RIGHT: Meriting more than a passing glance is an armoire long overlooked—until hand painting helped it shed its weary image and evoke awe and envy.

Faithful to their heritage, antique tapestries meander through villa halls, accompanied by cherished centuries-old paintings, some in need of cleaning. In truth, there is little doubt these days that most families live amid furnishings collected over several lifetimes, thoughtfully handed down generation after generation by caring ancestors—as if forever confirming what Americans have known all along: being the favorite has its privileges.

While next of kin may vie for a desk piped in history or covet a mosaic-topped table and a commode with *intarsio* (inlaid wood) finer than another, in reality, living spaces are generally sparsely furnished and, almost without exception, shy of pretension. Quite simply, in Italy affection has no place. And neither does clutter, which might deter guests from moving about freely during, say, a pre-opera buffet.

True to tradition, comfort abounds, as if pointing out that artistic merit does not take precedence over indulging family or pampering friends. Beside a chair there is always a table sufficiently sized to hold a glass of wine and small plate of cheese, often paired with sliced salami, prosciutto and olives. (By contrast, *antipasto*—meaning before the meal—is the traditional first course and generally served once guests are seated at the table.) There are pillows to relax against; soft, clinging shawls to gather for added warmth; and table and floor lamps placed just so for ending the day with *La Repubblica* or another of Italy's well-known daily papers. (Lights are dimmed when entertaining.)

Although the commonplace has never received the universal admiration of more important Italian pieces, layering the conventional with the glamorous makes stylish living look effortless, which is no small feat. *> 150*

A tray just the right size for breakfast in bed holds Hôtel Silver: a teapot, bud vase, flatware and toast rack, evoking the golden age of travel—1900 to 1940—before traveling became a love/hate adventure. Pieces from the era's grandest European hotels, ocean liners and trains bear a stamped crest or engraved name. The mix of china, designed for the restaurant L'Oustau de Baumanière, in Les Baux de Provence, is available from the charming boutique next door.

LEFT: Some people return home from a five-star hotel on the Italian Riviera bearing trinkets for the children and travel-size products for themselves. But then, what might they bring that adored pet waiting patiently to welcome them home? Worth considering is a door hanger that sends an invitation to "Sit. Stay. Settle In."

FACING: In the noble city of Venice, where artisans created this Patina bed, tourists outnumber permanent residents 100 to 1. Though the architecture, artwork and aura of romance make Venezia incredibly alluring, traveling to a stateside retreat with resplendent Frette bed linens and the kind of plush overnight accommodations that one might expect to find at the legendary Hôtel Danieli, Hôtel Gritti Palace or Hôtel Bauer surely is more affordable and certainly takes less-arduous planning. Furthermore, jet lag is a non-issue.

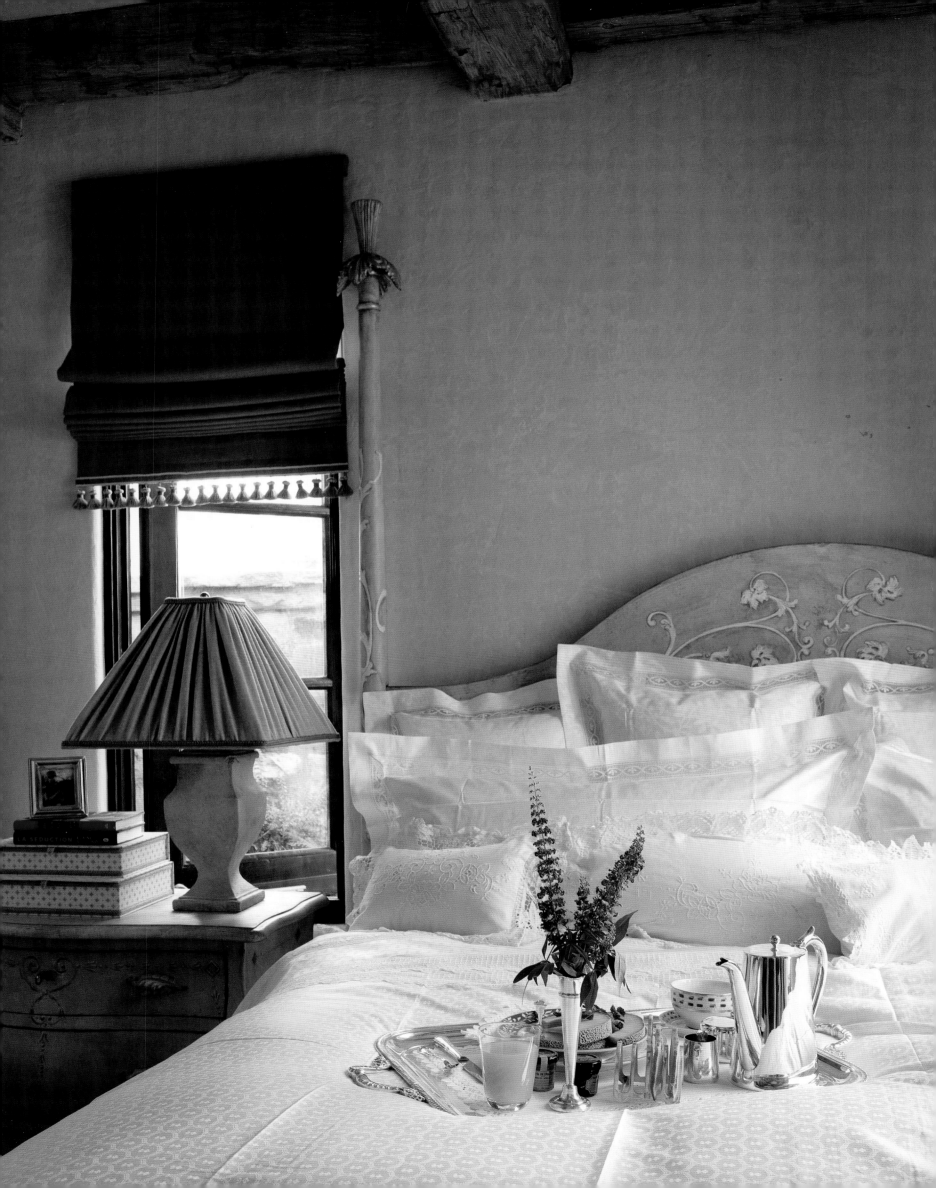

Musical dramas reach back to ancient Greece; however, modern opera—with its elaborate sets, costumes, dances and story lines—dates to 1597 and the premier of *Dafne* by composer Jacopo Peri, the story of Apollo falling in love with the nymph Daphne. By the middle of the seventeenth century, opera had spread throughout Italy and into France and Germany. Venice alone had more than thirty glamorously candle-lit opera houses, making an art form often viewed as snobbish available to the masses.

FACING: When generous windows frame enviable views, work-related tasks become significantly more pleasant, even on cherished weekends. Easily removed slipcovers insure chairs can readily travel to the dining room.

As it is, stately andirons, antique altar sticks, priceless clocks and libraries of leather-bound books project an air of authority, while firescreens, planters, close-ups of family and friends and bountiful bouquets, smartly arranged, plump settings that handle the cares, concerns and aspirations of everyday life.

Without fail, and without the princely prices of Le Sirenuse and other luxury hotels on the thirty-mile stretch of Amalfi Coast, impeccably pressed linens stretch across beds, hinting of femininity. Down-filled bolsters sprawl beneath soft down pillows as feather beds snuggle against mattresses. Modest box springs appear tightly wrapped in blanket covers, shielded from prying eyes. Next to the bathtub sits a chair for stacking towels, placing a robe or relaxing upon while the tub fills.

Given that Italians balk at like furnishings lacking character, most cannot imagine awakening in a bed flanked by identical night tables holding similar lamps and resting near a matching dresser or chest of drawers. Filling empty rooms with suites of shiny new furnishings lacking mystique rather than mismatched antique pieces is not something they understand. Most prefer a more aged or worn look, with any member of the younger generation being honored to receive *nonna's* armoire.

Indeed, to the Italian way of thinking, it is unpardonable to live in a house full of rootless pieces with no ties to the past or any sentiment attached. Furnishings must be as meaningful as they are decorative, with the secrets and bruises of history opening a window into the Italian way of life.

Botanicals hang in a master bathroom accessorized with Bulgari bath amenities (gels and soaps) straight from the classy hotel of the same name in oh-so fashionable Milan.

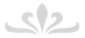

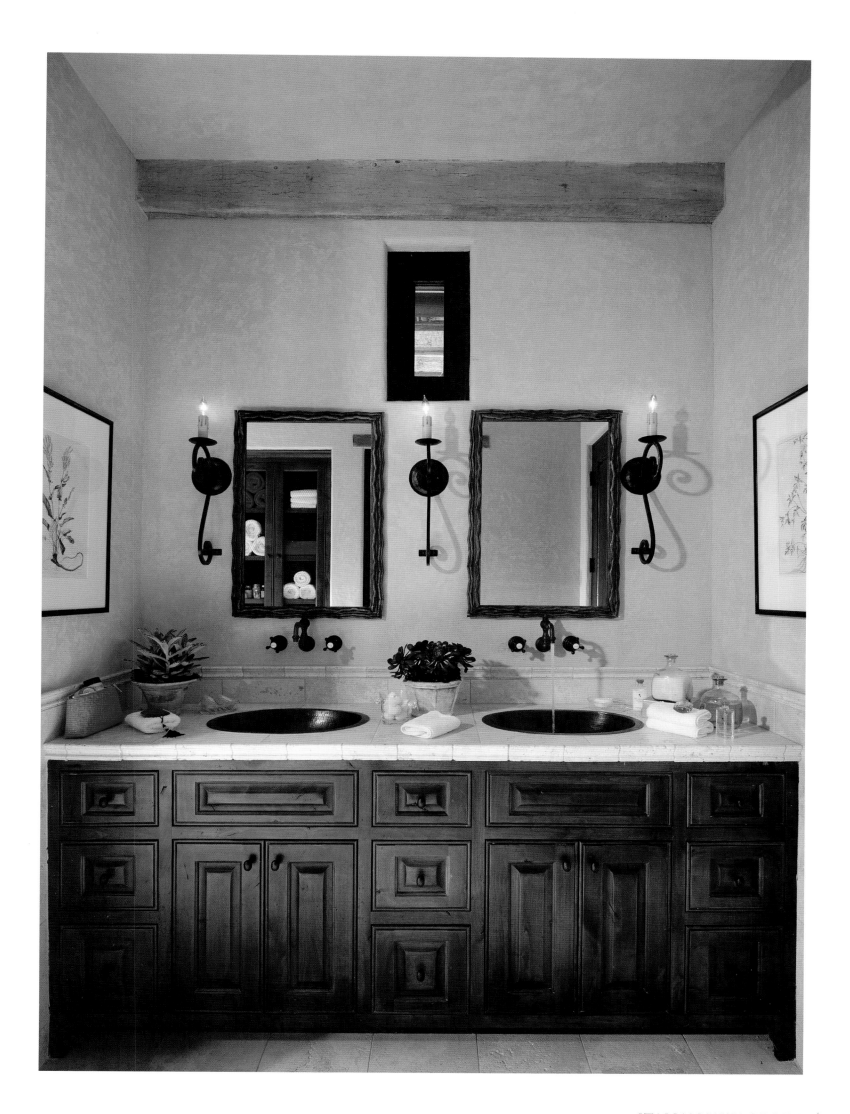

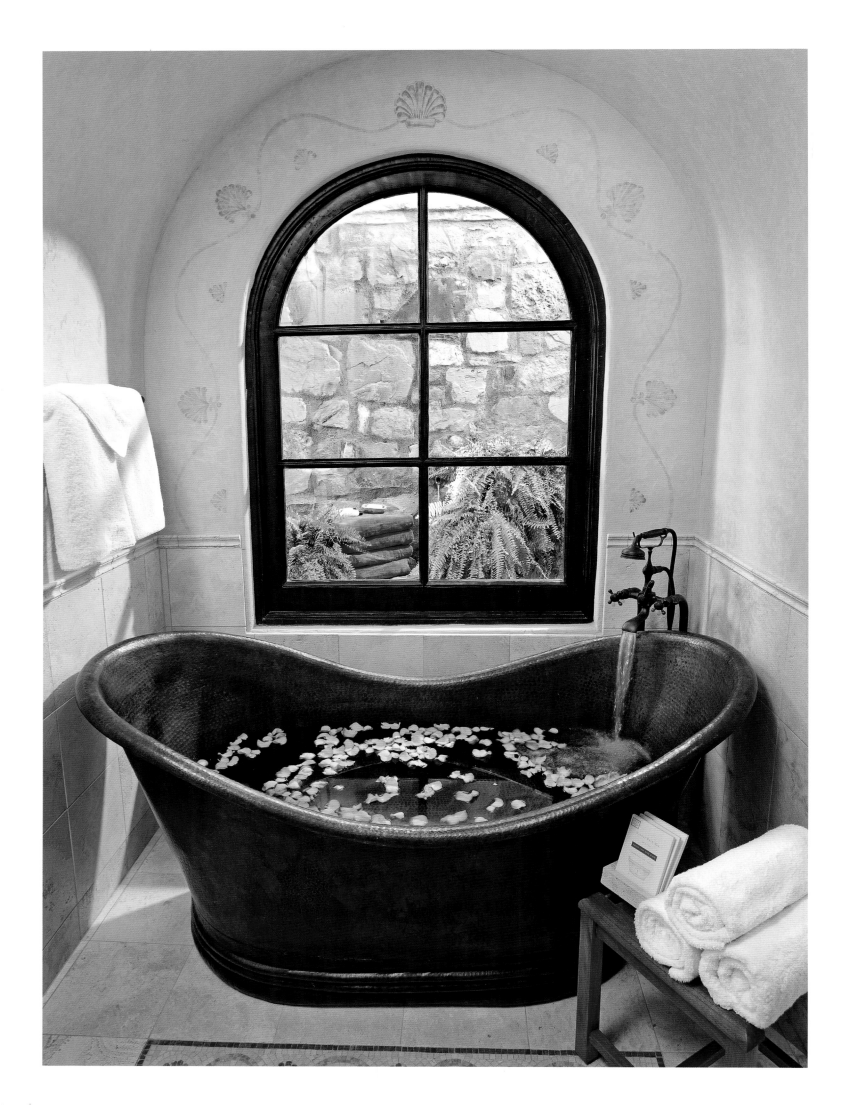

Experiencing the great outdoors: a shower—accessible through the master bathroom and hidden from view by thick stone walls—where it does not take much more than a bar of soap, teak mat and plush bath sheet to rinse off or de-stress.

FACING: Throughout history, copper soaking tubs have been the fixture of choice among kings, queens, emperors and aristocrats, who may or may not have known, or possibly even cared, that bacteria cannot live on copper. Reputedly, Louis XV's bathroom housed two copper tubs. In one, he would soap himself. In the other, he would rinse off. In keeping with his whims, both were on rollers, readily moved in and out of the room in which he opted to use for bathing, as not until near the end of his reign did his bathroom have running water. If aspiring for a reasonably priced French *bateau* copper tub, consider heading for Atelier du Cuivre in Paris, or to the shop with the same name in the charming twelfth-century village of Villedieu-les-Poêles—literally, God's town of frying pans—in the Normandy region.

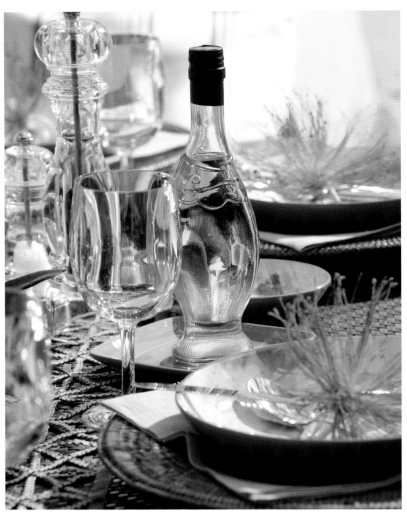

Some days are simply for lolling around, doing nothing, being pleasantly idle, or *dolce far niente,* the Italians say. But then, life is even sweeter when one can leave everyday cares on the pool's edge or, better yet, let them float away. The phrase *la dolce vita* splashed on plush lagoon-blue towels from Cuddledown is just another way of reminding us to do just that. The basket simply helps keep towels orderly.

UPPER RIGHT: Most every *trattoria*—casual neighborhood restaurant—table in Rome hosts a gleaming bottle of extra virgin olive oil produced from a nearby crop of olive trees. Each drips with regional pride while standing ready to drizzle over pastas and salads or to bathe freshly baked bread.

LOWER RIGHT: Drawing on memories of childhood visits to Tuscany, Parisian artist Marc Lacaze created winsome watercolor imagery for an earthenware collection made in Italy called "Paysage" (French for "landscape"), exclusively for Williams-Sonoma. In turn, "Paysage" inspired the pleasing palette of the living area in this Tuscan getaway.

FACING: Why not dine out? Just as living areas have moved outside, so have spots ideal for dining. In ancient times, the Romans feasted al fresco in their inner courtyards. Here, guests gather for leisurely lunches in the open air—and much like in earlier times, a fountain with trickling water creates a soothing backdrop. The Dransfield & Ross latticework table runner, available form Neiman Marcus, helps transport the flavor of Tuscany to the table.

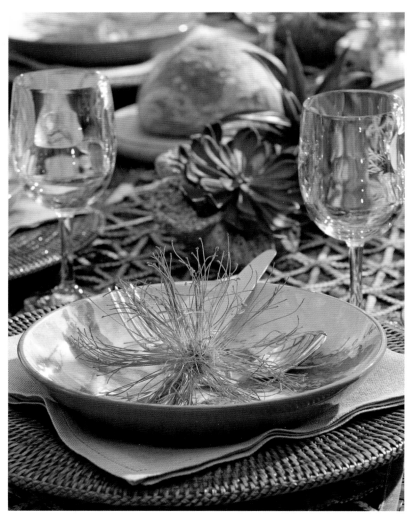

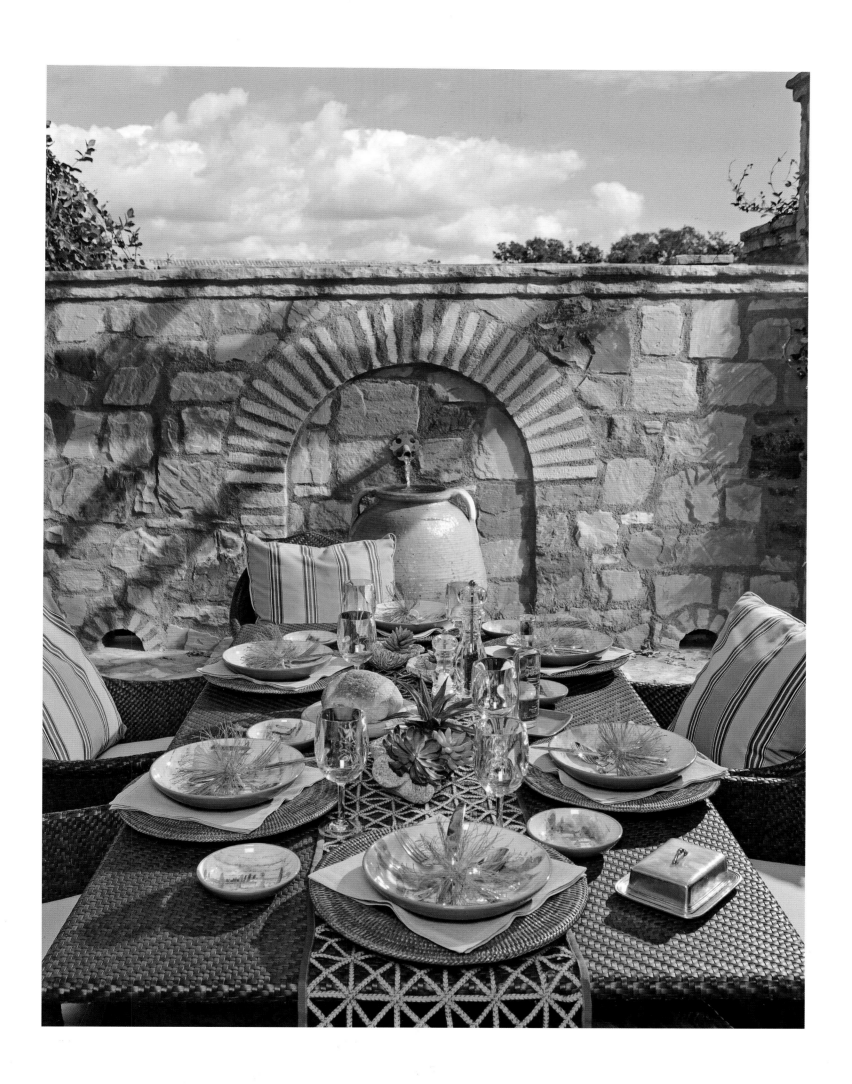

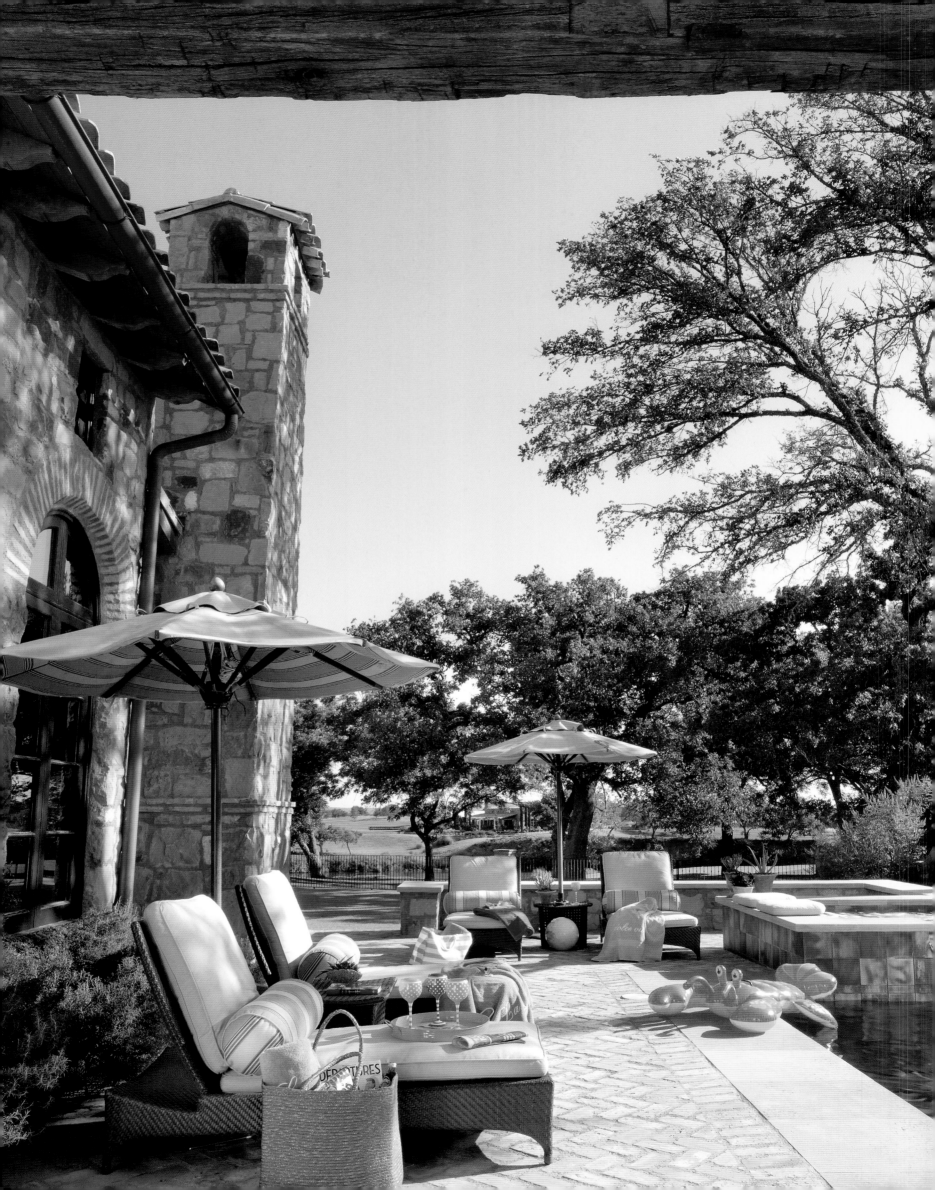

Some words, such as *bikini*, do not require translation. No matter that the Seine is too polluted for swimming or that not everyone can be, or wishes to be, green-bean thin. Yes, the French amusingly refer to slender women as *haricots vert*. Most have trained themselves to eat sparingly without calling attention to doing so. Those women who do not subscribe find a style that emphasizes positives and move on. In any case, the shapely bag is see-worthy.

RIGHT: Believing she could ward off the wrinkles of time, Diane de Poitiers, mistress to Henri II of France, bathed in donkey's milk, slept sitting up and drank liquid gold. Also, she wore a black velvet mask to prevent sunburn, which is unnecessary in 2012, for we simply slather on sunscreen bearing the coveted "offering broad spectrum protection," meaning that it shields against dangerous rays (UVB that cause burning and UVA that cause wrinkling—both of which cause skin cancer).

FACING: There's no need to purchase a ticket to a tropical escape when a few good books will do, with market umbrellas standing ready to make one feel as if on holiday. Wearing refreshing solids and carefree stripes from Giati and Old World Weavers, Janus et Cie's handsome wicker furniture—with unique water-draining construction—exudes the look of a well-known five-star Mediterranean resort.

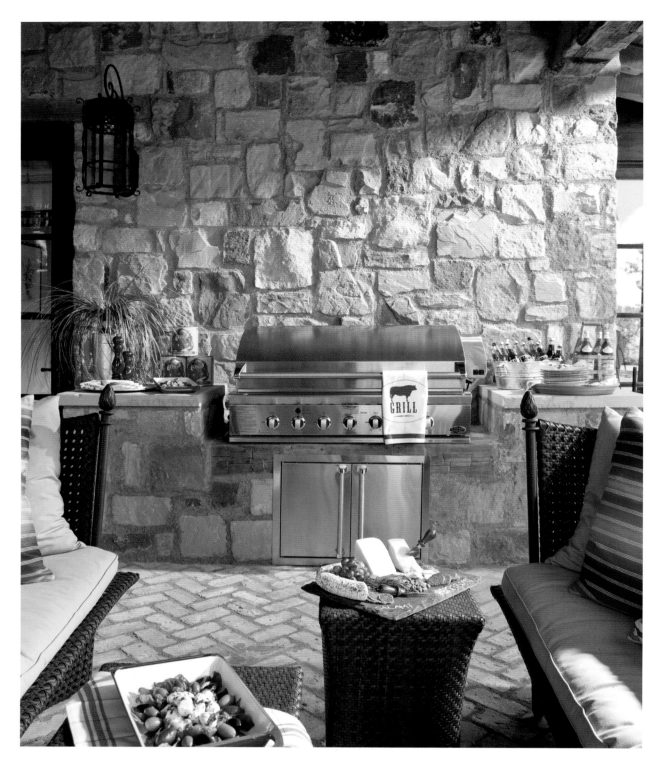

When an entire wall of French doors opens to a loggia with all the comforts of an area indoors, it is easy to collaborate with a Wolf gas grill.

LEFT: Vintage finds from Uncommon Market, Dallas, one of Ralph Lauren's favorite stops, are set to welcome a stream of guests fleeing the city for a quieter world with abundant beauty and all its associated delights: fishing, biking, golfing and playing soccer.

FACING: Where better to improve one's mind, cheer for a favorite team or take an afternoon power nap than on a daybed by Janus et Cie? The laid-back outdoor room—properly called a loggia—takes a fashionable turn bedecked in bright, fun fabrics from Giati and Old World Weavers. Regardless that a stone fireplace anchors the setting, the Hunter ceiling fan helps the space keep its cool.

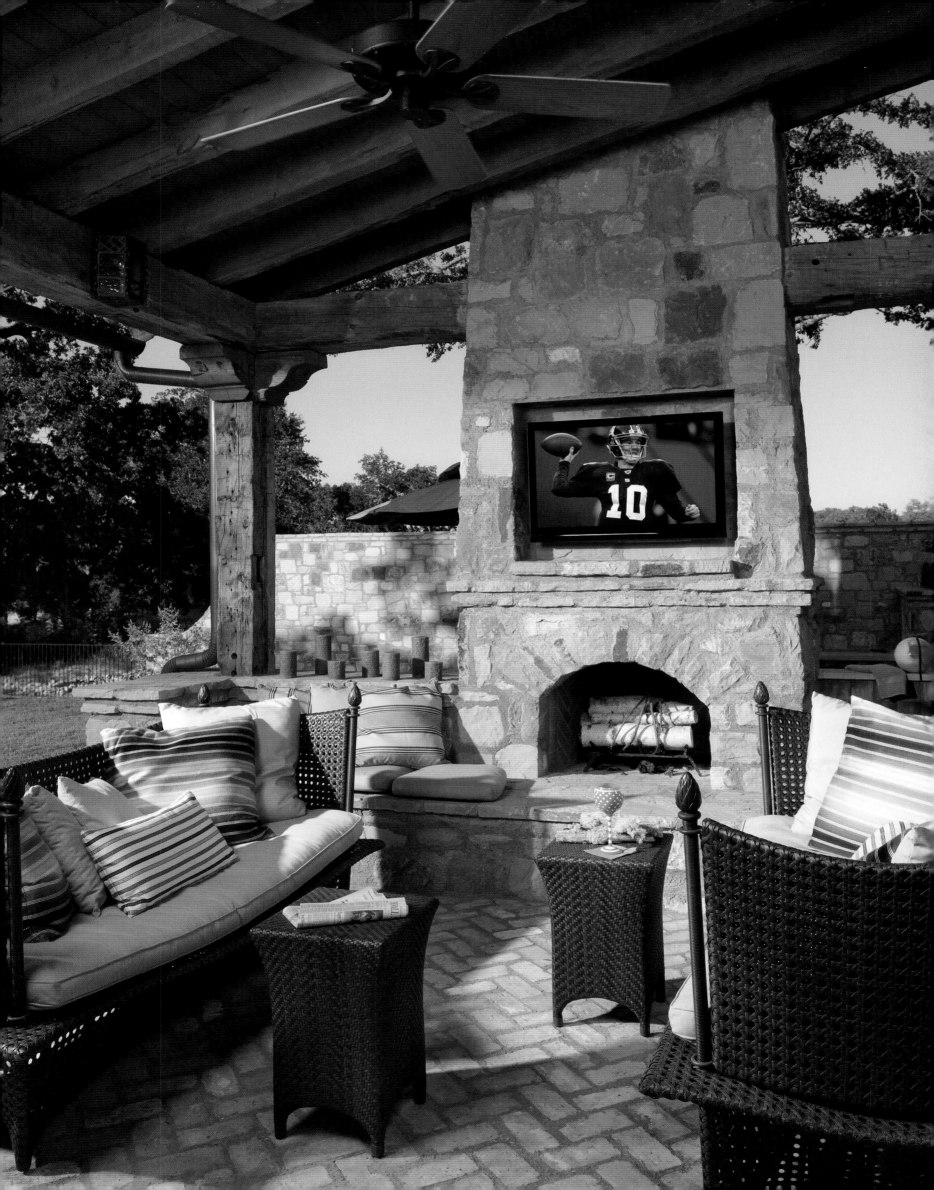

Regulation golf balls have an average of 360 dimples that reportedly amplify upward lift, making the ball fly faster than if the surface were smooth. A canister with golf balls helps make the room user friendly.

RIGHT: When it is summertime and the living is easy, the golf course lures many outdoors, both here and in Italy, where golfing and fishing are favorite pastimes. Reportedly, golf in Italy dates back to Roman times when a similar game, *paganica,* was played with a stick and feathers filled a leather ball.

FACING: A self-confessed neat freak, who prefers flatware and pencils all pointing in the same direction, never mind straight lampshades, meets her match when a grandson who is a "scratch" player— meaning, of course, sports a zero handicap—needs a spot to rest his fifteen-year-old head. With her priority his comfort zone, she designed hip bed linens aimed at lending luster to the setting. Regardless, he puts his own spin on the space, dashing any shred of hope for order. The iron bed is from Charles P. Rogers & Company.

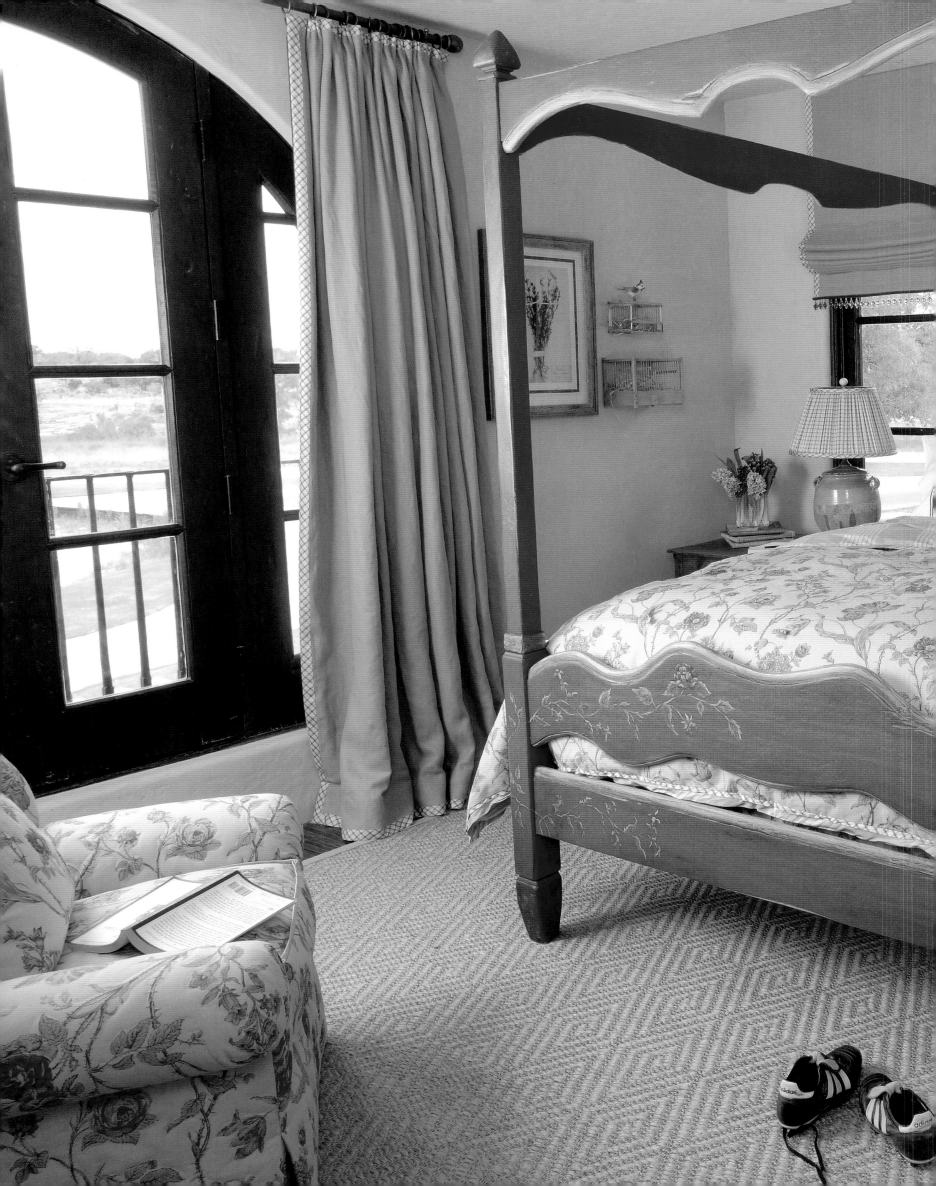

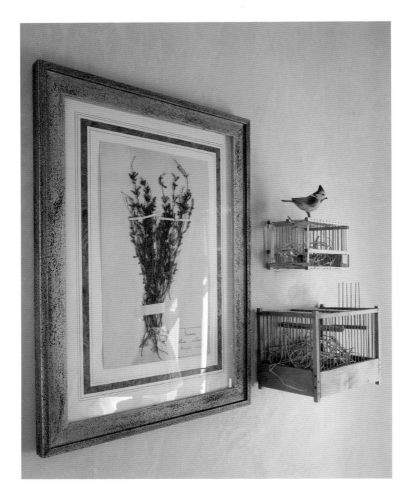

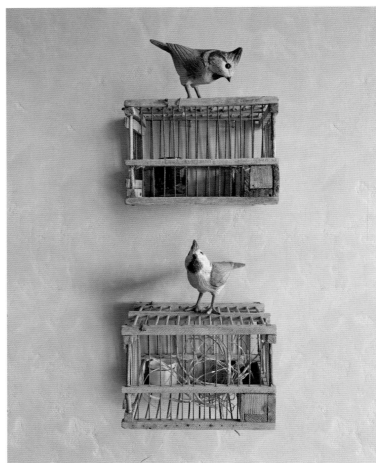

Vintage botanicals and birdcages found in London offer unexpected, unassuming charm, much like the rest of the getaway.

RIGHT: An appliqué of mosaic beading on textured white linen brings a bedroom to life with its fiery tones. Decorative pillow is from the Anthony Ruben Collection.

FACING: "Happiness is a long, hot bubble bath," or pure bliss, before saying good night.

PRECEDING OVERLEAF: Exuding the cherished worn look of the antiques that inspired them are a handcrafted and hand-finished bed and desk from The Farmhouse Collection. Painted furniture had its beginnings in China about 3,500 years ago.

appiness is long, ho ubb

In Italy, lunch is often the largest meal of the day. Dinner can be very simple, perhaps a soup and salad on the terrace.

FACING: Talk about flower power. A laundry with stacking Miele units (unseen) doubles as a potting room. Though dried flowers may bloom year-round and never need watering, naturally, our preference is for the real thing.

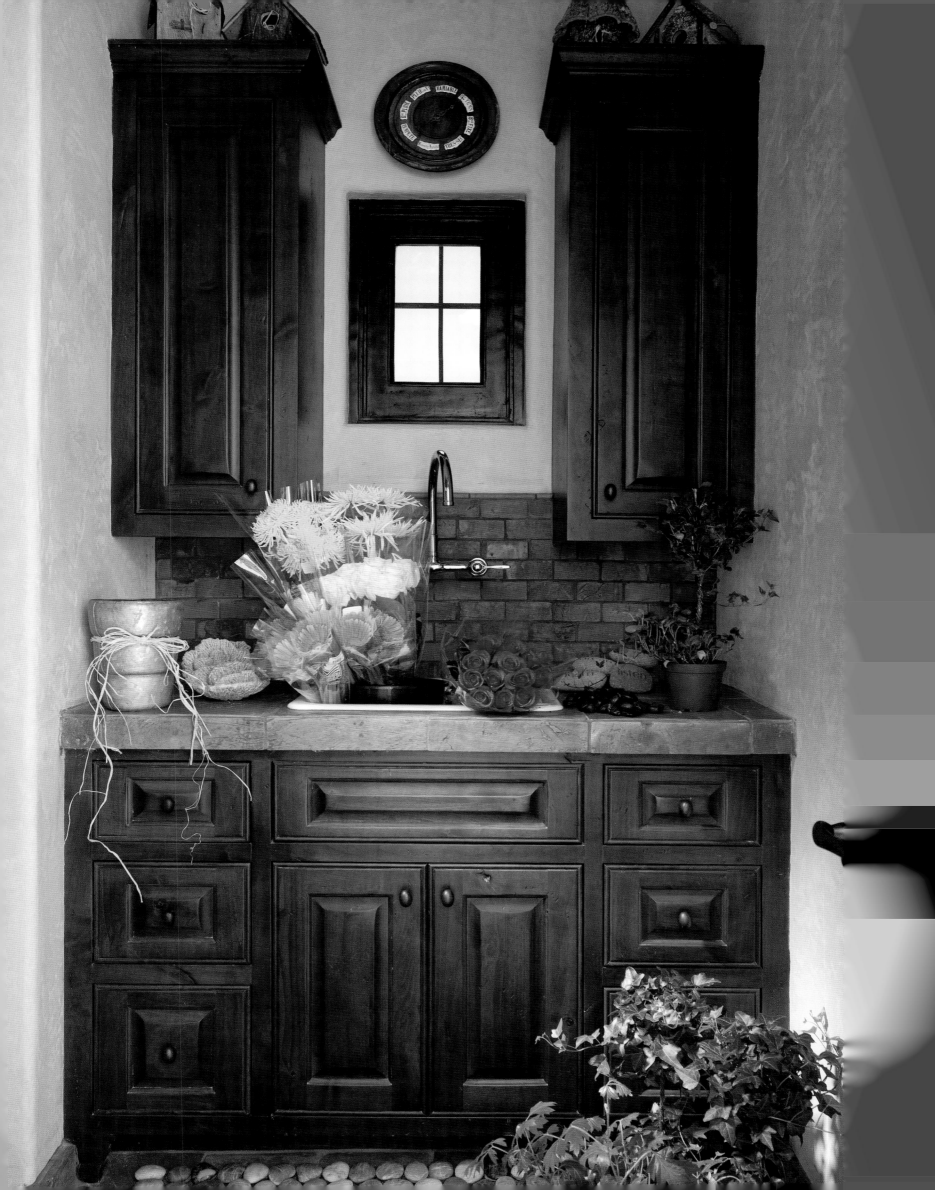

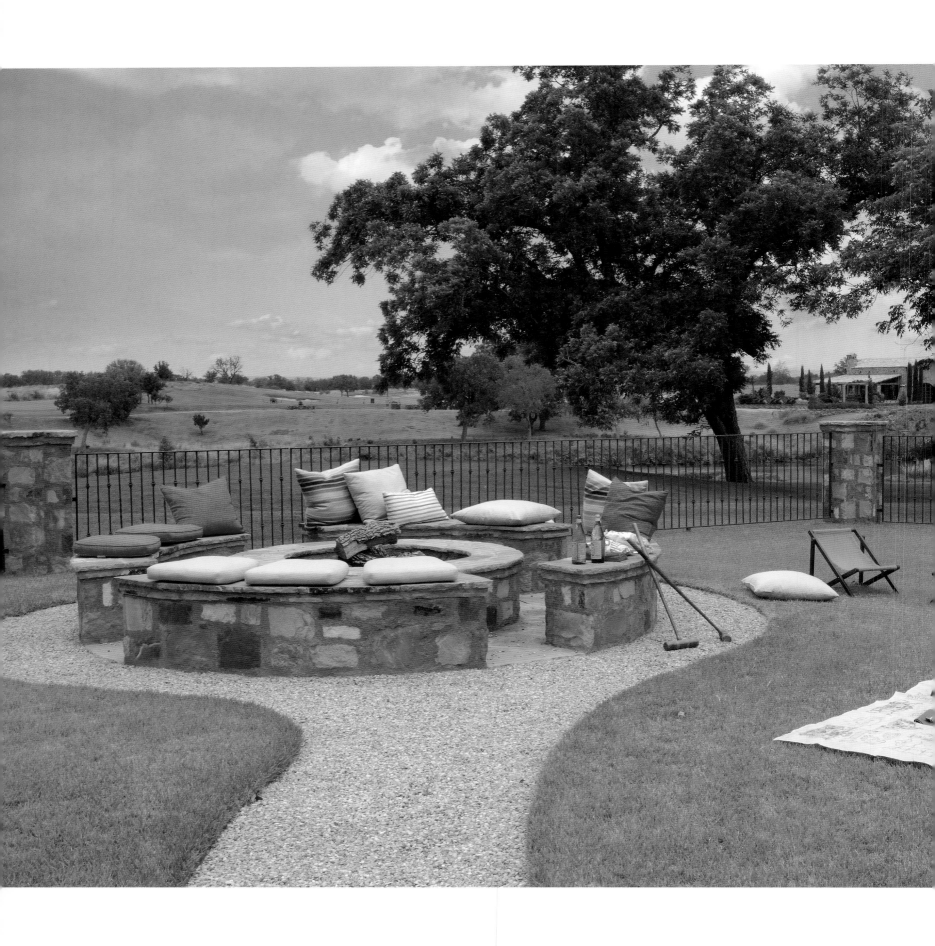

Of course, we have long had a love affair with summer. However, assembling s'mores around an open fire suits both warm and chilly weather, as does playing soccer or baseball in a gathering spot with plenty of space for family fun.

BELOW: Inspired by a travel diary filled with pencil drawings of Italian palaces and gardens, Pierre Frey—the seventy-five-plus-year-old family business with showrooms in Paris, London and the States—created "Palazzo," a fabric fitting most any villa, which is available from Yves Delorme as a table linen.

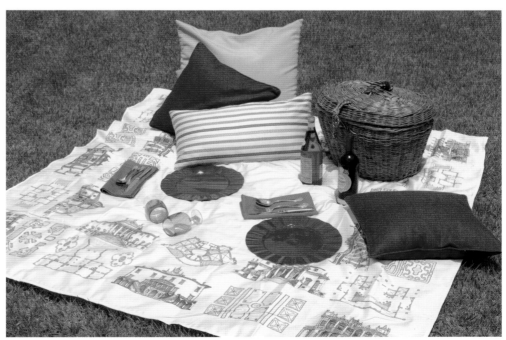

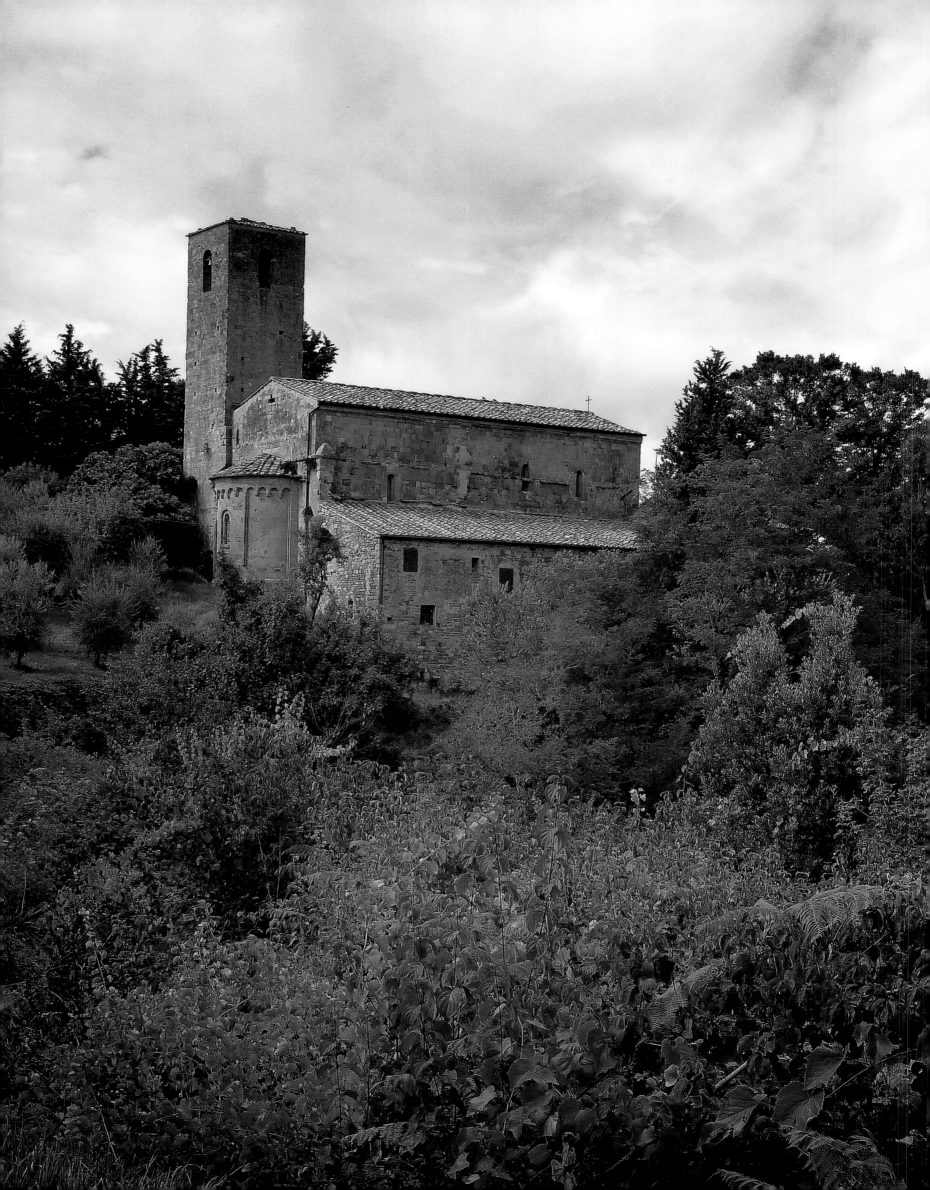

ROMANTIC
Italy

Intimate and inherently alluring, Italian bedrooms serve as a sensuous oasis and pleasing foil to the more formal public spaces in homes. From the *camera da letto*—those sublime nuptial chambers prevalent in the dwellings of the upper classes during the Renaissance—to present-day master suites, sophisticated sleeping quarters reflect the culture's enduring veneration of fine craftsmanship and luxuriant materials. As with the ceremony uniting two people in marriage and its accompanying age-old rites and customs, the Italian bedroom remains steeped in tradition. Historically, when a bride joined her father-in-law's household, her new husband would furnish their bedroom with large *cassapanca dipinte* (painted chests), a *panca* (bench), ornate mirrors, symbol-laden tapestries and carved religious artwork.

If the vision of owning a *palazzo* in Italy makes your heart race, it might help to know that there are stateside resources willing to help navigate the bureaucratic hurdles of buying in a country with more than 150,000 real estate and property tax laws.

Outside *appartamento* in Tuscany, it is common to see the wash line-drying in the breeze.

Then, as now, the bed served as the centerpiece of the suite. In a nod to the relatively high ceilings in lavish seventeenth- and eighteenth-century Italian *ville* and *palazzi*—some now converted into smaller apartments called *palazzetti*—headboards and bedsteads were monumental in scale. Throughout the nineteenth century, the popularity of brass and iron surged, though mahogany four-poster beds never ceased to enchant families of means.

For a culture with a longstanding adulation for textiles, the bedroom proved an ideal setting for a sumptuous array of silks, damasks and velvets—splendid and seductive—often woven on eighteenth-century looms. Perhaps predictably, gifted weavers sought to sate the appetites of patrons using newer methods. Innovative Milanese hands, for example, enlisted goldsmiths to create gossamer silver and gold filaments for extravagant brocades. Though many fabrics today are far less fancy, metallics offer modern opulence, thanks to technological advances.

Despite historical documents pointing to Venice, where silk weavers founded the first guild in 1265, exactly when production of Italian silk began in earnest has long been debated, since Italy was importing cotton fiber from Alexandria and Antioch a century earlier. Generations later, Genoan weavers pioneered cotton-linen blends; some say the word *jeans* traces its origins to their work. Others claim denim originated in Nîmes, France, where it was known as *serge de Nîmes*. Regardless, given that young men could spend upwards of eight years apprenticing in Italy's textile industry, it is hardly surprising that the bedroom benefited from their commitment, labors and time-honed skills.

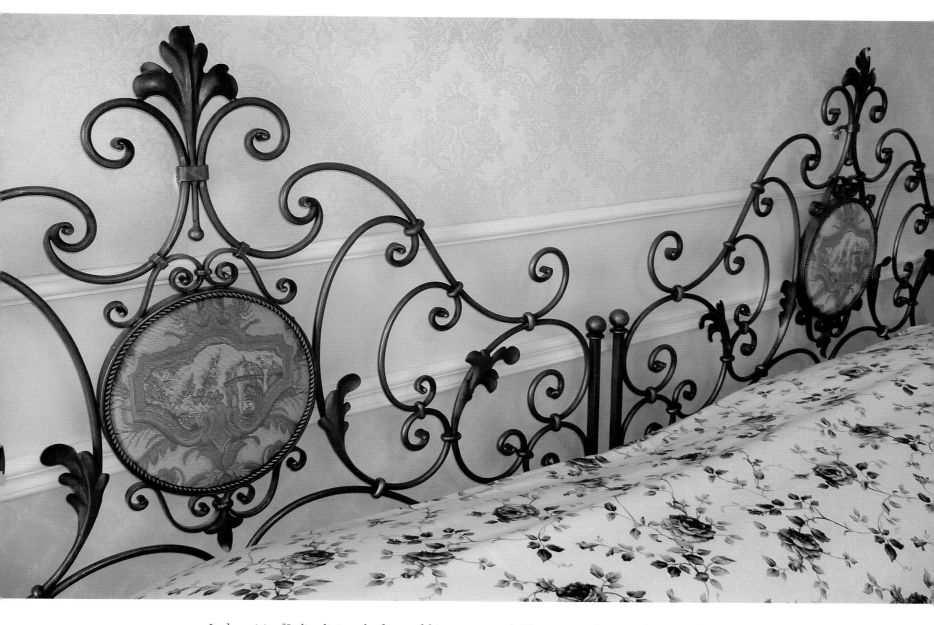

In the spirit of Italian living, the focus of this room outside Florence is, of course, the wrought-iron bed with inset tapestries that slip easily not only into this bedroom but into bedrooms in many European homes.

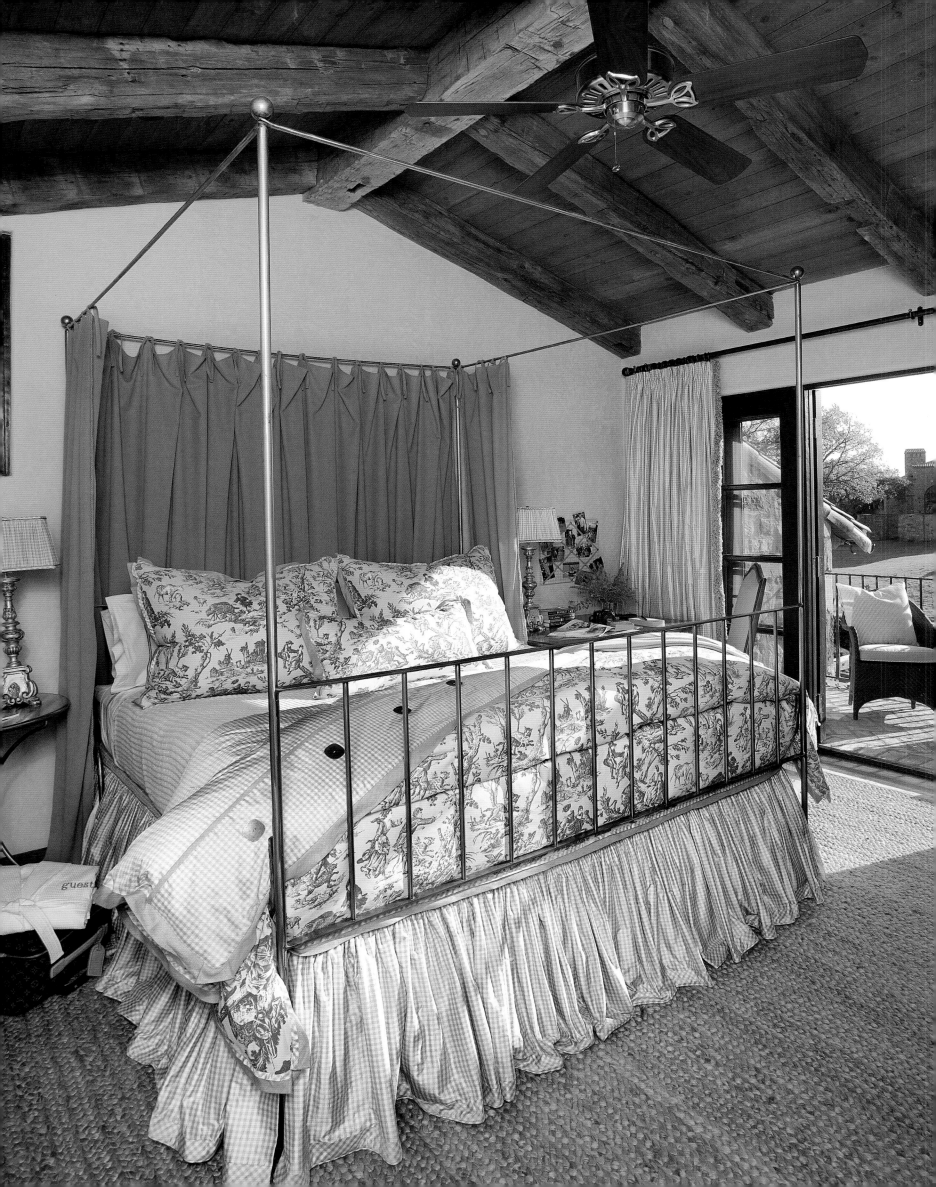

Layers of vintage botanicals framed in an avant-garde way surround an armoire, warming up a room with high ceilings.

FACING: There is no need for *grand-mère* or *nonna* to worry about arriving early, checking out late, or even waiting in line for a room key. At a family hideaway where generations gather for timeless weekends, a charming Sanderson pastoral scene tells a story. Toile de Jouys originated in the town of Jouy-en-Josas, near Versailles, 250 years ago. Most were monotone, printed in red, blue, green or black on white or off-white ground.

BELOW: With the sun streaming in and views camera-ready, how could the day be anything other than *perfetto,* come what may.

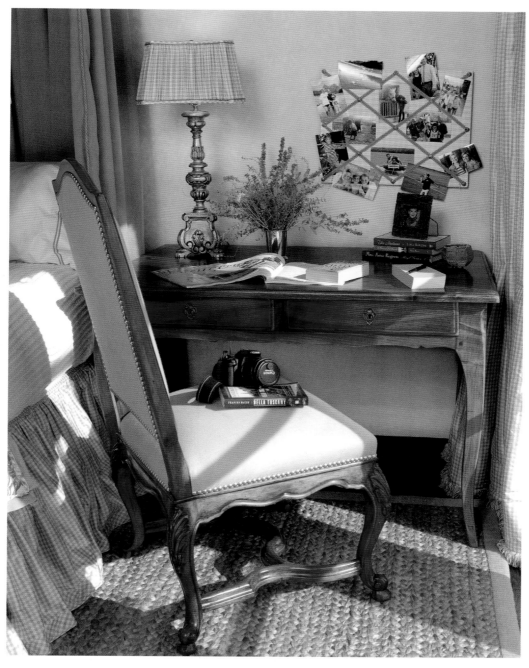

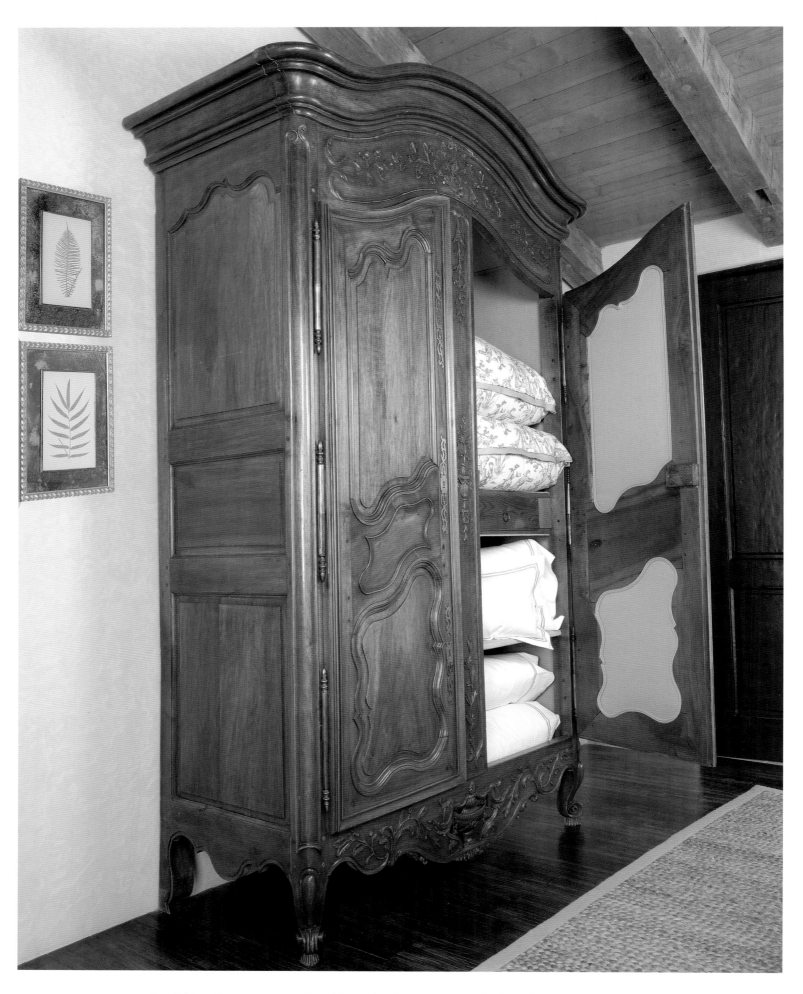

An eighteenth-century armoire with captivating presence is the furnishing most every guest room craves. Extra blankets, soft, medium and hard pillows and a duvet plumped with the finest goose down languish inside.

French doors open onto a terrace privately accessed from the guest room, offering an intimate place for drinking morning coffee, sipping a tall glass of *limonata* (lemonade) before taking a *pisolino* (nap) or enjoying a late-afternoon Bellini—the white peach cocktail created sometime in the 1930s by Giuseppe Cipriani, the founder of Harry's Bar in Venice. In 1948, he named the drink after Giovanni Bellini, the fifteenth-century Venetian painter.

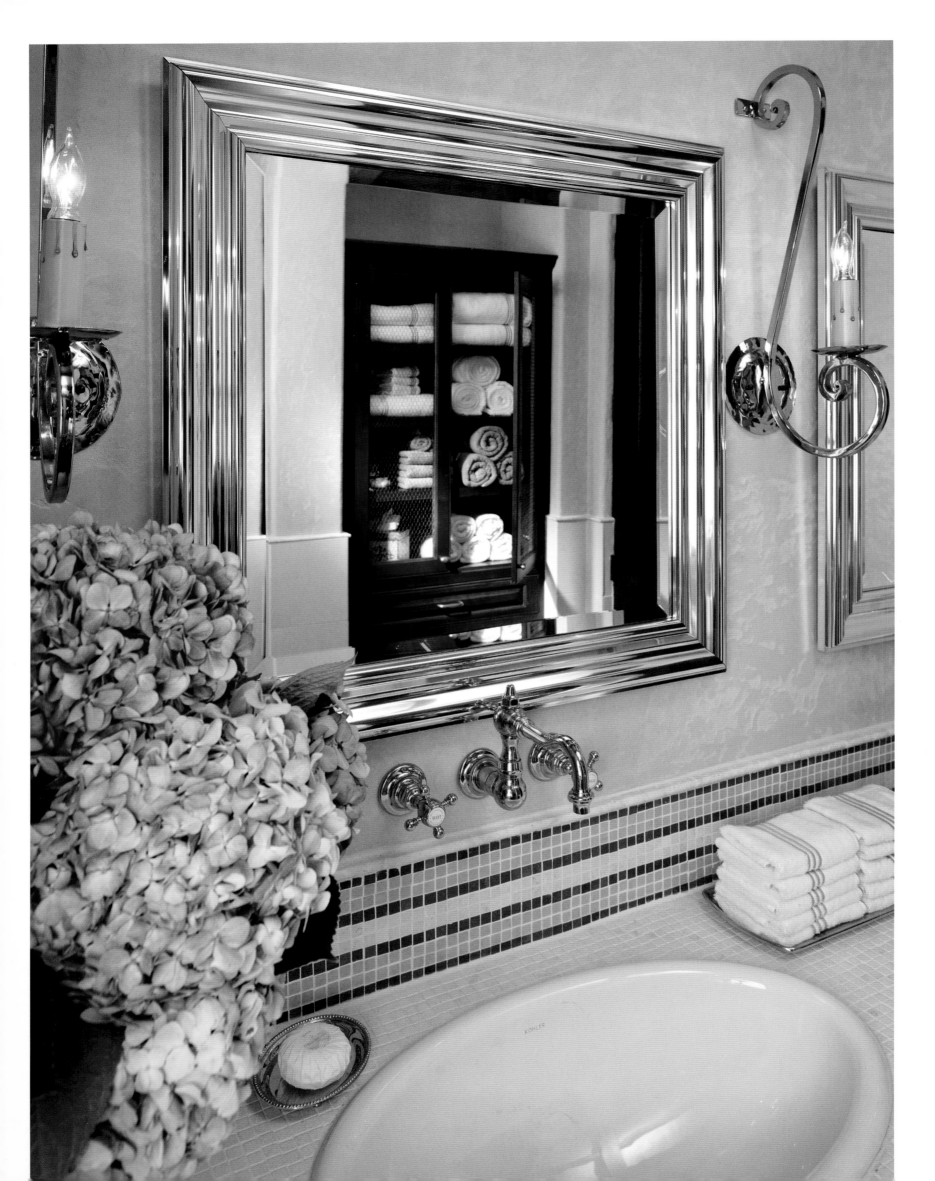

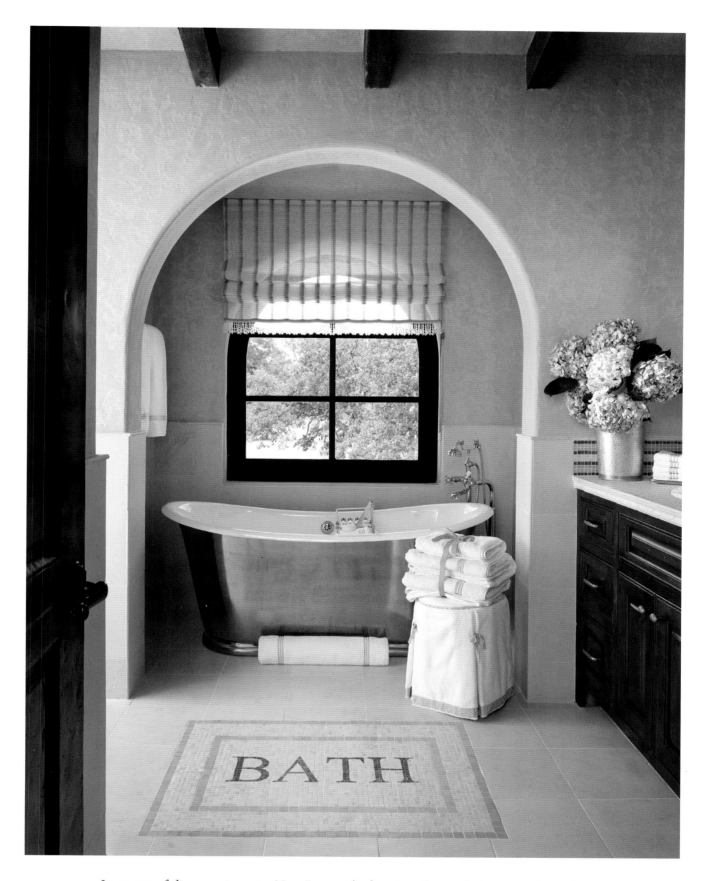

In an era of disappearing arts, New Ravenna's gleaming glass and stone mosaics make an ancient craft once viewed as elitist more accessible. At the same time, textures such as exposed beams, a nickel-plated tub from Waterworks and a terry cloth–covered vanity stool help shape a room as much as color. Unseen are travel-size bath products made with plants and herbs, a separate mosaic-tiled shower and, as in most bathrooms in Italy and France, an enclosed water closet with the toilet.

FACING: When a guest bath rivals a beguiling boutique hotel in Tuscany, hydrangeas and a palette inspired by the sand and sea help one start and end the day in serious luxury.

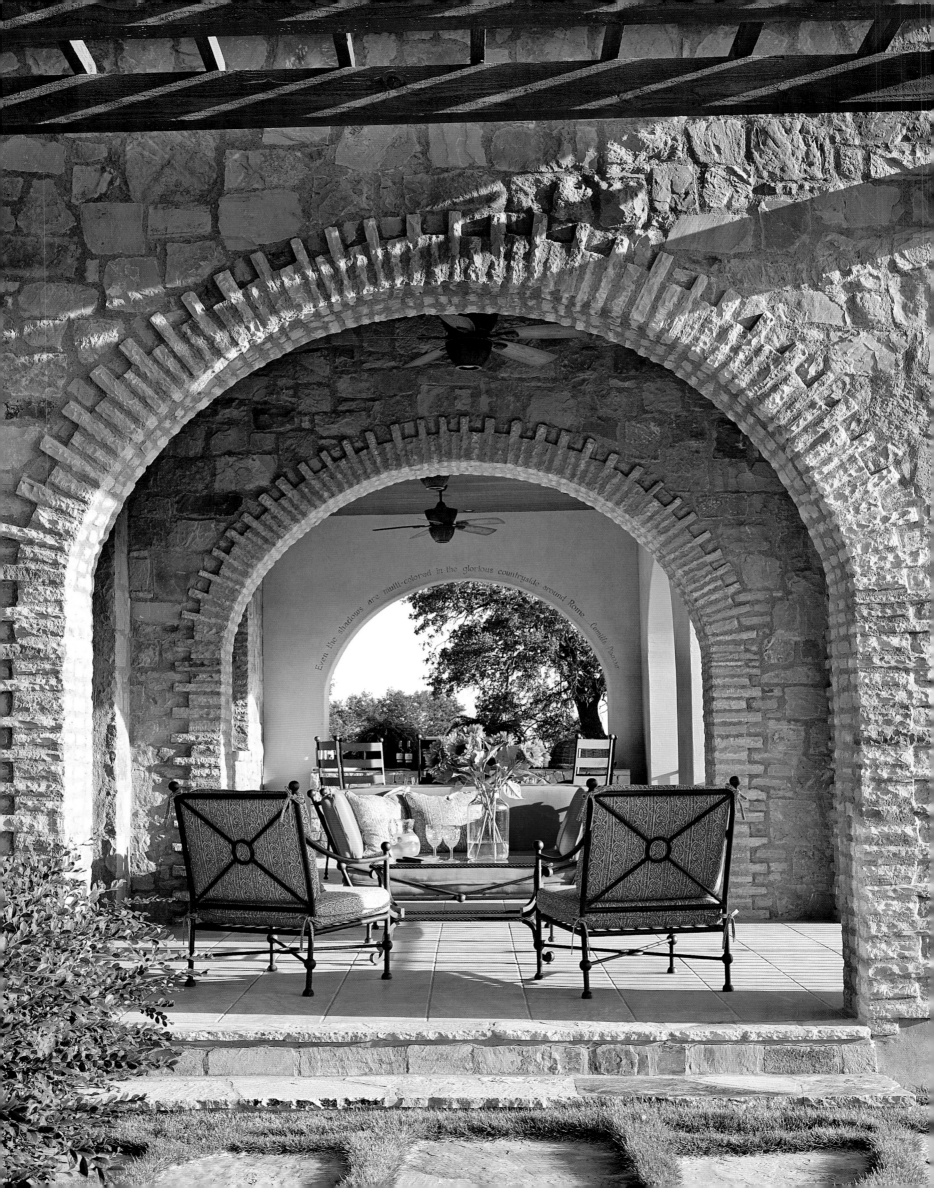

Bella VISTA

Sometime around the dawn of the new millennium, stateside interest in blurring the line between indoors and outdoors began escalating. Accordingly, Americans began moving the outside in—in its entire splendor—with a growing number of nature-inspired fabrics and trellis wall coverings, in addition to botanical prints, potted plants and armfuls of fresh-cut flowers. As the notion of extending rooms beyond four interior walls gained momentum, this well-documented, now full-fledged phenomenon, ultimately included transporting the inside out. Creating lush exterior areas for living was not new, however.

Arched stone walls frame a loggia where uplifting, 100 percent solution-dyed fabrics—produced in the mountains of Italy for the Maria Flora Collection and guaranteed against color loss for eight years—send a message that an exterior room can look equally inviting season after season.

For hundreds of years, indoor-outdoor living has been in the DNA of the Italian people. Not only have they embraced the enviable beauty of their country, but their most inspiring dwellings reflect this abiding affinity as well. From sea to shining sea, there is an intimate relationship between one's house and its setting. To this day in Italy, residences humble and grand—built with native stone and sand—celebrate the earth's gifts, boasting clusters of windows and plate glass doors that open to covered loggias and walled gardens that highlight the splendor of the natural world regardless of the season. >186

Heavy wooden doors swing open to an inner courtyard, where there is warm hospitality to spare: a pool for balmy afternoons and a fireplace for cool evenings. Beyond that is plenty of room for entertaining, whether morning, noon or night.

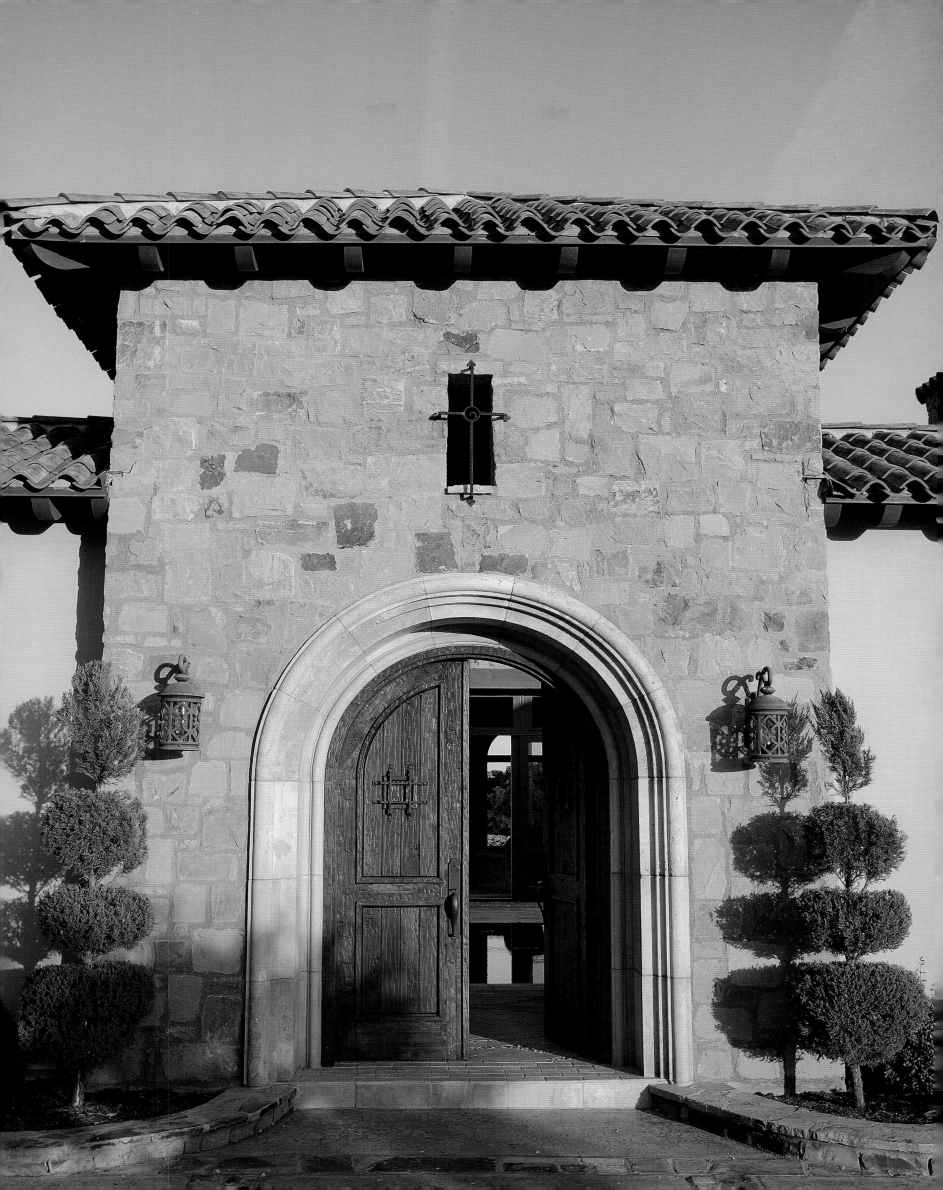

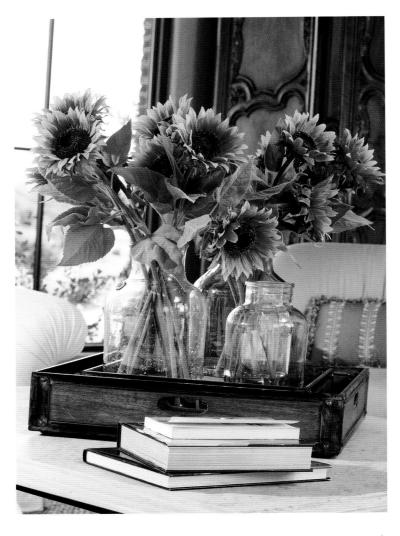

During 1888–89, the celebrated Dutch artist Vincent van Gogh lived northwest of Marseilles in the Provençal city of Arles, where he painted an astonishing number of cut sunflowers, many now in museums worldwide.

UPPER RIGHT: Swivel chairs (one unseen) have a coveted amenity: a down-filled pillow done up in an eye-catching Kravet fabric.

LOWER RIGHT: The humble lampshade looks noticeably smarter when contrasting fabric lines the inside and then peeks out to add an element of interest.

FACING: Fashionable and functional furnishings layered in harmonious blues and more daring persimmon offer an updated take on traditional Italian grandeur. In the family- and friend-friendly *salone*, texture plays a key role. The stone coffee table is by Murray's Iron Works. Knit backing keeps the Glant chenille on sofas from stretching, as well as both the Nancy Corzine linen on chairs and the Rogers & Goffigon stripe covering the bench.

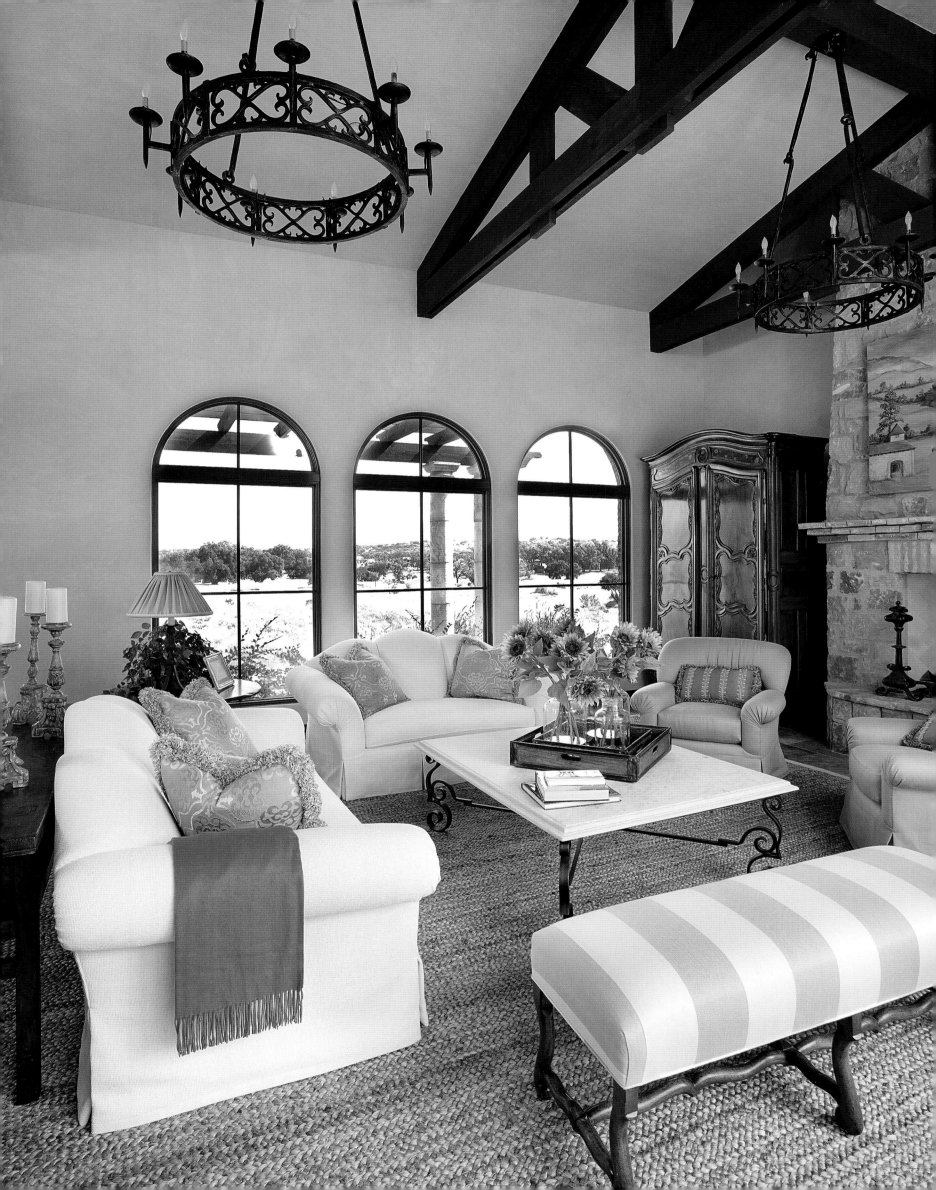

This overarching open-air aesthetic dates back centuries, to the earliest Roman architecture with its groundbreaking arches, majestic columns and intriguing angles. During ancient times, urban dwellers of means preferred homes with few windows on the front façade. Rather than look out at crowded streets, inevitably reverberating with noise, they chose instead to orient the fronts of their homes around inner courtyards and soaring atriums, which helped insure both a modicum of tranquility and a level of privacy. The backs of houses transitioned into gardens flanked by a network of columns. A few steps away sat the summer *triclinium,* or dining room, either an open-air space or one with west-facing windows designed to take advantage of the view as well as capture the last rays of the setting sun.

These days, the Roman legacy looms large in *palazzi* and *ville* from San Remo on the Ligurian Sea to Brindisi, the limestone-rich port city that hugs the azure waters of the Adriatic (where the ancient road Via Appia ended). In many cases, properties cling to rocky cliffs that descend toward the sea. But whether coastal or pastoral, doors open to loggias, terraces and balconies, some, of course, more intimate than others and many with sweeping views. >196

Many impeccably crafted, towering, eighteenth-century armoires did not survive the French Revolution, as aristocrats forced to downsize often left even those exuding old-world grandeur sitting on the street. One that endured now stands up to heavy stone walls with its provenance, adding to its allure and value.

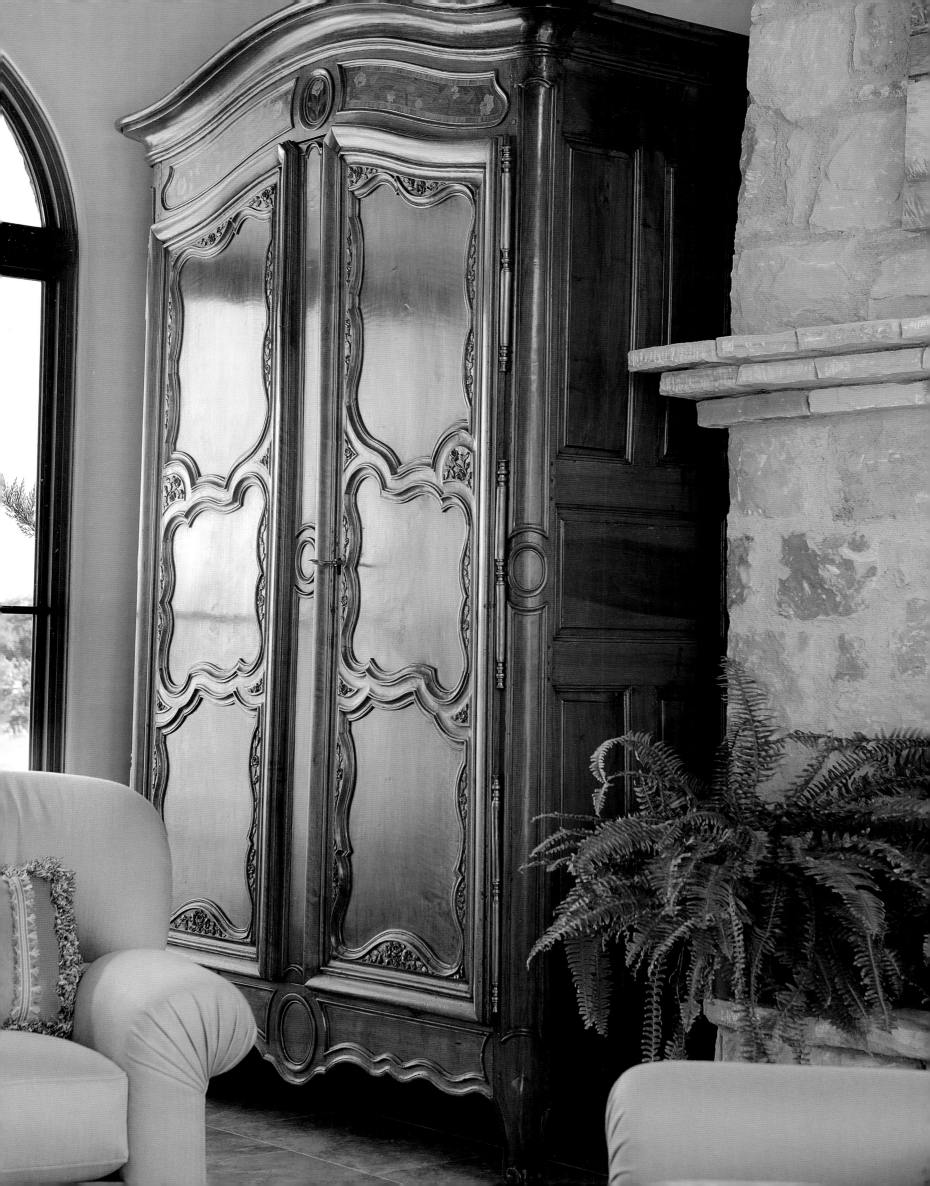

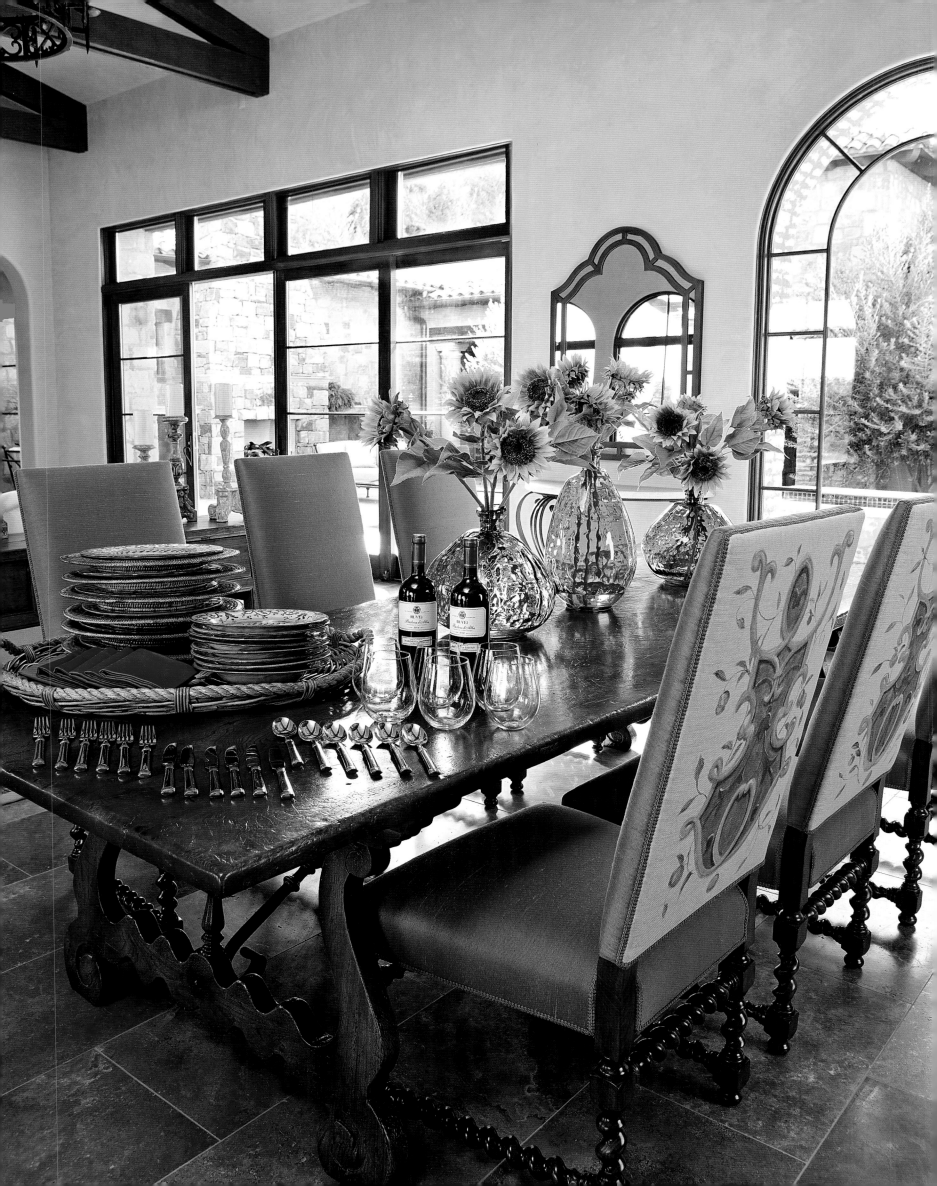

"Francesca Blu" Vietri pottery—hand painted in Umbria—honors the fifteenth-century Italian painter Piero della Francesca.

FACING: For guests who have an appetite for comfort food, what could be more welcomed and welcoming than a casual buffet with home-cooked Italian fare? Playing host is a nineteenth-century elm table from Country French Interiors, Dallas, unearthed in the Pyrénées region in southern France, bordering Spain.

With Italian restaurants continuing to proliferate across the nation, the United States is importing more wine from Italy than from any other country, so it is only fitting that we adopt a few of their wine-related practices. Never, ever overfill the glass—about one-third full is correct. When pouring, leave the glass on the table rather than picking it up, and do not tilt the glass as one would a beer glass if trying to avoid a frothy summit, as doing so is frowned upon.

RIGHT: In Chianti, a region best known for its fine wine and stone villas, olive groves proliferate. Extra virgin olive oil seems to be our present oil of choice, whether cooking indoors or grilling outside.

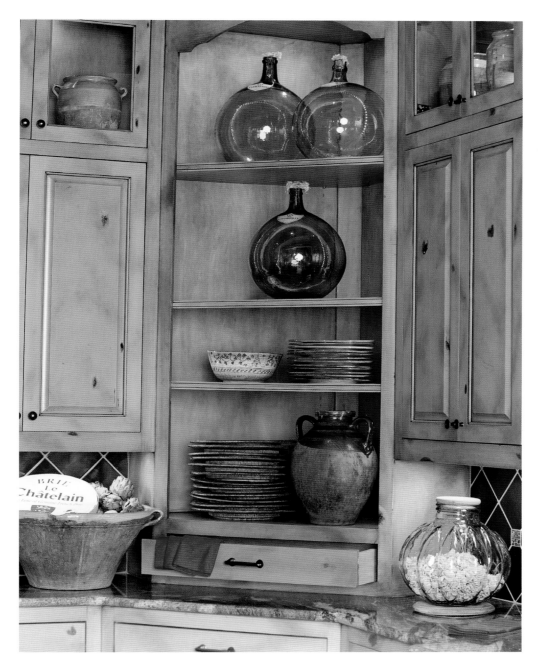

Vintage wine jugs, chargers and oversized plates add rural charm.

RIGHT: Most every room needs a touch of the unexpected, an element of playfulness that lifts one's mood. In Gilroy, California, the garlic capital of the world, one can find garlic braids, garlic ice cream, garlic most everything beloved by Mediterranean cooks.

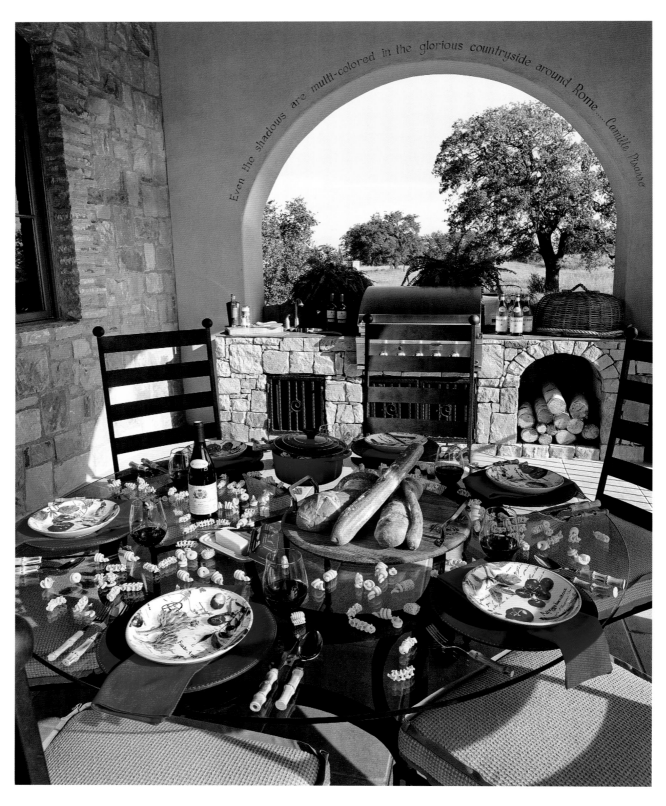

Much like Italy's undulating cities and towns, individual families have their own easy way of welcoming the steady flow of relatives and close friends central to their lives. It is only fitting, then, that a close-knit stateside family immersed in the Italian culture dines alfresco, whether entertaining a small group of friends or a crowd. Painting the loggia with further importance are the words of artist Camille Pissarro written over the grill: "Even the shadows are multicolored in the glorious countryside around Rome."

RIGHT: Pasta bowls and chargers are from Williams-Sonoma.

FACING: Script over the door leading to the courtyard and separate guest room says it well: "Good friends are always welcome."

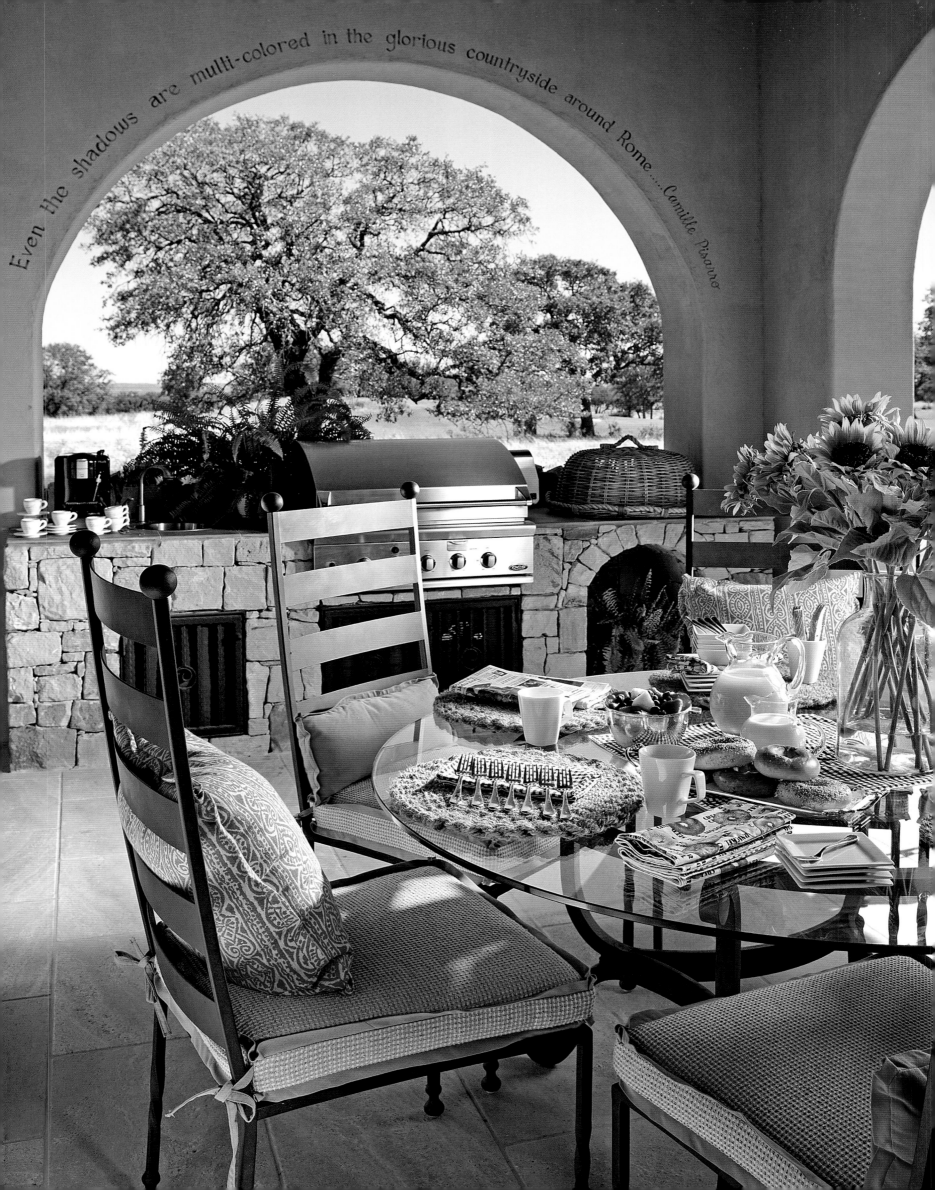

Even the shadows are multi-colored in the glorious countryside around Rome.....Camille Pisarro

With hundreds of brands advertised for their trendy appeal as well as their professed health benefits, bottled water is a booming global industry. And Italians can lay claim to being the world's leading consumers, drinking more than 40 gallons per person annually, according to Zenith International, a market research firm. In contrast, the Beverage Marketing Corporation reports that per capita consumption of bottled water in the United States is 29 gallons.

Whether hosting a sit-down dinner or a less fussy affair, *bruschetta* is an appealing appetizer. This bite-size staple of Italian fare takes mere minutes to prepare. Simply lace fresh tomatoes with garlic, basil and olive oil then serve on crisp, thick, toasted bread.

FACING: On summer weekends, this loggia becomes a destination spot where morning people meet for espresso, fruit and a toasted bagel—topped exactly the way one pleases—and those with a passion for sleeping in may later enjoy brunch. Italy's sun-bleached, solution-dyed acrylics from the Maria Flora Collection adorn furniture by Murray's Iron Works.

Apartment dwellers grow flowers, vegetables and herbs in pots on balconies. In lush pergolas, flowering vines climb iron arches or wooden trellises as clinging bougainvillea spills over walls, screening the space from passersby. Meanwhile, sweet-smelling oleander, roses and camellias bond with magnolia and cypress trees outlining park-like settings that offer a place to linger, if not rest, read or dine.

In historical Bologna, it is common for residents to enjoy the outdoors regardless of the weather, thanks to elaborate *portici,* or covered pathways, fashioned from marble, granite or other natural stones. Potted citrus trees, figs, olives and almond trees garnish paths and patios, while covered walkways double as hanging gardens that brim with fragrant flowers and herbs nestle in handsome terra-cotta pots.

Nineteenth-century fascination with nature led artists and craftsmen to incorporate garden motifs into all manner of paintings, pediments and furnishings, including ceramic tile and pottery. Floral embellishments adorned *divani letto* (daybeds), *decorazioni a muro* (wall-mounted decorations) and *cassapanca dipinte* (painted chests), either painted or carved. Opulent frescos or monumental tapestries frequently depicted riotous, Eden-like scenes, thereby proving a perfect foil for the monastic simplicity and sparseness that characterized Italian rooms from as far back as the reign of the Caesars.

A light-filled bay defines an intimate spot ideal for reading or doing a crossword puzzle.

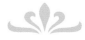

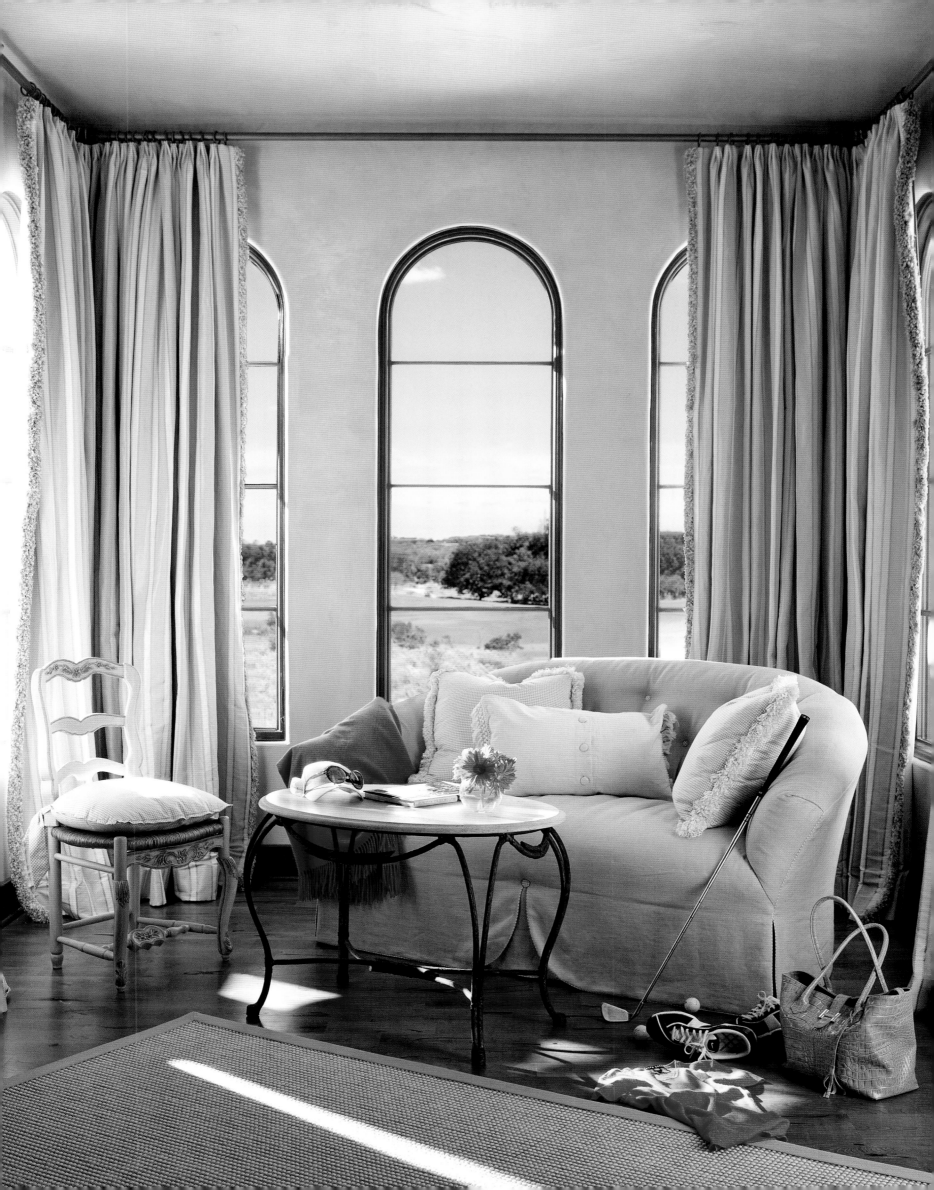

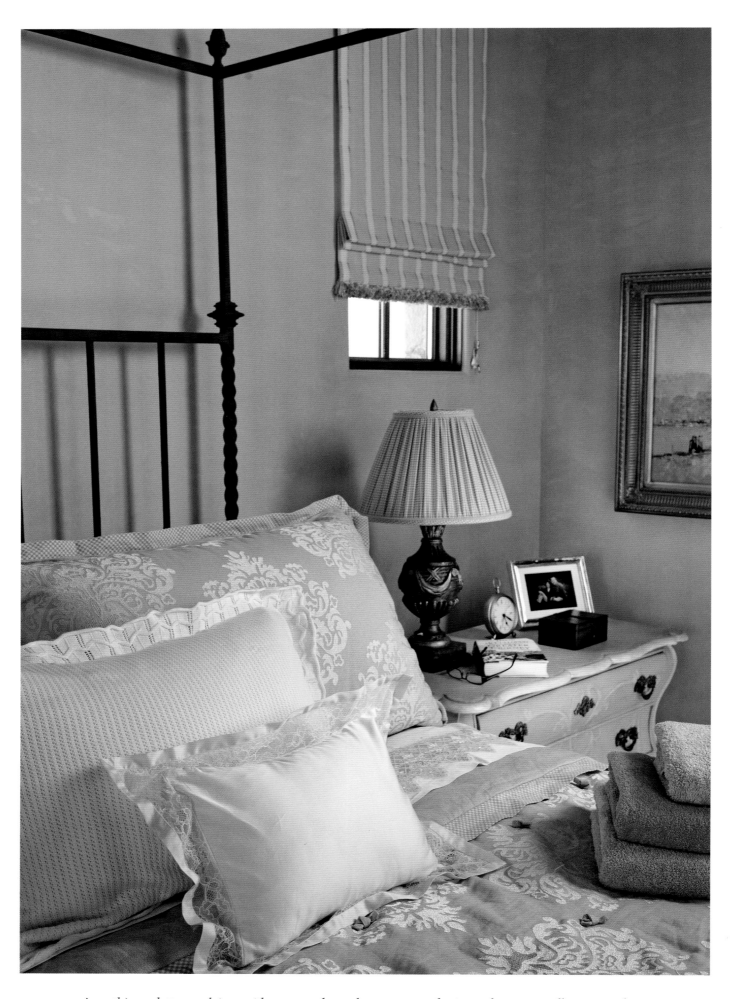

A soothing palette awash in seaside tones and a cool room are conducive to sleep, not at all counting sheep. Bed linens from Frette, Italian purveyors of high-thread-count sheets to popes, princesses and princes, transition from summer to fall with ease, while Yves Delorme towels add a splash of color year-round.

German novelist Heinrich Mann (1871–1950) proclaimed, "A house without books is like a room without windows." Tucked inside this prized, dove-gray-glazed, eighteenth-century *bibliothèque* are hardbacks, paperbacks, stationery and more.

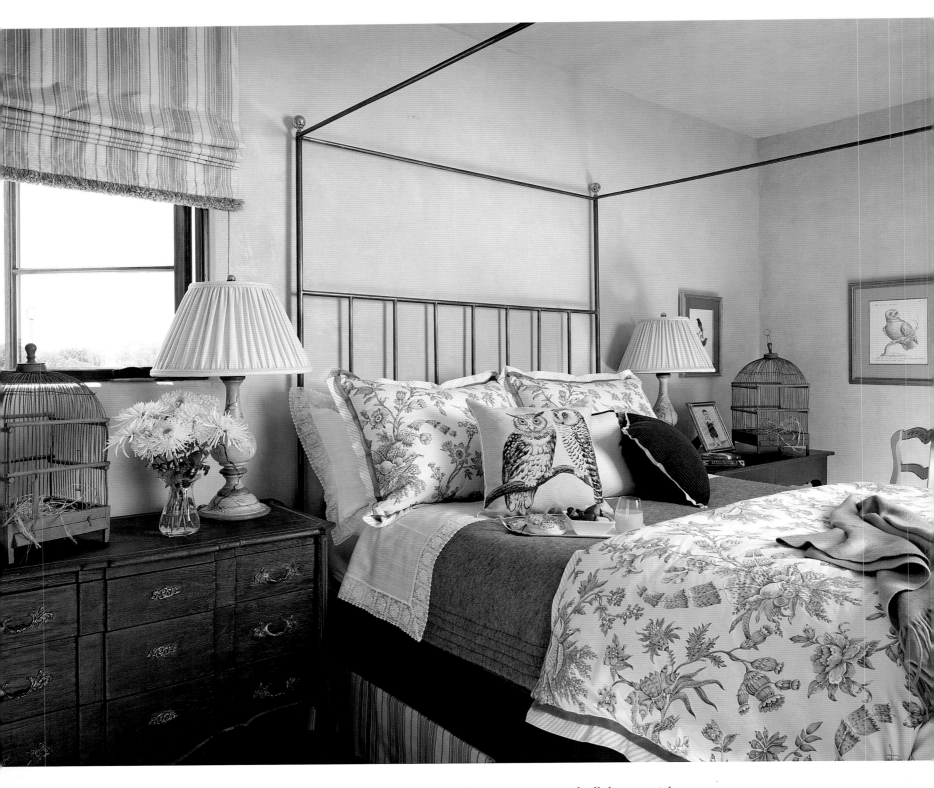

A pair of owls nest on a pillow from Yves Delorme in a room with all the essentials: a guest-worthy mattress, bedside lamps for reading, a desk to place one's laptop, plus a chair, a night table, and naturally, freshly laundered and pressed bed linens. And there's more: a spot to set one's suitcase, a goose down comforter, plus an extra blanket for chilly nights or just in case one opts for sleeping with the windows open. An alarm clock? In or out of sight. A spa-like bathrobe? Yes. A few good books? Definitely. And fresh flowers, of course.

FACING: Tucked into a corner is a blend of comfort and style that tips toward luxury, thanks to good light for reading, a throw to stay warm and fabrics from Brunschwig & Fils (on the canary yellow chair piped in black, in addition to the bed). Together, Sanders Studio and Robert Turner & Associates transformed a *bonnetière* that had lost its looks—the former giving the piece antique luster, the latter upholstering its interior. Carleton V silk plaid curtains, lined and interlined, insure that guests do not wake up with the birds.

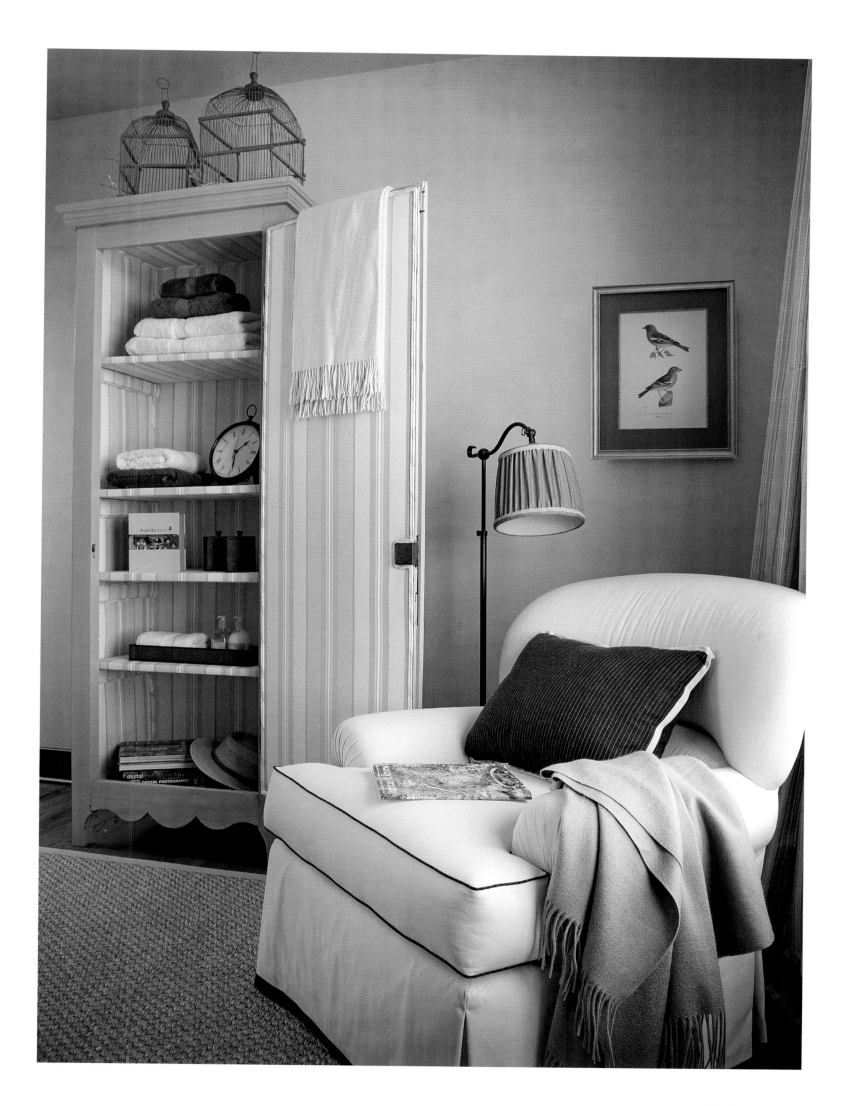

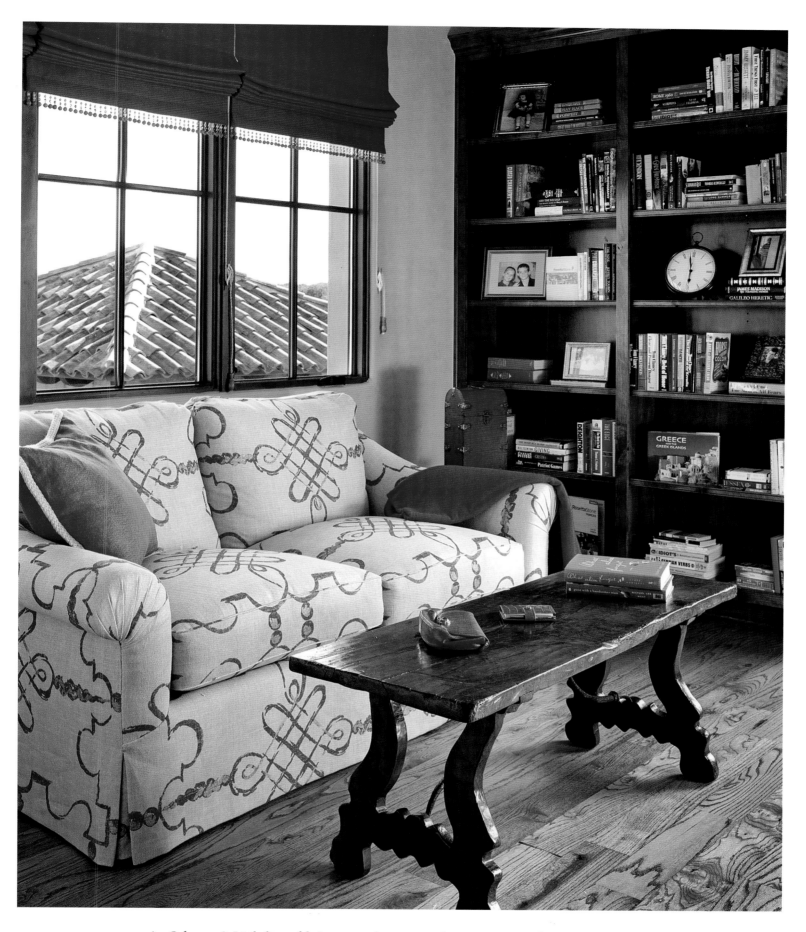

An Osborne & Little linen fabric pops red into neutral territory—a reading room that offers houseguests a quiet refuge of their own.

FACING: Making a Tuscan house even grander is faded tile that looks as if a century old, in addition to enviable views from second-floor windows. Rounded terra-cotta tiles facilitate the drainage of rainwater.

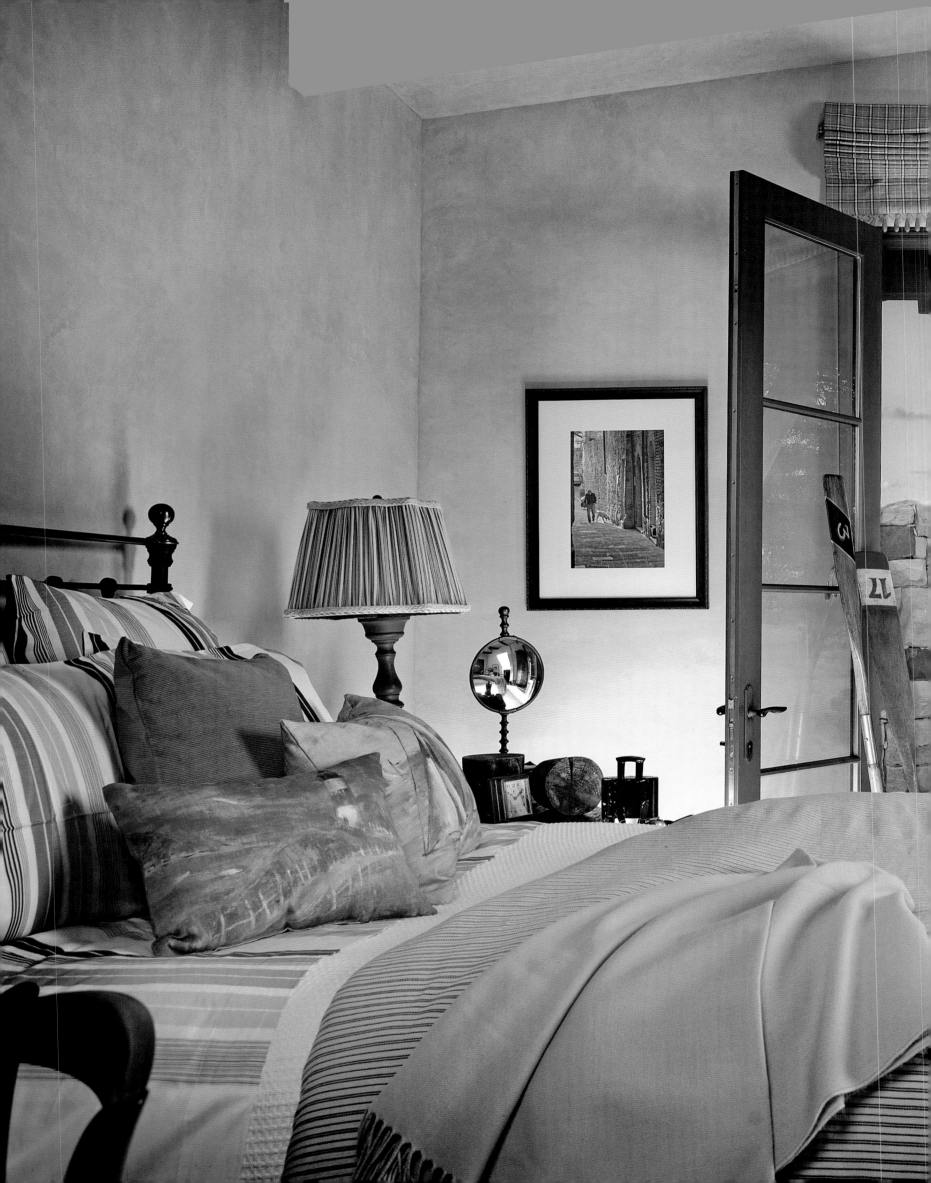

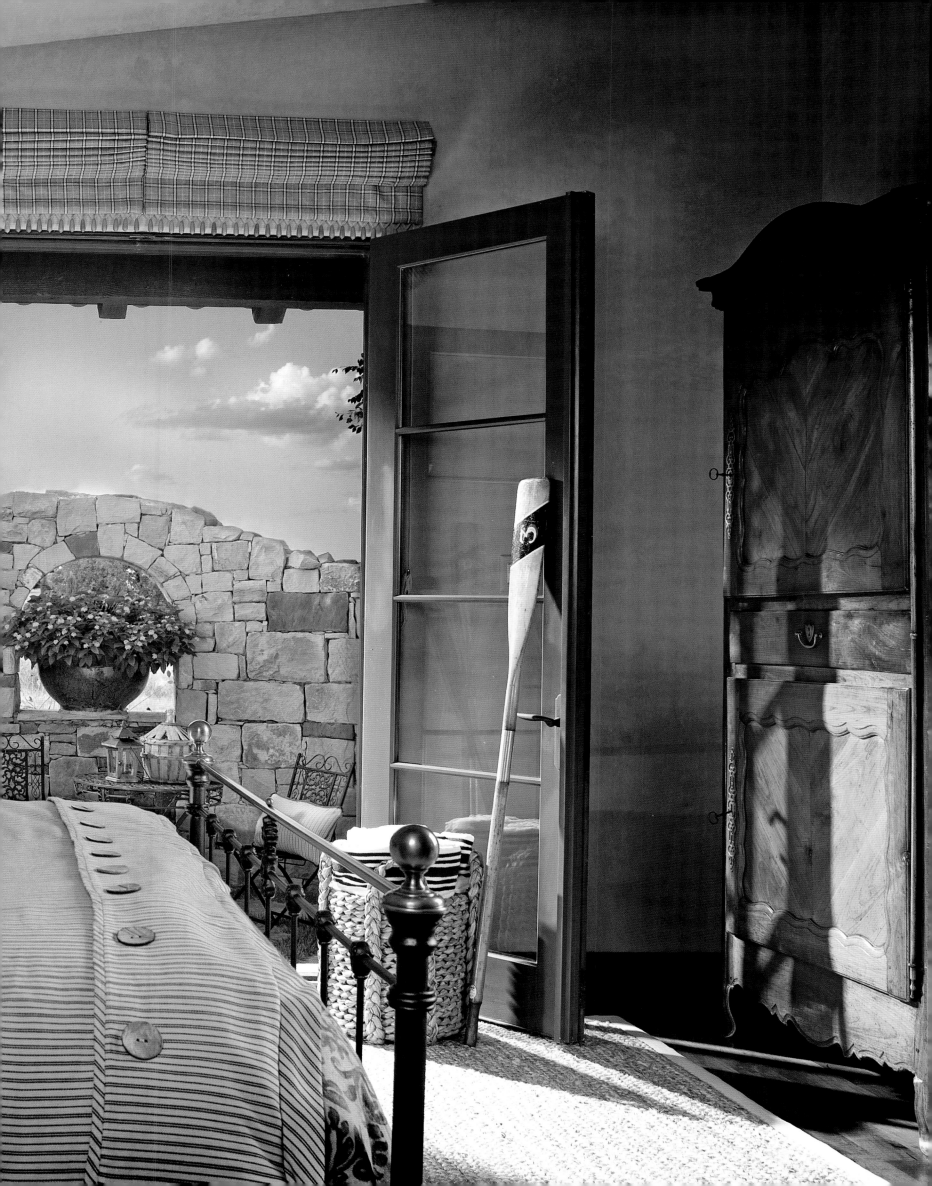

Whether the night is stormy or clear, a mere glance into a seaside-inspired retreat—just steps from the main house—has weary visitors grateful for an invitation to spend the night.

RIGHT: A brass lantern from Ralph Lauren Home and weathered frames crafted from reclaimed wood nod to Tuscany's seaside resorts. Desk is nineteenth century. Although we are talking Italy here, do you know why ships and aircraft use "mayday" as their call for help? Doing so resulted from a French mispronunciation: *mayday* comes from *m'aidez*, which translates as "help me." The pronunciation is approximately "mayday" and thus morphed into the word used today.

PRECEDING OVERLEAF: A guest room goes coastal, bedecked in layers of sea-worthy blues. "Col Monte" bed linens from Yves Delorme mix varying sizes of embroidered and woven stripes, taking bedding in an uncharted direction.

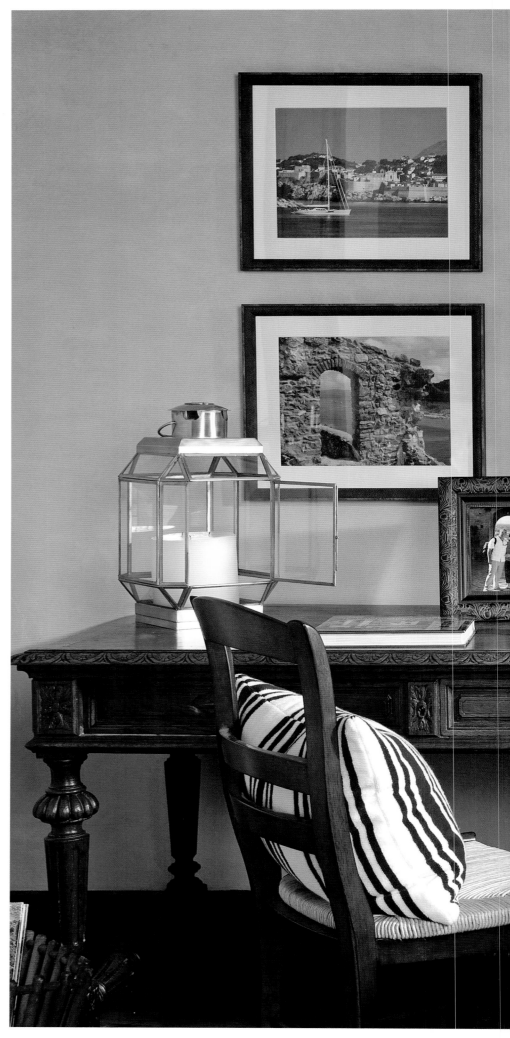

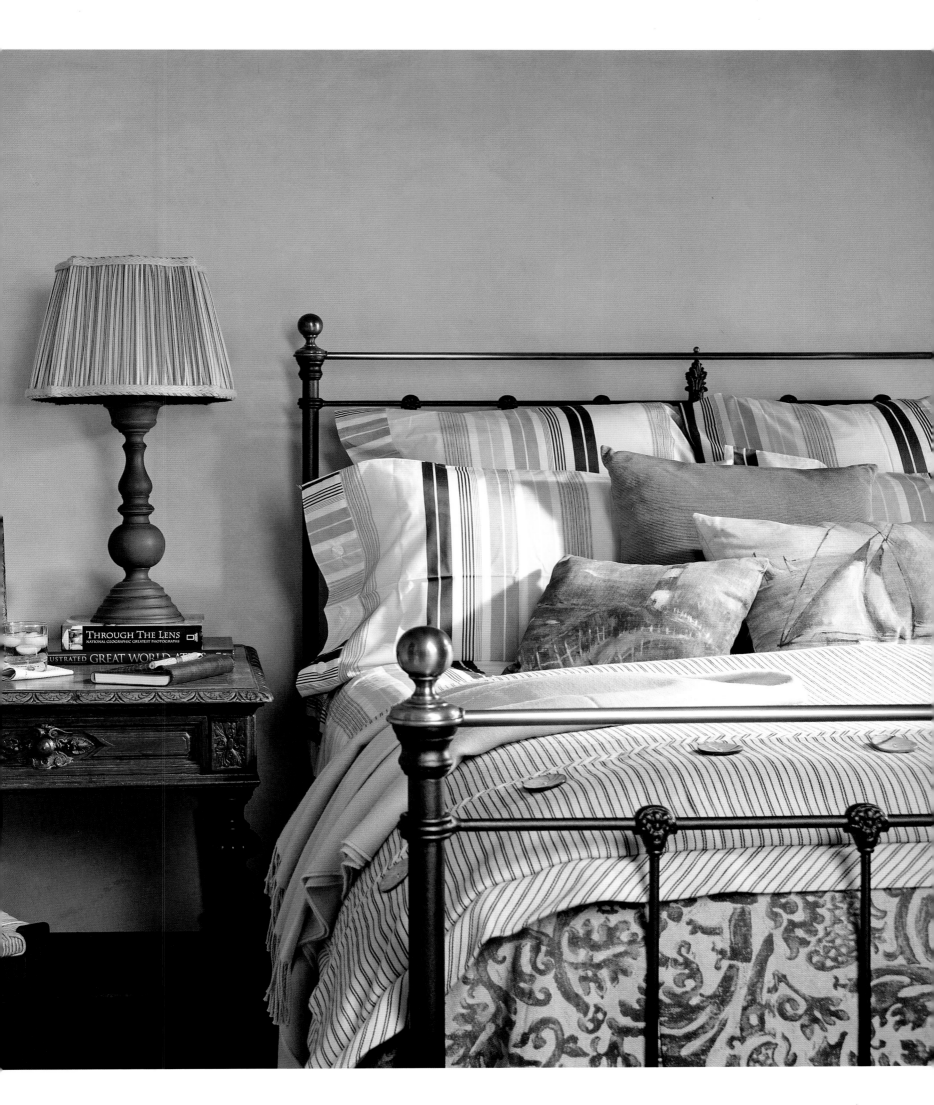

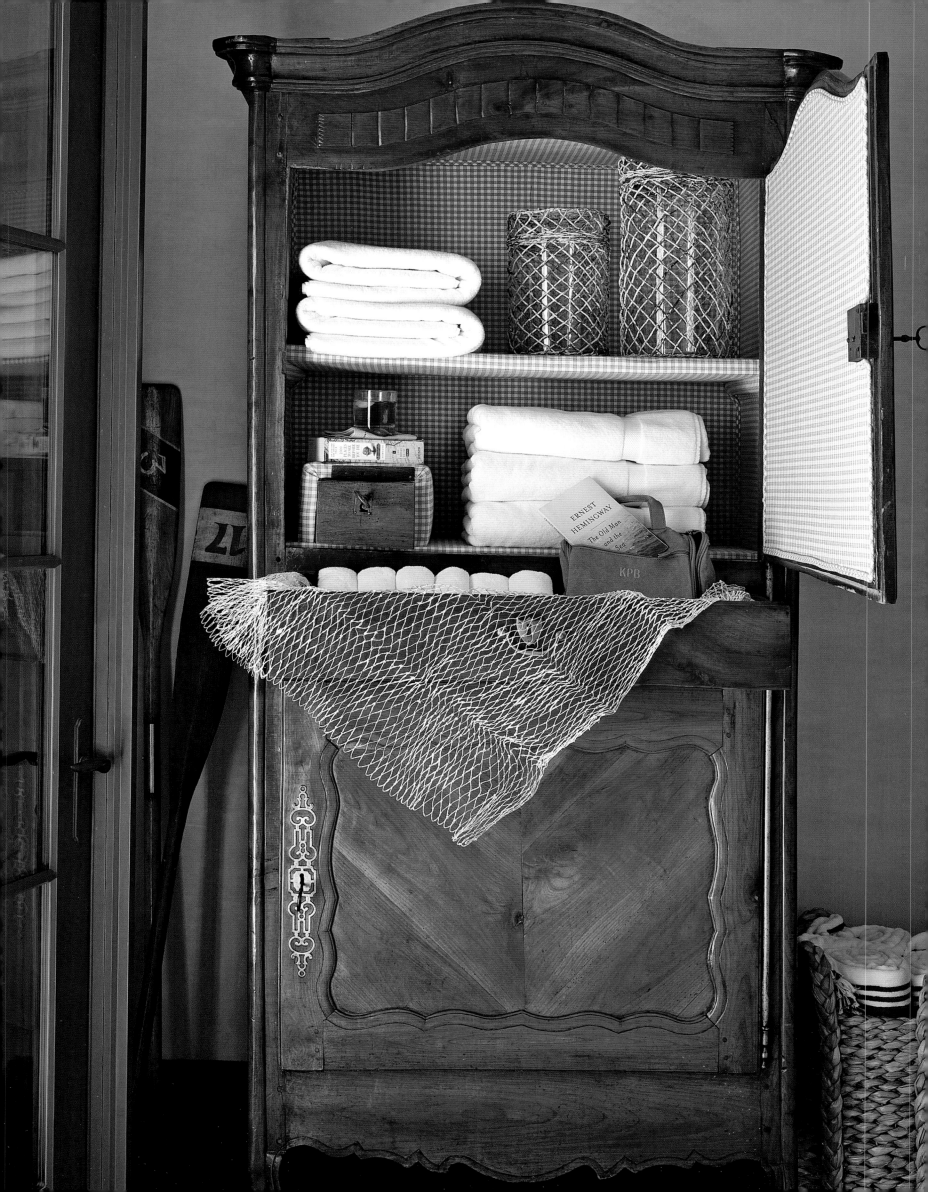

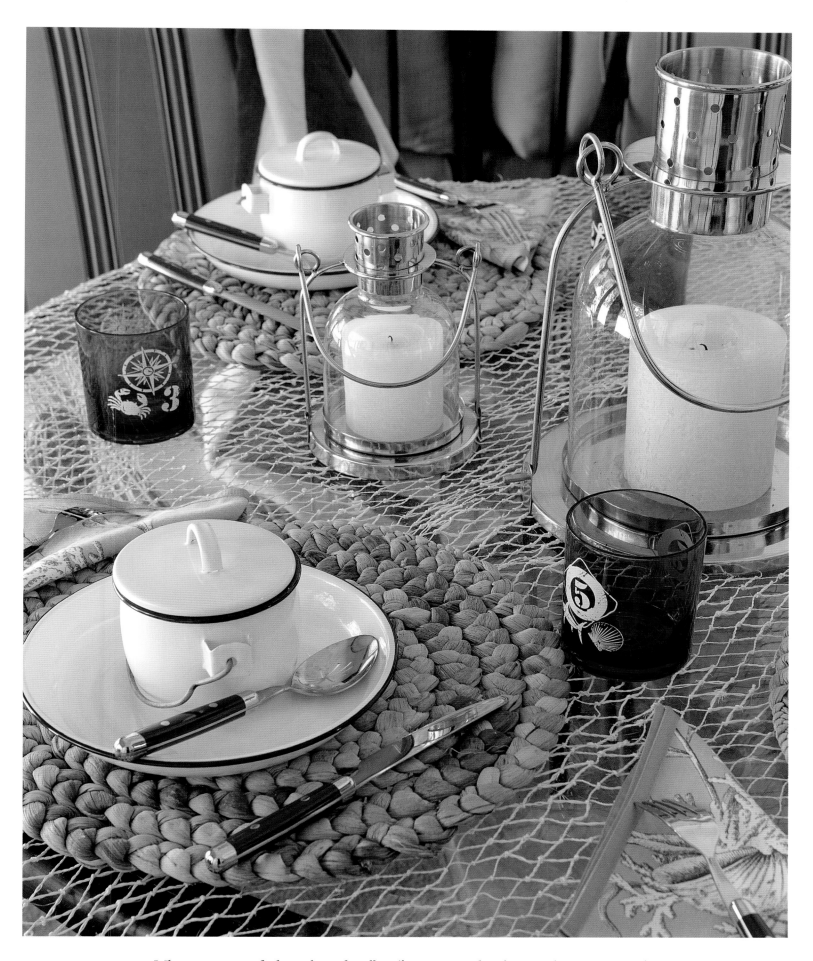

When it comes to finding a hip sidewalk *caffè* in a Tuscan beach town, there are sure to be ample options.

FACING: Anchoring these quarters is an eighteenth-century *bonnetière* from Country French Interiors that is set to harbor whatever a guest brings on board.

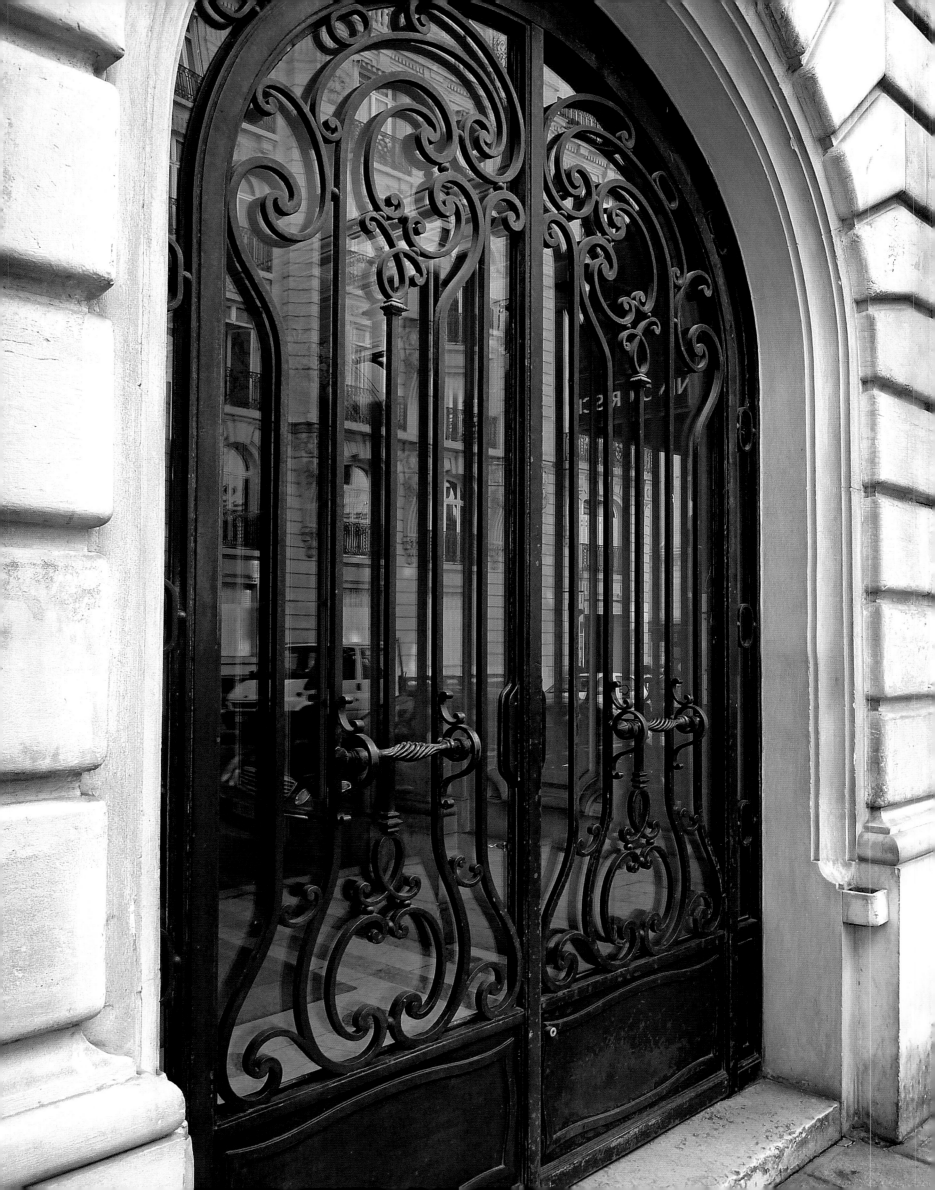

Artistic INFLUENCES

Igniting passions that we tend to reserve for the fine arts are the archeological wonders of ancient Rome, Florence's fading frescoes and, of course, the dazzling decorative stonework around Venice. These also serve as potent parts of the panorama that defines Italy's celebrated craft industry. Indeed, the peninsula's exceptional textiles, lace, marbled paper, Murano and millefiori glass, mirrors and ceramics have besotted Western Europeans since the early Middle Ages.

Hand-forged gates on Paris's Avenue Montaigne seldom fail to capture the attention of passersby.

Italy's culture of craft and commerce thrived with the rise of guilds—organized collectives that demanded loyalty oaths and absolute secrecy among member artisans. From the fourteenth century until the late-eighteenth century, these professional fraternities adhered to a master/apprentice system, which emphasized quality control. Any flawed object was destroyed; the offending craftsman might find himself subject to a variety of penalties, imprisonment and corporal punishment included.

At its best, guild life fostered an atmosphere of innovation, giving rise to certain practices that remain in use today. Lacework throughout the seventeenth century incorporated delicate floral motifs against fine mesh backgrounds. At approximately the same time, artisans in Florence worked to hone recipes for pigments and glue in order to create *erbu,* or marbled paper. On the island of Murano, all manner of glass—from clear *cristallo* to opaque and colorful—was transformed into lamps, chandeliers and goblets.

IRONWORK

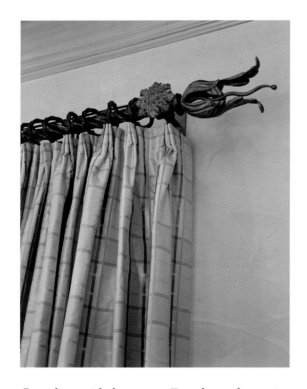

Compliant with the current French trend, curtains fall from an iron rod. Rod, rings, bracket and finials are by Iron Age Studios.

Though the Romans were not terribly interested in ornamental ironwork beyond the occasional cast urn or figurative sculpture, a thousand years later Venice would earn a reputation as the European epicenter for fine grillwork. Inspired by the array of imports flowing into their port city from the Indian subcontinent, medieval Venetian artisans forged dazzling hand-wrought iron gates, doors, balconies, staircase railings, screens, window arches and cornices as well as decorative objects ranging from candelabra and lanterns to gondola prows (whimsically dubbed *delfini,* or dolphins).

French inspiration from the capital's palace hotels comes to a Southern California home. Larry E. Boerder Architects designed and Iron Age Studios hand-forged the lantern pictured here.

Guilds in Siena, Florence, Verona, Lucca and Rome would soon prove equally adept with fire, anvil and iron, fashioning ornate Gothic patterns that would influence designs in France, England and Germany for hundreds of years.

Whereas Indian craftsmen often incorporated inlaid marble and other stones into their ironwork, Italians preferred embellishing their creations with precious metals. In their massive workshops, artisans typically inlaid thin sheets of gold leaf in grills and gates—a technique known as *damascening* that produced intricate patterns. As a more refined baroque look came into vogue at the end of the seventeenth century, smiths throughout Italy employed engravers to add yet another layer of texture to their works. Their artistry often adorned churches, such as the world-renowned St. Mark's Cathedral in Venice, as well as palatial private homes.

During the industry's aesthetic peak from the fourteenth to sixteenth centuries, omnipresent motifs included quatrefoils, leaves, rosettes and swirls.

In France, forged numerals—with dowels on the backside to mortise into stone or stucco walls—sprawl on façades, if not sapphire blue-and-white address plaques.

Though the forges of Renaissance Italy produced few innovations, particularly when compared with regional achievements in art, architecture and science, the seventeenth century gave birth to cold-chiseled ironwork with sculptural details in addition to highly polished pieces. With the rise of a rococo look a hundred years later, Italian artisans took to borrowing designs from their French, German and Spanish counterparts rather than the other way around.

The quality and creativity of Italian ironwork took another leap forward from the late-nineteenth century through the Great Depression, when Art Nouveau designs predominated. Still, the French retained their reputation as masters of the craft. Though countless decorative art examples were destroyed during World War II, the inherent strength and resilience of the ironwork secured the survival of many exceptional pieces. Today, sublime old Italian ironwork can be found in antique shops, flea markets and auction lineups around the globe. Showcasing the beauty of French ironwork is the gilded gate at the entrance of Versailles, an exact replica of the original royal gate—built by Jules Hardouin-Mansart in the 1680s—torn down during the French Revolution.

A bridge leading to a serene courtyard emits a warm welcome while setting the stage for gracious living inside the villa.

Colored marble splinters make up praiseworthy mosaics in the gardens of Villa d'Este, often called the most beautiful hotel in the world.

MOSAICS

During the Roman Empire, mosaics embellished paths, walkways and thresholds of affluent residences, including the private residence of Julius Caesar, as if laying the groundwork for an association with wealth and power. Evolving from simple geometric motifs and borders to expansive wall murals rich in detail, the art form became inextricably linked to Italy by the first century A.D. Mosaics consist of *tesserae*—hundreds, and at times thousands, of tiny pieces of multicolored materials such as marble, *smalti* (glittering enameled glass), precious stones and jewels, mother-of-pearl, pebbles and pottery shards—inlaid in intricate patterns that attain richness by the arrangement of various hues. Grout or mortar—a mixture of sand, water, cement and crushed terra-cotta—fills gaps, holding the most miniscule pieces securely in place.

Mosaics on the historic grounds of Villa d'Este, Italy's most storied retreat, are among the country's most photographed landmarks.

For modern interpretation of an ancient art—a mosaic bath mat. The mix of glass and stone tiles are from New Ravenna Mosaics, Exmore, Virginia.

Often employing colored glass tiles manufactured in northern Italy, mosaics became renowned for their luminous beauty, soon rivaling both the artistry and importance of the finest frescos and tapestries.

With the rise of Christendom in the fourth century, churches along the Mediterranean commissioned monumental projects, frequently boasting Byzantine domes, soaring columns and elaborate interior arches. As civilization progressed, techniques kept pace with expectations of grandeur, with the art form taking on new characteristics in the fifth century, thanks in part to Eastern influences. To enhance refraction, exacting mosaicists experimented with applying gold-leaf *tesserae* at angles, zealously guarding their formulas for cement as they would a family fortune.

The craft, plied most extensively in Florence, Pisa, Sicily and Ravenna (known as "Mosaic City"), had reached its apex by the Renaissance. Yet, as if to keep the world in awe, distinctive, compelling examples of workmanship continued being fashioned centuries later—in far from ordinary buildings, palaces and cathedrals, such as St. Mark's Basilica in Venice. At the now legendary Piazza San Marco—or "the world's most beautiful drawing room," as Napoléon famously proclaimed—intense artisans toiled from the eleventh until the mid-nineteenth century on some 8,000 square meters of panoramic mosaics, a breathtaking triumph that reportedly dazzles millions of tourists each year. (This is not to imply that Venetians hold Napoléon in high esteem; to the contrary. They have not forgiven him for conquering their land in 1797, then carting off some of the city's greatest artworks, including four bronze horses from the façade of St. Mark's. Though France returned the horses in 1815, loathing for Napoléon lingers. Those horses now on the façade of the cathedral are bronze replicas. The originals reside inside the basilica.)

Every day quintals of colored enamels and gold leaf mosaics leave Orsoni, destined for works of art, private spaces and public settings worldwide. Behind centuries-old high walls on via Cannaregio, Sottoportego dei Vedei, Venetians tend great vats of molten glass, producing large sheets of *tesserae* in 2,700 shades. There, techniques have changed little since the Middle Ages.

While much has changed in the past centuries, the aesthetic power of the Italian and French people continues today, garnering our attention and international praise. It follows, then, that we justly admire the accoutrements that set their worlds apart—dramatic architecture, celebrated cultures, well-tended gardens and strong classic interiors— and daringly, perhaps, fuse the influences for which they are known, artfully sculpting unique visions of twenty-first-century uptown living with, at best, breathtaking creativity and astonishing harmony and warmth.

"Open my heart and you will see, engraved inside of it 'Italy,' " wrote the British poet Robert Browning (1812–89). Upon marrying the poet Elizabeth Barrett (1806–61) in 1846, against her father's wishes, the two fled to Italy, where they lived until her death.

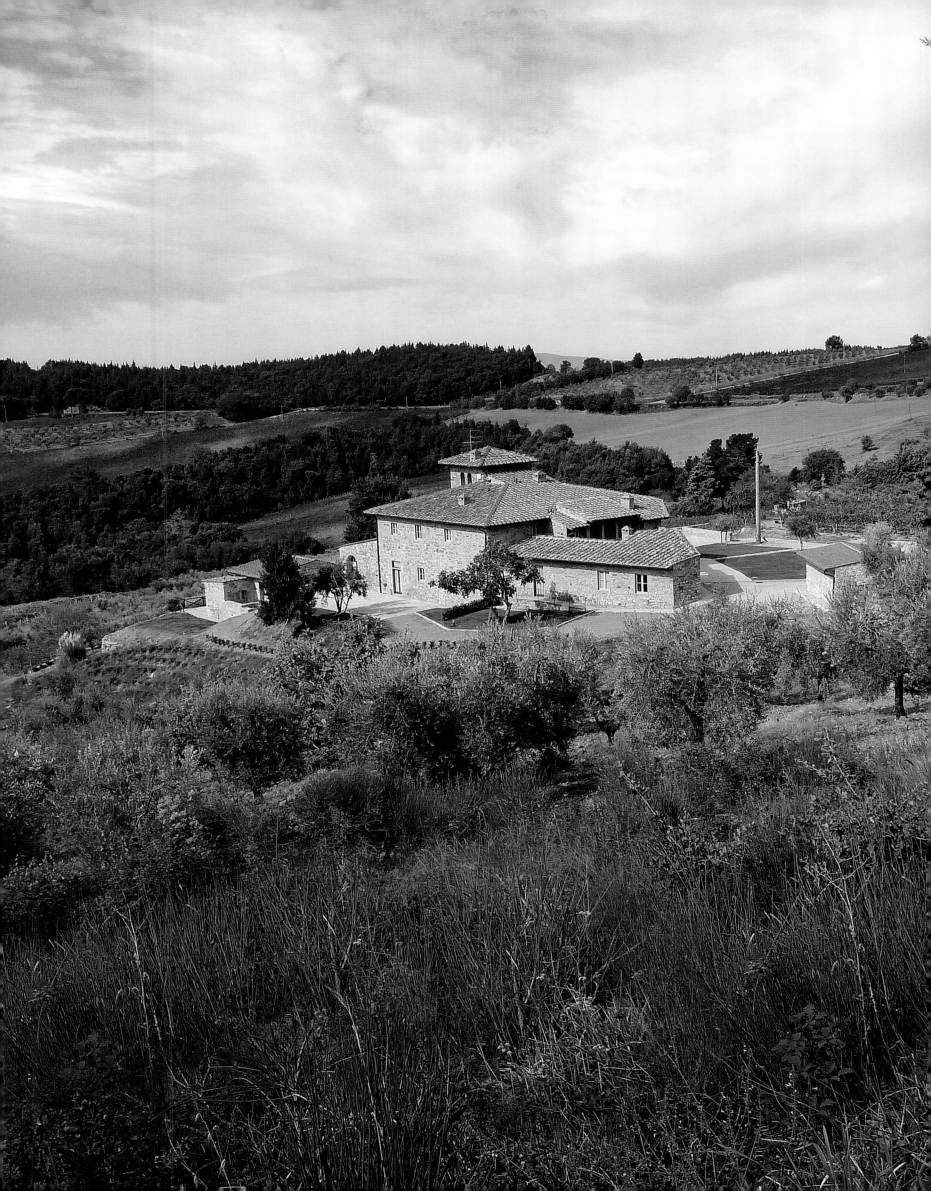

Resources

ANTIQUE FURNISHINGS & ACCESSORIES

Agostino Antiques, Ltd.
21 Broad St.
Red Bank, NJ 07701
Telephone 732.345.7301
agostinoantiques.com

Ainsworth Noah
351 Peachtree Hills Ave., #518
Atlanta, GA 30305
Telephone 800.669.3512
ainsworth-noah.com

Ambiance Antiques
550 15th St., #1
San Francisco, CA 94103
Telephone 415.626.0145
ambianceantiques.com

Anthony Antiques & Fine Arts
401 E. 200 South
Salt Lake City, UT 84111
Telephone 801.328.2231
anthonysfineart.com

Bremermann Designs
3943 Magazine St.
New Orleans, LA 70115
Telephone 504.891.7763
bremermanndesigns.com

Carl Moore Antiques
1610 Bissonnet St.
Houston, TX 77005
Telephone 713.524.2502
carlmooreantiques.com

Ceylon et Cie
1319 Dragon St.
Dallas, TX 75207
Telephone 214.742.7632
ceylonetcie.com

Château Domingue
3615-B W. Alabama St.
Houston, TX 77027
Telephone 713.961.3444
chateaudomingue.com

Country French Interiors
1428 Slocum St.
Dallas, TX 75207
Telephone 214.747.4700
countryfrenchinteriors.com

Dahlgren Duck & Associates
1617 Hi Line Dr., #260
Dallas, TX 75207
Telephone 972.478.5991
dahlgrenduck.com

Décor de France
24 N. Blvd. of the Presidents
Sarasota, FL 34236
Telephone 941.388.1599
decordefrance.com

DHS Designs, Inc.
6521 Friel Rd.
Queenstown, MD 21658
Telephone 410.827.8167
dhsdesigns.com

Donald J. Embree Antiques
1115 Slocum St.
Dallas, TX 75207
Telephone 214.760.9141
donaldembreeantiques.com

Duane Antiques
176 Duane St.
New York, NY 10013
Telephone 212.625.8066
duaneantiques.com

Erin Martin Showroom
1350 Main St.
St. Helena, CA 94574
Telephone 707.967.8787
martinshowroom.com

The Gables
711 Miami Cr.
Atlanta, GA 30324
Telephone 800.753.3342
thegablesantiques.com

Gore Dean
88 Village Sq.
Baltimore, MD 21210
Telephone 410.464.1789
goredean.com

The Gray Door
3465A W. Alabama St.
Houston, TX 77019
Telephone 713.521.9085
graydoorantiques.com

Inessa Stewart Antiques
5330 Bluebonnet Blvd.
Baton Rouge, LA 70809
Telephone 225.368.8600
inessa.com

Jacqueline Adams Antiques
425 Peachtree Hills Ave., #7
Atlanta, GA 30305
Telephone 404.869.6790
jacquelineadamsantiques.com

Jefferson West Inc.
9310 Jefferson Blvd.
Culver City, CA 90232
Telephone 310.558.3031
jeffersonwest.com

John Rosselli Antiques & Decorations
306 East 61st St., Ground Fl.
New York, NY 10065
Telephone 212.750.0060
johnrosselliantiques.com

1515 Wisconsin Ave. NW
Washington, DC 20007
Telephone 202.337.7676
johnrosselliantiques.com

Joseph Minton Antiques
1410 Slocum St.
Dallas, TX 75207
Telephone 214.744.3111
mintonantiques.com

Offering a glimpse of the distant past, a tray from Venice's elegant Danieli Hotel, on a bend of the Grand Canal, mixes with Hôtel Silver from forgotten bistros and bakeries. Top silversmiths of the day made pieces with a nickel base for grand hotels and restaurants.

Joyce Horn Antiques
1022 Wirt Rd., #326
Houston, TX 77055
Telephone 713.688.0507
joycehornantiques.com

Kay O' Toole Antiques
1921 Westheimer Rd.
Houston, TX 77098
Telephone 713.523.1921
kayotooleantiques.com

Kendall Wilkinson Home
3419 Sacramento St.
San Francisco, CA 94118
Telephone 415.409.2299
kendallwilkinson.com

Kuhl-Linscomb
2424 W. Alabama St.
Houston, TX 77098
Telephone 713.526.6000
kuhl-linscomb.com

Le Cadeaux
851 East 60th St.
Los Angeles, CA 90001
Telephone 323.233.8300
lecadeaux.com

Le Louvre French Antiques
1400 Slocum St.
Dallas, TX 75207
Telephone 214.742.2605
lelouvre-antiques.com

Legacy Antiques
1406 Slocum St.
Dallas, TX 75207
Telephone 214.748.4606
legacyantiques.com

Liz Spradling Antiques
2422 Bartlett St.
Houston, TX 77098
Telephone 713.526.1400
lizspradling.com

The Lotus Collection
445 Jackson St.
San Francisco, CA 94111
Telephone 415.398.8115
ktaylor-lotus.com

Lovers Lane Antique Market
5001 W. Lovers Ln.
Dallas, TX 75209
Telephone 214.351.5656
loverslaneantiques.com

M. Naeve Antiques
1926 Bissonnet St.
Houston, TX 77005
Telephone 713.524.0990
mnaeve.com

Maison Felice
73960 El Paseo
Palm Desert, CA 92260
Telephone 760.862.0021
maisonfelice.com

Marston Luce
1651 Wisconsin Ave., N.W.
Washington, DC 20007
Telephone 202.333.6800
marstonluce.com

The McNally Company Antiques
6033 L&M Paseo Delicias
Rancho Santa Fe, CA 92067
Telephone 858.756.1922
mcnallycompanyantiques.com

Mercato Italian Antiques & Artifacts
33071 W. 83rd St.
De Soto, KS 66018
Telephone 913.583.1511
mercatoantiques.com

Metropolitan Artifacts, Inc.
4783 Peachtree Rd.
Atlanta, GA 30341
Telephone 770.986.0007
metropolitanartifacts.com

The Mews
1708 Market Center Blvd.
Dallas, TX 75207
Telephone 214.748.9070
themews.net

Murielle Abeger
1645 Mayfield Rd.
Alpharetta, GA 30009
Telephone 404.784.3442

Neal & Co.
4502 Greenbriar St.
Houston, TX 77005
Telephone 713.942.9800

Newell Art Galleries, Inc.
425 E. 53rd St.
New York, NY 10022
Telephone 212.758.1970
newel.com

Nick Brock Antiques
2909 N. Henderson St.
Dallas, TX 75206
Telephone 214.828.0624
nickbrockantiquesonline.com

Parc Monceau, Ltd.
425 Peachtree Hills Ave., #15
Atlanta, GA 30305
Telephone 404.467.8107
parcmonceauatl.com

Parkhouse Antiques
114 Parkhouse St.
Dallas, TX 75207
Telephone 214.741.1199
parkhouseantiques.com

Petricia Thompson Antiques
3522 Magazine St.
New Orleans, LA 70115
Telephone 504.897.5477
petriciathompsonantiques.com

Pied-A-Terre
7645 Girard Ave.
La Jolla, CA 92037
Telephone 858.456.4433

Pittet & Co.
1215 Slocum St.
Dallas, TX 75207
Telephone 214.748.8999
pittet.com

Skelton St. John
2143 Westheimer Rd.
Houston, TX 77098
Telephone 713.524.1990

South of Market
345 Peachtree Hills Ave.
Atlanta, GA 30305
Telephone 404.995.9399
southofmarket.biz

In French, a male pig is *un verrat* (a boar), but mainly farmers use this noun. Most others simply say *un cochon (a pig)*. An *objets de charme* need not be old to work as an accessory.

Studio Veneto
7427 Girard Ave.
La Jolla, CA 92037
Telephone 858.551.2782
studioveneto.com

Tara Shaw Antiques
1240 Camp St.
New Orleans, LA 70130
Telephone 504.525.1131
tarashaw.com

Therien & Co.
716. N. La Cienega Blvd.
Los Angeles, CA 90069
Telephone 310.657.4615
therien.com

Tres Belle
2435 East Pacific Coast Hwy.
Corona Del Mar, CA 92625
Telephone 949.723.0022
tresbelleantiques.com

Uncommon Market, Inc.
100 Riveredge Dr.
Dallas, TX 75207
Telephone 214.871.2775
uncommonmarketinc.com

W. Gardner, Ltd.
2930 Ferndale St.
Houston, TX 77098
Telephone 713.521.1027
wgardnerltd.com

Watkins Culver
2308 Bissonnet St.
Houston, TX 77005
Telephone 713.529.0597
watkinsculver.com

ARTISANS

Allan Rodewald
Expressive Design Studios
1402 Dart St.
Houston, TX 77007
Telephone 713.501.6613
allanrodewald.com

Anthony Ruben Luxe Home
2025 Irving Blvd. Ste. 214
Dallas, TX 75207
Telephone 214.764.9805
anthonyruben.com

Authentic Joinery & Millwork, LLC.
1266 West Paces Ferry Rd. #563
Atlanta, GA 30327
Telephone 404.841.4818
ajm-llc.com

Brad Oldham, Inc.
2603 Farrington St.
Dallas, TX 75207
Telephone 214.239.3993
bradoldham.com

Daniel Heath
4624 Charles Place
Plano, TX 75093
Telephone 214.697.4489
heathwatercolors.com

David Lyles
514 Summit Dr.
Richardson, TX 75081
Telephone 972.841.0463
seedavidlyles.com

Gillian Bradshaw Smith
311 N. Winnetka Ave.
Dallas, TX 75208
Telephone 214.948.8472
gillianbradshaw-smith.net

Harold Leidner Company
1601 Surveyor Blvd.
Carrollton, TX 75006
Telephone 972.418.5244
haroldleidner.com

Helene Batoff Interiors Inc.
1118 Berwind Rd.
Wynnewood, PA 19096
Telephone 610.642.7533

Jennifer Chapman Designs
7049 Via Cabana
Carlsbad, CA 92009
Telephone 760.613.4613
jenniferchapmandesign.com

Jo Mattison
4100 San Carlos St.
Dallas, TX 75205
Telephone 214.354.3527
jomattisonart.com

Johnathan Andrew Sage, Inc.
3900 Polk St.
Houston, TX 77023
Telephone 713.227.7300
johnathanandrewsageinc.com

Lacy's Inc.
7320 Ashcroft Dr., #301
Houston, TX 77081
Telephone 713.773.2444

Patrick Edwards
3815 Utah St.
San Diego, CA 92104
Telephone 619.298.0864
wpatrickedwards.com

Paul J. Labadie
1315 Conant St.
Dallas, TX 75207
Telephone 214.905.9455
Paullabadie.com

Robert Turner Associates
4410 Walnut Hill Ln.
Dallas, TX 75229
Telephone 214.351.4870

Sanders Studio
PO Box 670501
Dallas, TX 75367
Telephone: 972.233.1777
sanders-studio.com

Shaun Christopher Designs
6593 Garlinghouse Ln.
Dallas, TX 75252
Telephone 214.597.9059
shaun-christopher.com

To capture the soul of the Tuscan countryside as well as to greet guests in style, artist Allan Rodewald hand painted chair backs, each slightly different.

Straight Stitch
2910 Belmeade Dr., #105
Carrollton, TX 75006
Telephone 972.416.6124

BATH FITTINGS

Czech & Speake
244/254 Cambridge Heath Rd.
London E2 9DA
Telephone 44.20.8983.7400
czechandspeake.com

Herbeau Creations of America
3600 Westview Dr.
Naples, FL 34104
Telephone 800.547.1608
herbeau.com

Kallista, Inc.
1227 North 8th St., #2
Sheboygan, WI 53081
Telephone 888.4.Kallista
kallistainc.com

Sherle Wagner, International
300 E. 62nd St.
New York, NY 10065
Telephone 212.758.3300
sherlewagner.com

Sunrise Specialty
930 98th Ave.
Oakland, CA 94603
Telephone 510.729.7277
sunrisespecialty.com

Urban Archeology
143 Franklin St.
New York, NY 10013
Telephone 212.431.4646
urbanarchaeology.com

Waterworks
60 Backus Ave.
Danbury, CT 06810
Telephone 800.899.6757
waterworks.com

CARPETS

Abrash Rugs
1025 N. Stemmons Frwy., #760
Dallas, TX 75207
Telephone 214.573.6262
abrashrugs.com

Asmara, Inc.
108 Clematis Ave., #C
Boston, MA 02453
Telephone 800.451.7240
asmarainc.com

Beauvais Carpets
595 Madison Ave.
New York, NY 10022
Telephone 212.688.2265
beauvaiscarpets.com

Carol Piper Rugs, Inc.
1809 W. Gray St.
Houston, TX 77019
Telephone 713.524.2442
carolpiperrugs.com

Design Materials
241 S. 55th St.
Kansas City, KA 66106
Telephone 913.342.9796
dmifloors.com

Farzin Rugs & Design
1414 Slocum St.
Dallas, TX 75207
Telephone 214.747.1511
Farzinrugs.com

Hokanson
5120 Woodway Rd., #190
Houston, TX 77056
Telephone 800.255.5720
hokansoncarpet.com

Mansour
8600 Melrose Ave.
Los Angeles, CA 90069
Telephone 310.652.9999
mansourrug.com

Mark, Inc.
34 E. Putnam Ave.
Greenwich, CT 06830
Telephone 203.861.0110
markinccarpets.com

Matt Camron Rugs and Tapestries
2702 Sackett St.
Houston, TX 77098
Telephone 713.528.2666
mattcamron.com

Patterson, Flynn, & Martin
979 Third Ave., #632
New York, NY 10022
Telephone 212.688.7700
Pattersonflynnmartin.com

Renaissance Collection
1532 Hi Line Dr.
Dallas, TX 75207
Telephone 214.698.1000
rencollection.com

Stark Carpet
979 Third Ave.
New York, NY 10022
Telephone 212.752.9000
starkcarpet.com

Stephen Miller Gallery
800 Santa Cruz Ave.
Menlo Park, CA 94025
Telephone 650.327.5040
stephenmillergallery.com

DECORATIVE HARDWARE

Atlas Homewares
1310 Cypress Ave.
Los Angeles, CA 90065
Telephone 818.240.3500
atlastothetrade.com

E. R. Butler & Co., Inc.
38 Charles St.
Boston, MA 02114
Telephone 617.722.0230
erbutler.com

Manor House
188 S. Main St.
Collierville, TN 38017
Telephone 901.861.1957
manorhouseusa.com

With patrician good looks conjuring up images of old-world splendor, a tablecloth from the fabric house of Fortuny begs for an eclectic group worthy of the setting. In 1988, Fortuny's headquarters moved to New York City. Production, however, remains on the Venetian island of Giudecca, where mystery shrouds hand-printing techniques, only natural vegetable dyes are used and retouching is done by hand, *metro by metro.*

Nanz Custom Hardware
20 Vandam St.
New York, NY 10013
Telephone 212.367.7000
nanz.com

Notting Hill
PO Box 1376
Lake Geneva, WI 53147
Telephone 262.248.8890
nottinghill-usa.com

P. E. Guerin, Inc.
23 Jane St.
New York, NY 10014
Telephone 212.243.5270
peguerin.com

Palmer Designs
7863 Herschel Ave.
La Jolla, CA 92037
Telephone 858.551.1350
palmer-design.com

FABRICS & FURNITURE

Artistic Frame
979 Third Ave, 17th Fl.
New York, NY 10022
Telephone 212.289.2100
artisticframe.com

B. Berger Fabrics
1380 Highland Rd.
Macedonia, OH 44056
Telephone 330.425.3838
bberger.com

Beacon Hill
225 Foxboro Blvd.
Foxboro, MA 02035
Telephone 800.333.3777
beaconhilldesign.com

Bennison Fabrics, Inc.
232 E. 59th St.
New York, NY 10022
Telephone 212.223.0373
bennisonfabrics.com

Bergamo Fabrics, Inc.
265 Washington St.
Mount Vernon, NY 10553
Telephone 914.665.0800
bergamofabrics.com

Boussac Fadini
1692 Chantilly Dr. #C
Atlanta, GA 30324
Telephone 866.707.1524
pierrefrey.com

Brentano Inc.
260 Holbrook Dr.
Wheeling, IL 60090
Telephone 847.657.8481
brentanofabrics.com

Brillant USA
117 Littlejohn St.
Spartanburg, SC 29301
Telephone 864.278.8162
brillantusa.com

Brunschwig & Fils, Inc.
245 Central Ave. So.
Bethpage, NY 11714
Telephone 800.538.1880
brunschwig.com

The Cameron Collection
1025 N. Stemmons Frwy., #150
Dallas, TX 75207
Telephone 214.744.1544
cameroncollection.com

Carlton V, Ltd.
979 Third Ave., #1532
New York, NY 10022
Telephone 212.355.4525
carletonvltd.com

Charles Pollock Reproductions, Inc.
6824 Lexington Ave.
Los Angeles, CA 90038
Telephone 323.962.0440
charlespollockrepro.com

Christopher Hyland, Inc.
979 Third Ave., #1710
New York, NY 10022
Telephone 212.688.6121
christopherhyland.com

Clarence House, Inc.
979 Third Ave., #205
New York, NY 10022
Telephone 212.752.2890
clarencehouse.com

Coraggio Textiles
PO Box 3332
Bellevue, WA 98009
Telephone 800.624.2420
coraggio.com

Cowtan & Tout
205 Hudson St., 6th Fl.
New York, NY 10013
Telephone 212.647.6900
cowtan.com

Delany & Long, Ltd.
41 Chestnut St.
Greenwich, CT 06830
Telephone 203.532.0010
delanyandlong.com

Dennis & Leen
8720 Melrose Ave.
Los Angeles, CA 90069
Telephone 310.652.0855
dennisandleen.com

Designers Guild Ltd.
3 Latimer Pl.
Greater London W10 6QT, U.K.
Telephone 44.207.893.7400
designersguild.com

Donghia, Inc.
256 Washington St.
Mount Vernon, NY 10553
Telephone 914.662.2377
donghia.com

Dransfield and Ross, Ltd.
54 W. 21st St.
New York, NY 10010
Telephone 212.741.7278
dransfieldandross.biz

Elizabeth Dow, Ltd.
11 Indian Wells Hwy.
Amagansett, NY 11930
Telephone 631.267.3401
elizabethdow.com

Erika Brunson
5115 W. Adams Blvd.
Los Angeles, CA 90016
Telephone 323.931.3225
erikabrunson.com

F. Schumacher & Co.
79 Madison Ave.
New York, NY 10016
Telephone 212.213.7900
fschumacher.com

The Farmhouse Collection, Inc.
PO Box 3089
Twin Falls, ID 83303
Telephone 208.736.8700
farmhousecollection.com

The Florio Collection
8815 Dorrington Ave.
West Hollywood, CA 90048
Telephone 310.273.8003
floriocollection.com

Fortuny, Inc.
979 Third Ave., #1632
New York, NY 10022
Telephone 212.753.7153
fortuny.com

GP & J Baker House
6 Stinsford Rd.
Poole, Dorset BH17 OSW, U.K.
Telephone 44.120.226.6700
gpjbaker.com

Giati Designs, Inc
6398 Cindy Ln.
Carpinteria, CA 93013
Telephone 805.684.8349
giati.com

Glant Textiles Corporation
PO Box 84228
Seattle, WA 98124
Telephone 206.725.4444
glant.com

Gregorius/ Pineo
5873 Blackwelder St.
Culver City, CA 90232
Telephone 310.204.0400
gregoriuspineo.com

Hamilton, Inc.
8417 Melrose Pl.
Los Angeles, CA 90069
Telephone 323.655.9193
thehouseofhamilton.net

Henry Calvin Fabrics
2046 Lars Way
Medford, OR 97501
Telephone 541.732.1996
henrycalvin.com

Hinson & Company
181 Westchester Ave.
Portchester, NY 10573
Telephone 914.881.1470
hinsonco.com

Holly Hunt
801 W. Adams St., #300
Chicago, IL 60607
Telephone 800.320.3145
hollyhunt.com

Indulge Maison Decor
2903 Saint St.
Houston, TX 77027
713.888.0181
indulgedecor.com

J. Robert Scott
500 N. Oak St.
Inglewood, CA 90302
Telephone 310.680.4300
jrobertscott.com

Jab USA
155 E. 56th St., #102
New York, NY 10022
Telephone 718.706.7000
jab.de.com

Jane Churchill
205 Hudson St., 6th Fl.
New York, NY 10013
Telephone 212.647.6900
janechurchill.com

Jane Keltner
94 Cumberland Blvd.
Memphis, TN 38112
Telephone 800.487.8033
janekeltner.com

Jane Shelton
205 Catchings Ave.
Indianola, MS 38751
Telephone 800.530.7259
janeshelton.com

Jayson Home & Garden
1885 N. Clybourn Ave.
Chicago, IL 60614
Telephone 773.248.8180
jaysonhome.com

Jim Thompson
1694 Chantilly Dr.
Atlanta, GA 30324
Telephone 800.262.0336
jimthompson.com

John Derian
6 East 2nd St.
New York, NY 10003
Telephone 212.677.3917
johnderian.com

Kerr Collection
150 Turtle Creek Blvd., #204
Dallas, TX 75207
Telephone 214.741.4850
kerrcollection.com

Kravet Fabrics, Inc.
225 Central Ave. So.
Bethpage, NY 11714
Telephone 516.293.2000
kravet.com

Lee Jofa
225 Central Ave. So.
Bethpage, NY 11714
Telephone 800.453.3563
leejofa.com

Malabar Fabrics
8A Trowbridge Dr.
Bethel, CT 06801
Telephone 877.625.2227
malabar.co.uk

Manuel Canovas
111 Eighth Ave., #930
New York, NY 10011
Telephone 212.647.6900
manuelcanovas.com

Maria Flora
Via Q Sella 20
13856 Vigliano Biellese-Italy
Telephone 39.015.897.6271
mariaflora.com

Marroquin Custom Upholstery
4835 Reading St.
Dallas, TX 75247
Telephone 214.905.0461
marroquincustomuph.com

Marvic Textiles, Ltd.
31 Westpoint Trading Estate
Alliance Rd.
London W3 ORA UK
Telephone 44.20.8993.0191
marvictextiles.co.uk

Michael Taylor Designs
155 Rhode Island St.
San Francisco, CA 94103
Telephone 415.558.9940
michaeltaylordesigns.com

Minton Spidell, Inc.
8467 Steller Dr.
Culver City, CA 90232
Telephone 310.836.0403
minton-spidell.com

Mokum Textiles
6-10 Akepiro St.
Mt. Eden, Auckland 1026
New Zealand
Telephone 866.523.4437
mokumtextiles.com

Murray's Iron Works
1801 E. 50th St.
Los Angeles, CA 90058
Telephone 323.521.1140
murraysiw.com

Nancy Corzine
256 W. Ivy Ave.
Inglewood, CA 90302
Telephone 310.672.6775
nancycorzine.com

Niermann Weeks
760 Generals Hwy.
Millersville, MD 21108
Telephone 410.923.0123
niermannweeks.com

Nobilis, Inc.
3006 Emrick Blvd
Bethlehem, PA 18020
Telephone 800.464.6670
nobilis.fr

Old World Weavers
D&D Building
979 Third Ave., 10th Fl.
New York, NY 10022
Telephone 212.752.9000
old-world-weavers.com

Osborne & Little
90 Commerce Rd.
Stamford, CT 06902
Telephone 203.359.1500
osborneandlittle.com

Patina, Inc.
1876 Defoor Ave., #3
Atlanta, GA 30318
Telephone 404.233.1085
patinainc.com

Perennials Outdoor Fabrics
140 Regal Row
Dallas, TX 75247
Telephone 214.638.4162
perennialsfabrics.com

Peter Fasano, Ltd.
964 S. Main St.
Great Barrington, MA 01230
Telephone 413.528.6872
peterfasano.com

Pierre Frey, Ltd.
12 E. 32nd St.
New York, NY 10016
Telephone 212.213.3099
pierrefrey.com

Pindler & Pindler, Inc.
11910 Poindexter Ave.
Moorpark, CA 93021
Telephone 805.531.9090
pindler.com

Pintura Studio
207 East 4th St.
New York, NY 10009
Telephone 212.995.8655
pinturastudio@msn.com

Quadrille Wallpapers & Fabrics, Inc.
50 Dey Street, Building One
Jersey City, NJ 07306
Telephone 201.792.5959
quadrillefabrics.com

Ralph Lauren Home
650 Madison Ave.
New York, NY 10022
Telephone 800.377.7656
ralphlauren.com

Randolph & Hein, Inc.
2222 Palou Ave.
San Francisco, CA 94124
Telephone 866.844.9921
randolphhein.com

Raoul Textiles
8687 Melrose Ave., #G-160
West Hollywood, CA 90069
Telephone 310.657.4931
raoultextiles.com

Renaissance Collection
1523 Hi Line Dr.
Dallas, TX 75207
Telephone 214.698.1000
rencollection.com

Robert Allen Fabrics
225 Foxboro Blvd.
Foxboro, MA 02035
Telephone 800.333.3777
robertallendesign.com

Rodolph
999 West Spain St.
PO Box 1249
Sonoma, CA 95476
Telephone 707.935.0316
rodolph.com

Roger Arlington, Inc.
30-10 41st Ave., #2R
Long Island City, NY 11101
Telephone 718.729.5554
rogerarlington.com

Rogers & Goffigon, Ltd.
41 Chestnut St., #3
Greenwich, CT 06830
Telephone 203.532.8068

Rose Cumming Fabrics
232 E. 59th St., 5th Fl.
New York, NY 10022
Telephone 212.758.0844
rosecumming.com

Rose Tarlow Textiles
8540 Melrose Ave.
Los Angeles, CA 90069
Telephone 323.651.2202
rosetarlow.com

Scalamandré
350 Wireless Blvd.
Hauppauge, NY 11788
Telephone 631.467.8800
scalamandre.com

Stroheim & Romann, Inc.
30-30 47th Ave.
New York, NY 11101
Telephone 718.706.7000
stroheim.com

Summer Hill, Ltd
1374 Willow Rd.
Menlo Park, CA 94025
Telephone 650.462.9600
summerhill.com

Travers & Company
979 Third Ave., #915
New York, NY 10022
Telephone 212.888.7900
traversinc.com

York Wallcoverings
750 Linden Ave.
York, PA 17404
Telephone 717.846.4456
yorkwall.com

Zimmer + Rohde
15 Commerce Rd.
Stamford, CT 06902
Telephone 203.327.1400
zimmer-rohde.com

GARDEN ORNAMENTS

Archiped Classis
154 Glass St., #100
Dallas, TX 75207
Telephone 214.748.7437
archipedclassics.com

Elizabeth Street Gallery
209 Elizabeth St.
New York, NY 10012
Telephone 212.941.4800
elizabethstreetgallery.com

Lexington Gardens
1011 Lexington Ave.
New York, NY 10021
Telephone 212.861.4390
lexingtongardensnyc.com

Pittet Architecturals
318 Cole St.
Dallas, TX 75207
Telephone214.651.7999
pittetarch.com

Tancredi & Morgen
7174 Carmel Valley Rd.
Carmel Valley, CA 93923
Telephone 831.625.4477
tancredimorgen.com

IRON WORK

Brun Metal Crafts, Inc.
2791 Industrial Ln.
Bloomfield, CO 80020
Telephone 303.466.2513

Cole Smith, FAIA and ASID
Smith, Ekblad & Associates
2719 Laclede St.
Dallas, TX 75204
Telephone 214.871.0305
smithekblad.com

Iron Age Studios
4528 Crosstown Expwy.
Dallas, TX 75223
Telephone 214.827.8860
ironagemetal.com

Among the list of rules meant to be broken by a beloved pet that knows a thing or two about bona fide luxury, is jumping on the bed. To avoid having him trespass on one's personal space while getting comfy-cozy, pillowcases with His, Hers and Ours are worth fetching or hand painting.

Ironies
2222 5th St.
Berkeley, CA 94710
Telephone 510.644.2100
ironies.com

Murray's Iron Work
1801 E. 50th St.
Los Angeles, CA 90058
Telephone 323.521.1100
murraysiw.com

LINENS

Casa Del Bianco
866 Lexington Ave.
New York, NY 10021
Telephone 212.249.9224
casadelbianco.com

Casa di Lino
4026 Oak Lawn Ave.
Dallas, TX 75219
Telephone 214.252.0404
casadilino.com

D. Porthault, Inc.
18 E. 69th St.
New York, NY 10021
Telephone 212.688.1660
d-porthault.com

E. Braun & Co.
484 Park Ave.
New York, NY 10022
Telephone 212.838.0650
ebraunandco.com

Frette
850 Third Ave., 10th Fl.
New York, NY 10022
Telephone 212.299.0400
frette.com

Léron Linens
979 Third Ave., Ste. 1521
New York, NY 10022
Telephone 212.753.6700
leron.com

Matouk
925 Airport Rd.
Fall River, MA 02720
Telephone 508.997.3444
matouk.com

Pratesi
829 Madison Ave.
New York, NY 10021
Telephone 212.288.2315
pratesi.com

Sharyn Blond Linens
2718 W. 53rd St.
Fairway, KS 66205
Telephone 913.362.4420
sharynblondlinens.com

Schweitzer Linen
457 Columbus Ave.
New York, NY 10024
Telephone 212.570.0236
schweitzerlinen.com

Sferra Fine Linens
15 Mayfield Ave.
Edison, NJ 08837
Telephone 732.225.6290
sferra.com

Yves Delorme
1725 Broadway Ave.
Charlottesville, VA 22902
Telephone 800.322.3911
yvesdelorme.com

LIGHTING, LAMPS, AND CUSTOM LAMP SHADES

Ann Morris Antiques
239 E. 60th St.
New York, NY 10022
Telephone 212.755.3308
Annmorrisantiques.1stdibs.com

Bella Shades/Bella Copia
255 Kansas St.
San Francisco, CA 94103
Telephone 415.255.0452

Brown
2940 Ferndale St.
Houston, TX 77098
Telephone 713.522.2151
theshopbybrown.com

Cele Johnson Custom Lamps and Shades
1410 Dragon St.
Dallas, TX 75207
Telephone 214.651.1645

I Lite 4 U
12620 Westminster Ave., #D
Santa Ana, CA 92706
Telephone 714.554.5909
ilite4u.com

Jayson Home & Garden
1885 N. Clybourne Ave.
Chicago, IL 60614
Telephone 773.248.8180
jaysonhome.com

Marvin Alexander, Inc.
315 E. 62nd St., 2nd Fl.
New York, NY 10065
Telephone 212.838.2320
marvinalexanderinc.com

Murray's Iron Work
1801 E. 50th St.
Los Angeles, CA 90058
Telephone 323.521.1100
murraysiw.com

Nesle Inc.
38-15 30th St.
Long Island City, NY 11101
Telephone 212.755.0515
nesleinc.com

Niermann Weeks
760 Generals Hwy.
Millersville, MD 21108
Telephone 410.923.0123
niermannweeks.com

Panache
8687 Melrose Ave.
Los Angeles, CA 90069
Telephone 310.659.1700
panache-designs.com

Paul Ferrante, Inc.
8464 Melrose Pl.
Los Angeles, CA 90069
Telephone 323.653.4142
paulferrante.com

Pettigrew Associates
1805 Market Center Blvd.
Dallas, TX 75207
Telephone 214-745-1351
pettigrew-usa.com

Thomas Grant Chandeliers, Inc.
1804 Hi Line Dr.
Dallas, TX 75207
Telephone 214.651.1937
thomasgrantchandeliers.com

Urban Electric Co.
2130 N. Hobson Ave.
N. Charleston, SC 29405
Telephone 843.723.8140
urbanelectricco.com

Vaughan Designs, Inc.
979 Third Ave., Ste. 1511
New York, NY 10022
Telephone 212.319.7070
vaughandesigns.com

STONE AND TILE

Ann Sacks Tile & Stone Inc.
8120 N.E. 33rd Dr.
Portland, OR 97211
Telephone 800.278.8453
annsacks.com

Architectural Design Resources
2808 Richmond Ave., #E
Houston, TX 77098
Telephone 713.877.8366
adrhouston.com

Country Floors
15 E. 16th St.
New York, NY 10003
Telephone 212.627.8300
countryfloors.com

It is no secret that as children the French learn patience. Picking up on Gallic ways, we believe in taking time and care to find those significant additions that help pull a room together, rather than crowding a setting with a dizzying array of meaningless accessories. An understated look, meanwhile, can draw attention to furnishings such as these antique Swedish demilunes (one unseen) glazed in the traditional manner to reflect light. Cele Johnson Custom Lamp & Shades fabricated the shade.

Exquisite Surfaces
289 N. Robertson Blvd.
Beverly Hills, CA 90211
Telephone 310.659.4580
exquisitesurfaces.com

Galerie Origines
F78550 Richebourg-Houdan
Telephone 33.130.881.515
galerie@origines.fr

Materials Marketing
120 W. Josephine St.
San Antonio, TX 78212
Telephone 800-368-3901
mstoneandtile.com

M.A. Tile & Stone Design
2120 Las Palmas Dr., #H
Carlsbad, CA 92011
Telephone 760.268.0811

New Ravenna Mosaics
PO Box 1000
Exmore, VA 23350
Telephone 757.442.3379
newravenna.com

Paris Ceramics USA Inc.
150 East 58th St.
New York, NY 10155
Telephone 212.644.2782
parisceramicsusa.com

Renaissance Tile & Bath
349 Peachtree Hills Ave., N.E.
Atlanta, GA 30305
Telephone 404.231.9203
renaissancetileandbath.com

Unique Stone Imports
1130 W. Morena Blvd.
San Diego, CA 92110
Telephone 619.275.8300
uniquestoneimports-sd.com

Walker Zanger, Inc.
8901 Bradley Ave.
Sun Valley, CA 91352
Telephone 818.252.4000
walkerzanger.com

Waterworks
60 Backus Ave.
Danbury, CT 06810
Telephone 800.899.6757
waterworks.com

TRIMMINGS AND PASSEMENTERIE

Ellen S. Holt, Inc.
1013 Slocum St.
Dallas, TX 75207
Telephone 214.741.1804
ellensholt.com

Houlès USA Inc.
979 Third Ave.
New York, NY 10022
Telephone 212.935.3900
houles.com

Janet Yonaty
8642 Melrose Ave.
West Hollywood, CA 90069
Telephone 310.659.5422
janetyonaty.com

Kenneth Meyer Company
325 Vermont St.
San Francisco, CA 94103
Telephone 415.861.0118
kennethmeyer.com

Leslie Hannon Custom Trimmings
665 Vetter Ln.
Arroyo Grande, CA 93420
Telephone 805.489.8400
lesliehannontrims.com

M & J Trimming
1008 6th Avenue
New York, NY 10018
Telephone 212.204.9595
mjtrim.com

Renaissance Ribbons
PO Box 699
Oregon House, CA 95962
Telephone 530.692.0842
renaissanceribbons.com

Samuel & Sons
983 Third Ave.
New York, NY 10022
Telephone 212.704.8000
samuelandsons.com

West Coast Trimming Corp.
7100 Wilson Ave.
Los Angeles, CA 90001
Telephone 323.587.0701
westcoasttrimming.com

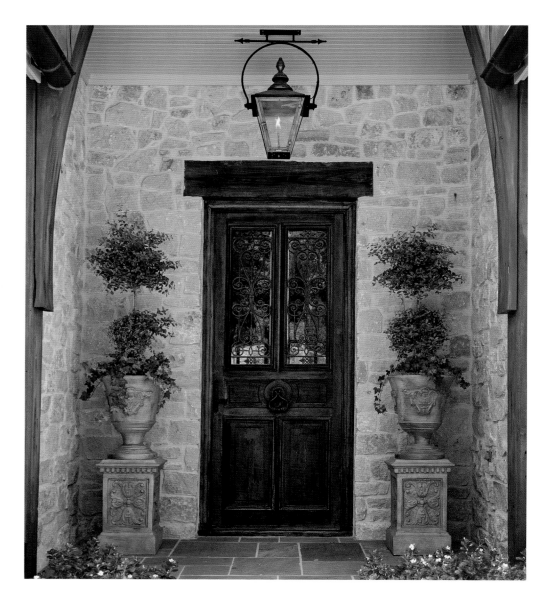

Taking a cue from those animal advocates pushing dog safety, these devoted pet parents leave nothing to chance, such as someone inadvertently stepping on Maximus's paws, whose size can surely work against him. Though many American dogs may lead privileged lives, nowhere is the impulse to spoil one's most loyal friend more apparent than in France. Moustaches—a department store in Paris's 4th *arrondissement,* dedicated solely to style-conscious dogs and their cat cousins—attests to that. If Paris is not in one's travel plans, Diggidy Dog, in Carmel-by-the Sea, California, is also hard to beat.

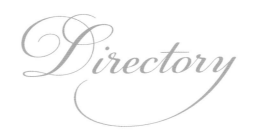

Directory

INTERIOR DESIGN

Betty Lou Phillips, ASID
Andrea Smith Overly, ASID
INTERIORS by BLP
4200 St. Johns Drive
Dallas, Texas 75205
Telephone: 214.599.0191
www.Bettylouphillips.com

Marilyn Phillips
Loren Interiors
1125 River Bend Drive
Houston, Texas 77063
Telephone: 713.973.6475
www.marilynphillipsinteriors.com

Traditionally, *pots de confit* were utilitarian pieces used for preserving duck or goose for *cassoulet*—a classic stew—in the South of France. The bottom halves of the pots were unglazed, so the contents remained cool when cooks buried the pots halfway in the ground throughout the summer. Today these old jars sporting cracks and chips of time are prized by antiques hunters.

ARCHITECTS

Kenneth A. Newberry, AIA, LEED AP
Troy M. Campa AIA
Newberry Campa Architects, LLC
708 East 19th Avenue
Houston, Texas 77008
Telephone: 713.862.7992
www.Newberrycampa.com

Ryan Street
Ryan Street & Associates
2414 Exposition Boulevard
Suite B-140
Austin, Texas 78703
Telephone: 512.421.0800
www.rsassoc.com

DESIGNER CREDITS

Betty Lou Phillips and **Andrea Smith:**
Front Jacket, Title Page, Back Jacket, 9, 10, 11, 14, 18, 20, 21, 22, 23, 24, 26, 27, 28, 29, 30, 31, 33, 34, 35, 36, 37, 38, 39, 40, 42, 44–45, 46, 47, 48, 49, 50, 51, 52, 53 54, 55, 56–57, 58, 59, 60–61, 64–65, 66, 67, 69 70, 71 72, 73 74–75, 76, 77, 78, 79, 80, 81, 82, 83, 84, 85, 86, 88, 89, 94, 111, 112, 113, 114, 115, 128, 130–131, 132, 133, 134, 135, 136, 137, 138, 139, 140, 141, 142, 143, 144, 146, 147, 148, 149, 151, 152, 153, 154, 155, 156, 157, 158, 159, 160, 161, 162–163, 164, 165, 166, 167, 168, 169, 174, 175, 176, 177, 178, 179, 180, 184, 185, 187, 188, 189, 190, 191, 192, 193, 194, 195, 197, 198, 199, 200, 201, 202, 203, 204–205, 206–207, 208, 209, 212, 213, 214, 218, 223, 227, 231, 233, 234, 235.

Marilyn Phillips:
Pages 4, 5, Opposite Contents Page, 97, 98, 99, 100, 101, 102, 103, 105, 106–107, 108–109, 116, 121, 215, 240.

ARCHITECT PHOTOGRAPHIC CREDITS

Kenneth A. Newberry and **Troy M. Campa:**
Page 5, Opposite Contents Page, 97, 98, 99, 100, 101, 102, 103, 105, 106–107, 108–109, 116, 121, 215, 240.

Ryan Street:
128, 130, 131, 132, 133, 134, 135, 136, 137, 138, 139, 140, 141, 142, 143, 146, 147, 148, 149, 151, 152, 153, 155, 156, 157, 158, 159, 160, 161, 162–163, 165, 167, 168–169, 174–175, 176, 177, 178, 179.

PHOTOGRAPHY CREDITS

Betty Lou Phillips:
12, 15, 16, 17, 90, 91, 93, 118, 119, 120, 122, 123, 125, 126, 134 Top, 146 Left, 161 Right, 170, 172, 173, 190 Top Left, Top Right, Lower Left, 195 Bottom, 210, 216, 217, 221, 228, 236, 239.

Dan Piassick:
Front Jacket, Title Page, Back Jacket, 4, 5, 6, 9, 10, 11, 14, 20, 22, 23, 24, 28, 33, 36, 39, 42, 44, 45, 46, 47, 48, 49, 50, 51, 52, 53, 54, 55, 56–57, 58, 59 , 60–61, 62, 64–65, 66, 67, 69, 70, 71, 72, 73, 74–75, 76, 77, 78, 79, 80, 81, 82, 83, 84, 85, 86, 88, 89, 94, 97, 98, 99, 100, 101, 102, 103, 105, 106–107, 108–109, 111, 116, 121, 138 Top Right, 139, 140, 141, 144 Upper Left, Upper Right, 146 Top, 147, 148, 149, 153, 154 Top, 157 Right, 158 Top, 159, 161 Top, 167, 178, 179, 193, 194, 197, 198, 199, 200, 201, 203, 204–205, 206–207, 208, 212, 213, 214, 215, 218, 223, 224, 227, 231, 233, 234, 235, 240.

Scott Womack:
18, 21, 26, 27, 29, 30, 31, 34, 35, 37, 38, 40, 112, 113, 114, 115, 128, 130, 131, 132, 133, 134 Left, 135, 136, 137, 138 Upper Left, Lower Left, 142, 143, 144 Lower Right, 146 Left, 152, 154 Upper Right, Lower Right, 155, 156, 157 Top, 158 Left, 160, 162–163, 164, 165, 166, 168–169, 174, 175, 176, 177, 180, 182, 183, 184, 185, 187, 188, 189, 190, 191, 192, 195 Top, 202, 209, 225.

First Edition
16 15 14 13 12 5 4 3 2

Text © 2012 by Betty Lou Phillips
Photographic credits on page 237

Published by
Gibbs Smith
P.O. Box 667
Layton, Utah 84041

1.800.835.4993 orders
www.gibbs-smith.com

Pages designed by Cherie Hanson
Jacket front designed by Sheryl Dickert
Printed and bound in China
Gibbs Smith books are printed on either recycled, 100% post-consumer waste, FSC-certified papers or on paper produced from sustainable PEFC-certified forest/controlled wood source. Learn more at www.pefc.org.

Library of Congress Cataloging-in-Publication Data

Phillips, Betty Lou.
 The allure of French and Italian décor / Betty Lou Phillips. — First Edition.
 pages cm
 ISBN 978-1-4236-2318-2
 1. Interior decoration—United States—History—21st century.
 2. Decoration and ornament—France—Influence.
 3. Decoration and ornament—Italy—Influence. I. Title.
 NK2004.P537 2012
 747.0944—dc23
 2012011668

A cascade of geraniums, though in the States, is befitting a home in Italy or a window box in the South of France.

Au revoir and *arrivederci* for now. Thank you for joining me on this Grand Tour.